David Bowie
The Illustrated Biography

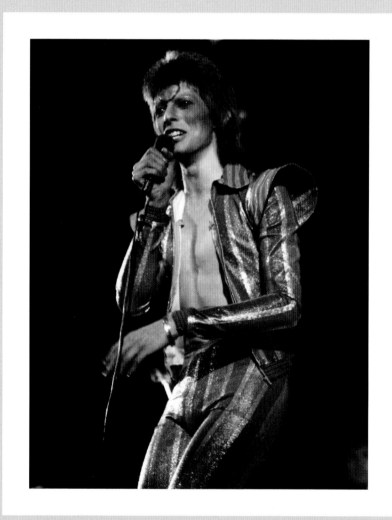

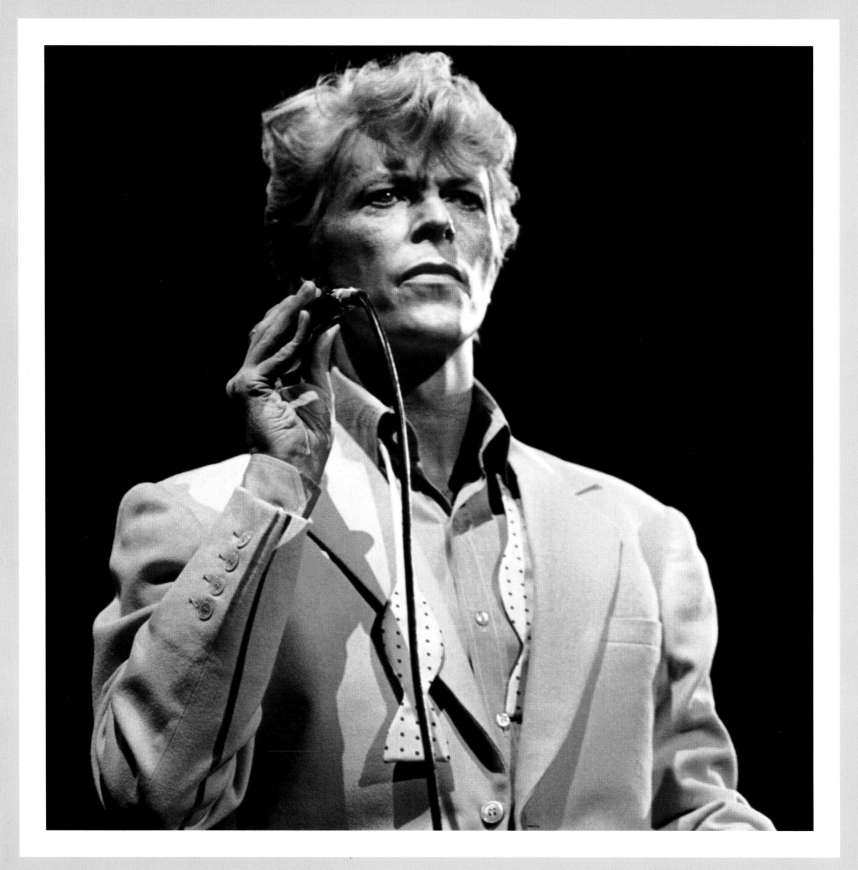

David Bowie
The Illustrated Biography

GARETH THOMAS

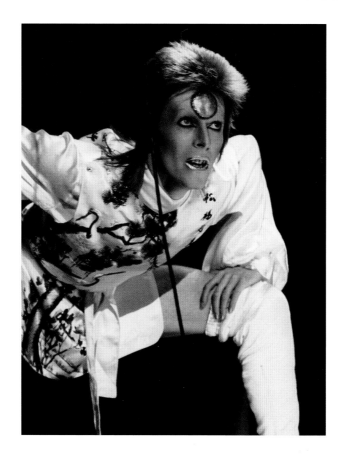

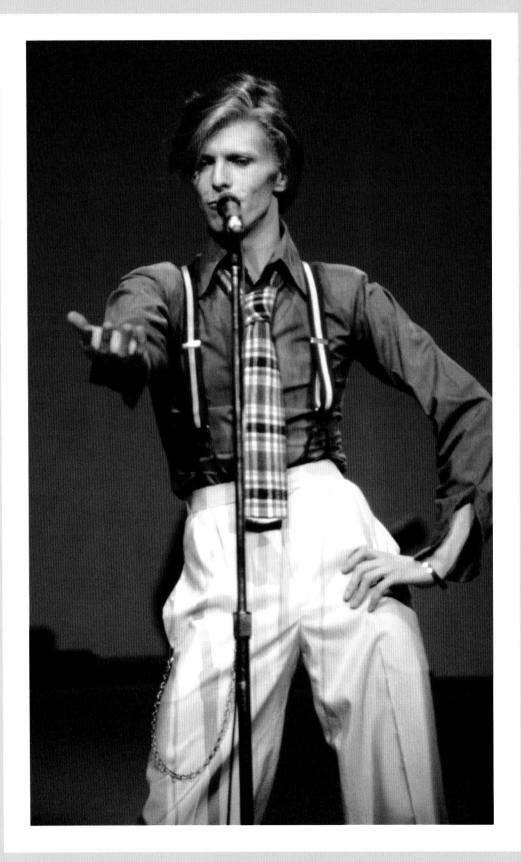

This edition published by Welcome Rain Publishers LLC 2011

First published by Transatlantic Press in 2011

Transatlantic Press
38 Copthorne Road
Croxley Green
Hertfordshire
WD3 4AQ, UK

© Transatlantic Press
For photograph copyrights see page 224

ISBN 978-1-56649-093-1

Printed and bound in China

Contents

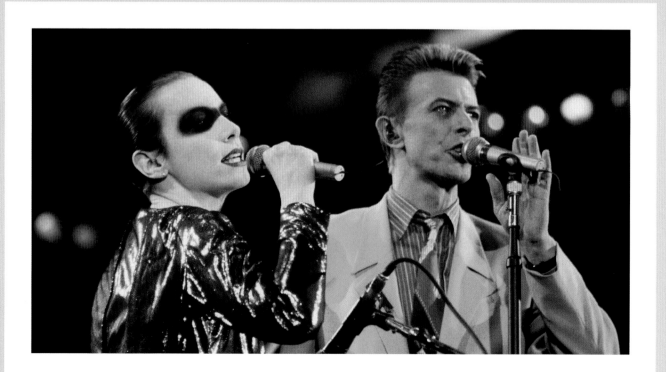

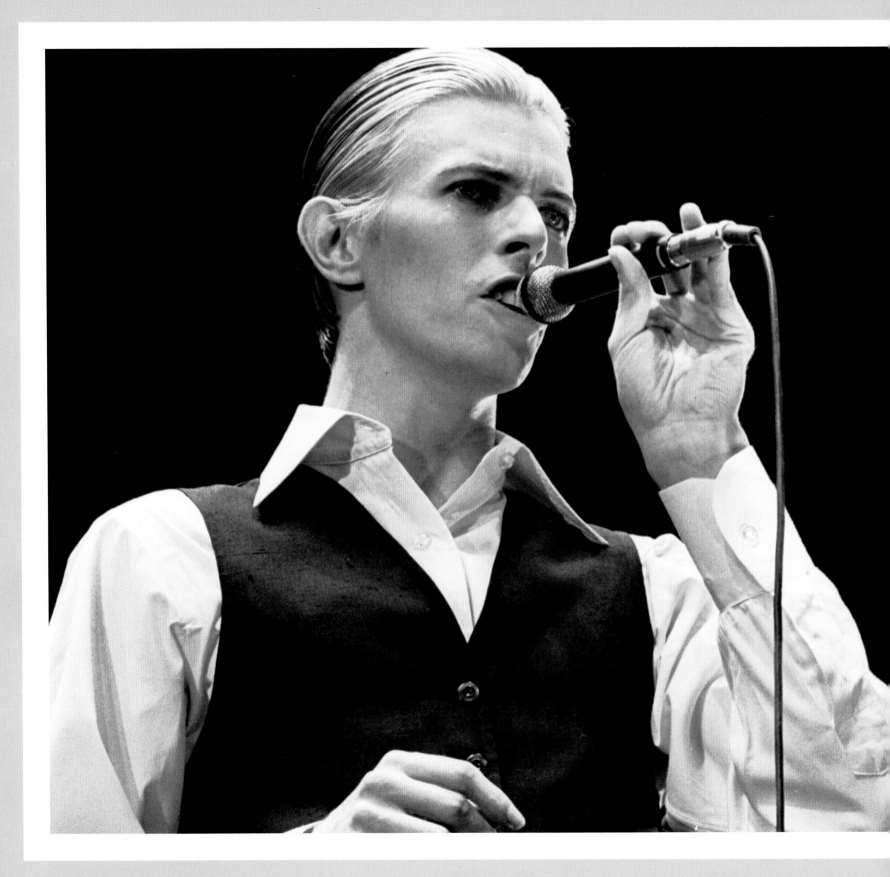

Introduction

Born David Jones in Brixton, South London, in 1947, David Bowie has been a major figure in popular music for some five decades, during which time his name has become synonymous with experimentation and reinvention. Both musical magpie and innovator, all too often Bowie has been described as "The Chameleon of Pop", but while he has presented us with a variety of striking onstage personas and musical styles, Bowie's exploration of themes such as existential angst, spirituality and otherness remain constant throughout his song writing. In this light, Bowie's career could be seen as a continued quest for authenticity through artifice, rather than a succession of self-reinventions. He has successfully incorporated a degree of theatricality in his performances rarely encountered in rock, and his inventive approach in the studio has also seen him carve out a successful career as an arranger and producer. In addition, Bowie's fascination with a wide range of creative pursuits has allowed him to enjoy considerable acclaim as an actor on both stage and screen, and won him praise as a painter of some talent.

During the 1960s, David struggled to find his niche, restlessly moving from one band to another before finally scoring a major hit with "Space Oddity" in 1969, but it would be several years before he cemented his reputation with the alter-ego Ziggy Stardust; an androgynous proto-punk rocker that turned David Bowie into a household name and one of the most commercially successful artists of the early 1970s. By the middle of the decade, Bowie had broken America with his blue-eyed "plastic soul", but the radical change in direction came at the cost of alienating many of his original fans, a gamble compounded by the minimalist experimentation of "The Berlin Trilogy" – a trio of albums recorded with Brian Eno in the late 1970s. During the early 1980s, Bowie reached a commercial peak with the LP *Let's Dance*, but two follow-up albums left him looking for a new direction, which prompted the formation of the uncompromising (and much criticized) Tin Machine. His musical passions reignited, in the 1990s Bowie continued to confound expectations by releasing albums infused with industrial rock and drum and bass, while more recently, LPs such as 2002's *Heathen* and his last release to date, *Reality* in 2003, have been cited as being amongst his best works.

Bowie's success has not always come easily, or consistently, but his determination, inimitable style and a willingness to take risks for his art, coupled with his own wit, charm and intelligence, have secured him an enduring and unique place in the history of popular music and mark him out as a true cultural icon.

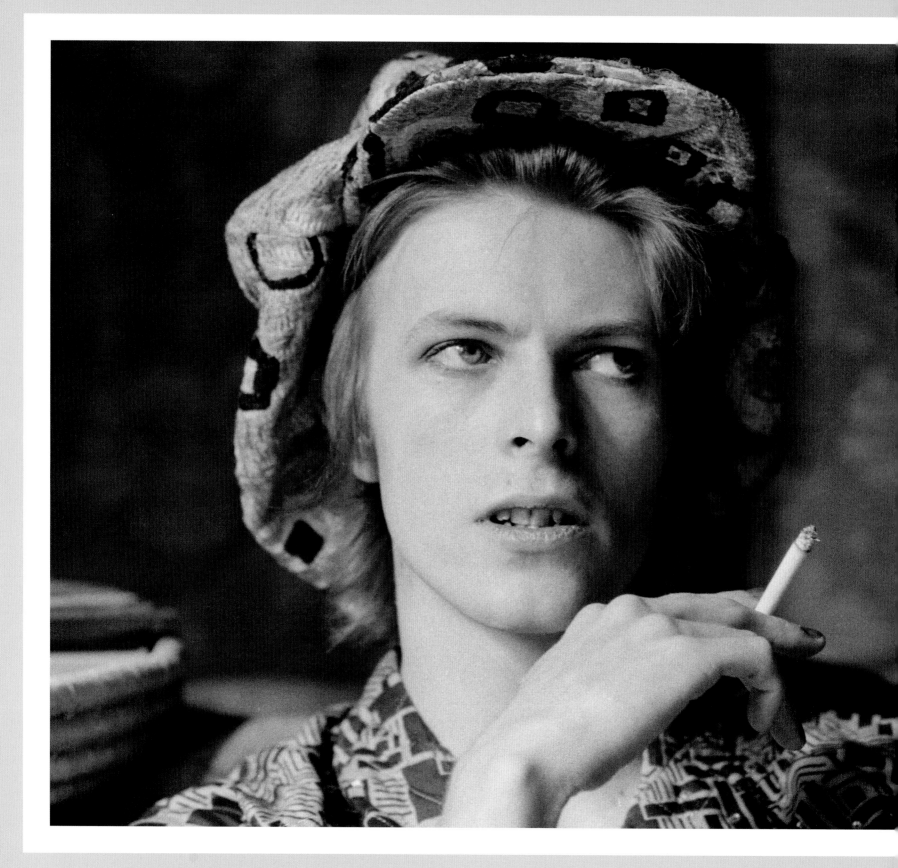

Chapter One

Changes

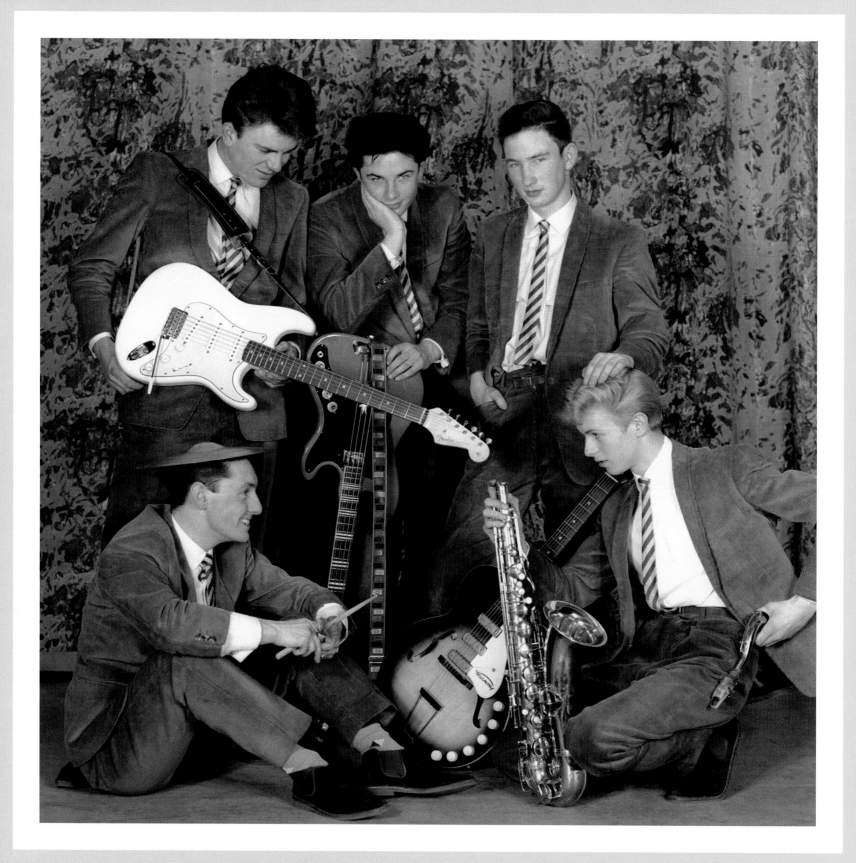

Starting point

As a young boy, David Jones had listened intently to his mother sing at home and had been taken to see performances by both Tommy Steele and Anthony Newley. These early influences were augmented as the rock and roll craze swept across Britain, with Elvis Presley and Little Richard becoming particular favourites. David was also introduced to jazz by his half-brother Terry, and in late 1961 he received his first saxophone as a gift from his father, who had his own connections to the entertainment world through his charity work for Barnardos. Despite sustaining an eye injury in a fight with his friend George Underwood, David joined Underwood's band the Konrads in 1962, and had soon adopted his first stage name, "Dave Jay". By 1963 Underwood had been replaced by Roger Ferris and the group had built a fairly substantial local following, but a failed audition at Decca studios would prompt David to leave the band and reunite with his old friend. Their earlier altercation may have left David's left pupil permanently dilated, but it had not seriously damaged their friendship.

Right and opposite: Publicity shots of The Konrads at Stepney Assembly Rooms, February 1963.

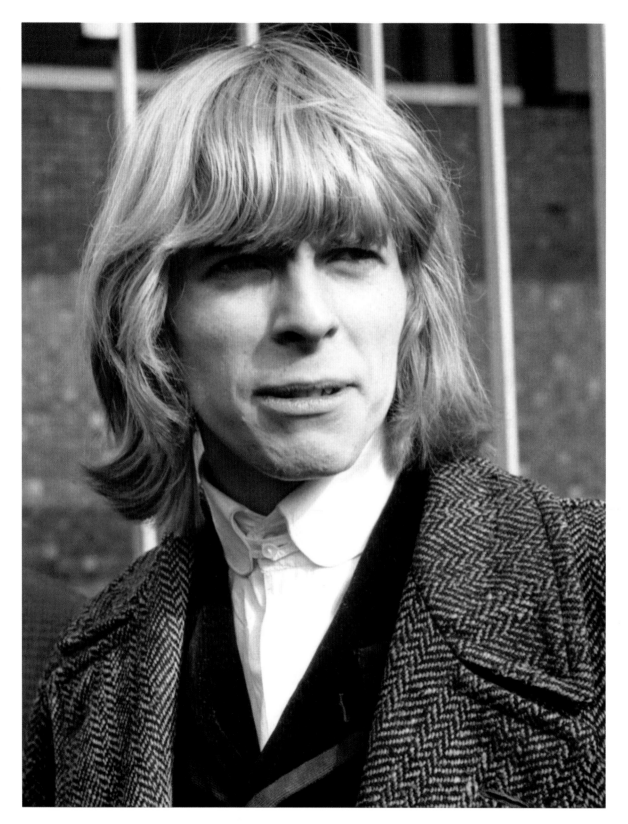

Manish Boys

Opposite and left: Davie Jones and The Manish Boys with TV producer Barry Langford, March 1965.

After stints as The Hooker Brothers and Dave's Reds and Blues, David and George Underwood went on to form The King Bees in 1964. They were now performing in a harder rhythm and blues style and soon attracted the attention of the music publisher and talent scout Leslie Conn. In June, with Conn acting as their manager, The King Bees released their first single, "Liza Jane", which led to television appearances on *Ready Steady Go!* and *Juke Box Jury*, but when the single failed to sell, David decided to join a new group, The Manish Boys. In December, Davie Jones and The Manish Boys embarked upon a short package tour supporting Gerry and The Pacemakers, The Kinks and Marianne Faithful, and the following month they recorded the single "I Pity The Fool" with Kinks' producer Shel Talmy. The record, which also featured session guitarist Jimmy Page, earned The Manish Boys an appearance on the BBC TV show *Gadzooks! It's All Happening*, but owing to a stunt that David had helped to orchestrate, the band received more publicity for the length of their hair than for their musical ability.

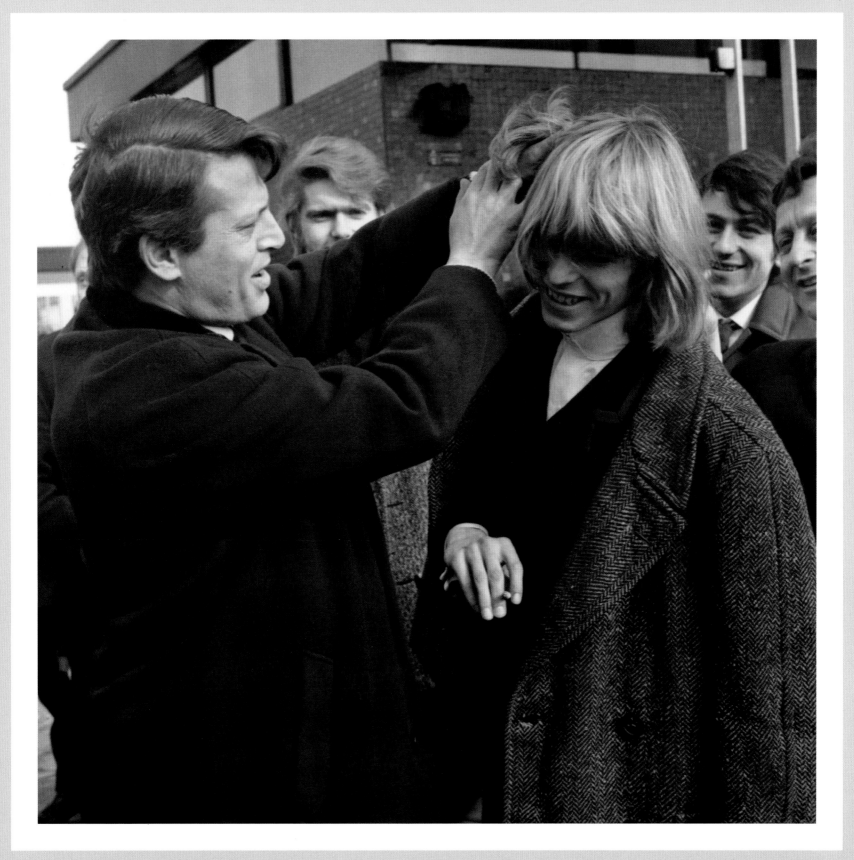

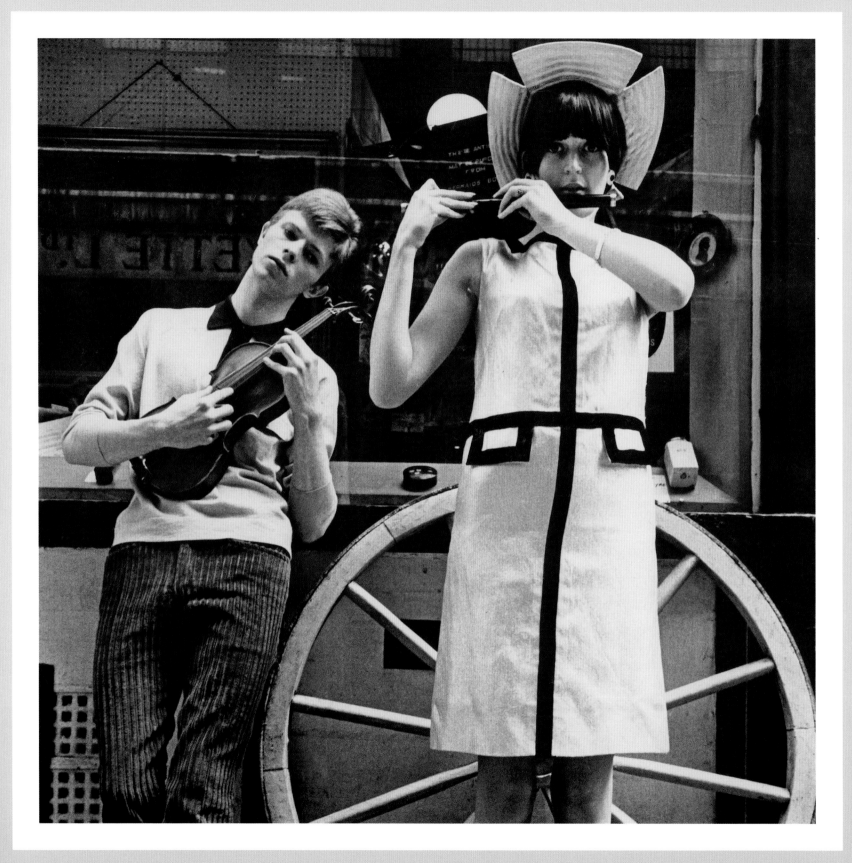

Making a name

Opposite: David joins Jan De Souza for a magazine modelling assignment in Kingly Street, London, October 1965.

By May 1965 David had become increasingly disenchanted with his tenure in The Manish Boys and had decided once again to move on. He successfully auditioned as the lead singer for The Lower Third, and with the help of agent Ralph Horton the group secured a series of gigs supporting such acts as Johnny Kidd and the Pirates, The Pretty Things and The Who. The Lower Third shared a similar look and sound to The Who, but in one of two magazine interviews published that autumn, David was keen to point out that he did not consider himself to be a mod.

In mid-September following the release of another single, "You've Got a Habit of Leaving", Horton helped David to obtain a songwriting deal and the pair then turned to the established agent Kenneth Pitt for support. At this stage, Pitt's only real advice was that David might consider a name change, but it was to prove an auspicious suggestion, for on 21 October 1965, "David Bowie" took to the stage for the very first time. The following January, David and The Lower Third recorded a new single with Tony Hatch at Pye Records, but the band split soon afterwards, and when David appeared on *Ready Steady Go!* to promote "Can't Help Thinking About Me" he did so with his new band, The Buzz.

Right: David performing with The Buzz on *Ready Steady Go!,* March 1966.

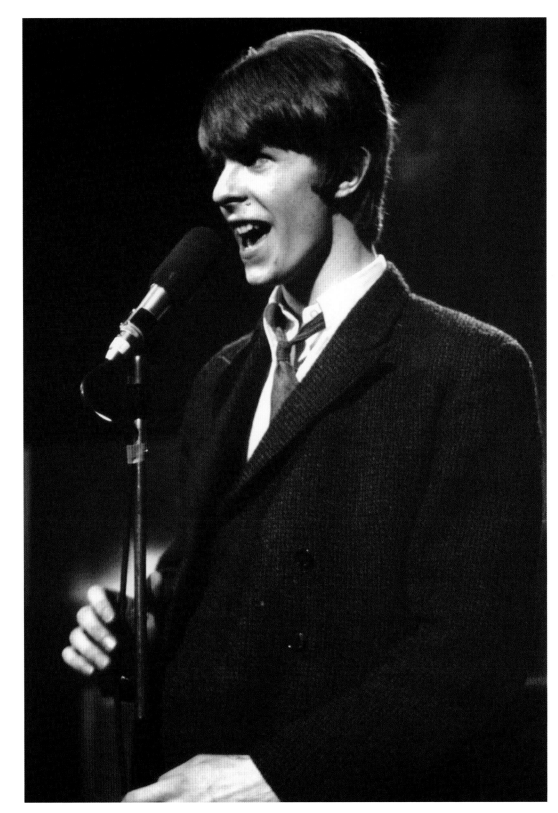

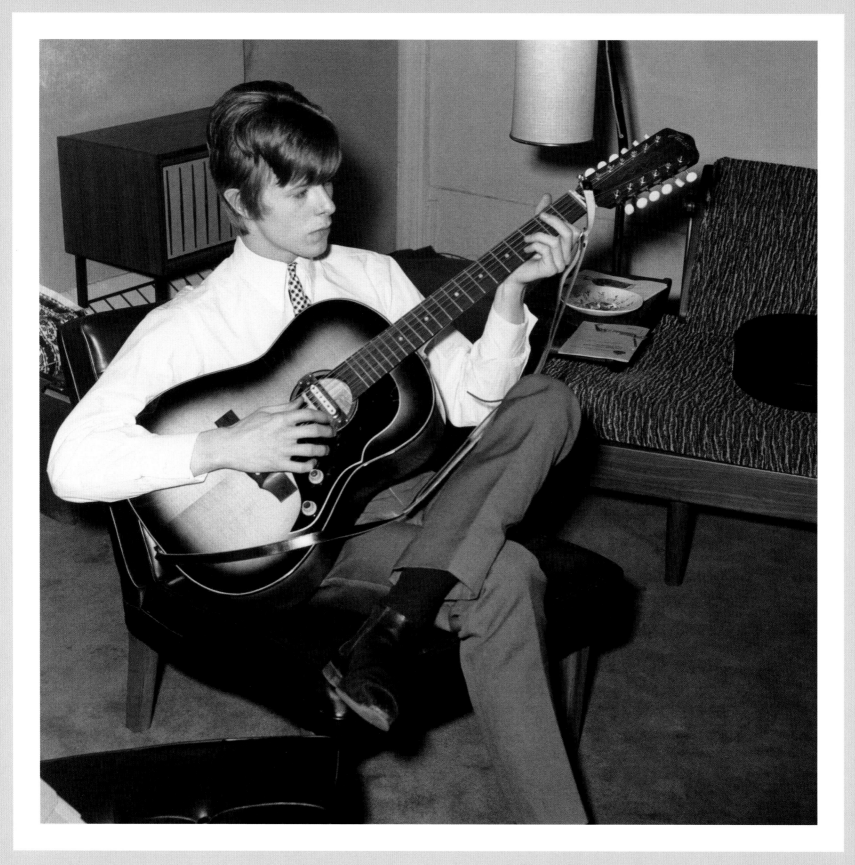

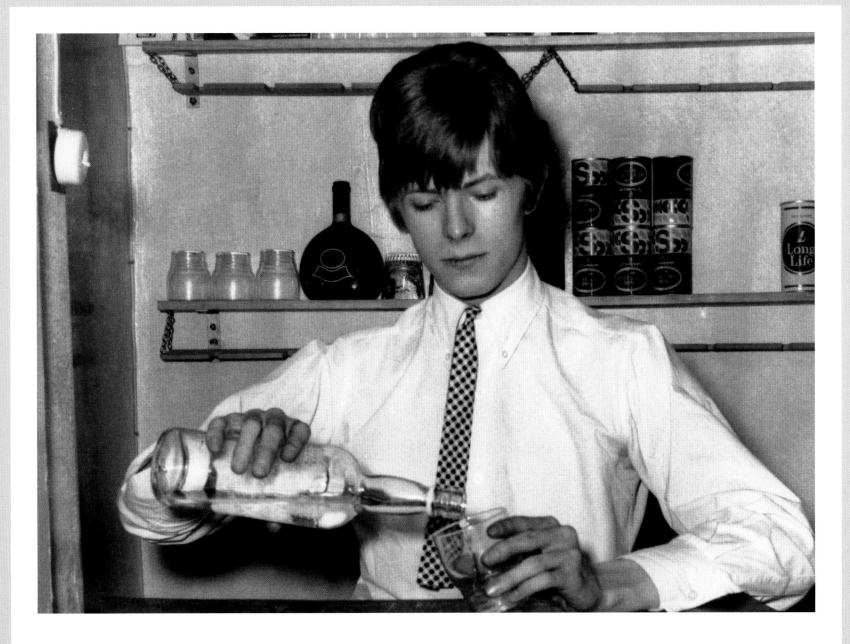

Under new management

Hot on the heels of his first solo single "Do Anything You Say", and taking his cue from Pink Floyd's Spontaneous Underground shows, David launched a Sunday residency at London's Marquee Club in April 1966 under the banner "The Bowie Showboat". Kenneth Pitt attended the second of these shows and was instantly won over; agreeing to co-manage Bowie alongside Ralph Horton. An experienced manager, Pitt was able to offer David both advice and financial support but, perhaps more importantly, he fostered Bowie's interests in theatre, art and literature, and would help to shape him as a cabaret performer as much as a pop star.

In August, David released another single, the upbeat "I Dig Everything" but, after disappointing sales, Horton and Pitt were able to negotiate his release from Pye with relative ease and quickly arranged for their budding star and his group to record some fresh material. In mid-October, David Bowie and The Buzz laid down a handful of new tracks at R.G. Jones's Oak Studios and before the month was out Bowie found himself signing an album contract with Deram, Decca's progressive new subsidiary.

Opposite and above: David pictured at Ken Pitt's London flat in 1966.

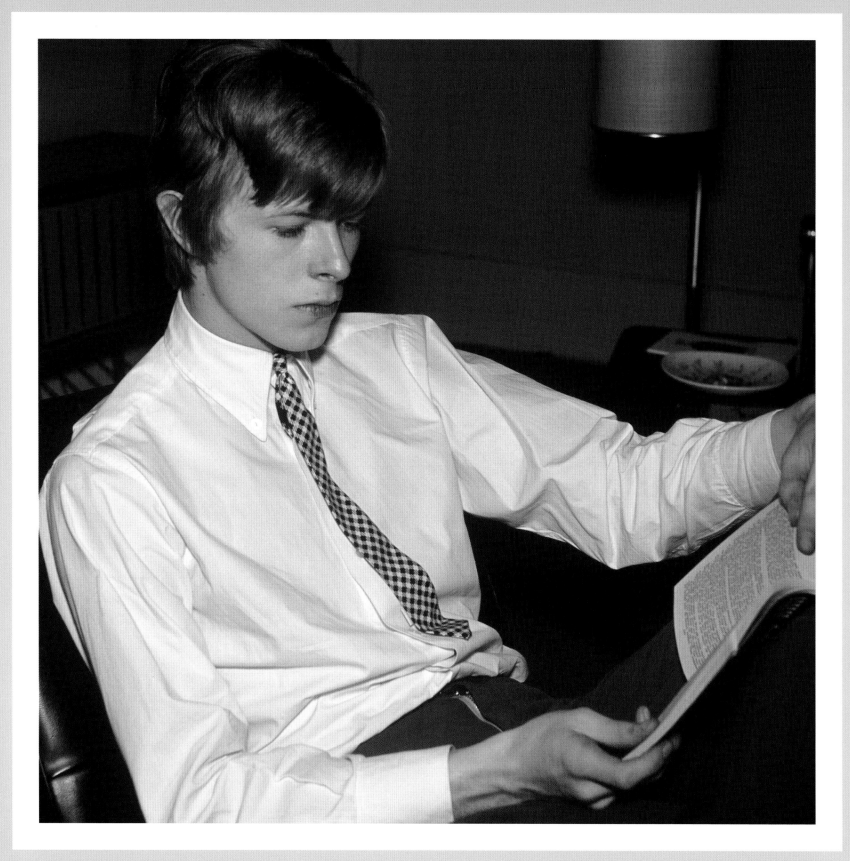

Debut album

Opposite: David pictured at Ken Pitt's London apartment.

In late 1966 Bowie entered the studio to record his eponymous debut album with the producer Mike Vernon, who had previously worked with Anthony Newley. Bowie was heartened by this, but when his first Deram single "Rubber Band" was issued on 2 December, some critics drew unfavourable comparison between the two singers. With his sights now firmly set on a solo career, he played his last gig with The Buzz that same day, although members of the group continued to work on the LP.

By the time of the album release in June 1967, David had begun to appear on stage with The Riot Squad, and as the year progressed, his experimentation with theatrical elements such as make-up, props and mime increased. He was also keen to extend his repertoire, and by the end of the year he had featured in the short film *The Image* and made his theatre debut in Lindsay Kemp's *Pierrot in Turquoise*. In early 1968 David went on to appear in the BBC2 play *The Pistol Shot* alongside Hermione Farthingale, and as a romance blossomed between them, they formed the music and mime act Turquoise alongside guitarist Tony Hill. He was quickly replaced by John Hutchinson, however, and the trio took the name Feathers. Around the same time, Bowie also secured a walk-on part in John Dexter's film *The Virgin Soldiers*.

Right: David sporting cropped hair and army fatigues for his role in *The Virgin Soldiers*.

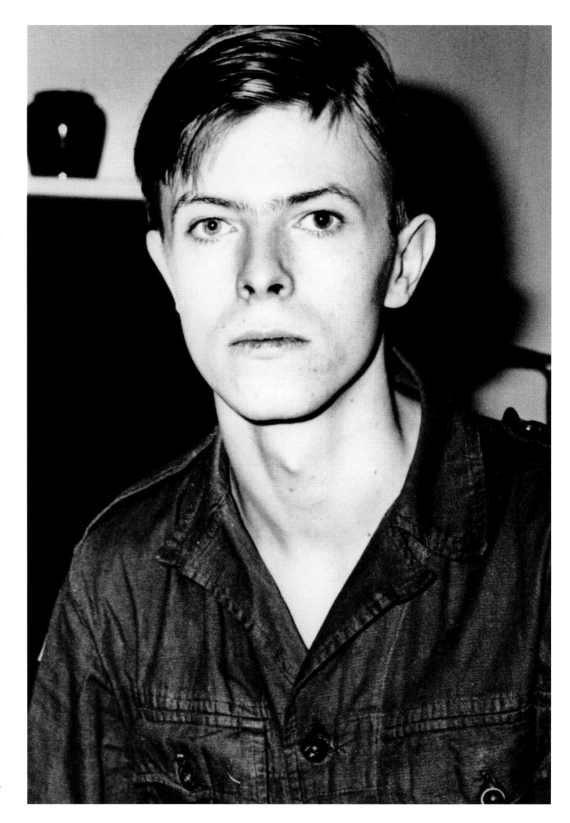

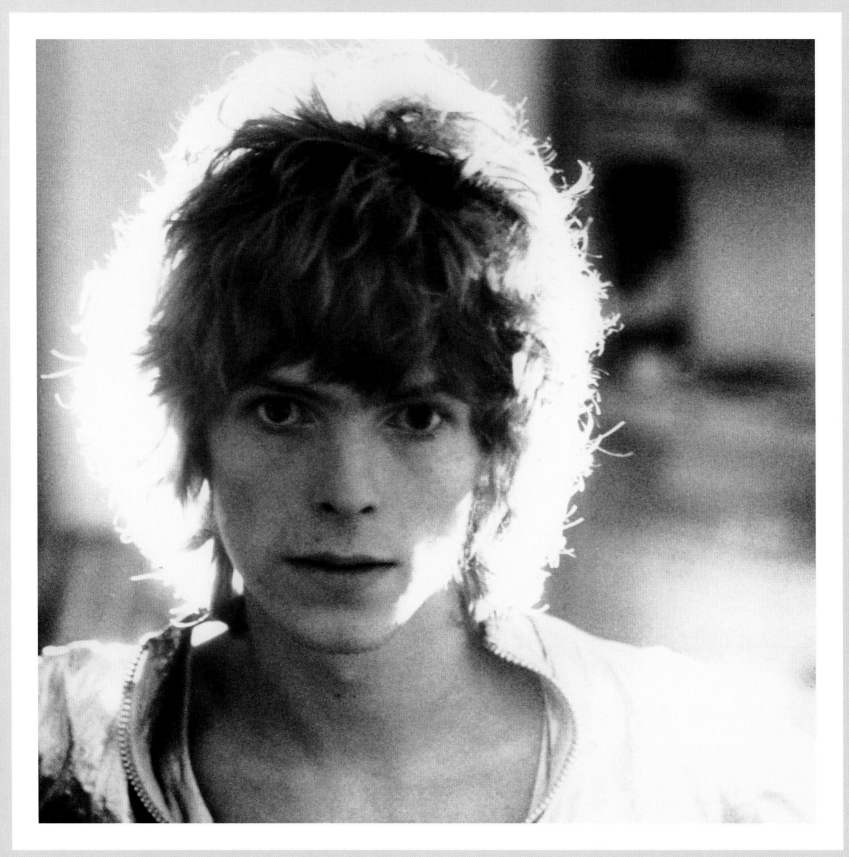

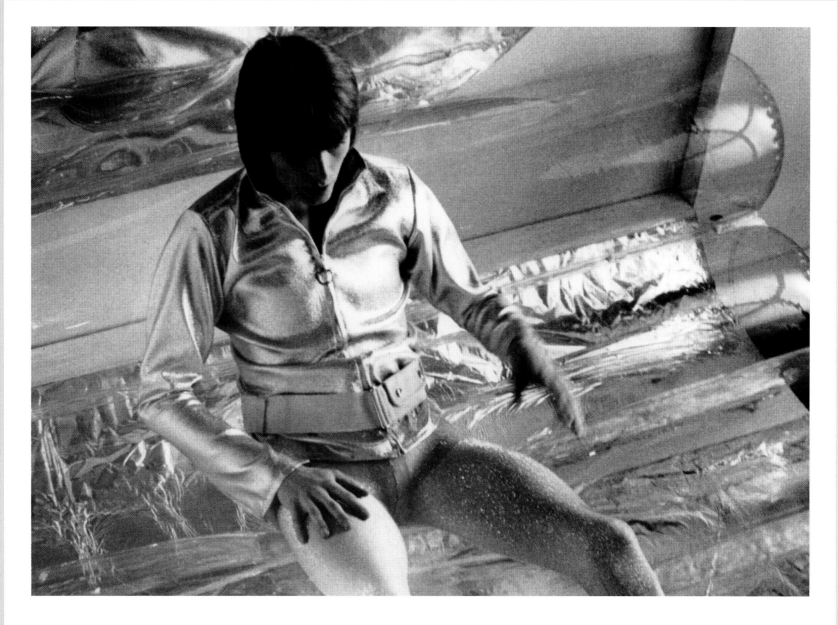

Space Oddity

Soon after the release of his first album, Bowie began to work with the American musician and producer Tony Visconti, with whom he would develop a productive working relationship. However, no singles would be issued in 1968, and as 1969 dawned it seemed that David's career might have stalled before it had ever really got going. He had made numerous appearances on television and radio, enjoyed film and theatre parts, and in addition to having secured a publishing deal for his songs, he had released almost ten singles and an LP, but despite all of this David Bowie was still not the household name that he longed to be. As a result, in early 1969 David and Ken Pitt hit upon the idea of recording the promotional film

Love You Till Tuesday, which they hoped to sell to television networks in both the UK and Europe. Directed by Pitt's friend Malcolm J. Thomson, the film showcased excerpts from Bowie's mime act alongside a number of his compositions. These included four songs from his first album and some new material, most notably the song "Space Oddity", which he had written in response to watching Stanley Kubrick's movie *2001: a Space Odyssey*.

Above and opposite: Bowie pictured during the filming of the "Space Oddity" sequence for his promotional movie.

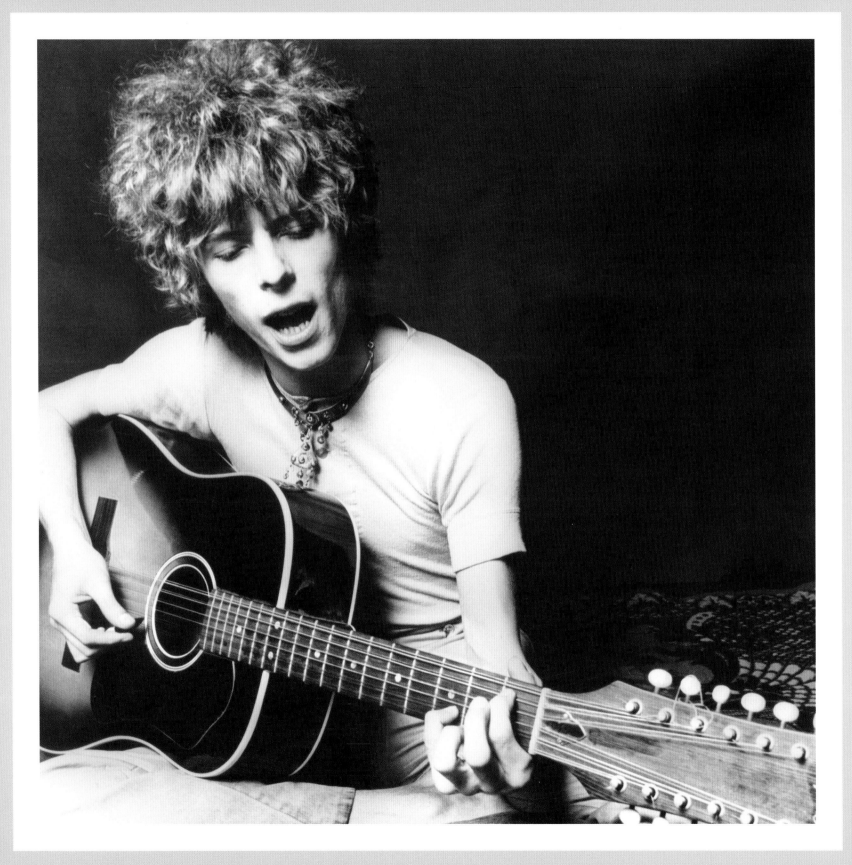

New partnerships

Right and opposite: Bowie promoting his new single "Space Oddity" in Holland.

By the time Bowie had completed work on the *Love You Till Tuesday* project in February 1969, his relationship with Hermione had ended and Feathers had disbanded. Nevertheless, he continued to perform with guitarist John Hutchinson as "David Bowie and Hutch" and to put on further solo mime shows, including support slots for Tyrannosaurus Rex. Although devastated by his break-up with Hermione, soon afterwards David enjoyed a brief romance with the journalist Mary Finnegan, and then began dating a young woman named Angela Barnett. By the summer, Bowie and Finnegan had launched a series of "Arts Labs" at the Three Tuns pub in Beckenham, while his demo of "Space Oddity" had secured him a new recording contract with Mercury Records. The single was released in July and employed by the BBC to accompany the historic footage of the moon landings on the 20th of that month. A few days later Bowie headed off for two music competitions in Europe, and returned on 3 August with a prize for the best produced record. Although pleased with his success, David's joy quickly turned to sadness, for just two days later his father died of pneumonia.

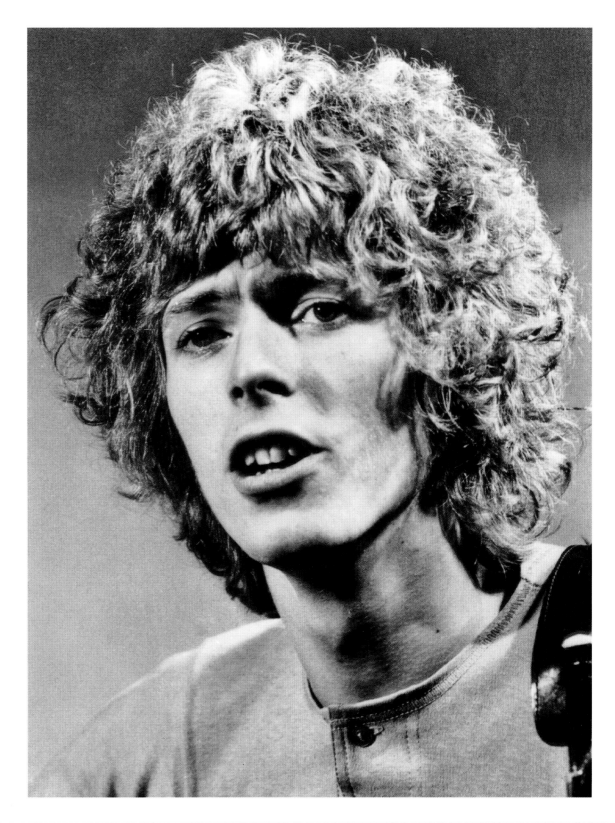

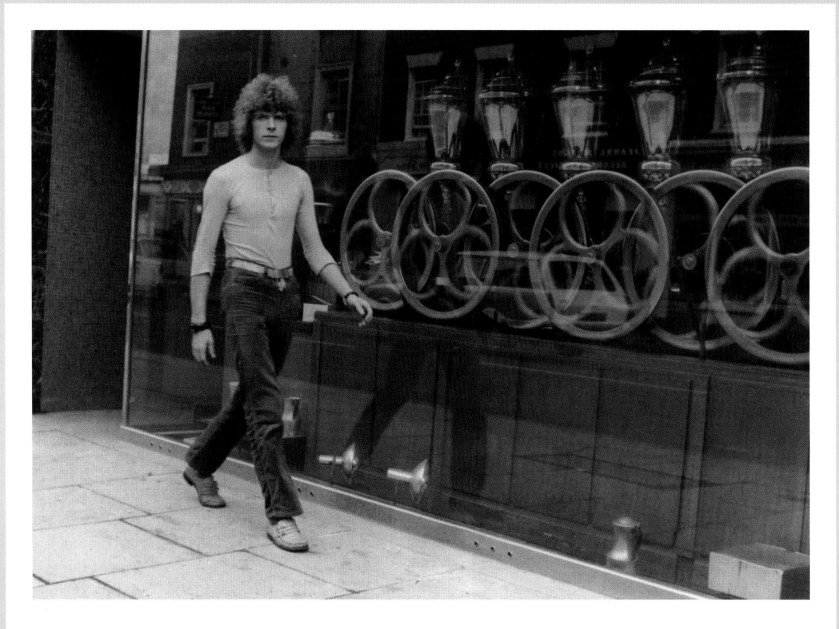

New ventures

Above: David passing Varner's Coffee Shop, a popular haunt for jobbing musicians in 1960s London. Almost immediately after his father's death, Bowie, who had still been living with Mary Finnegan in Beckenham, moved to nearby Haddon Hall with Angela. The couple rented the ground floor of this Victorian redbrick mansion, where they busied themselves with the organisation of the Beckenham Free Festival. Featuring performances from Comus, The Strawbs, Keith Christmas and Bridget St John, the festival took place on 16 August and was essentially a fundraiser for Bowie's Beckenham Arts Lab. Despite his grief, he compèred the event and also gave a solo performance, during which he previewed

a number of songs that he had been working on for his forthcoming second album. At this time, Bowie's "Space Oddity" was still yet to enter the charts, and there was even talk of withdrawing it from sale, but with increased airplay the song soon began to attract attention from the press and public alike. Soon after the festival, Bowie travelled to Amsterdam to perform on Dutch TV, gave interviews to Radio One and *Record Mirror*, and by the end of September the single had entered the top 30.

Opposite: Posing outside the Lincoln Inn, close to Ken Pitt's Manchester Street apartment, London.

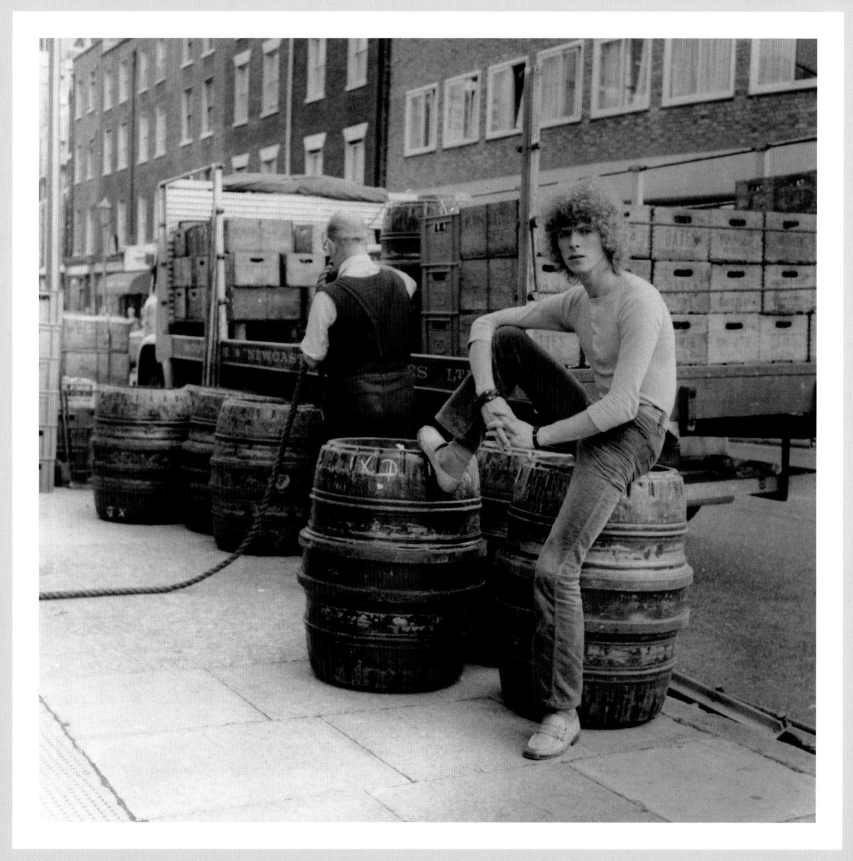

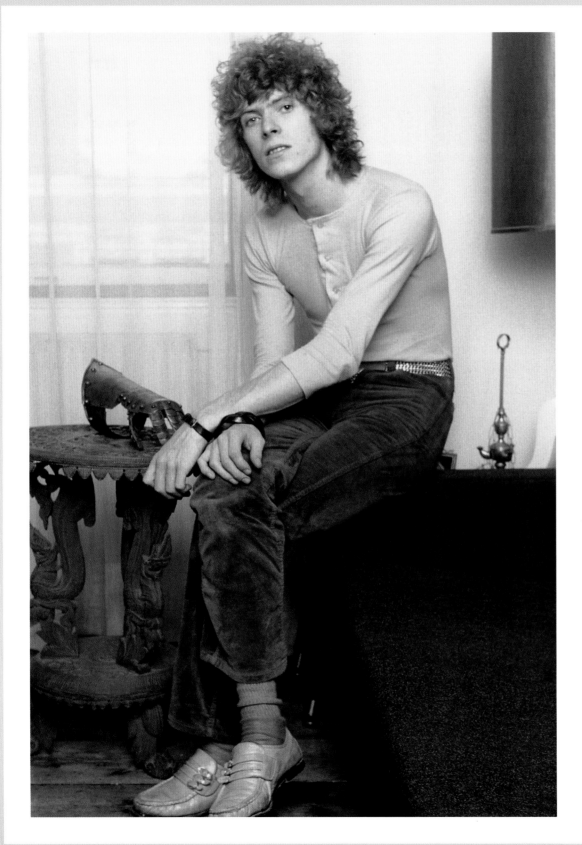

A taste of success

Left: David Bowie in Ken Pitt's apartment. With "Space Oddity" finally rising up the UK singles charts, Bowie was asked to record his first appearance for *Top of the Pops* on 2 October, to be broadcast the following week. He duly obliged, appearing in a silver catsuit borrowed from his friend Calvin Mark Lee, and was filmed playing both the stylophone and guitar. It was this performance that finally catapulted David into the limelight, and earned him favourable notice across the music press. Articles appeared in the *Disc & Music Echo*, *Record Mirror*, *Melody Maker*, and also the *NME*, for which he was photographed in and around Ken Pitt's apartment by Stuart Richman.

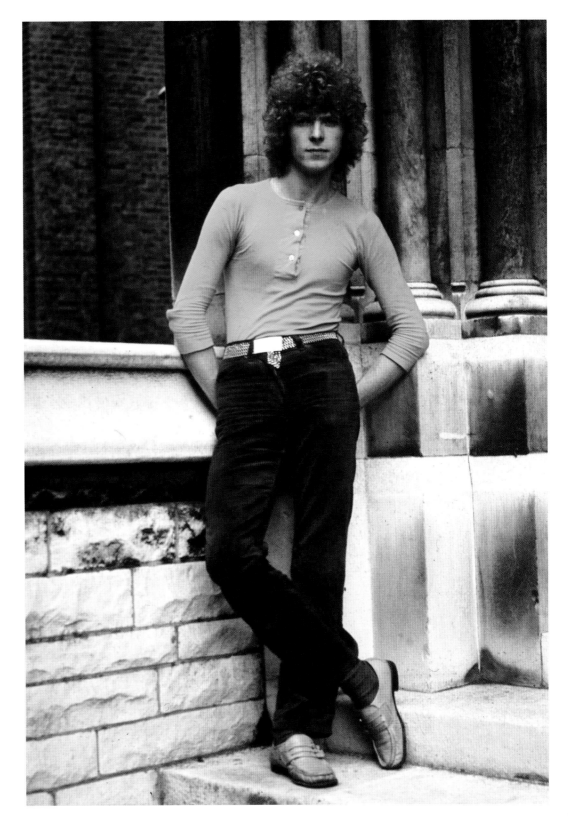

At the Palladium

Right: David Bowie pictured on the steps of the Catholic church on George Street, near Ken Pitt's apartment. Following the positive press coverage he embarked upon a short UK tour in support of Humble Pie, a band fronted by his schoolmate Peter Frampton, and on 1 November "Space Oddity" peaked at no. 5, providing Bowie with his very first hit single. Riding high on this wave of success, David Bowie set out on a headlining tour of Scotland less than a week later, backed by the group Junior's Eyes. During this tour his second eponymous album was released, and he completed the year with highly acclaimed performances at the Purcell Rooms and the London Palladium, the latter as part of a charity concert attended by Princess Margaret.

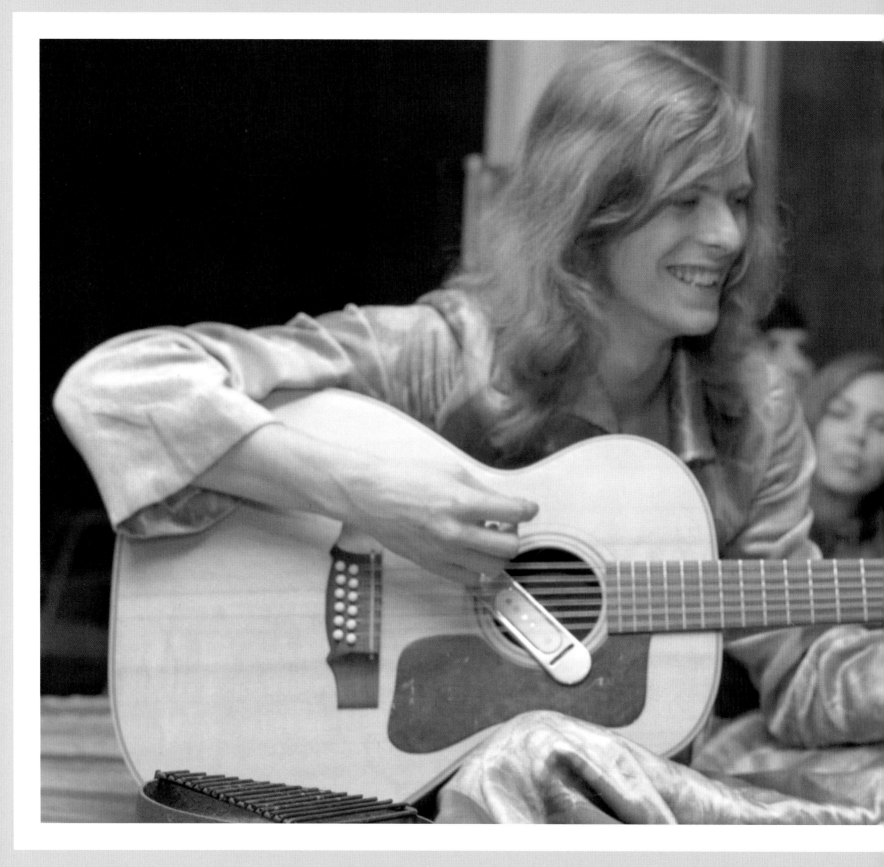

Changes

As 1970 began, Bowie may have had his first hit, but response to his LP and the follow-up single "The Prettiest Star" (which featured a guitar solo by Marc Bolan) was muted to say the least. Nevertheless, it would prove to be a pivotal year for Bowie. In February he formed a new group, Hype, with Tony Visconti on bass, Junior's Eyes' drummer John Cambridge, and the guitarist Mick Ronson, with whom Cambridge had previously performed in the Hull-based band The Rats. Dressed as costumed characters, they gave their first performances at London's Roundhouse on 22 February and 11 March, gigs which have since been cited as marking the birth of Glam Rock.

By the end of May, when he completed the recording of his third album, provisionally entitled *Metrobolist*, a number of other important changes had taken place – towards the end of March he and Angela had married and the following month, John Cambridge was replaced by Mick "Woody" Woodmansey. Perhaps more importantly, however, Bowie had found a new manager in the form of Tony Defries.

In November, without consultation, Mercury decided to release the new LP in the US with the title *The Man Who Sold The World*. Despite his misgivings about this, in early 1971 it presented Bowie with the opportunity to make his first visit to America.

Left: Bowie gives his first performance in the US at a private party in Los Angeles.

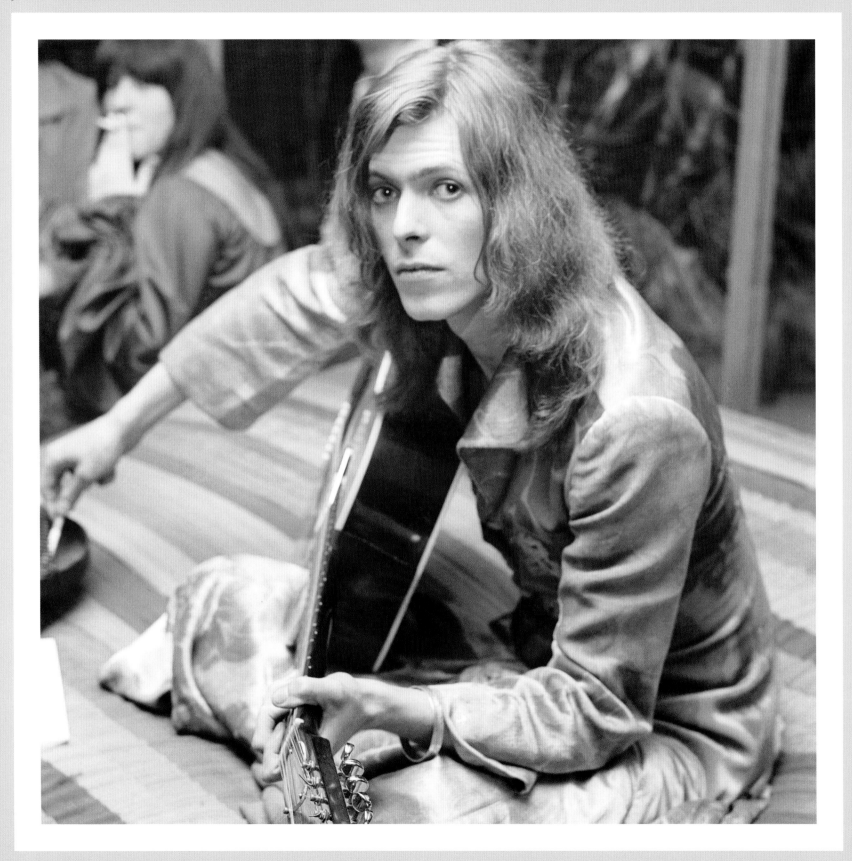

American debut

Opposite: Bowie in Los Angeles in early 1971 and (right) with Dana Gillespie, whom he had known since his time with the Manish Boys.

Despite the lack of a work permit, in January 1971 Bowie set off alone for a promotional tour of the US. While in the States he visited New York, Detroit, and Chicago, before heading to Houston, where he had a gun pulled on him, apparently on account of his long hair and feminine attire. From there he travelled to Los Angeles, where he found time to record some new demos and to perform at a party thrown by Rodney Bingenheimer.

Returning from the US in mid-February, he entered the studio to begin recording new material, initially with a side project entitled The Arnold Corns, before being reunited with Ronson and Woodmansey, who would bring bassist Trevor Bolder on board. At the same time, *The Man Who Sold The World* LP was issued in the UK and caused quite a stir, not least because the cover featured Bowie recumbent on a chaise longue, wearing a silk dress. At the end of May, while Peter Noone was taking David's "Oh You Pretty Things!" into the top twenty, David and Angie celebrated the birth of their son, Duncan Zowie Jones. However, there was little time for David to enjoy fatherhood. In June he performed at the Glastonbury Fayre and the rest of the year was largely occupied by recording sessions for his next LP, *Hunky Dory*, and a promotional album with former girlfriend Dana Gillespie, which would secure him a three-album deal with RCA.

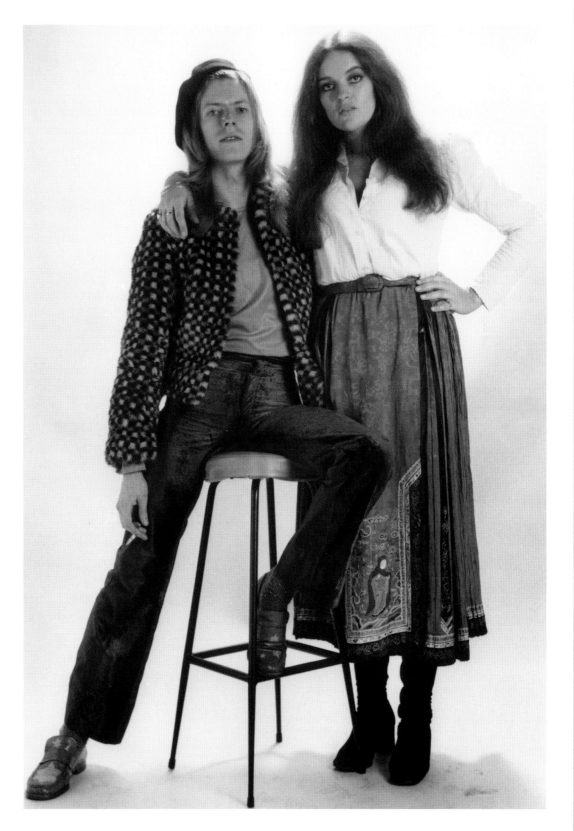

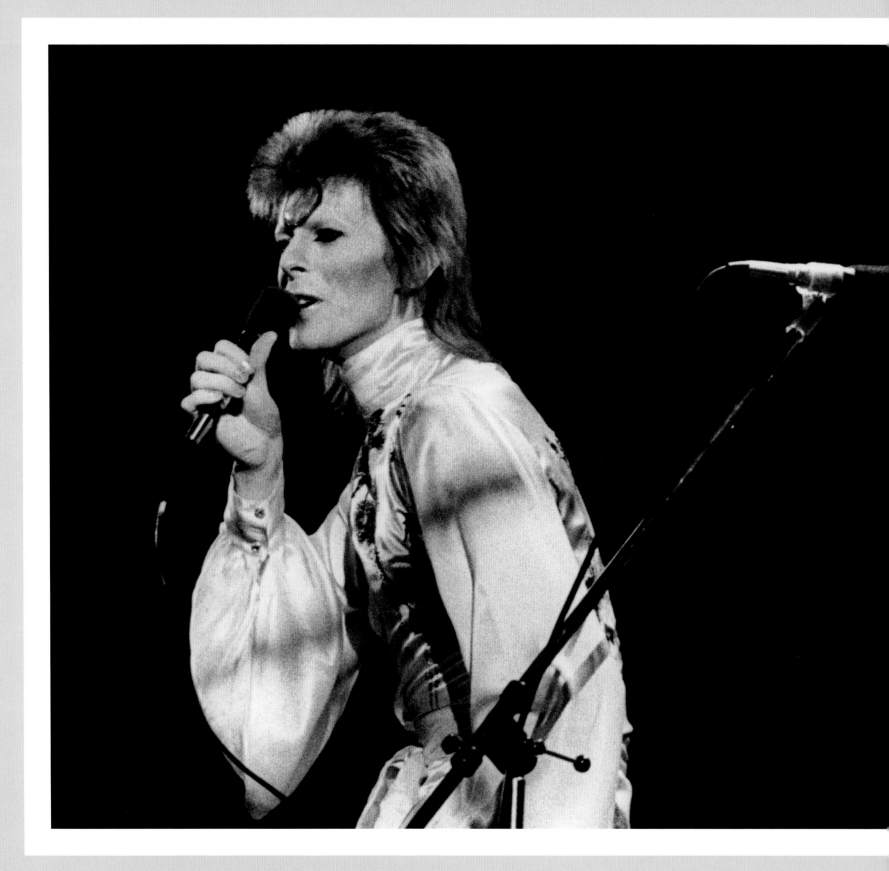

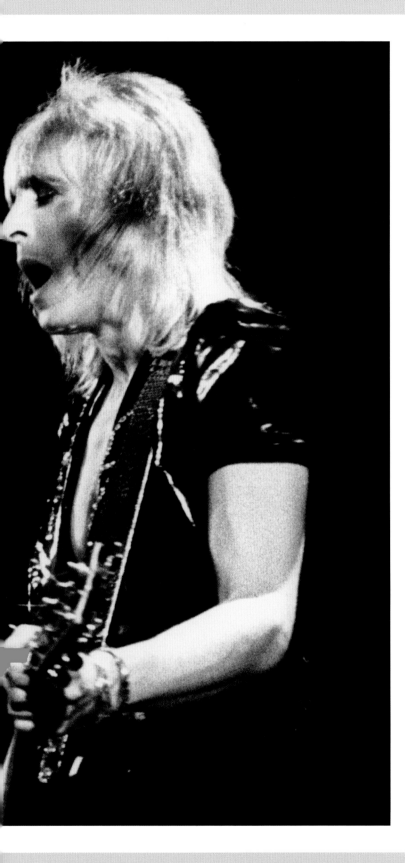

Chapter Two

Ziggy and Aladdin

Becoming Ziggy

Right: David photographed in January 1972 at Haddon Hall, by Michael Putland for *Disc & Music Echo*.

1972 began and so did a new era in Bowie's life, career, and perhaps even in popular music. Gone were the dresses and the shoulder-length hippy hair-do, to be replaced by a spiky mod cut and outfits that took their cue from Kubrik's latest offering, his film version of Anthony Burgess' *A Clockwork Orange*. Bowie had long flirted with artifice and identity, and his forays with Arnold Corns and Hype had hinted at the idea of a fantastical rock group. Now, however, he was to go one step further, creating a character that went beyond performance. He would not merely play the role of his new alter ego Ziggy Stardust, but become him.

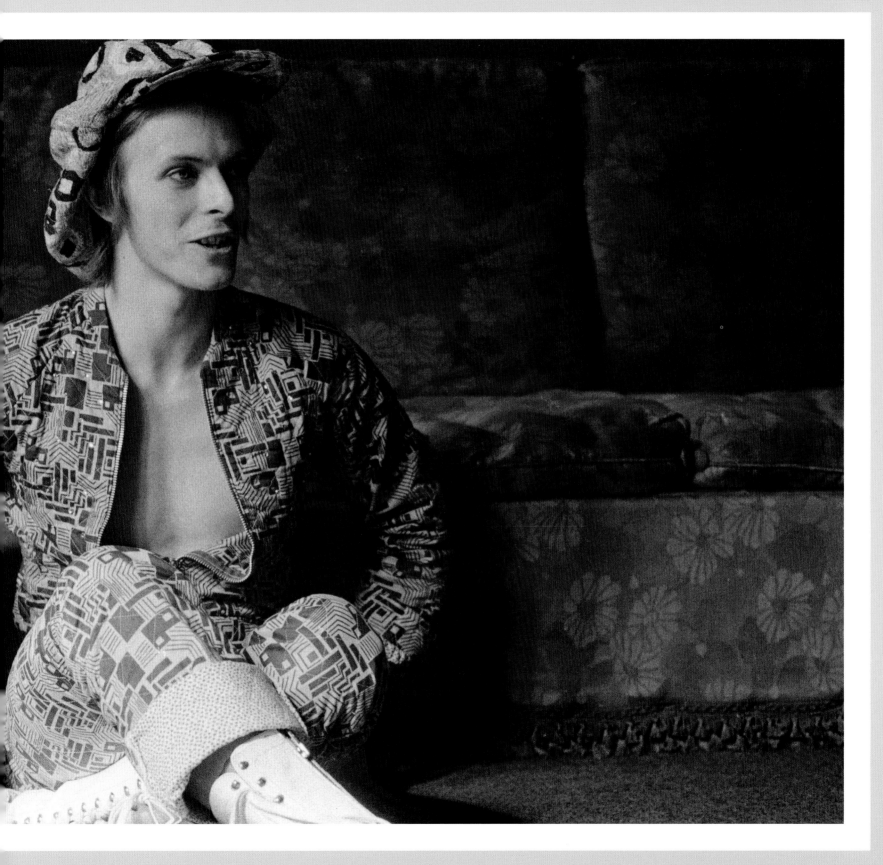

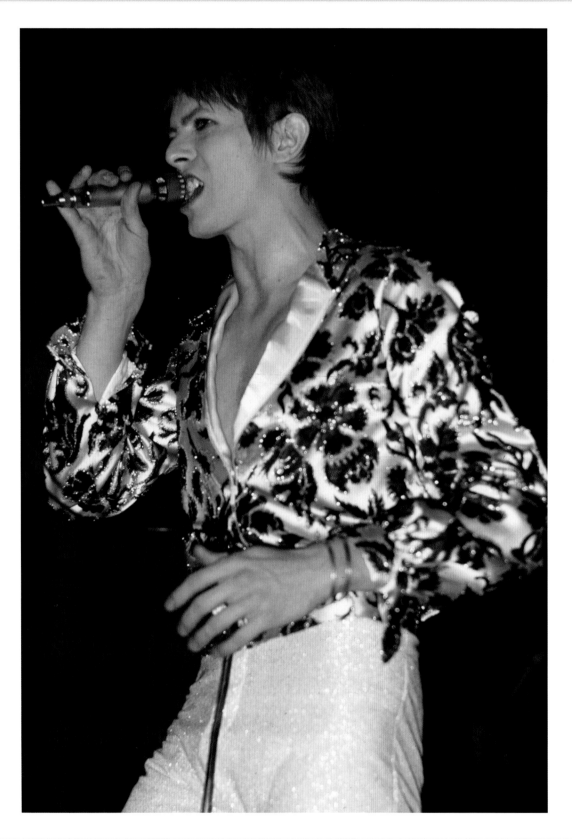

A star is born

Left: David Bowie made his live debut as Ziggy Stardust at the Borough Assembly Rooms, Aylesbury, on 29 January 1972.

With interest already growing as a result of a poster campaign for *Hunky Dory*, in January David caused quite a stir by announcing that he was gay in a *Melody Maker* interview, and as his first major UK tour got underway in early February, an appearance on *The Old Grey Whistle Test* maintained the momentum. A new single, "Starman", was released in April and the following month he would help to revive Mott The Hoople's flagging career by supplying them with the single "All The Young Dudes".

With the release of the new LP, *The Rise And Fall Of Ziggy Stardust And The Spiders From Mars*, and an appearance on Granada TV's *Lift Off With Ayshea* in June, concert bookings soared, and by early July, following a performance of "Starman" on *Top of The Pops* and a triumphant benefit concert for Friends of the Earth at the Royal Festival Hall, "Bowiemania" was assured. As "Starman" climbed towards the top ten, the British music press was enamoured, leading the *Melody Maker* to declare "A Star Is Born".

Opposite: On stage in the Ziggy period.

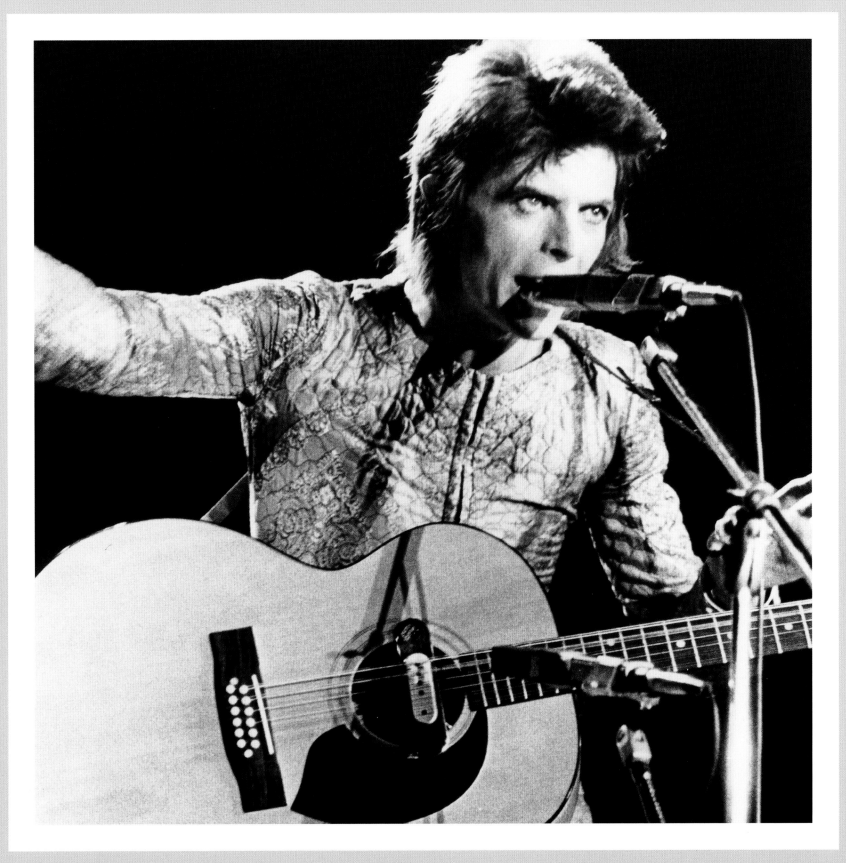

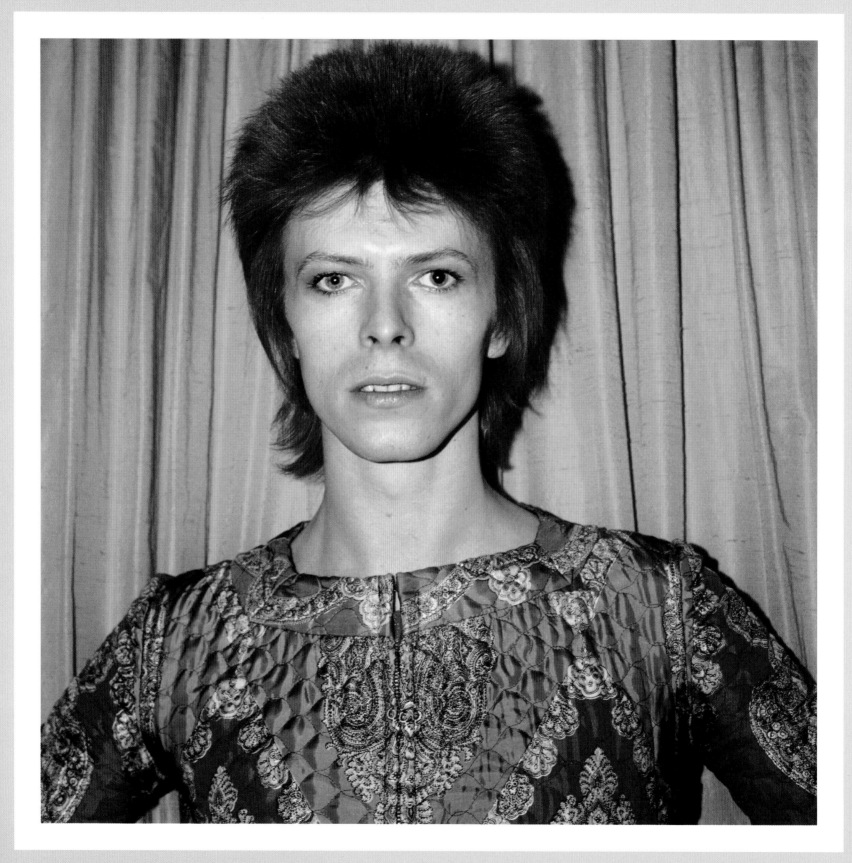

Ziggy in America

Opposite and right: David at the Plaza Hotel, New York.

With plans underway to take the Ziggy Stardust tour to the US before the end of the year, in mid-July a number of American journalists were flown over by RCA to attend a live performance at the Borough Assembly Rooms. The gig was followed by a chaotic press conference at the Dorchester Hotel, which was attended by Lou Reed and Iggy Pop, for whom David would soon start working as a producer. Beginning with two spectacular shows at the Rainbow Theatre, Finsbury Park, the UK tour continued throughout August, with Bowie heading to the States in September. Having experienced a severe storm on a recent flight from Cyprus, David decided to cross the Atlantic aboard the *QE2*, and arrived in New York on the 17th, five days after setting off from Southampton. The US leg opened with a sold out show in Cleveland, and there were positive responses in cities such as Memphis, New York, Los Angeles and Philadelphia, but with poorly attended shows in Kansas, St. Louis, Seattle and Phoenix, the tour was far from an outright success. In addition, Tony Defries's new company MainMan, replete with its staff gleaned from Andy Warhol's entourage, was financially stretched beyond its means.

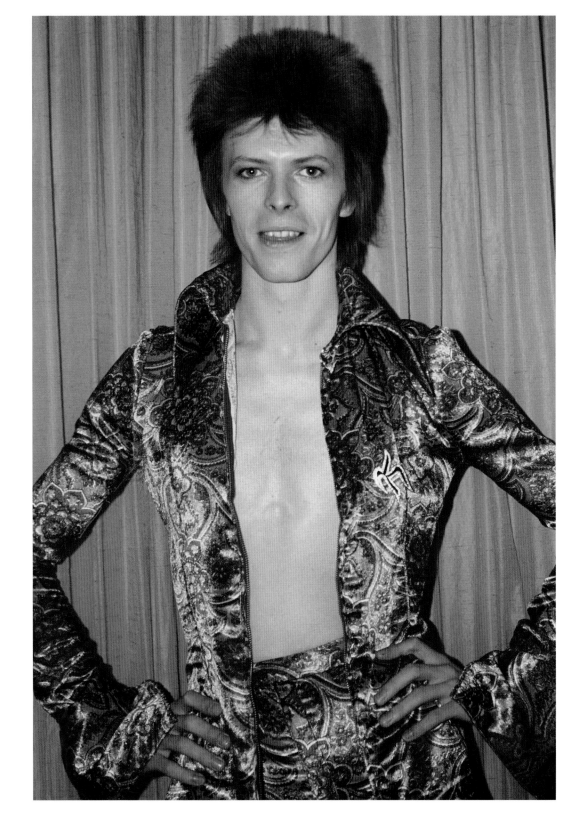

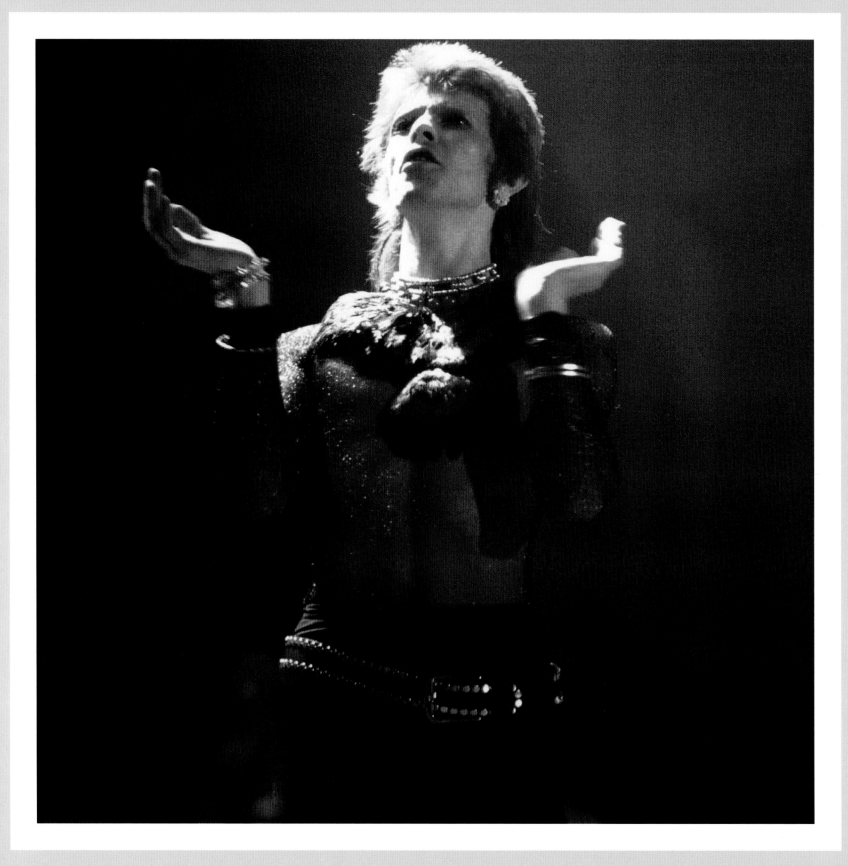

The Jean Genie

Opposite and right: Bowie on stage in the UK, January 1973. Despite mixed reactions in the US, when Bowie returned to the UK in December, he did so as a genuine star. Whilst on tour, RCA had repackaged and reissued his first two albums in the US, and the title track from the renamed *Space Oddity* LP would go on to peak at no. 15. Meanwhile, Bowie had been busy writing and recording new material between gigs, and his latest single, "The Jean Genie" was on its way to becoming his most successful yet. In addition, by the close of 1972 the *Ziggy Stardust* album had sold around 100,000 copies on each side of the Atlantic, and David ended the year with a triumphant return to the Rainbow Theatre, where he debuted a storming version of the Rolling Stones' "Let's Spend The Night Together".

After a family Christmas at Haddon Hall, the New Year began with further British dates in Glasgow, Edinburgh, Newcastle and Preston, and following a performance on T*op of the Pops*"The Jean Genie" had reached no. 2 in the UK by the middle of January. It was initially held from the coveted no. 1 spot by Little Jimmy Osmond's "Long Haired Lover From Liverpool", and subsequently kept at bay by The Sweet's "Blockbuster", which featured an almost identical riff to that on Bowie's track.

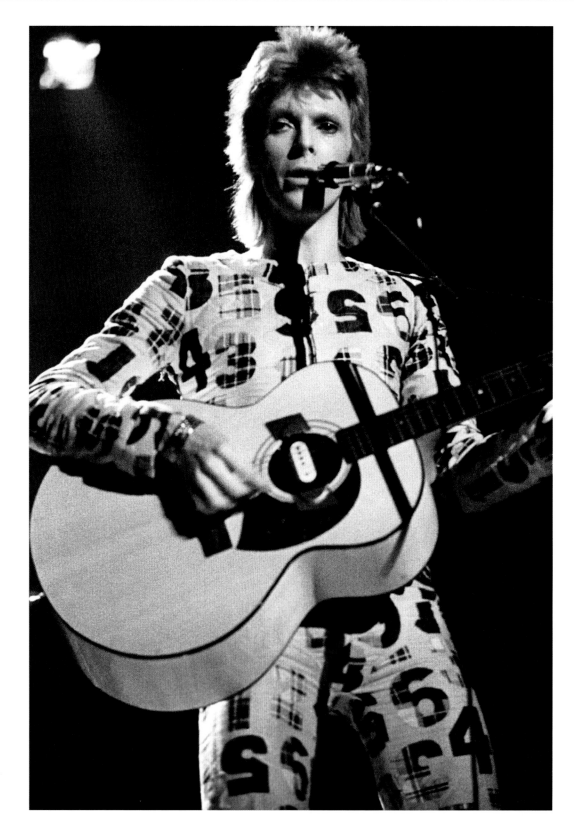

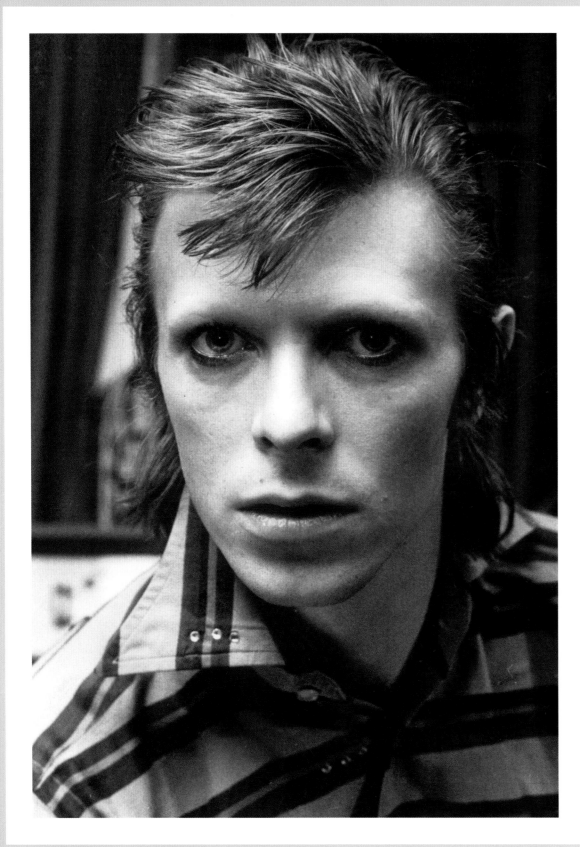

Aladdin Sane

Left and opposite: Bowie photographed in London. On 27 January 1973, with preparations well underway for a return to the US and work on David's sixth album all but complete, the *NME* announced in an exclusive article, "Goodbye Ziggy...Hello Aladdin Sane". Three days later, Bowie arrived in New York aboard the SS *Canberra* to begin his second American tour. In order to avoid the disappointments and box office failures of their previous Stateside excursion, this time Ziggy and The Spiders would play multiple shows in just a handful of well-chosen cities. Bowie's entourage had also been reduced, although the band itself would be augmented by Geoffrey MacCormack on percussion and backing vocals, sax players Ken Fordham and Brian Wilshaw, and David's old friend John Hutchinson on rhythm guitar.

Following rehearsals at RCA studios, the tour got underway with a sold-out show at New York's Radio City Music Hall on St Valentine's Day. Guests in attendance included Andy Warhol, Salvador Dali, Todd Rundgren, Johnny Winter and the Japanese fashion designer Kansai Yamamoto, who presented Bowie with a number of his latest costumes. After a blistering set, the performance climaxed in suitably dramatic fashion; as "Rock 'n' Roll Suicide" drew to a close, a fan rushed onstage to embrace Bowie, who promptly fainted.

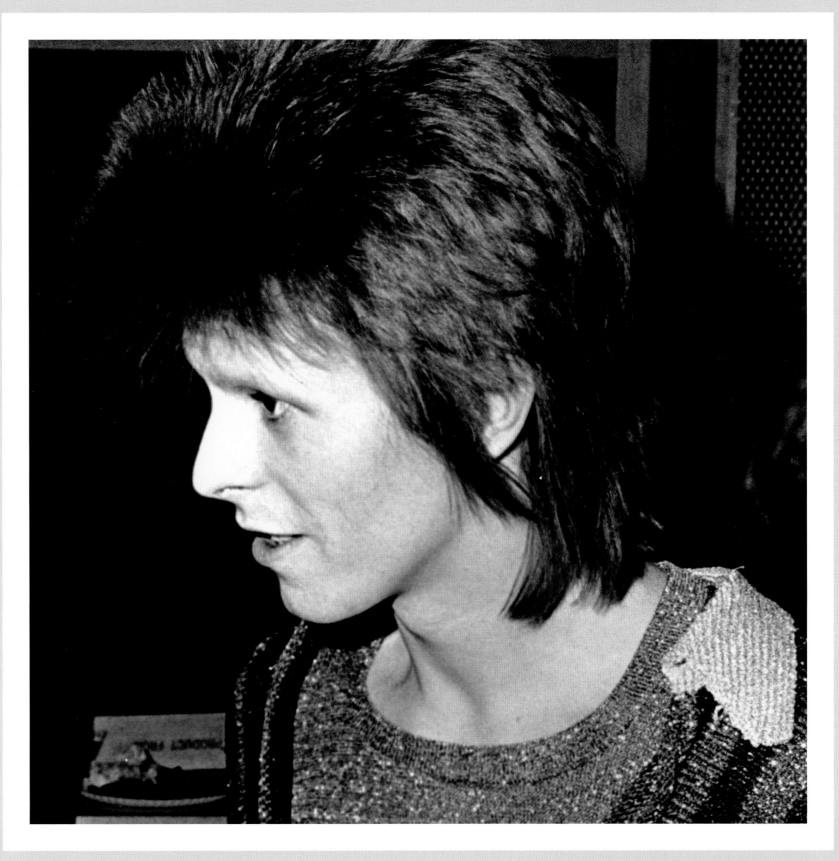

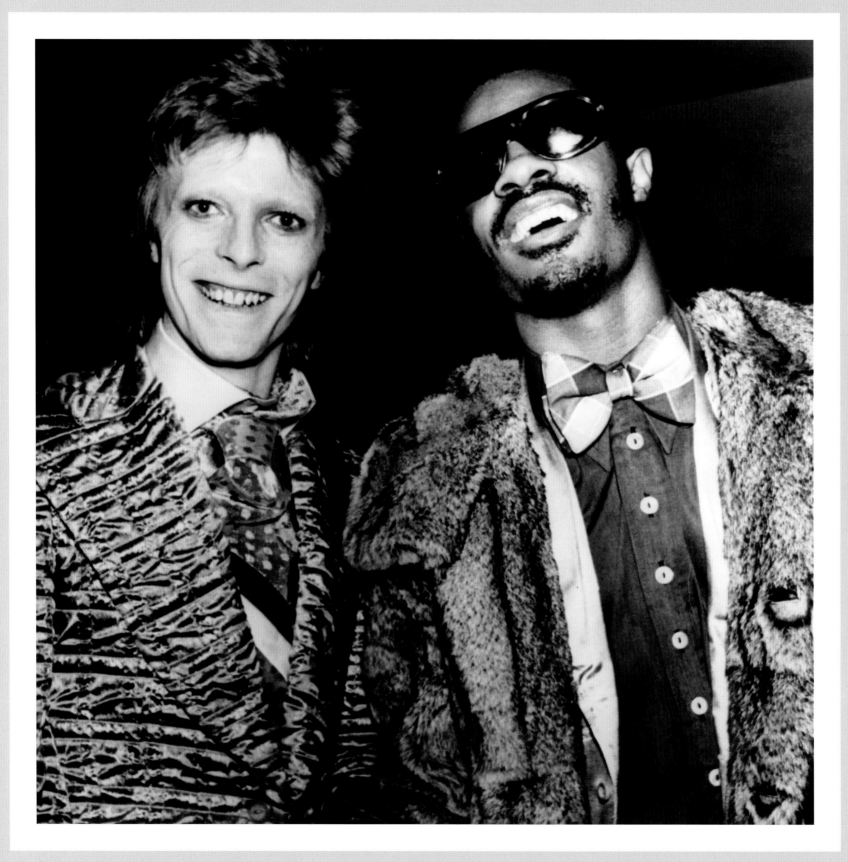

Stranger in a Strange Land

Opposite: David Bowie with Stevie Wonder in Philadelphia. After a second night in New York, the tour moved on to the Tower Theatre in Philadelphia for seven shows over four days. The previous US tour had ended at the venue to a rapturous response, and the city was rapidly becoming something of a stronghold for Bowie and his band. After the opening night on 16 February, David attended a party for Stevie Wonder at the Genesis nightclub, where he was to meet cocktail waitress Ava Cherry. With David and Angie committed to an open marriage, Bowie and Ava would soon become lovers, and she would also find herself joining him onstage as a backing vocalist. During the run of concerts in Philadelphia, the British press announced that Bowie was to take the lead in a film version of Robert Heinlein's *Stranger in a Strange Land*, although the project would eventually be shelved.

Right: Signing autographs in Los Angeles. From Philadelphia the tour continued through Nashville, Memphis and Detroit, before reaching Los Angeles on 10 March.

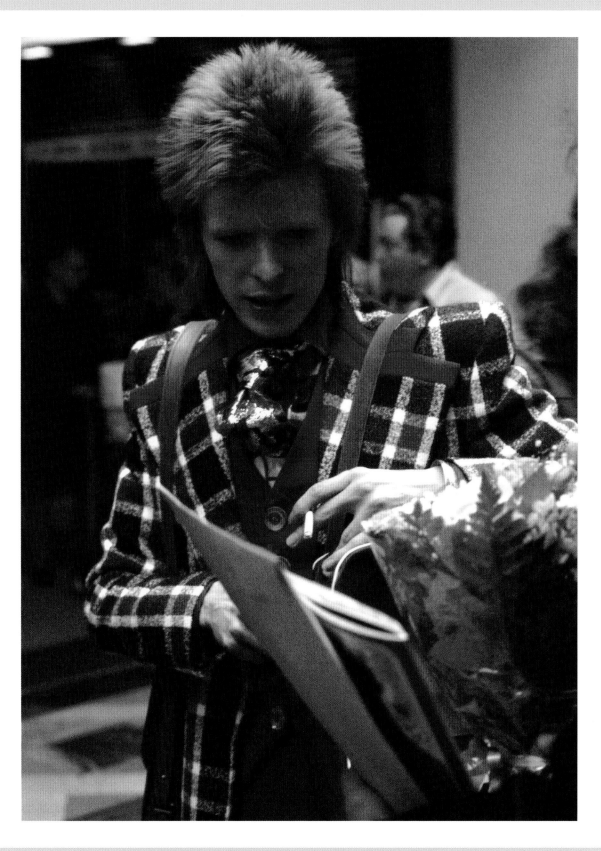

Big in Japan

Right: Bowie with fans in LA. Having
enjoyed several sold out shows, the US leg
of the tour closed with two performances
in Los Angeles, the first at the Long Beach
Auditorium, where Bowie was formally
introduced to Mick Jagger for the first
time, and the second at the Hollywood
Palladium, following which he celebrated
at a party with Ringo Starr and Klaus
Voorman. A week later, David and Geoff
McCormack set sail for Japan aboard the
SS *Oronsay*, arriving in Yokohama on
5 April. David had already enjoyed some
chart success in Japan, and his nine-date
tour of the country would prove to be a
sell-out. It was also highly inspirational
for Bowie, who having already begun
to incorporate elements of Japanese
kabuki theatre into his shows, was further
impressed by the first-hand exposure
to traditional Japanese performance,
costume and make-up. After a final show
in Tokyo on 20 April, where hysterical fans
caused some damage to the venue, David
and Geoff headed home through Russia
aboard the Trans-Siberian Express. By the
time they arrived at Charing Cross Station
in London on 4 May, they had covered
more than 8,000 miles over land.

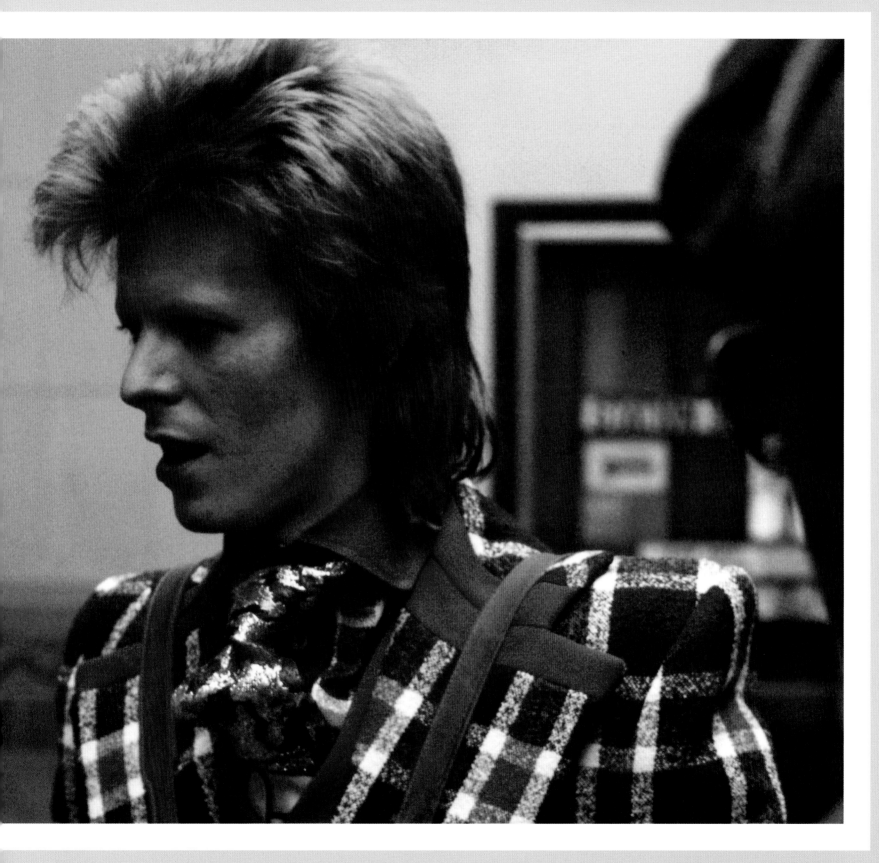

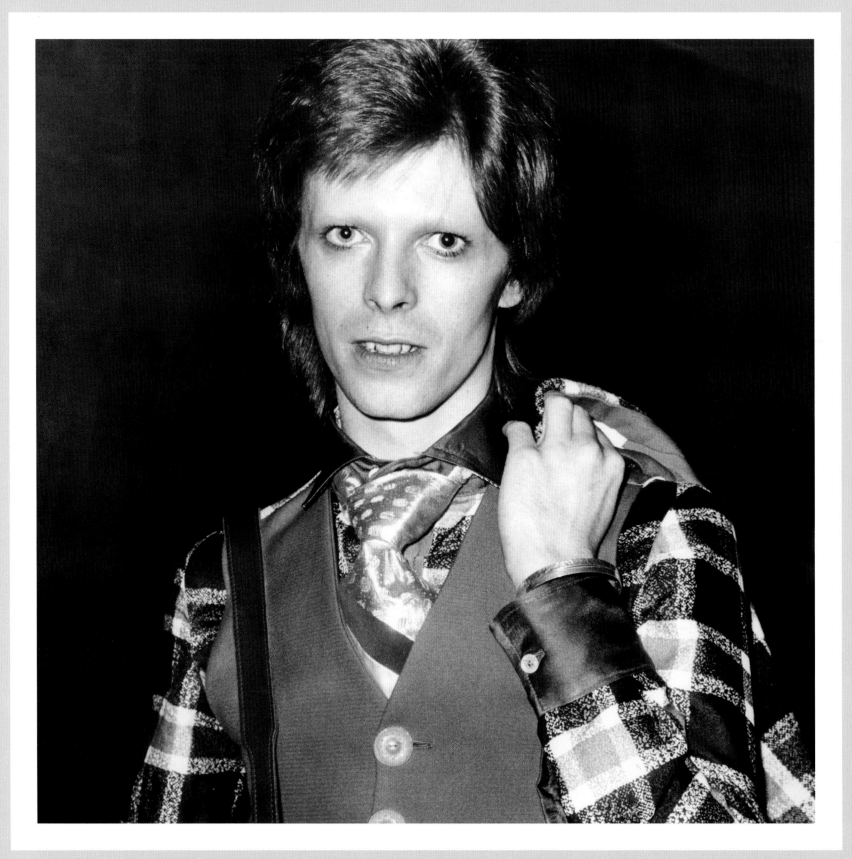

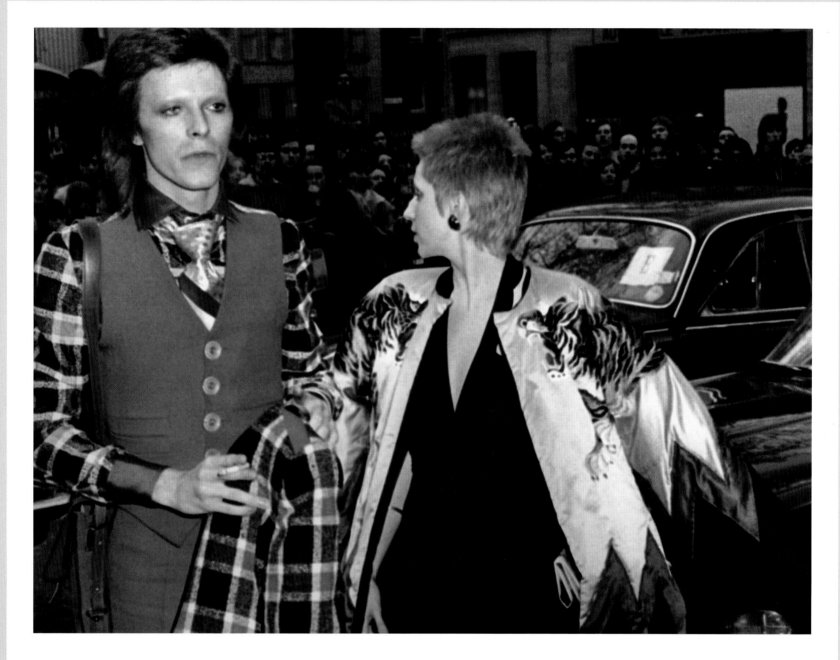

Top of the charts

Above and opposite: In scenes reminiscent of Beatlemania, Bowie and his retinue were mobbed by scores of fans upon their arrival at Charing Cross, and he had to be escorted to a waiting car by the police. However, there was little peace to be found upon returning to his home at Haddon Hall, which by now was almost permanently besieged by admirers. As a result, David and Angie decided that it was now time to find a new residence, and so David's homecoming party on 5 May would be their final celebration at the property. The evening was also notable for a reunion between Bowie and his former producer Tony Visconti, who attended with his wife, the Welsh folk singer Mary Hopkin. On the same day, Bowie's latest single, the doo-wop infused "Drive-in Saturday", peaked at no. 3 in the UK, while *Aladdin Sane* debuted at the top of the UK charts, thanks to advance orders that also recalled the Beatles at their peak. Two days later, David and Angela arrived at the Empire Cinema, Leicester Square, London, for the premiere of Ennio De Concini's *Hitler: The Last Ten Days*, starring Alec Guinness

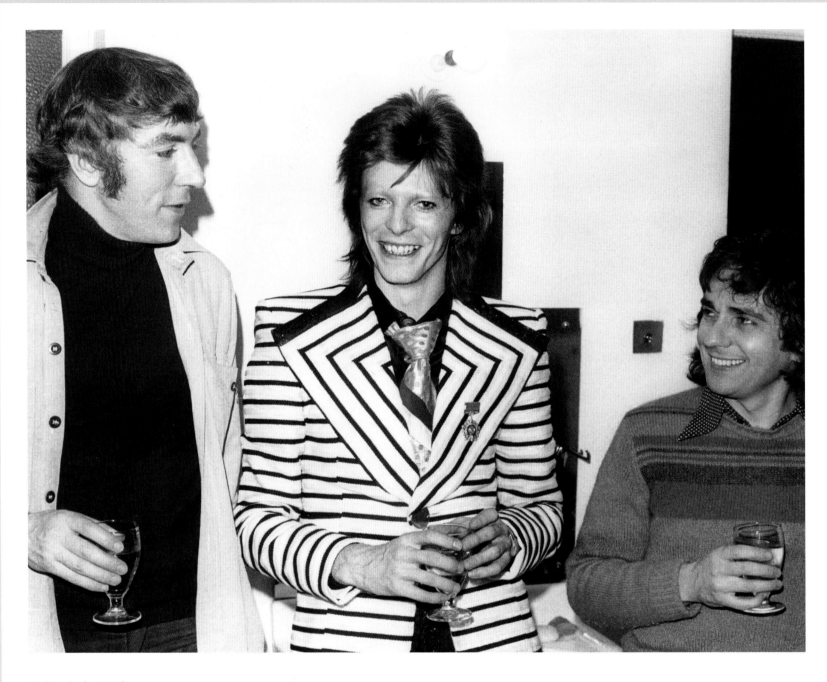

Behind The Fridge

Above: With the final, British leg of the "Ziggy Stardust / Aladdin Sane Tour" looming, Bowie concluded his brief round of social engagements with an outing to Peter Cook and Dudley Moore's *Behind The Fridge* comedy revue at the Cambridge Theatre in London's Covent Garden, accompanied by Angie, Tony Visconti and Mary Hopkin. Bowie would later incorporate the show's title into the opening lyrics of his hit single "Young Americans". Two years earlier he had apparently invited Moore to play

Piano on his *Hunky Dory* album, a role that was eventually fulfilled by Rick Wakeman, who until then had been performing with The Strawbs.

Opposite: Two days before Bowie and the Spiders resumed their tour at the Earls Court Arena, David and Angie also found time to drop in on David's former manager Ken Pitt at his Manchester Street apartment, which for a brief spell in the 1960s David had also called home.

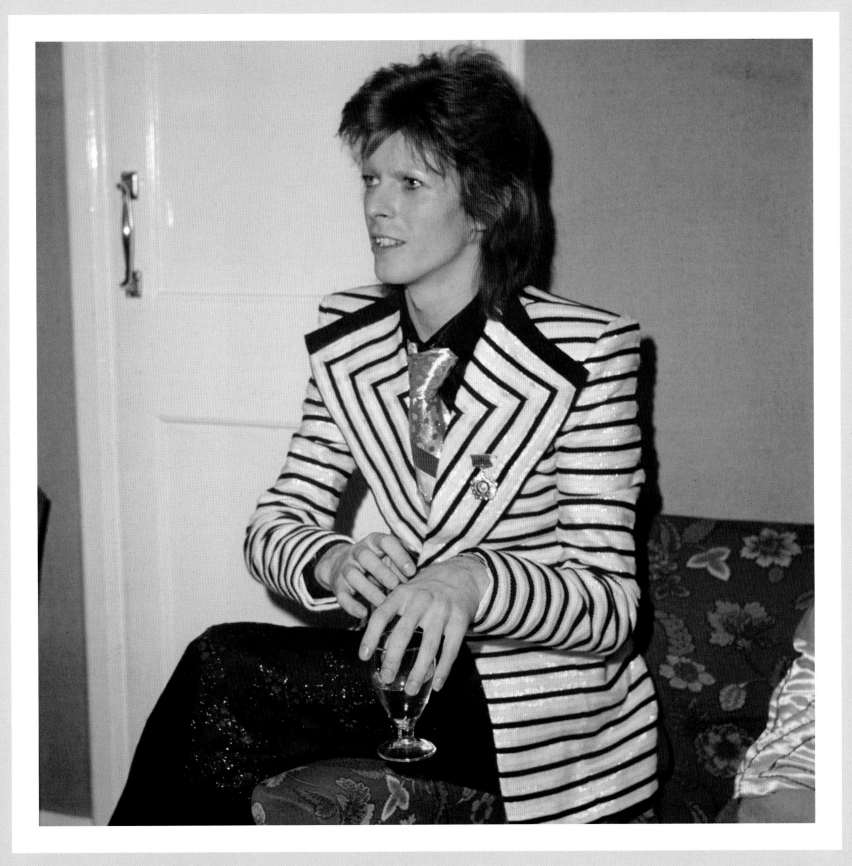

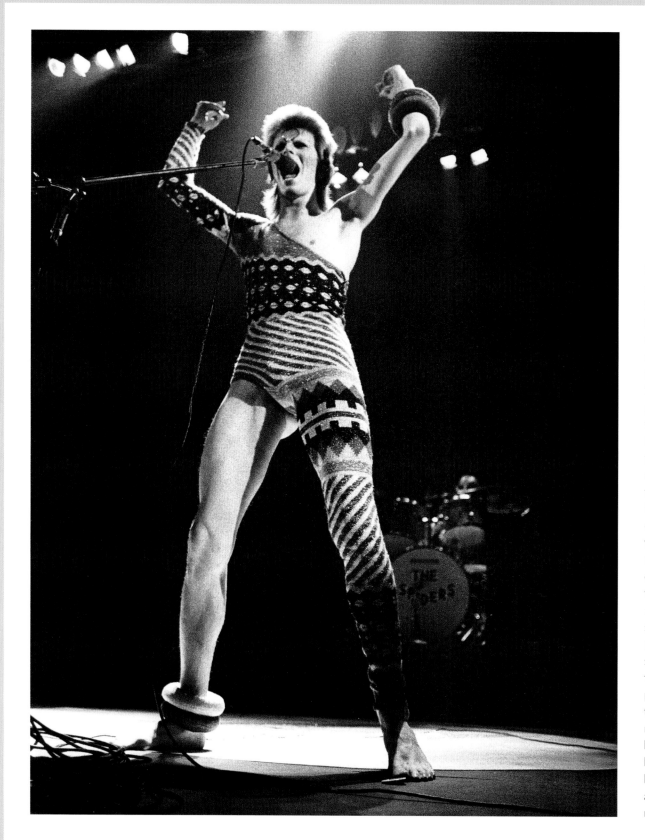

Earls Court

Opposite and left: On 12 May, the last leg of David Bowie and the Spiders' tour got underway at the 18,000-seater Earls Court Arena in London. The venue was huge in comparison to any that Bowie had performed at prior to this date, but things were initially looking positive. Rehearsals had gone well and tickets had sold out within a matter of hours. However, this was the first time that the hall had borne witness to an event of this kind, and the concert would ultimately prove to be something of a disaster. It quickly became apparent that the group's PA system was not loud enough to fill the vast space and this, coupled with the poor acoustics inside the arena, soon led to unrest amongst the crowd. In addition, the low positioning of the stage meant that many fans had a severely restricted view, and around half way through the set, the band were forced to take their leave while the security staff attempted to return audience members to their seats.

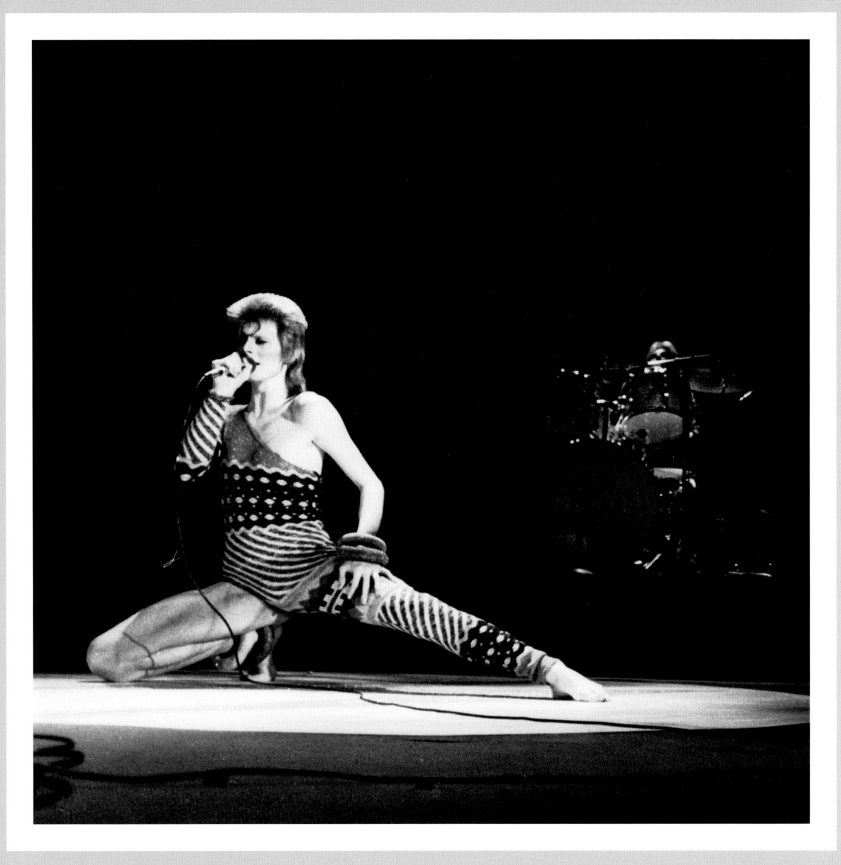

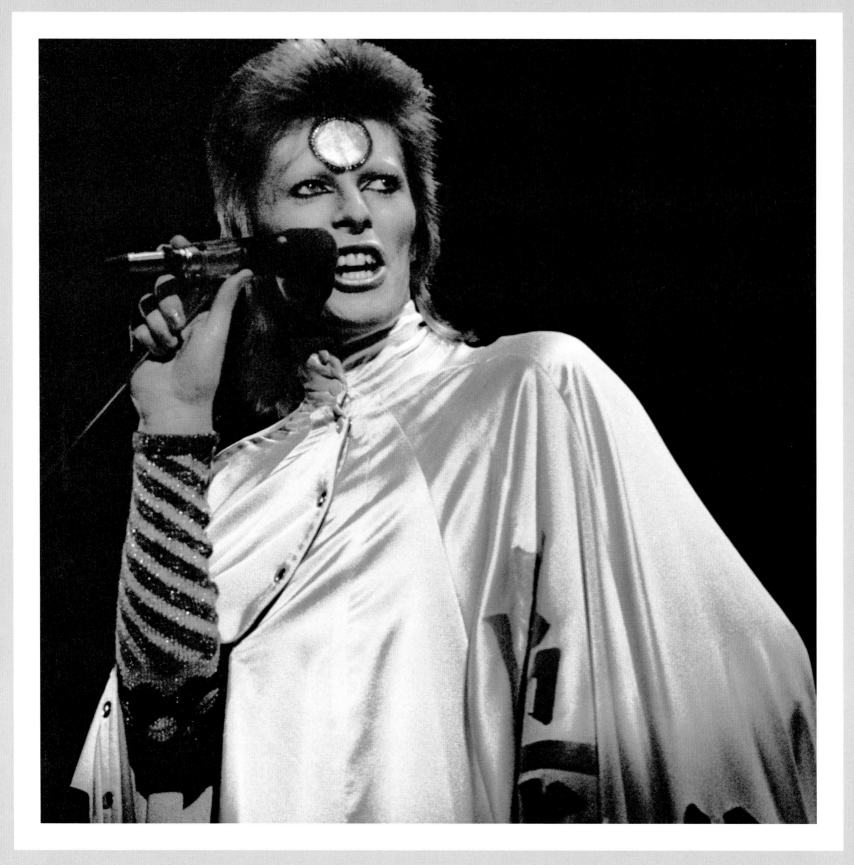

...on the road with the freakiest show...

Right and opposite: On stage in 1973. Bowie was undoubtedly disappointed by the problems associated with the Earls Court show and the critical reports that followed in such publications as the *Melody Maker* and *NME*, but as the tour headed north to Scotland, he appeared to launch into his performances with renewed fervour, and the fans responded in kind. There were minor problems with the PA at the next two shows in Aberdeen, but the remainder of the tour was characterized by solid performances from the band and near-hysterical audience responses at almost every gig. In Glasgow and Brighton there were scenes of destruction as rows of seats were ripped from the floor, and numerous over-exuberant fans succumbed to fainting and injury as the tour continued. More conservative sections of the press responded by denouncing Bowie as a purveyor of loose morals, whilst others hailed him as the new god of rock and roll, "...back on the road with the freakiest show in Britain".

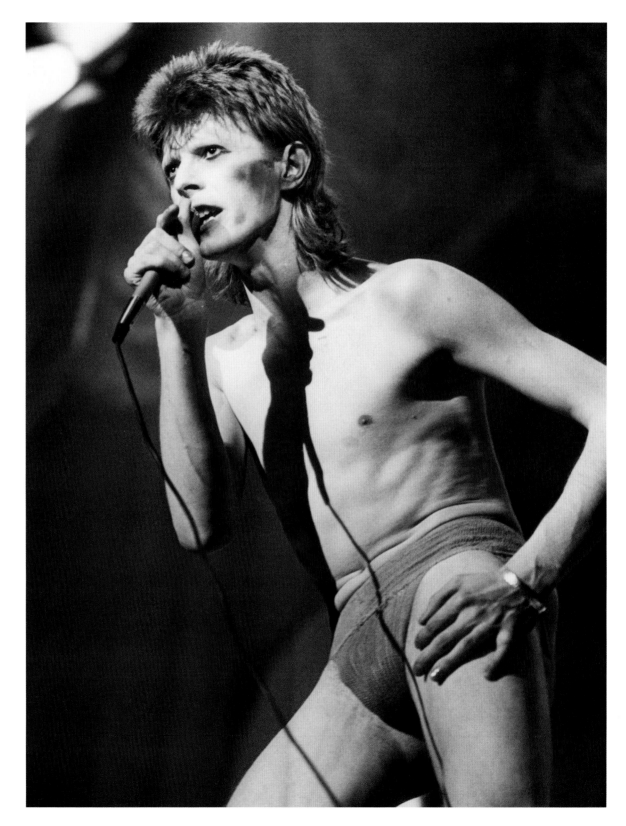

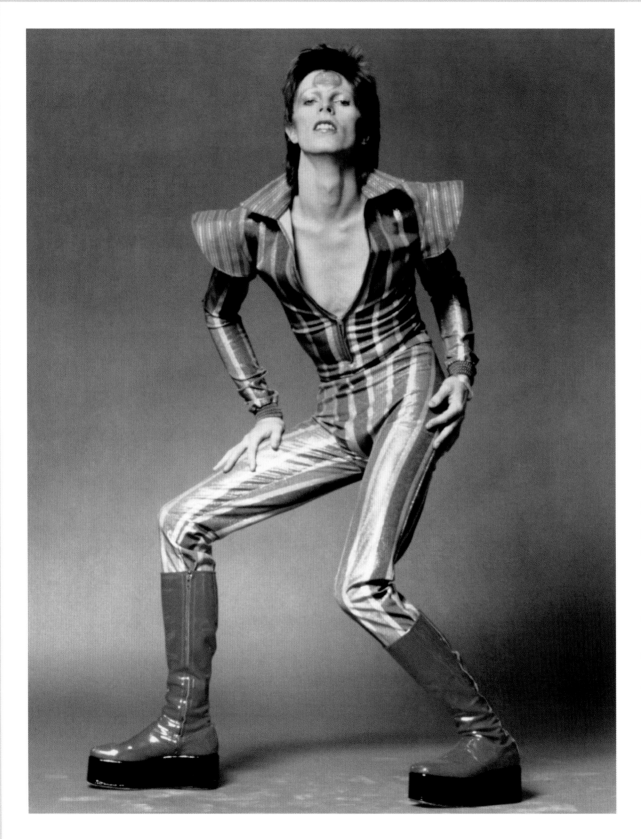

Kabuki monster

Left: David in a promotional shot taken by Japanese photographer Masayoshi Sukita and onstage in the UK, sporting the same costume (opposite). Having been given several more costumes by the fashion designer Kansai Yamamoto while in Japan, Bowie's embrace of kabuki theatre was very much in evidence during the latter part of the tour. While the early Ziggy period in 1972 could be characterized as proto-punk, during the Aladdin Sane era Bowie's appropriation of Japanese cultural symbols and their incorporation into the rock spectacle was markedly different and innovative. Elements of mime were restored to the performances, and there were numerous costume changes during shows, reflecting the kabuki tradition of representing changes in character and mood, as well as Bowie's own fascination with ideas of identity. Sukita took numerous pictures of Bowie sporting Kansai costumes in 1973, and although styled by Suzy Fussey, his flame-red "Ziggy cut" was apparently originally inspired by one of Sukita's modelling shots.

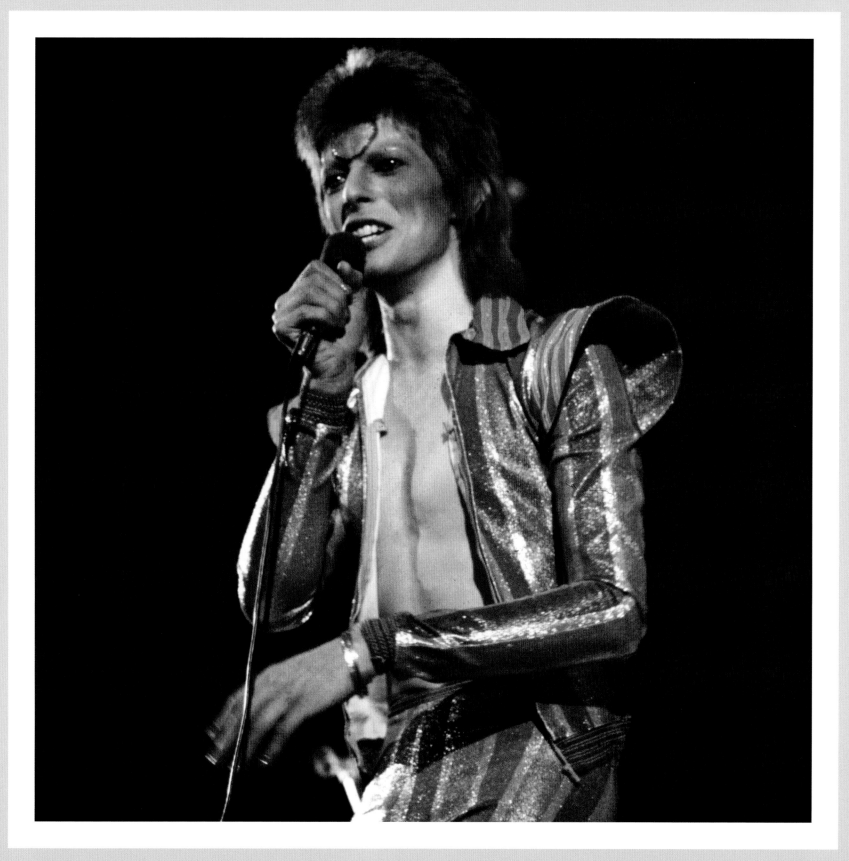

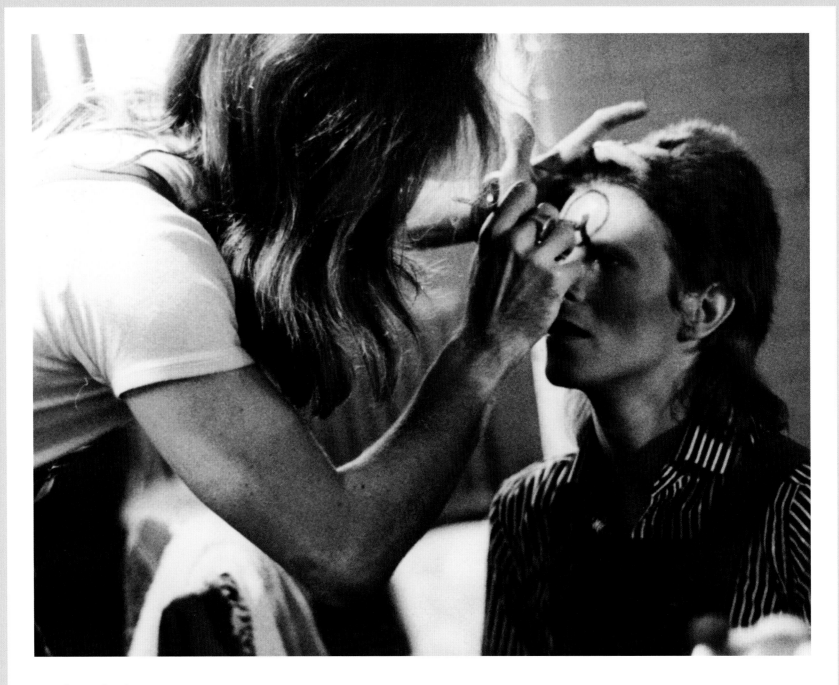

Powder and paint

Above and opposite: Bowie with make-up artist Pierre Laroche. In addition to his striking hairstyle and flamboyant costumes, Bowie's fondness for elaborate make-up also reached a peak during the Aladdin Sane era, as evidenced by the dramatic lightning bolt that adorned his face on the sleeve art for *Aladdin Sane*. Up until this time, Bowie had typically applied his own powder and paint, but in January 1973 he had been introduced to Pierre Laroche, an expert from the Elizabeth Arden Salon, who having styled Bowie for the album cover, went on to become his personal make-up artist for the or the remainder of the tour. In addition to the lightning bolt, which was suggestive of a divided self, Laroche was also responsible for the third eye, or astral sphere, that adorned Bowie's forehead in 1973, although the idea is thought to have been initially inspired by David's friend Calvin Mark Lee.

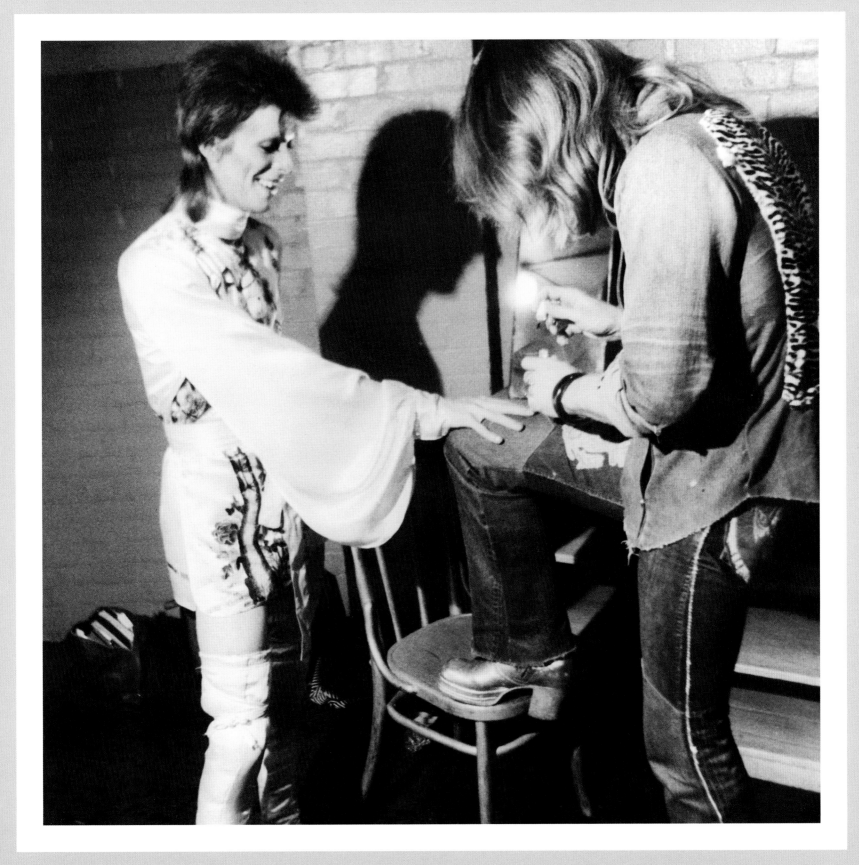

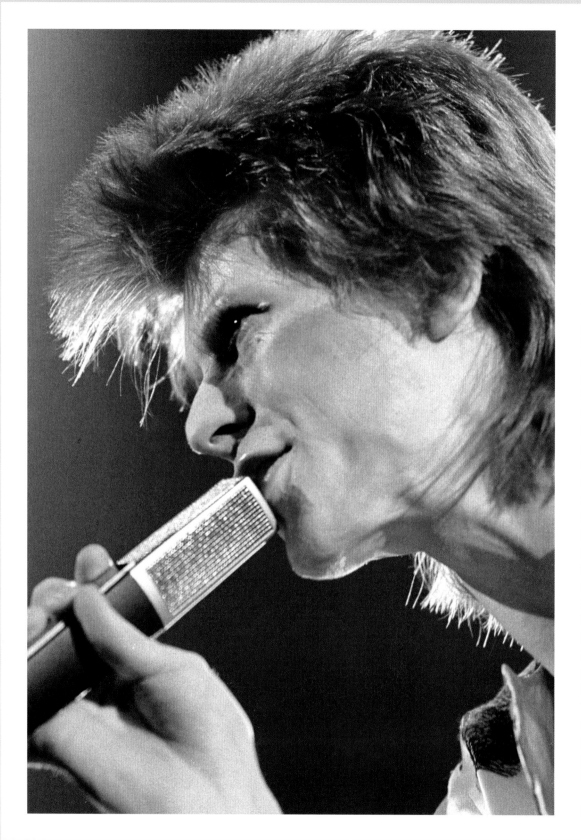

The demands of touring

Although banned from the airwaves in Britain due to its references to masturbation and drug use, at the beginning of June the single "Time" was released in the US. Meanwhile, back in the UK, the tour continued apace. Throughout the month, Bowie and The Spiders played almost daily, often performing two shows a day, and as with earlier dates, there were further scenes of mayhem. In Liverpool on 10 June, Bowie once again decided to stop the show after taking exception to the way security were dealing with fans, and he eventually had the stewards removed from the front of the stage. As a result, the audience surged forward into the orchestra pit, causing damage to the venue. Four days later in Salisbury, Bowie damaged himself when he landed awkwardly after jumping from the PA. He was forced to retire from the stage, and returned to perform his encore from a chair. The two subsequent shows in Taunton were then also performed largely seated. Although by 16 June his ankle appeared to have made a full recovery, the punishing schedule was clearly beginning to take its toll.

Left and opposite: On stage in 1973.

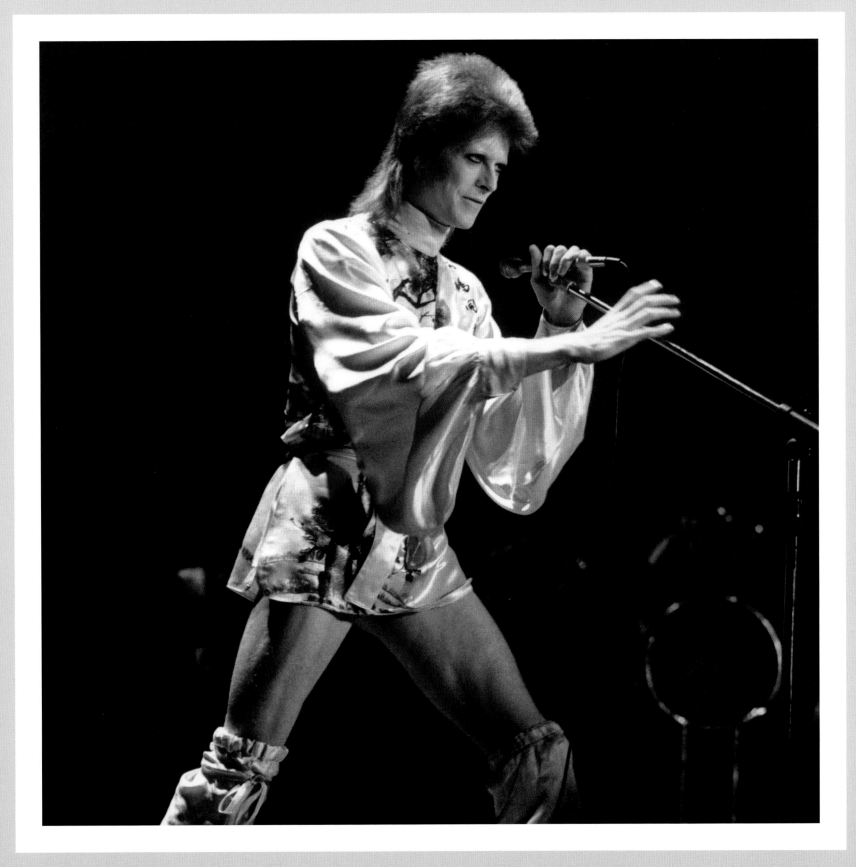

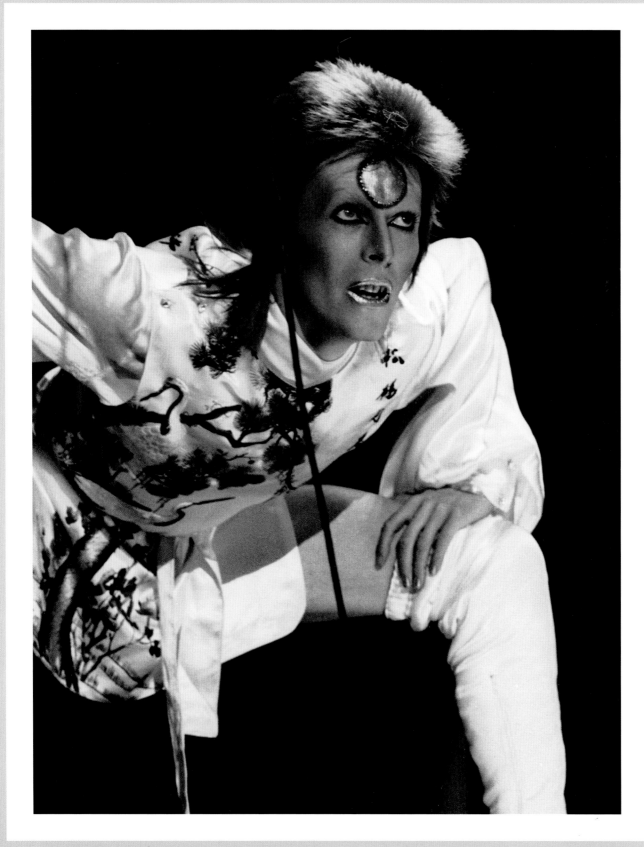

Life On Mars?

Left and opposite: After gigs in Torquay, Bristol and Southampton, Bowie headed to the Midlands for four shows at Birmingham's Town Hall over 21 and 22 June. The 22nd also heralded the release of "Life On Mars?" as a single in the UK. Initially released in 1971 as an album track on *Hunky Dory*, RCA were prompted to issue the song as a single following its excellent reception during the tour, and it would climb the charts to reach no. 3. Interestingly, Bowie had written the piece as a parody of Frank Sinatra's "My Way", which Paul Anka had adapted from the French song "Comme D'habitude", having purchased the rights in 1969. The previous year, Bowie himself had used the French composition as the basis for his song "Even a Fool Learns to Love", although this never saw release. "Life On Mars?" was accompanied by a promotional video by the photographer Mick Rock, who had previously directed similar promos for the US rerelease of "Space Oddity", "John I'm Only Dancing", and "The Jean Genie".

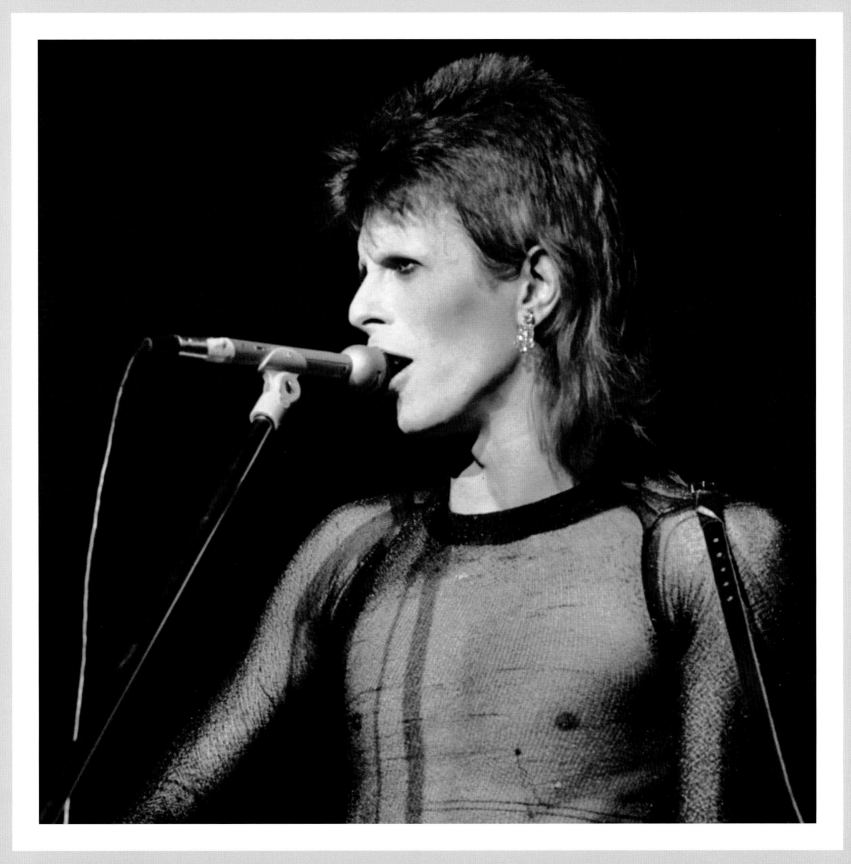

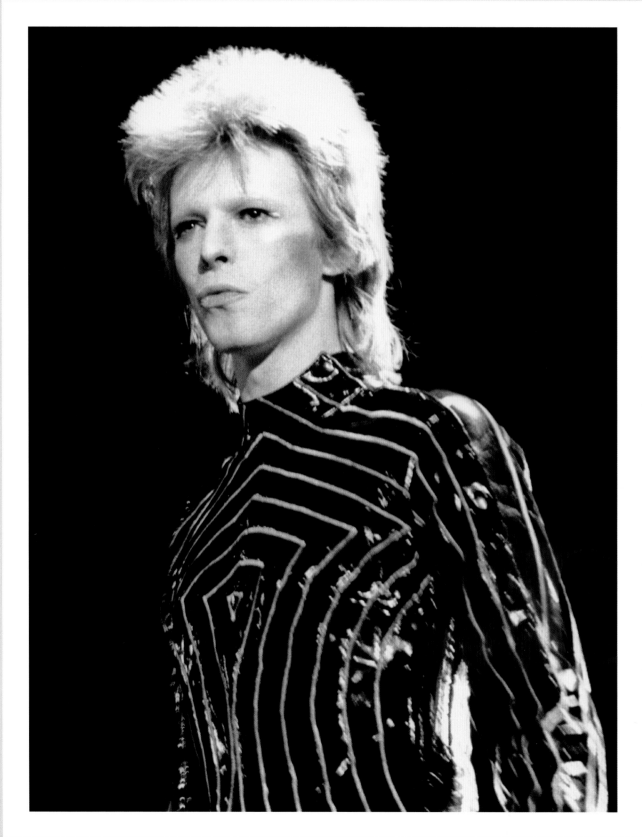

Ziggy's last stand

Left: On stage during the Ziggy Stardust tour. Having begun way back in February 1972, the tour concluded with two shows at the Hammersmith Odeon on 2 and 3 July, with the final show passing into the annals of rock history. Attended by a host of celebrity guests, including Mick and Bianca Jagger, Lou Reed, Rod Stewart and Ringo Starr, and filmed for posterity by D.A. Pennebaker, the show began with a solo performance by Bowie's keyboard player Mike Garson, before David Bowie and The Spiders From Mars wowed the audience with an electrifying set. They were then joined onstage by Mick Ronson's hero, the former Yardbirds guitarist Jeff Beck, for an encore consisting of "The Jean Genie", a verse of "Love Me Do" and "Round And Round". However, to top the show, Bowie stepped up to the microphone and made the startling announcement that "Not only is it the last show of the tour, but it's the last show that we'll ever do". With that, the band launched into "Rock 'n' Roll Suicide", and as Bowie took his final bow, he had sounded Ziggy's death knell.

Opposite: David and Angela Bowie arrive at London's Café Royal for Ziggy's retirement party.

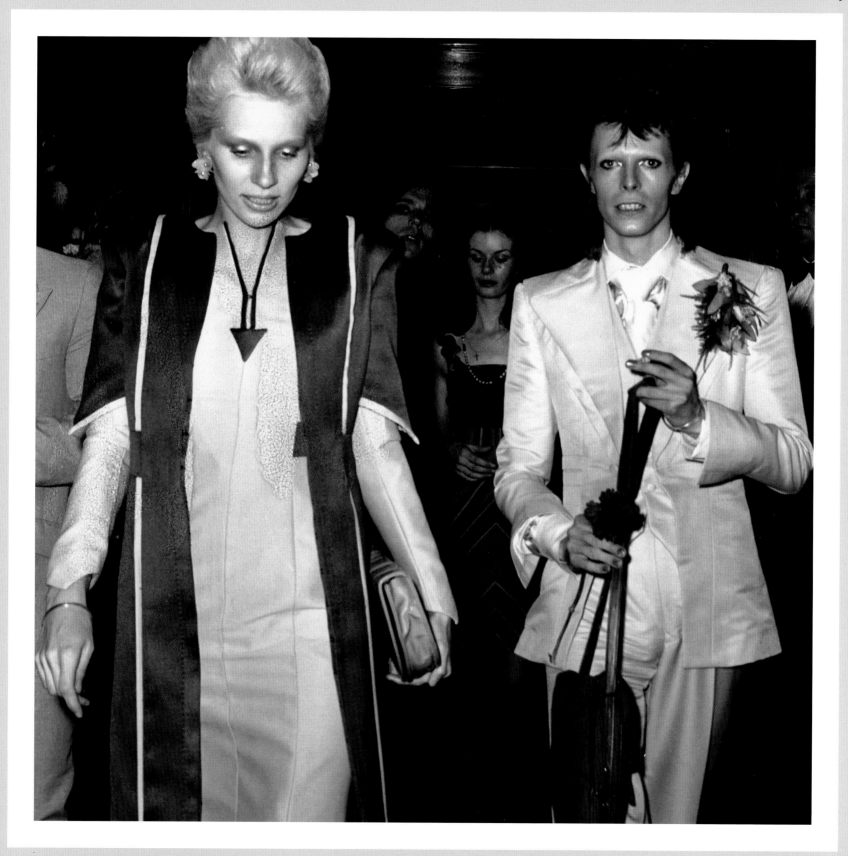

"The Last Supper"

Right: Bowie with Ringo Starr, Lulu and Cat Stevens at the Café Royal. After leaving the stage at Hammersmith, the Bowies held a small gathering at London's Inn On The Green but a far more lavish retirement party was planned for the following evening. Often referred to as "The Last Supper", this opulent affair was held in the plush surroundings of one of London's most expensive restaurants, the Café Royal on Regent Street, and was attended by a roll call of stars from the worlds of rock and roll, film and comedy. The guests included Paul and Linda McCartney, Mick and Bianca Jagger, Keith Moon, Lou Reed, Jeff Beck, Sonny Bono, Barbra Streisand, Britt Ekland, Tony Curtis, Elliot Gould, Ryan O'Neal, Hywel Bennett, Spike Milligan, Peter Cook, Dudley Moore and The Goodies, and live music was supplied by Dr John.

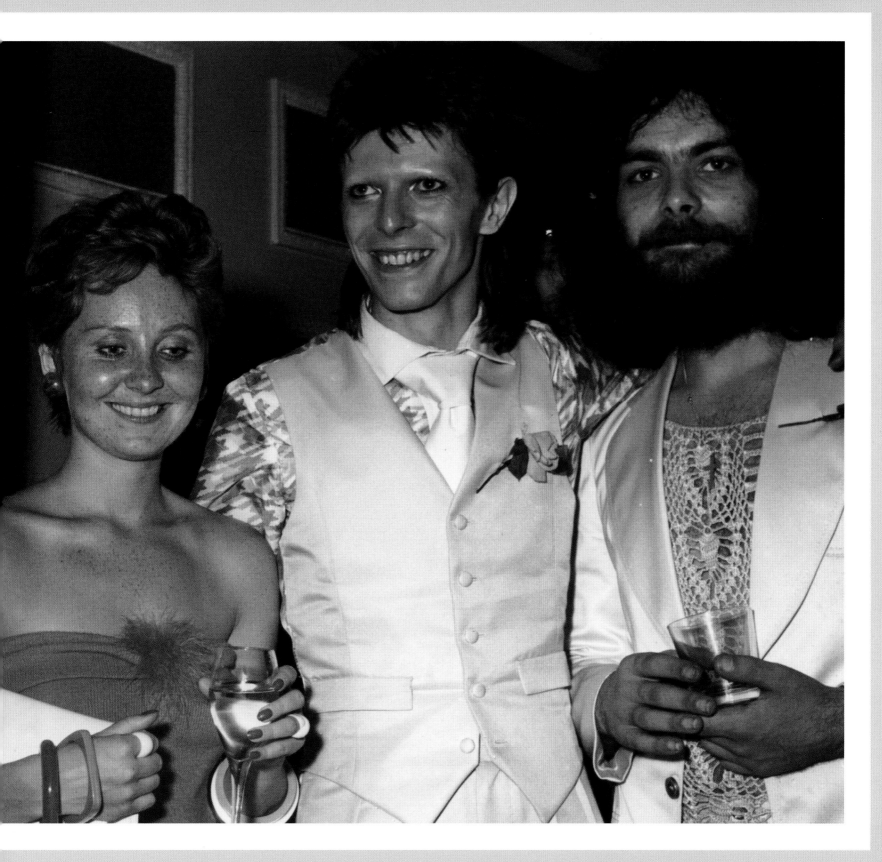

"When the kids had killed the man I had to break up the band"

Right: David and Angela Bowie with Bianca Jagger at the Café Royal party. The announcement of David's retirement not only came as a shock to his hordes of fans, but also to members of his own band. Although Mick Ronson had been kept in the loop, neither Trevor Bolder nor Woody Woodmansey had been told of David's intentions, and they were understandably hurt and confused. However, there were several reasons why killing off Ziggy and The Spiders at their peak made perfect sense. Artistically, Bowie was in part simply fulfilling the Ziggy Stardust narrative, but the character had also become stifling for David. On a theatrical and perhaps even personal level, Bowie was killing off his creation before it consumed him, while clearing the way for him to move on to new projects. However, there were also more practical and financial concerns – not only had there already been a certain amount of unrest within the band concerning pay, but there was also a question mark over whether a projected third US tour was financially viable. In any case, it would prove a shrewd move to leave his audience hungry for more.

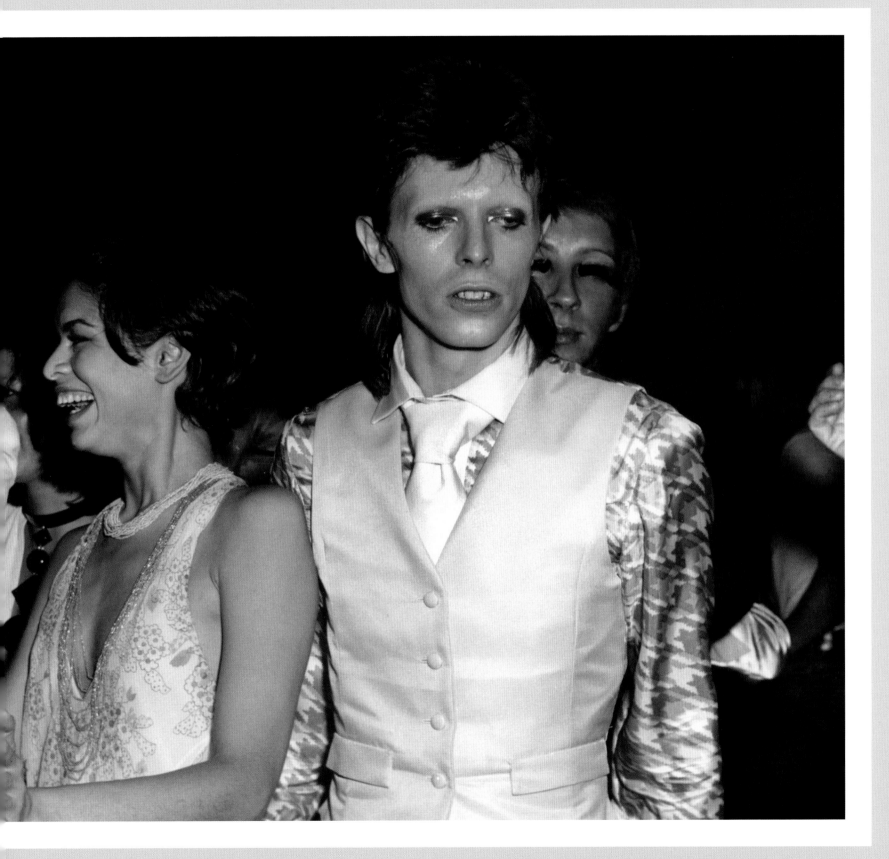

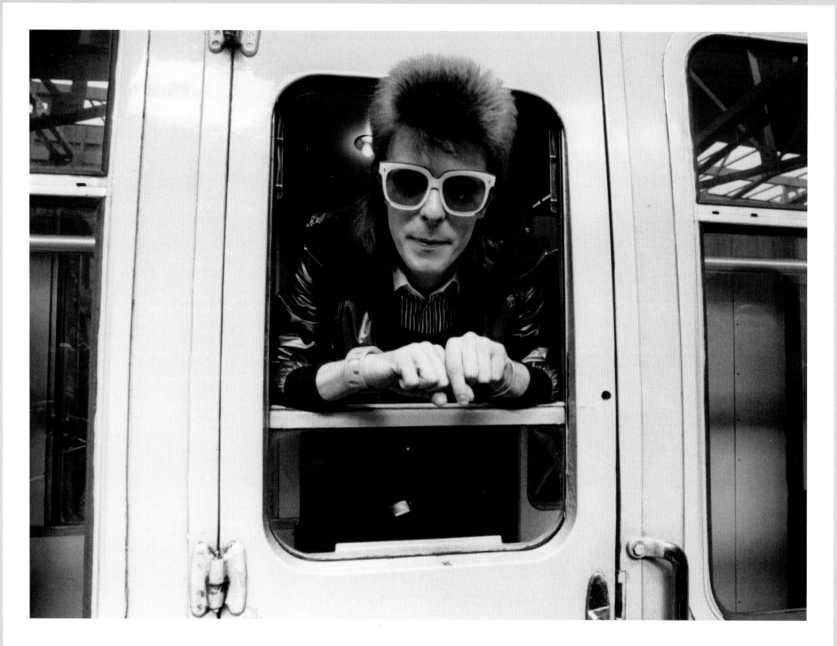

Pin Ups

Above and opposite: David and Angie Bowie at Victoria Station. Just days after the retirement party, as the British press were still reporting Bowie's decision to quit, he boarded a train at London's Victoria Station bound for Dover, from where he would travel to the Château d'Hérouville Studios in France to begin work on his next project, the LP *Pin Ups*. Conceived as a tribute to the artists that had inspired Bowie as a teenager in the 1960s, the album took just three weeks to record, and included versions of songs by The Yardbirds, Pink Floyd, The Who, and The Kinks, amongst others. Despite the recent uncertainty over his future with the band, Trevor

Bolder was retained for these sessions, which also featured Mick Ronson, Mike Garson, Ken Fordham and Geoffrey MacCormack, although Woody Woodmansey had been replaced at short notice by Aynsley Dunbar, who had previously worked as a drummer with such names as John Mayall and Frank Zappa. The sessions were also attended by Ava Cherry, the waitress that David had met in Detroit, Twiggy, who modelled for the *Pin Ups* sleeve, and Lulu, who arrived to record her own version of David's "The Man Who Sold The World", which would provide her with a major hit the following year.

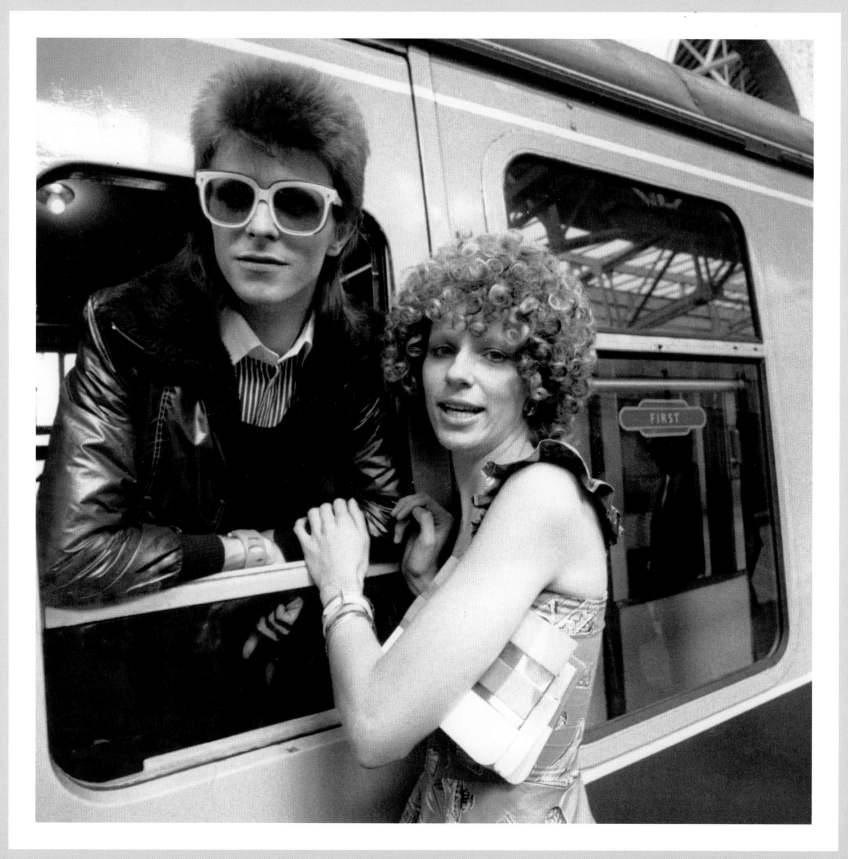

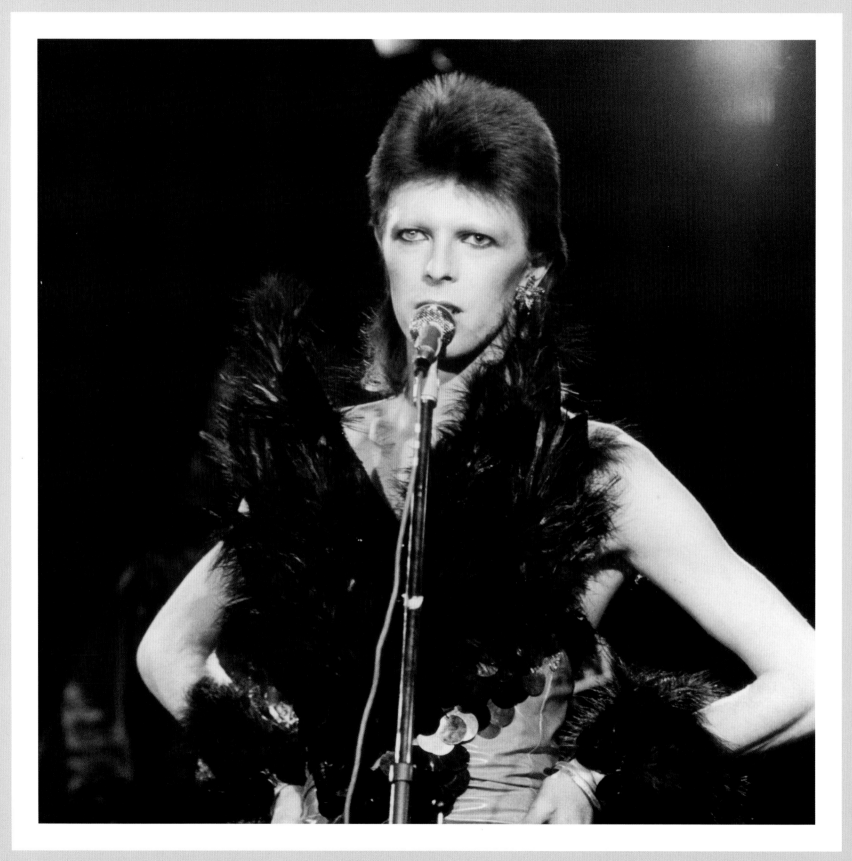

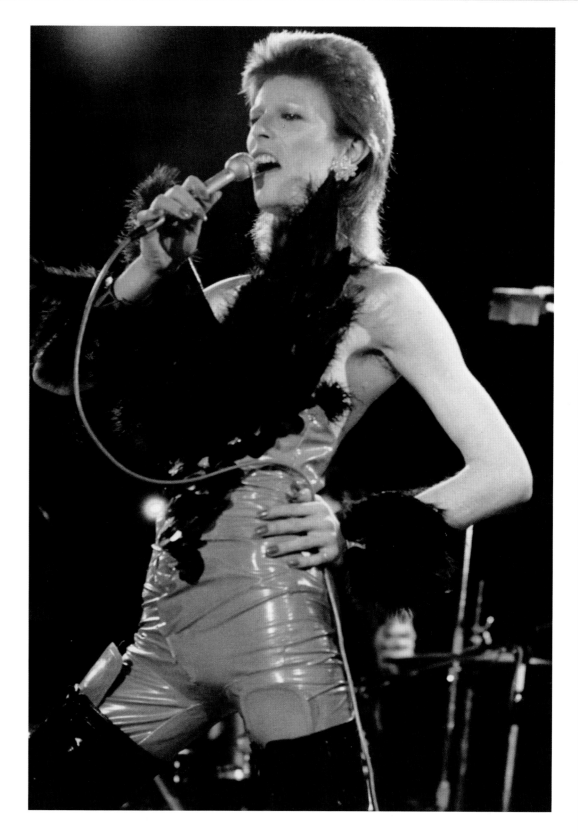

The 1980 Floor Show

Opposite and right: Bowie in his "Angel of Death" costume performing for The 1980 Floor Show. In August, with the *Pin Ups* sessions complete, David headed for some time off in Rome. While there he began to plan his next venture: an album and stage musical based on George Orwell's *Nineteen Eighty-Four*. Eager to return to work, he arrived back in the UK around a week later to mix *Pin Ups* with Ken Scott and to set his new project in motion. By this time, Bowie had achieved an unprecedented feat for a solo artist: simultaneously holding five positions in the UK top 40 album chart, with three in the top 20. Keen to cash in on this success, Decca decided to re-release Bowie's 1967 novelty song "The Laughing Gnome", which, somewhat embarrassingly, reached no. 6 in the UK. As a result, the release of the first single from *Pin Ups*, a cover of The Merseys' "Sorrow", would be delayed until 12 October. Meanwhile, David had struck a deal with the US TV network NBC to film The 1980 Floor Show as part of their *Midnight Special* rock series.

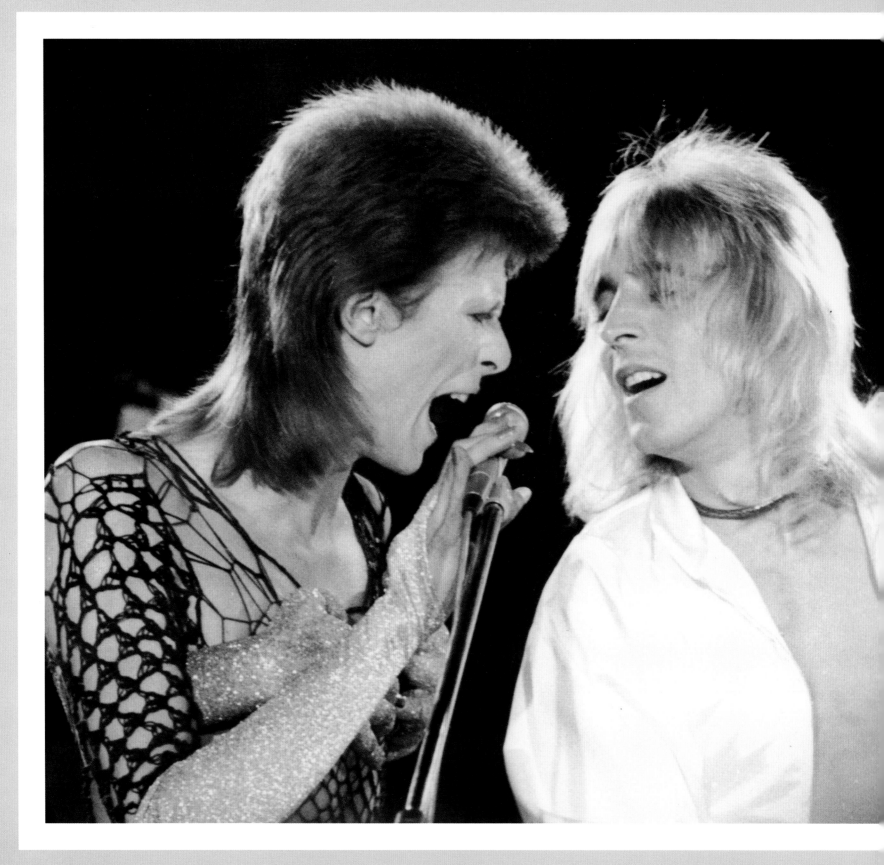

Return to the Marquee

Left: Bowie and Mick Ronson at the Marquee. Still sporting his Ziggy haircut and in possession of a host of new and outrageous costumes, including his red and black "Angel of Death" basque and a fishnet body-stocking embellished with a pair of gold hands, Bowie's return to the Marquee for the *Midnight Special* show marked something of a resurrection for the Ziggy Stardust character and was partly a means of placating US audiences following the cancellation of the 1973 autumn tour. The show was filmed over three days at the Marquee in front of an audience selected from the fan club, and featured Bowie performing a number of songs gleaned from the *Aladdin Sane* and *Pin Ups* albums, augmented by the addition of his breakthrough hit "Space Oddity", and just one track from the *Ziggy Stardust* LP, "Rock 'n' Roll Suicide". Bowie also used The 1980 Floor Show to showcase some new material that he had been preparing for his planned musical adaptation of *Nineteen Eighty-Four*, performing a medley of his two latest compositions, "1984" and "Dodo".

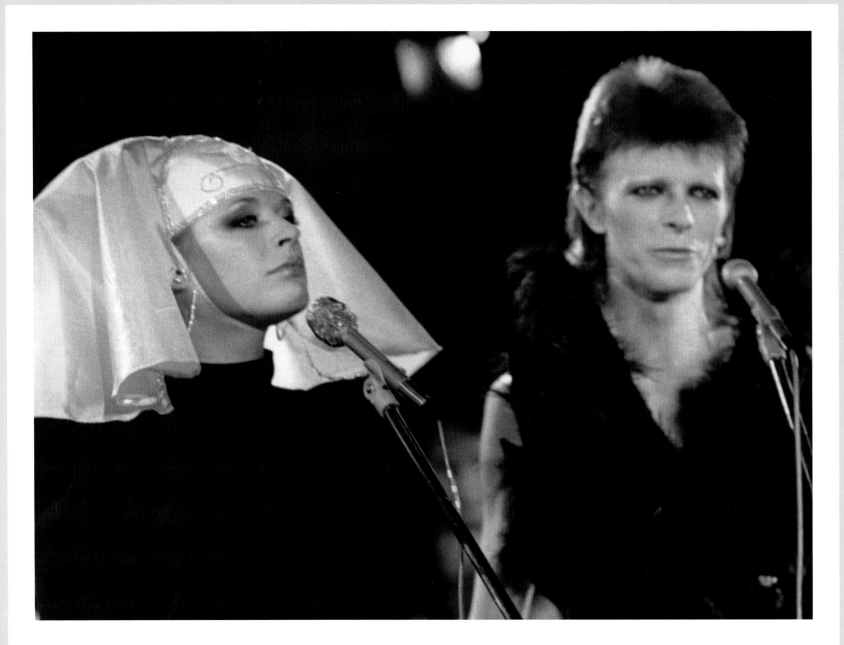

"I Got You Babe"

Above: Performing with Marianne Faithfull for The 1980 Floor Show. Bowie's group for the *Midnight Special* recordings consisted of former Spiders Mick Ronson and Trevor Bolder, new drummer Aynsley Dunbar, and keyboard player Mike Garson, who had become a regular fixture, both on stage and in the studio, since Bowie had first taken Ziggy to the States. The band was also joined by guitarist Mark Carr Pritchard, whose association with Bowie dated back to the days of the Beckenham Arts Lab, and The Astronettes, a trio of backing singers consisting of Ava Cherry, Geoffrey MacCormack and Jason Guess. Also featured on the bill were

The Troggs, Latin American glam rockers Carmen, and Marianne Faithful, who joined Bowie for a rendition of Sonny & Cher's "I Got You Babe", dressed in a nun's habit and wimple. Although never broadcast in the UK, an edited version of the show, minus "Rock 'n' Roll Suicide", was shown in the US on 16 November 1973, by which time both *Pin Ups* and "Sorrow" were on their way to providing Bowie with further British chart success.

Opposite: On stage in one of the more flamboyant costumes.

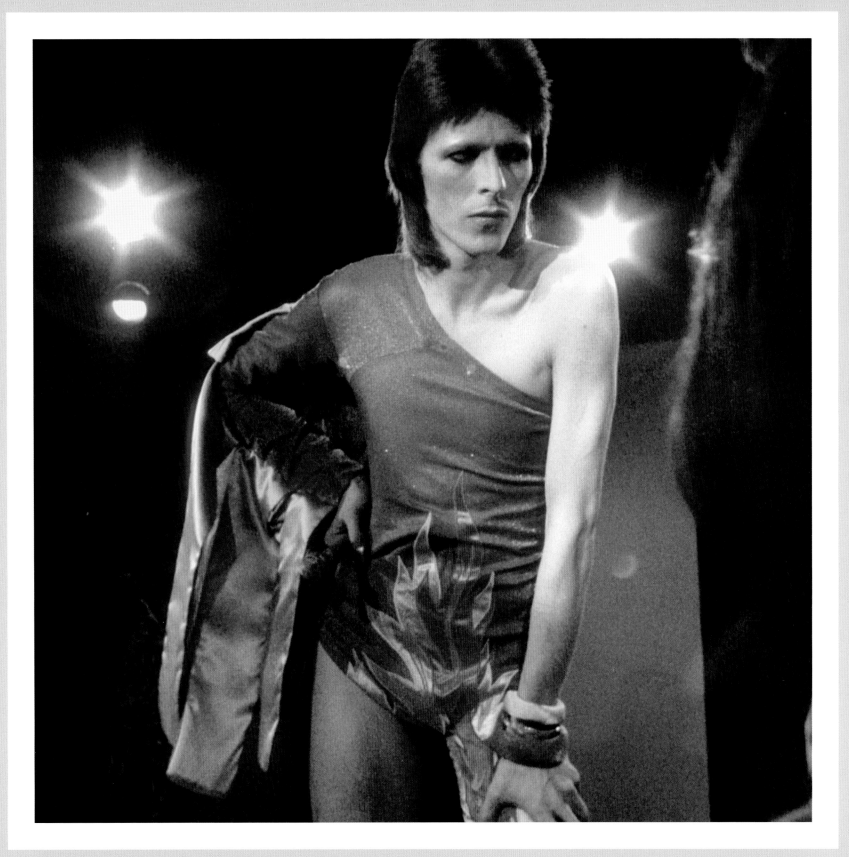

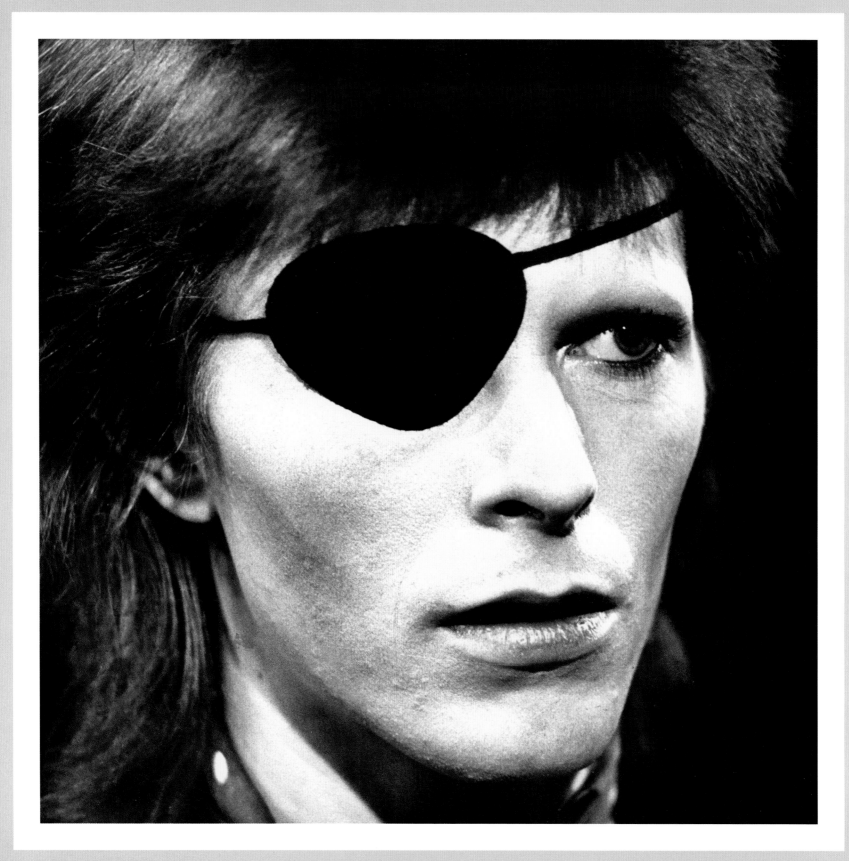

Rebel Rebel

Right and opposite: Performing in Holland. The day after the The 1980 Floor Show broadcast, in an interview for *Rolling Stone* magazine alongside the writer William Burroughs, David discusses his concepts for a musical based on Ziggy Stardust, revealing the influence of Burroughs' cut-up technique. Bowie had also begun to employ this in his songwriting, and towards the end of the year Burroughs would go on to visit him in the studio as he began work on a new album. In early December, *Disc* revealed that Bowie was working on two stage productions, but ultimately neither the projected Ziggy show nor the theatrical version of George Orwell's *Nineteen Eighty-Four* would see the light of day, with the latter being shelved after Sonia Brownell, Orwell's widow and the trustee of his estate, refused to license the rights to his novel. Rather than scrap the project entirely, Bowie decided instead to incorporate the ideas into his new album, *Diamond Dogs*, over which the influence of Orwell and his dystopian vision of the future would loom large. By the middle of February 1974, with his new single "Rebel Rebel" due for release, Bowie headed off to Holland, where he performed the song on the TV show *Top Pop*.

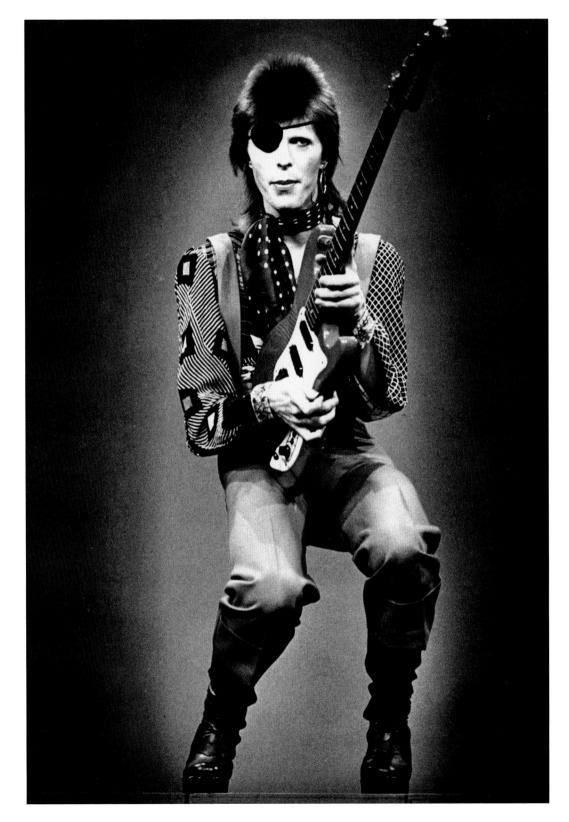

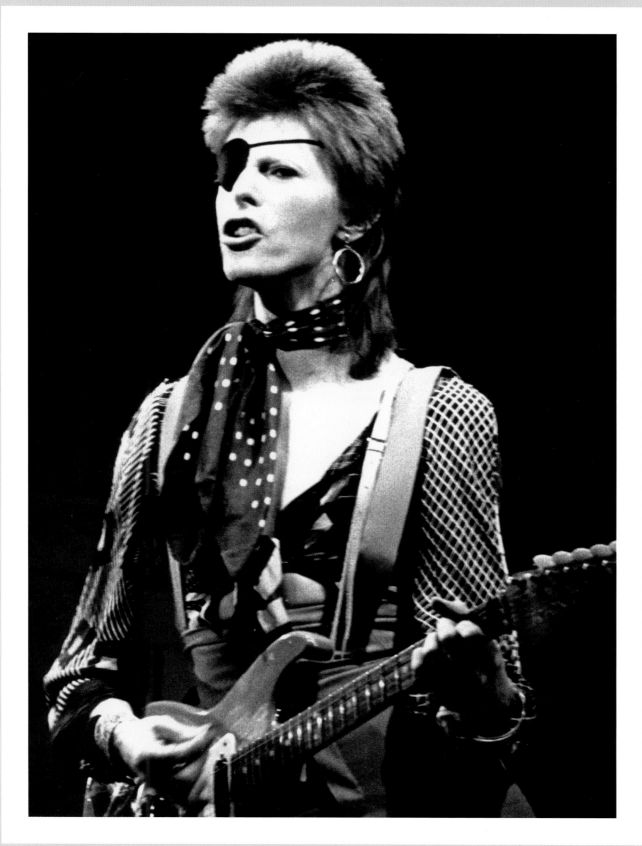

Pirate chic

Left and opposite: In addition to the new single, while in Holland Bowie also revealed his new, if rather short-lived, pirate look. He would later explain that the eye patch was essential as he was suffering from conjunctivitis, but combined with a blousy shirt and large, hooped earring, it looked as if Ziggy Stardust had returned for the day as a swashbuckling rocker. The "Rebel Rebel" single certainly seemed to indicate a move away from glam with its rougher sound, but the song had originated out of Bowie's idea for a Ziggy stageshow and, for the Ziggy fans that bought it in their droves, the song came to be seen as one of the final anthems of the first wave of glam rock, and the end of Bowie's association with the style. Ahead of his *Top Pop* performance on 13 February, he was presented with the Dutch equivalent of a Grammy, receiving the Edison award for most popular male vocalist at a ceremony held at the Amstel Hotel.

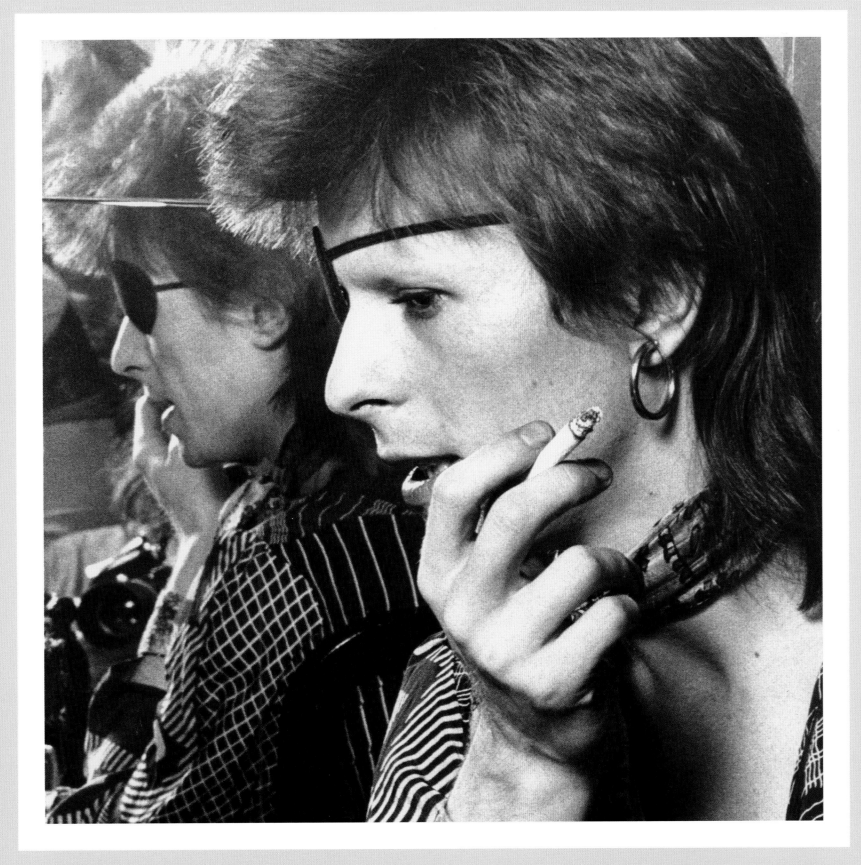

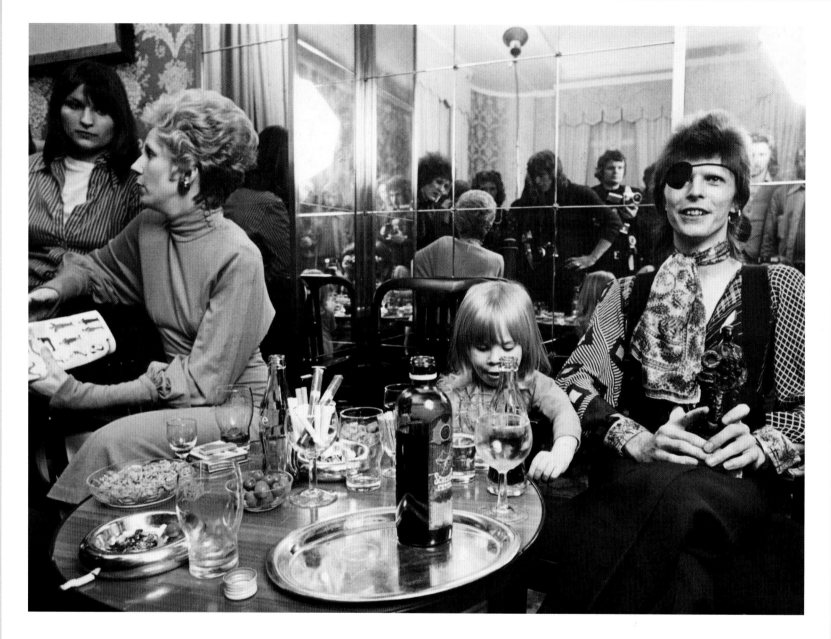

Diamond Dogs

Above: Bowie with Angie and at the Amstel Hotel, Amsterdam. They returned from Holland just in time for the release of "Rebel Rebel" on 15 February, and as the song rose towards the top five, so too did Lulu's version of "The Man Who Sold The World", which would peak at no. 3.

Opposite: Bowie also featured on Mick Ronson's *Slaughter On 10th Avenue*, which was released at this time, but more importantly, he was preparing for the release of his own *Diamond Dogs* LP. Having initially toyed with the idea of recording the LP alone, Bowie's apocalyptic vision was ultimately realised with the help of Mike Garson and Aynsley Dunbar, extra drummer Tony Newman, and bassist Herbie Flowers, who had last recorded with David on "Space Oddity". Production was initially overseen by Keith Harwood, although David would ultimately welcome Tony Visconti back into the fold to assist with the album's mixing. The LP was completed at a frantic pace, and in early March David collected the sleeve art from Guy Peellaert. Featuring Bowie as a hybrid of dog and man, the initial design was regarded as too risqué for release until a certain amount of airbrushing had taken place.

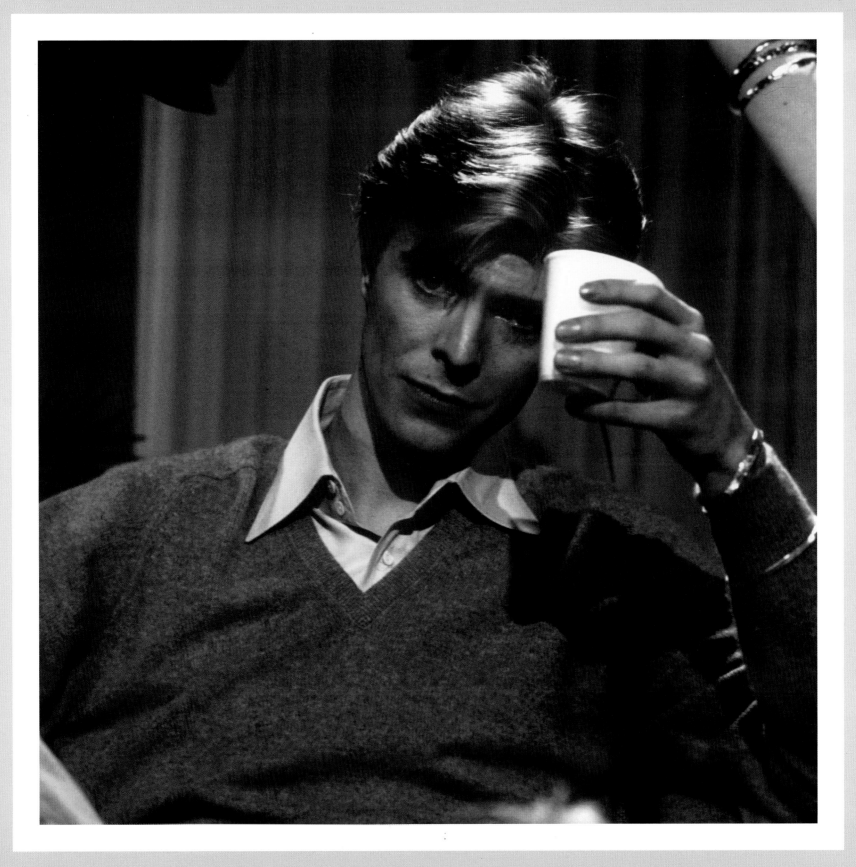

Chapter Three

The Thin White Duke

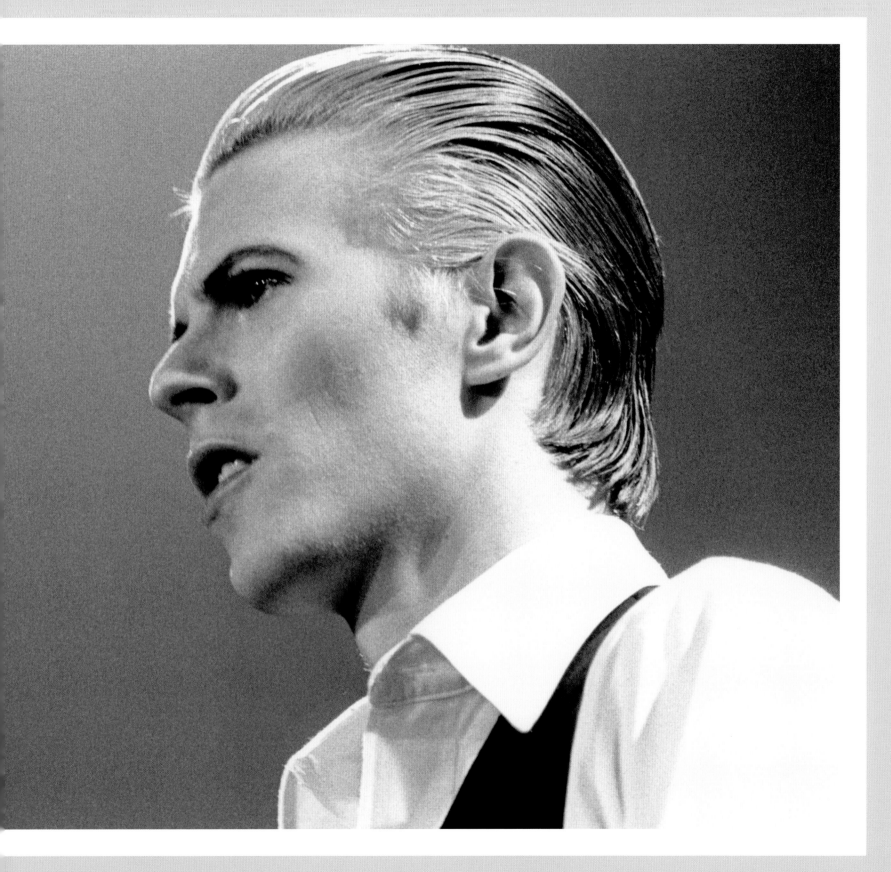

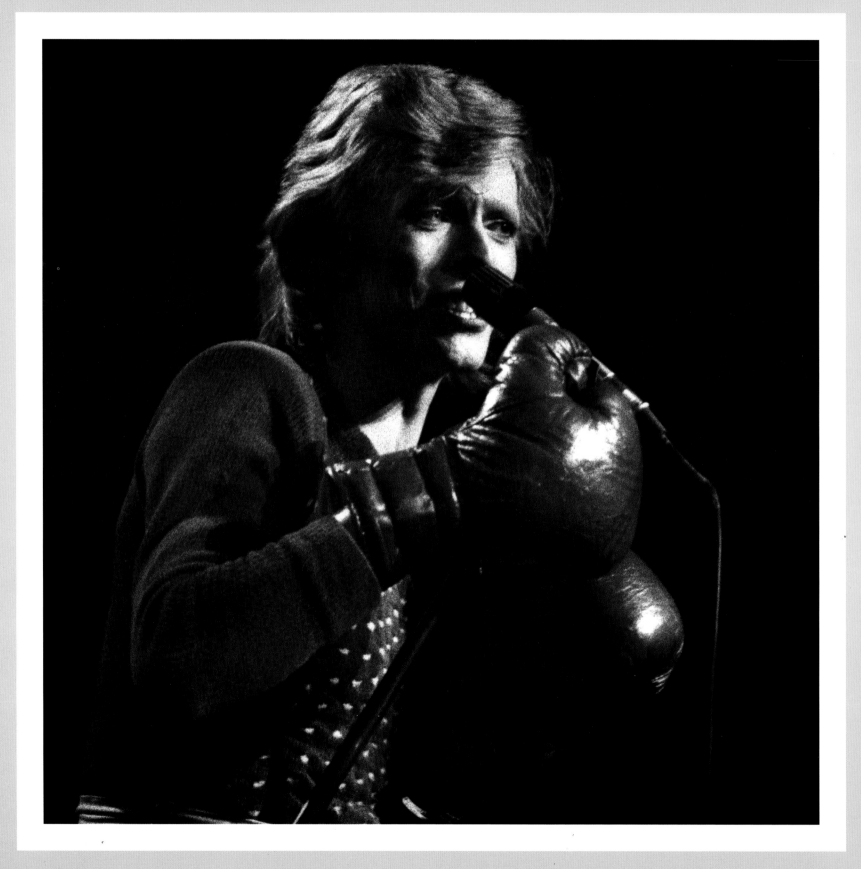

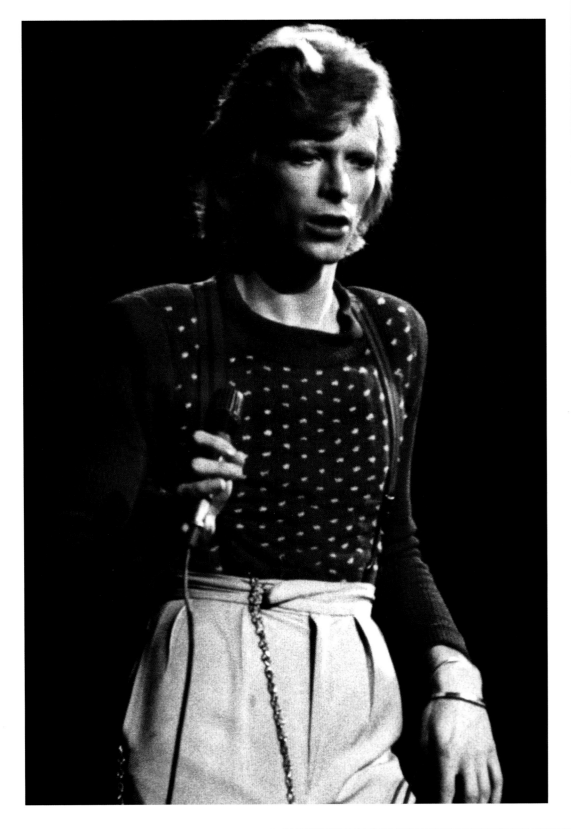

Halloween Jack

Opposite and right: When David Bowie left Britain for the United States on 29 March 1974, he did so riding the crest of a wave. He had proven himself as the best-selling act in the UK in 1973, and although his level of success in America had so far been more modest, he now set out to address this imbalance with the spectacularly staged Diamond Dogs Tour. Arriving in New York in April, just ahead of the album release, Bowie set about assembling his touring band, recruiting keyboard player and musical director Michael Kamen, guitarist Earl Slick and saxophonist David Sanborn to join Mike Garson, Herbie Flowers and Tony Newman. In New York, Bowie also immersed himself in the sounds of Black America, and when he took to the stage at the Montreal Forum on 14 June, the fans were greeted with a new sound and a new image. Ziggy Stardust had been replaced by Diamond Dogs' "real cool cat", Halloween Jack. Perhaps the biggest surprise, however, was delivered by the stage show, which was almost certainly the most complex and expensive yet mounted to accompany a rock tour.

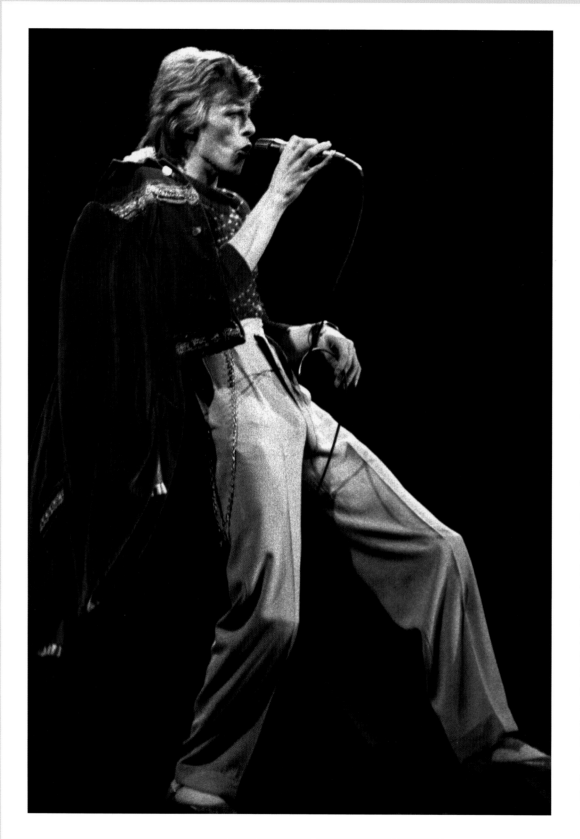

David Live

Opposite and left: The Hunger City of Diamond Dogs was represented by a cityscape set inspired by Fritz Lang and Robert Wiene, and featured a hydraulic lift and suspended walkways, all brought to life by dramatic lighting, theatrical choreography and numerous props. The show was immediately hailed as a huge success, which helped to propel the album to no. 5 in the US, but as the tour progressed from Canada through the States, the cracks began to appear. Firstly, there were problems with the set, which did not always function as intended, or was simply too large to be accommodated by some venues, and in Florida the show went ahead without it after a road accident en route to the gig. Perhaps more importantly, however, tensions were also rising within the Bowie camp, and in Philadelphia Herbie Flowers led an open revolt when the band discovered that they would receive their standard fee, despite the fact that the concert was being recorded for the *David Live* album. Bowie and Defries, who were essentially paying for the tour out of their own pockets, eventually relented but the debacle would serve to hasten Flowers' departure from the tour.

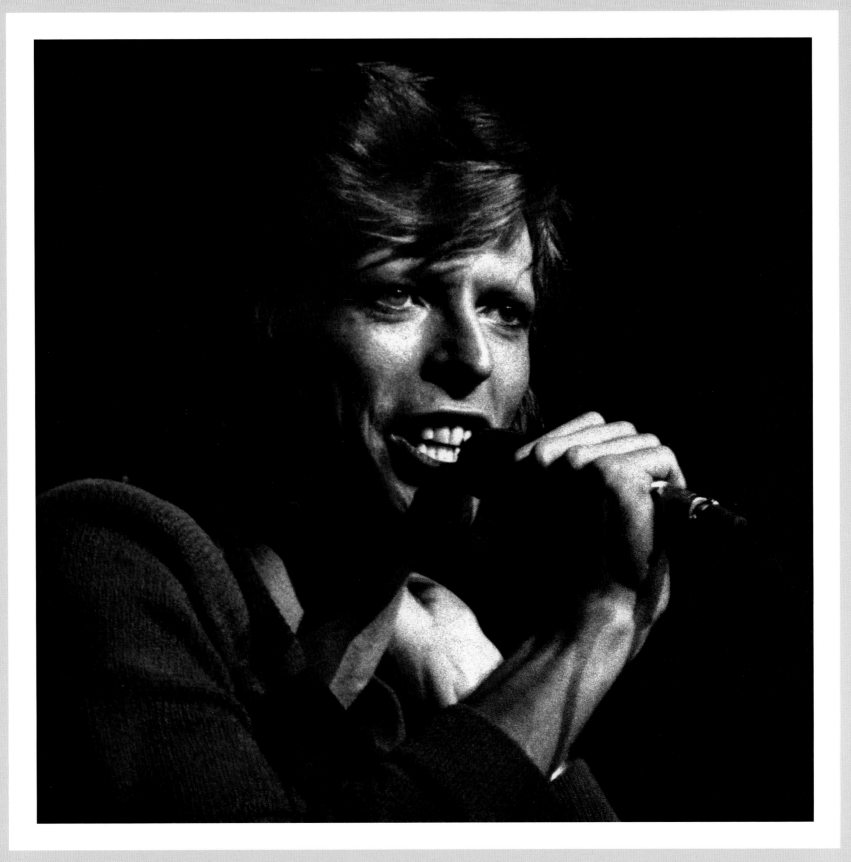

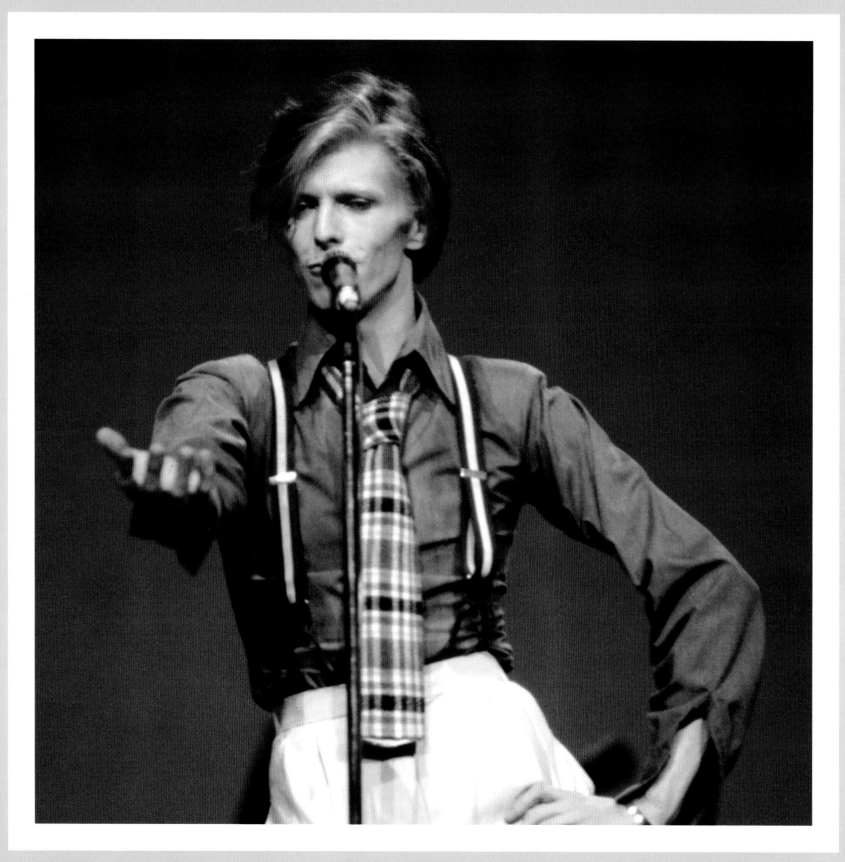

Philly Dogs

Opposite and right: The first leg of the tour concluded with two shows at New York's Madison Square Garden in July, following which there was a six-week break from performing. In late July, Bowie, Visconti and Eddie Kramer mixed the *David Live* LP at Electric Lady Studios, before David relocated to Sigma Sound in Philadelphia, where he began recording new material for his next studio album. Carlos Alomar was brought in on guitar and Flowers and Newman were replaced by Andy Newark and Willie Weeks, but due to previous commitments, Doug Raunch and Greg Enrico took over on bass and drums when the tour resumed, before being replaced by Emir Kassan and Dennis Davis. However, these were not the only changes afoot. Bowie was already beginning to demo the new material he had been working on, and after a short break in September, the tour was relaunched as the Philly Dogs or Soul Tour. The cumbersome scenery was dispensed with, and the band, which now incorporated six backing singers, including Ava Cherry and Luther Vandross, opened the shows with a soul set.

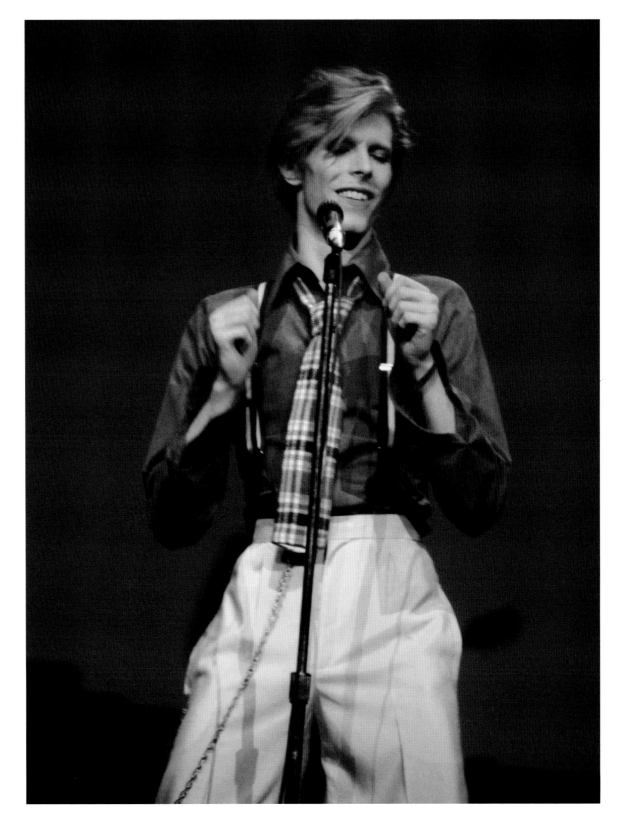

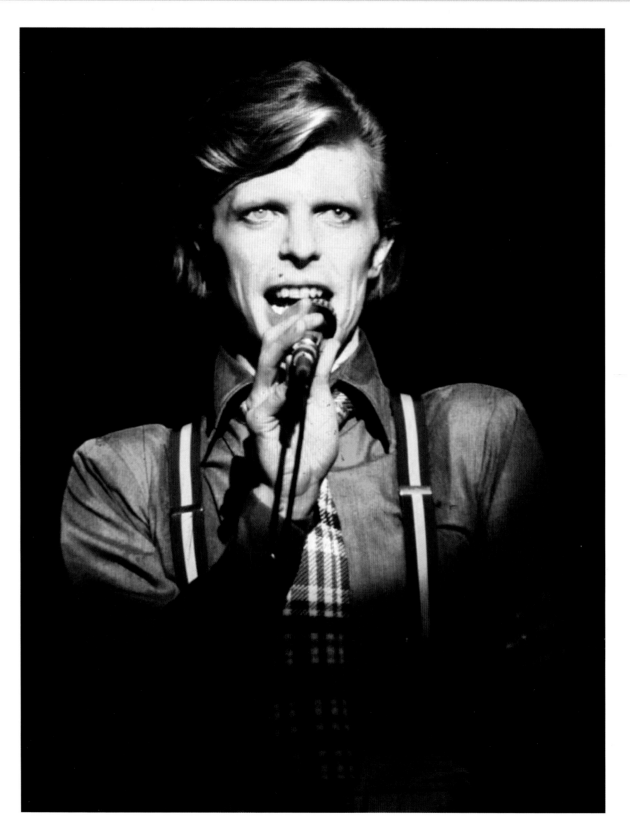

Cracked Actor

Left: Despite the freedom Bowie was now afforded by the ditching of the Diamond Dogs stage show, by November, when he arrived for a residency at New York's Radio City Music Hall, the press had become more critical. The scenery may have become restrictive, but without it, all attention was now focused squarely on David himself, and it was clear that all was not well. Since his arrival in the US his use of cocaine had increased and he was suffering both mentally and physically. He was now painfully thin and pale, his voice had begun to wane, and according to members of his own band, on some nights he was lucky to get through the show. There were also real concerns over his mental state, and footage from Alan Yentob's *Cracked Actor* documentary and his appearance on *Dick Cavett's Wide World Of Entertainment* showed that Bowie was at times becoming incoherent.

Opposite: After the tour closed in December, Bowie remained in the US over the festive season, and in early 1975 was frequently seen out on the town, taking in performances by such acts as Led Zeppelin, Manhattan Transfer, and Rod Stewart (pictured opposite left)

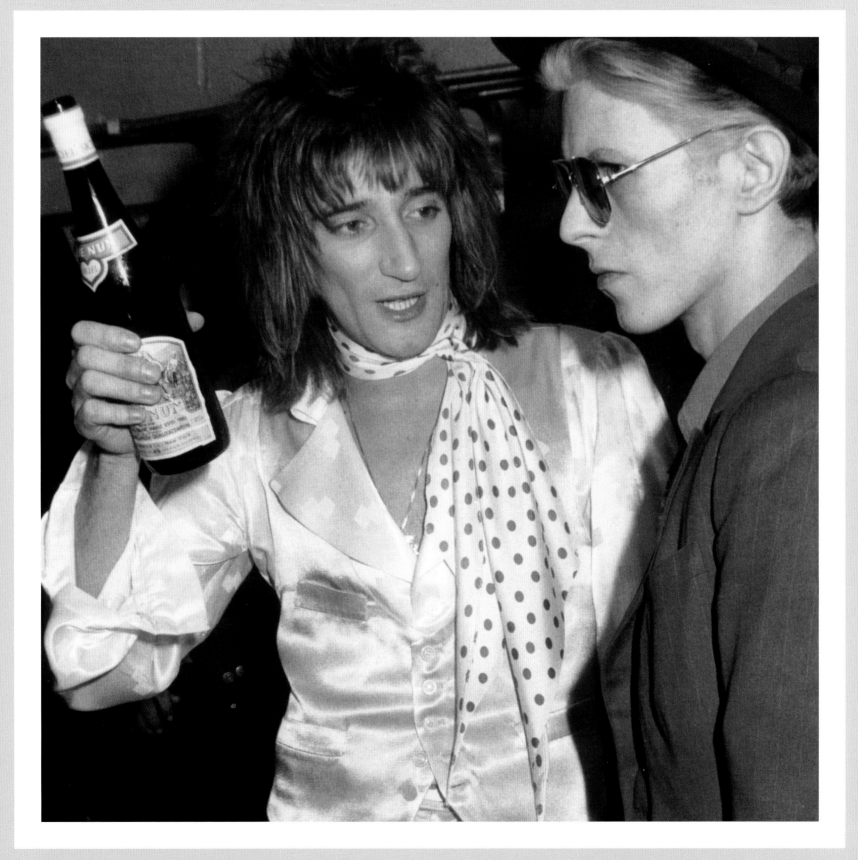

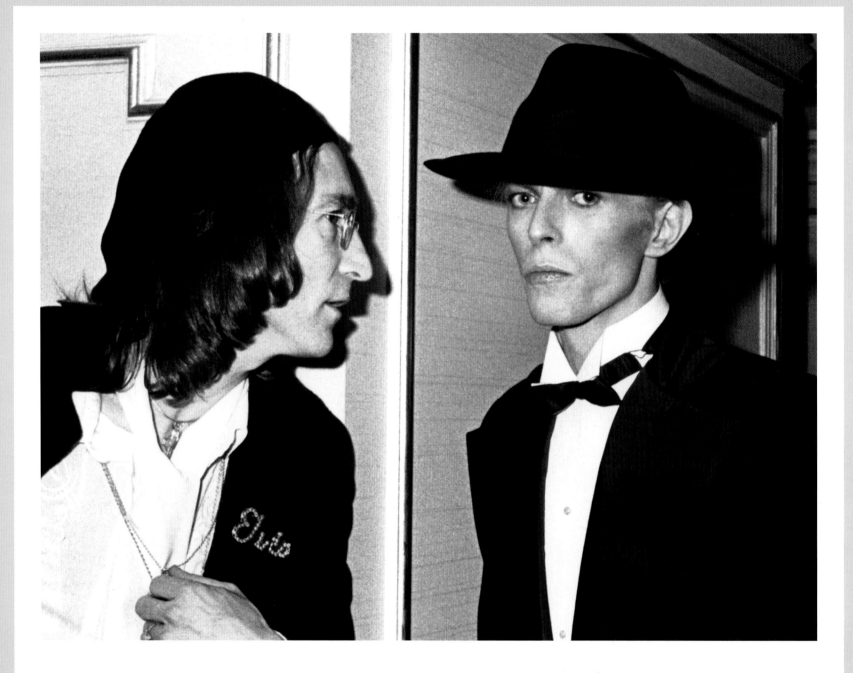

Collaborating with Lennon

Above: With John Lennon at the 17th Annual Grammy Awards in March 1975. Having met in Los Angeles in 1974, David Bowie and John Lennon began to socialize upon their return to New York, where both had taken up residence. Lennon was recording his *Rock 'n' Roll* album at Record Plant Studios, which David also frequented, and in January an impromptu jam led to a collaborative recording session at Electric Lady Studios, where Bowie, Lennon and Carlos Alomar reworked The Flares' "Footstompin'"

into "Fame", and Bowie recorded his version of The Beatles' "Across The Universe". Although his *Young Americans* LP was essentially complete by late 1974, Bowie immediately contacted Tony Visconti in London to request that the new songs be included on the album. Lennon was also instrumental in encouraging Bowie to break away from Tony Defries and his MainMan organization, with whom he had by now become increasingly disillusioned.

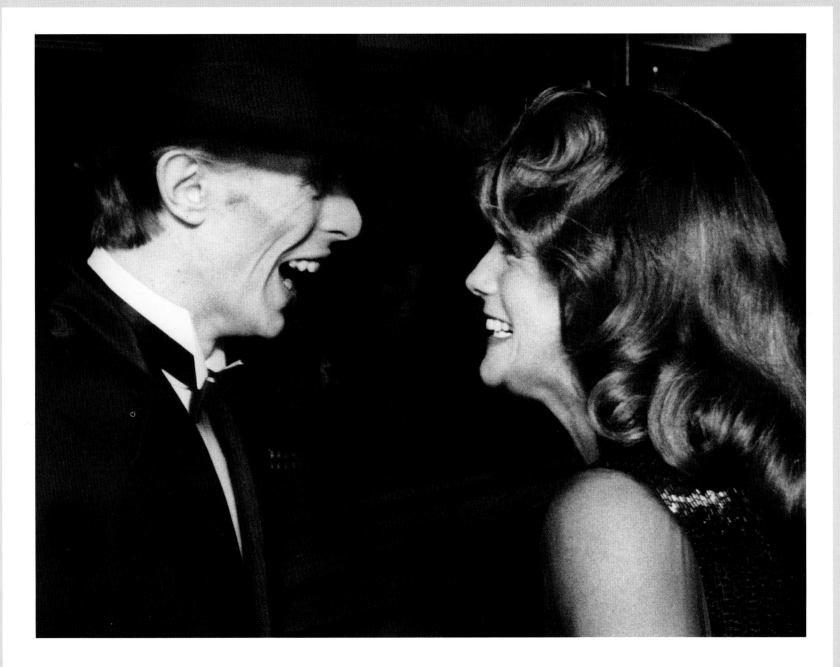

Breaking America

Above: With actress Ann Margret at the 1975 Grammy Awards.

By February, Bowie had begun legal proceedings to extricate himself from MainMan, and while this may have been a source of some anxiety, on a more positive note he was about to score a hit with his latest single, "Young Americans". In the UK the song reached no. 18, which improved on the performance of the recent singles "Rock 'n' Roll Suicide" and "Diamond Dogs", but was a disappointment when compared to the glory days of glitter rock, and even to his last single, "Knock On Wood" which had reached the top ten. However, in the US, "Young Americans" made the top 30, marking something of a breakthrough for Bowie at that time. A further mark of acceptance in America came when he was asked to present Aretha Franklin with the award for "Best Rhythm & Blues Performance by a Female Artist" at the Grammys.

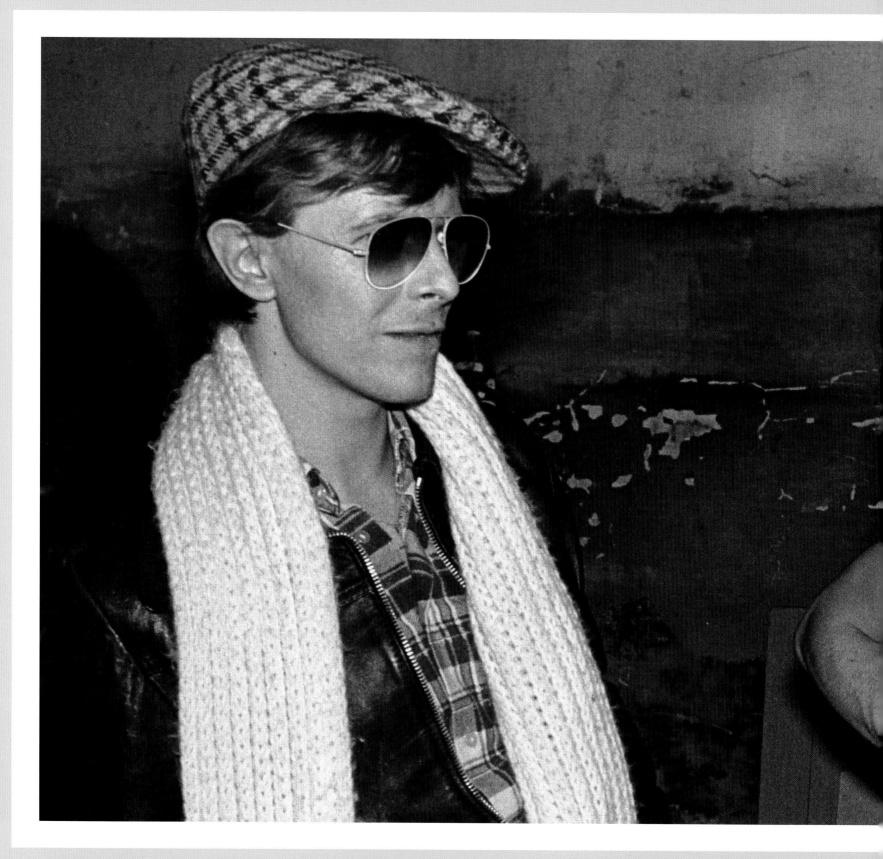

Plastic soul

Left: With Lenny Kaye of the Patti Smith Group,
outside the CBGB nightclub in Manhattan. Just
days after presenting "The Queen Of Soul" with her
Grammy Award, Bowie's own soul infused-album,
Young Americans, was released. In the UK, where both
the fans and critics had seemed slower to adjust to
the Americanization of his music, *Young Americans*
performed surprisingly well, and ironically, the album
was only held from the no. 1 position by the genuine
Philadelphia soul of The Stylistics with their *Best Of*
compilation. In the US *Young Americans* provided
Bowie with his second top ten LP, but perhaps more
importantly, the album was largely embraced by the
American music press, ensuring that he was finally on
the cusp of superstardom in the States. If, as he has
subsequently claimed, his "plastic soul" record was the
result of a phase, designed to cement his reputation in
the US, then he appeared to have succeeded.

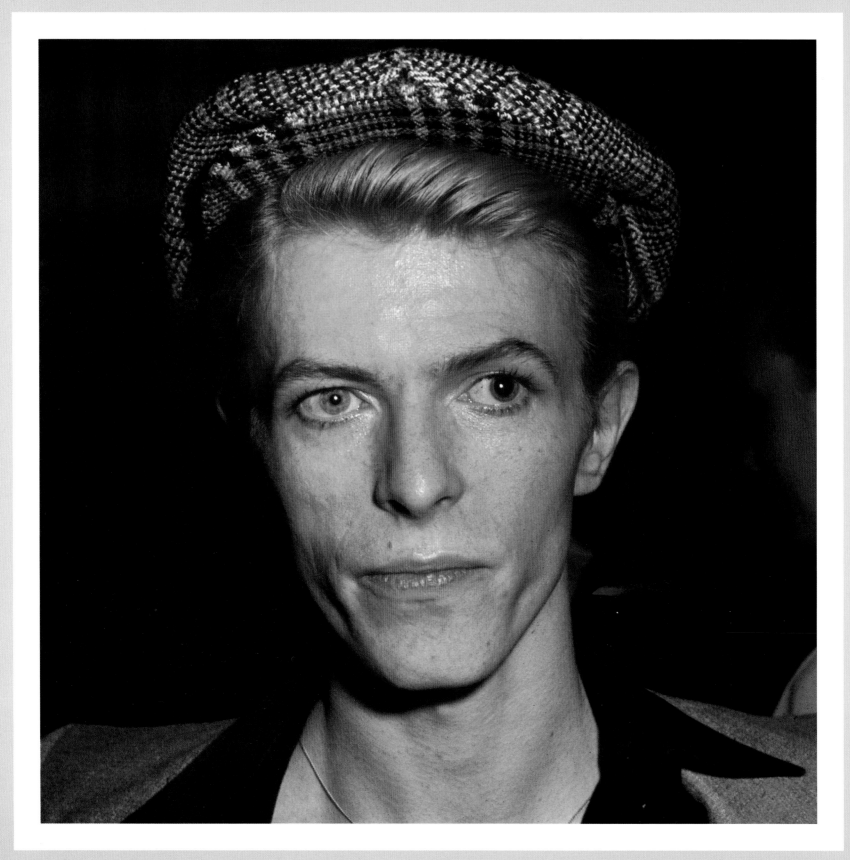

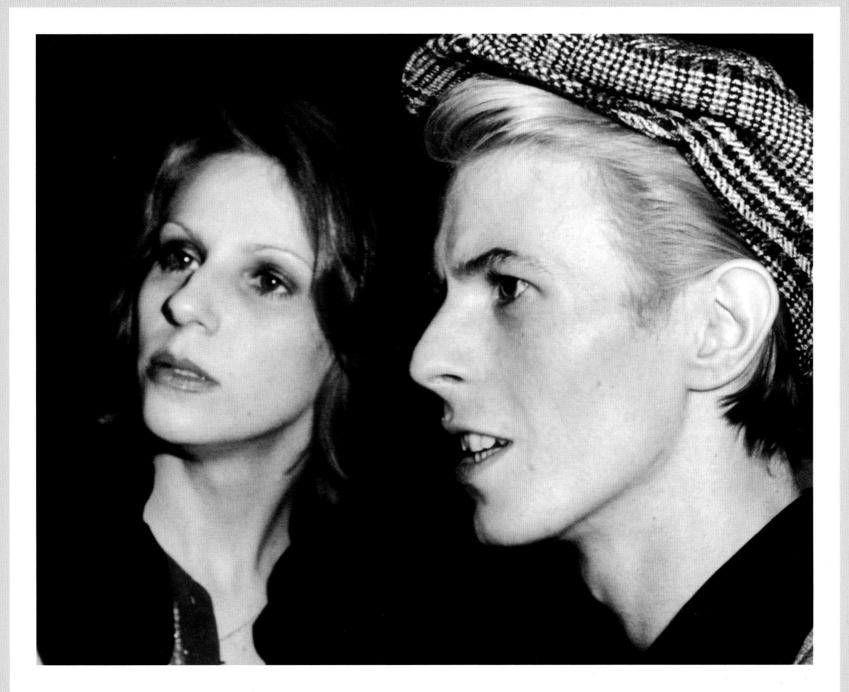

"No more rock and roll"

Above: David and Angela Bowie pictured in April 1975 at the American Film Institute reception for director Michelangelo Antonioni, in Beverly Hills, California. That same month, and for the second time in as many years, Bowie announced his retirement, declaring "I've rocked my roll. It's a boring dead end. There will be no more rock 'n' roll records or tours from me". Whether Bowie, who had never really considered himself to be a rock singer, was being genre-specific or talking about retiring from music altogether was unclear, but by May, having relocated to Los Angeles, he could be found at Oz Studios in Hollywood, producing and collaborating with Iggy Pop. The following month, however, the sessions ended in disarray when Iggy was charged with drug possession and opted to check in to rehab rather than face jail.

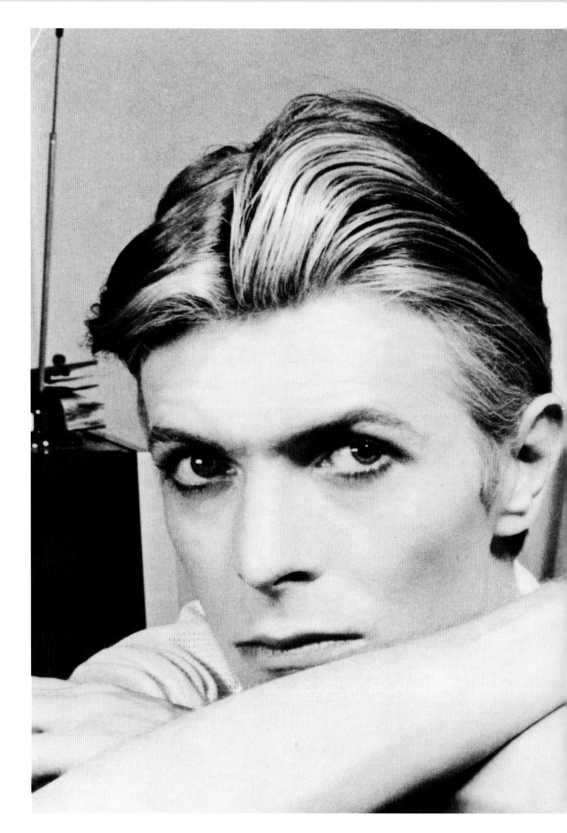

Under pressure

Right: David Bowie and Candy Clark in a scene from *The Man Who Fell To Earth*.

Holed up in a rented house on Doheney Drive with the curtains permanently drawn, Bowie's already fragile mental and physical condition continued to deteriorate. However, he also had to contend with the pressures of the legal battle with his former manager Tony Defries, and the realization that his open marriage to Angela was by now in a state of almost total collapse. Yet somehow in the midst of all this chaos, he was able to compose himself enough to take on his first major acting role in Nicolas Roeg's production of Walter Tevis' 1963 cult sci-fi novel, *The Man Who Fell To Earth*.

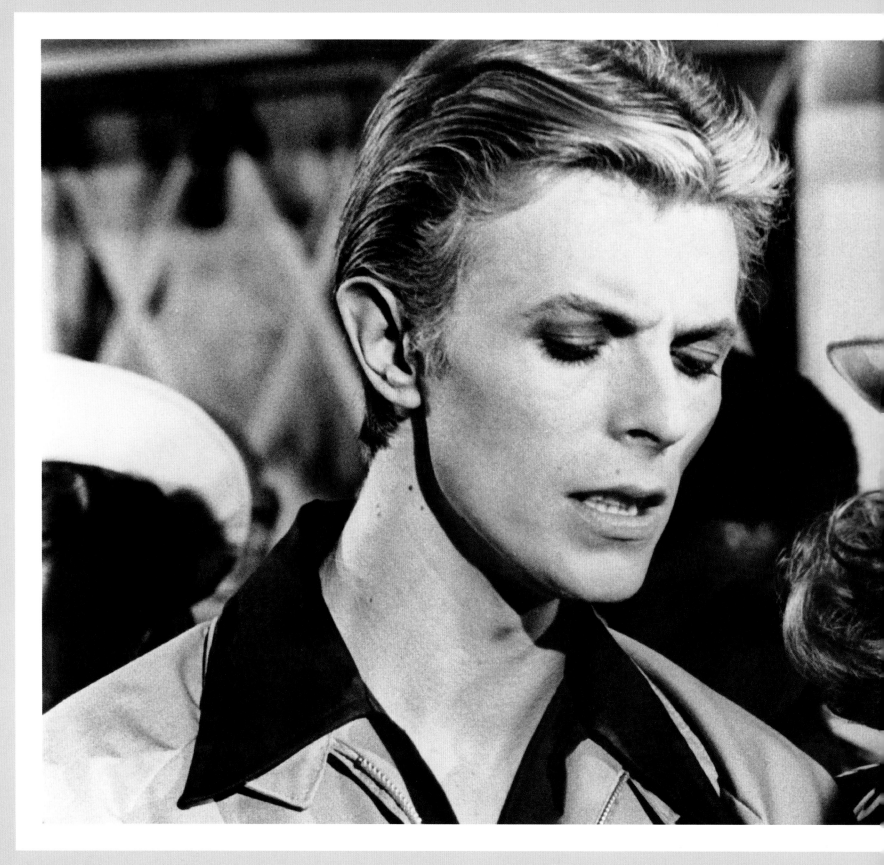

The Man Who Fell To Earth

Left: David Bowie and Candy Clark in *The Man Who Fell To Earth*. Bowie had met with director Nic Roeg in New York back in February, and had jumped at the chance to take on the lead role of Thomas Jerome Newton, an otherworldly being who comes to Earth in search of salvation, but finds himself corrupted by alcohol, money and the media. The part not only resonated with Bowie, but would once again blur the boundaries between his own identity and that of the character he was portraying. For Roeg too, Bowie seemed made for the role, and he found himself impressed by Bowie's concentration and self-discipline on set, as well as the genuine enthusiasm he demonstrated for the film-making process. Scheduled to last for 11 weeks, filming began in New Mexico in July. Between takes he spent time shooting footage with his own 16mm camera, as well as writing music and lyrics for the movie's soundtrack. The press seemed largely mystified by the movie, although Bowie received praise for his performance, and he would later be rewarded with a Best Actor award from the US Academy of Science Fiction, Fantasy and Horror Films.

"Fame"

Right: Arriving at the Cherokee Studios in West Hollywood. Having completed *The Man Who Fell To Earth*, Bowie returned to Los Angeles and to recording, entering the studios in October to begin work on his next LP, *Station To Station*. Carlos Alomar, Earl Slick, Dennis Davis and producer Harry Maslin were retained from the *Young Americans* sessions, to be joined by bassist George Murray, and pianist Roy Bittan of Bruce Springsteen's E Street Band. At the time Bowie was at a creative and commercial peak. In September he had scored his first no. 1 single when "Fame" rose to the top of the US charts, while in the UK a second chart-topper was assured with the rerelease of "Space Oddity". By early November he was ready to debut "Golden Years" on ABC's *Soul Train*. It was issued as a single within the month, and went on to reach the top ten on both sides of the Atlantic. Also in November, he performed on *The Cher Show*, and appeared on *Russell Harty Plus* via a live satellite link, announcing that he would be returning to England as part of an imminent European tour.

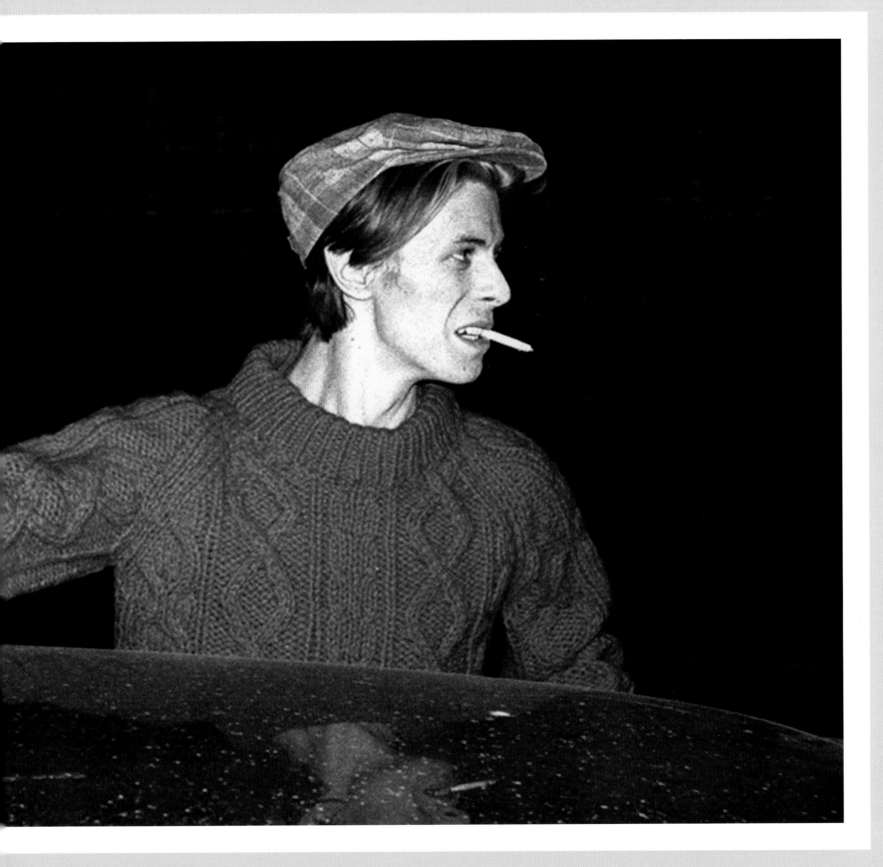

The Thin White Duke

Right: On tour as The Thin White Duke in 1976. With *Station to Station* on its way to no. 3 in the US and no. 5 in the UK, the Isolar Tour was launched at the beginning of February. Also known variously as the Station to Station, White Light, or Thin White Duke Tour, this outing saw Bowie taking to the road with a stark and stripped down show. The elaborate sets and props, costumes and hairstyles of previous tours were eschewed in favour of vast banks of white lights, a five-piece band, and Bowie with short, slicked-back hair and a simple white shirt, black waistcoat and black trousers.

Completed by the end of 1975, *Station To Station* marked something of a musical transition for Bowie. The funk and soul of *Young Americans* was still in evidence, but the album also betrayed the influence of the electronica being developed by such groups as Kraftwerk, and he would later describe the album as a kind of plea to return to Europe. The LP was also notable for channelling Bowie's final alter ego, the starkly detached Thin White Duke, who was part Bowie, part Thomas Newton, and part Aryan superman. Once the *Station To Station* sessions were over, he turned his attention to the soundtrack for *The Man Who Fell To Earth*. However, this was abandoned when he discovered that he would not be solely responsible for the score, but merely a contributing artist. This caused a great deal of ill feeling between David and Michael Lippman, the lawyer that he had appointed as his manager just six months earlier, and by January 1976, when *Station To Station* was released, Bowie had initiated legal proceedings against him. At the same time guitarist Earl Slick was replaced by Stacey Heydon.

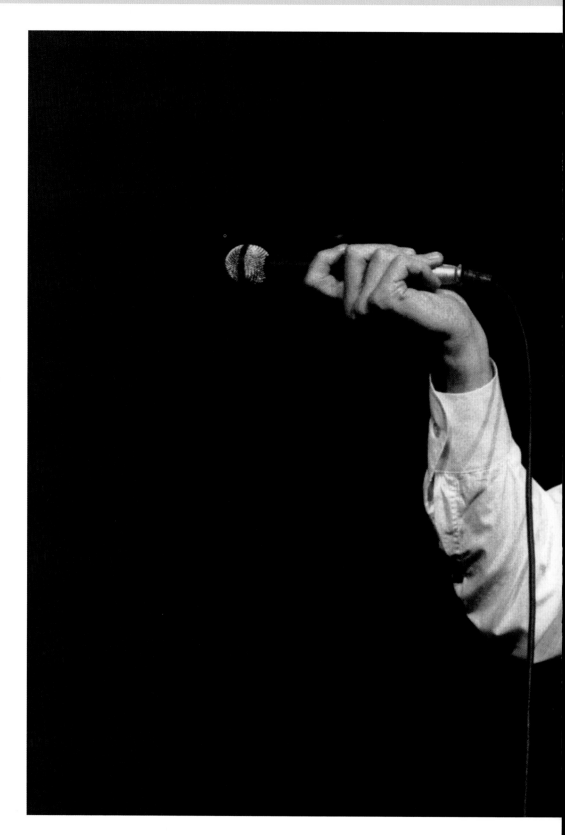

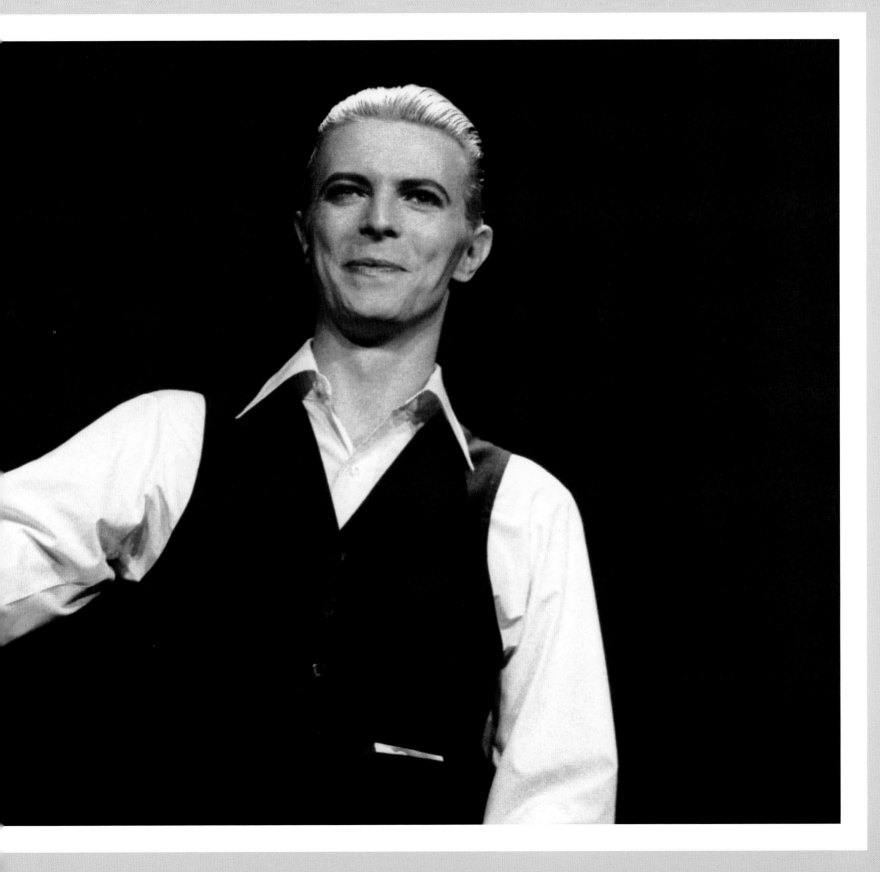

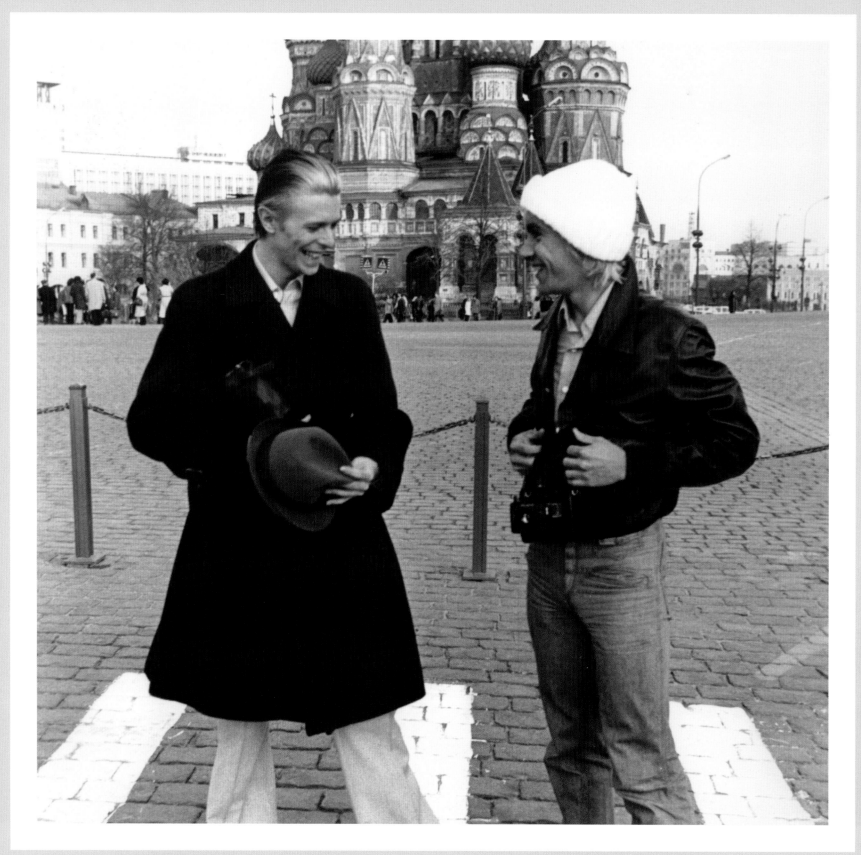

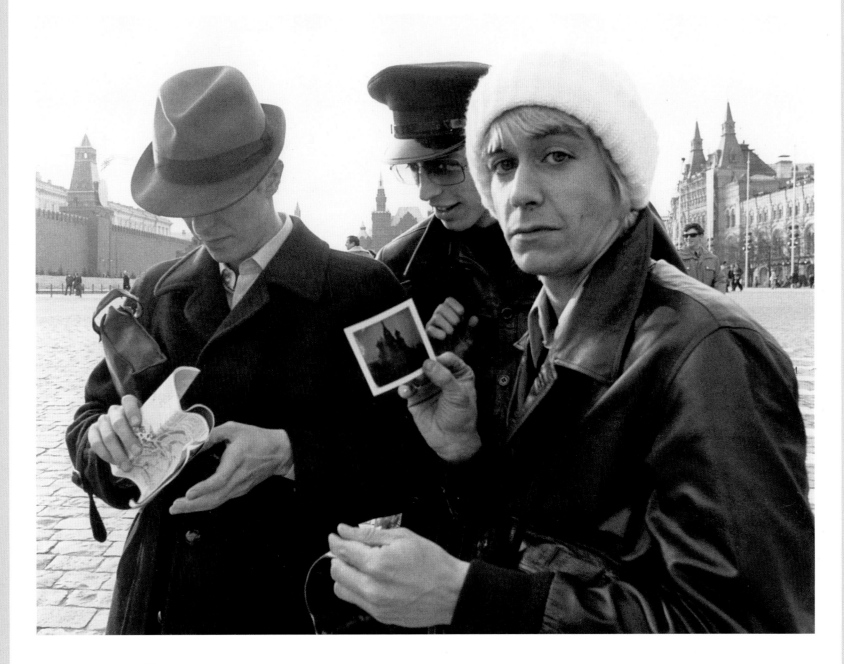

Running into trouble

Opposite and above: David Bowie and Iggy Pop in Moscow's Red Square. In February, David had invited Iggy Pop, fresh from rehab, to join him as a companion for the 1976 tour, but just a few weeks later they ran into trouble when they were arrested at the Flagship Americana hotel in Rochester on suspicion of marijuana possession. The case was adjourned and the charges later dropped, but the pair would encounter further problems when they visited Moscow in early April, during a brief lull in the European leg of the tour. Returning to Finland for the next show in Helsinki, David and Iggy were searched on a train at the Russian-Finnish border and biographies of Josef Goebbels and Albert Speer were confiscated. As far back as "The Supermen", Bowie had explored proto-fascist themes and imagery in his music, but now the media seized upon his supposed fascination with the far-right, sparking a controversy that was to endure well beyond the duration of the tour.

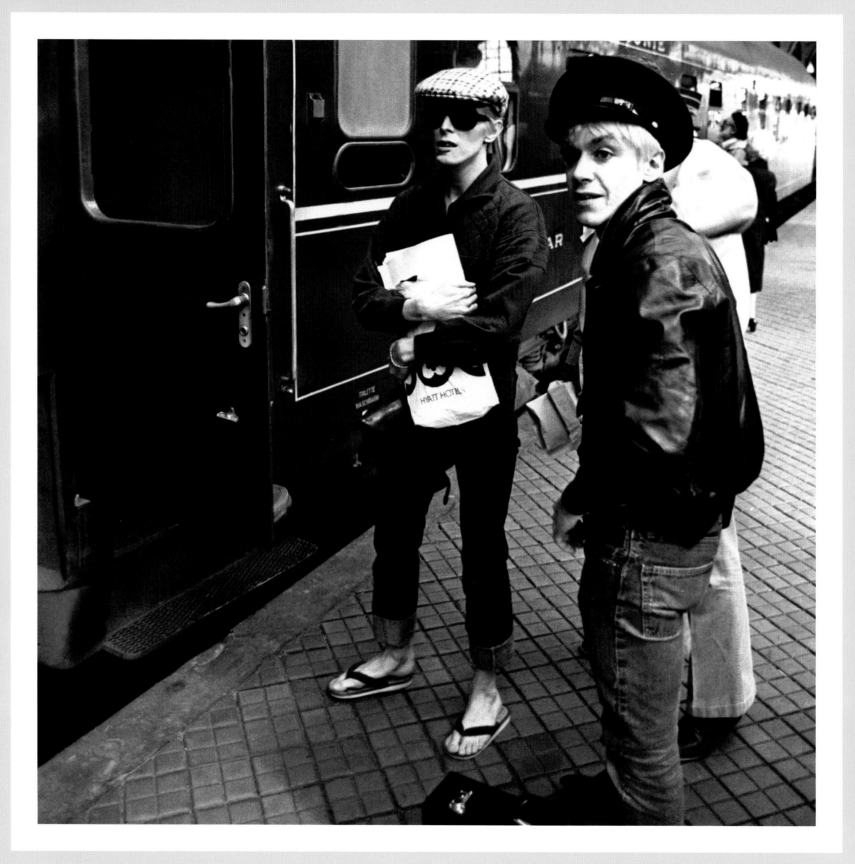

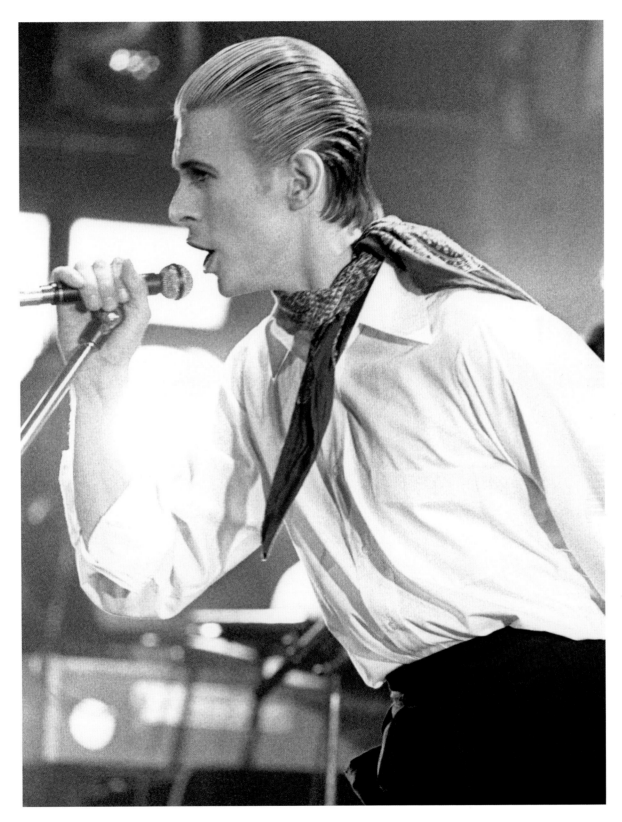

Courting controversy

Right: Onstage in Copenhagen at the end of April. A few days after the show in Helsinki, at a press conference in Sweden, Bowie was quoted as saying, "As I see it, I am the only alternative for the premier in England. I believe Britain could benefit from a fascist leader. I mean, fascist in its true sense, not Nazi. After all, fascism is really nationalism." If such a statement was designed to placate the journalists who were looking for a Nazi slant for their stories, it only seemed to add fuel to the fire. Any sense of deliberate sensationalism or irony, theatre or art were now lost as the media machine's own taste for controversy stepped up a gear and rumours began to emerge that Bowie had been photographed outside Hitler's bunker in Berlin.

Opposite: David and Iggy Pop at Copenhagen Central Station.

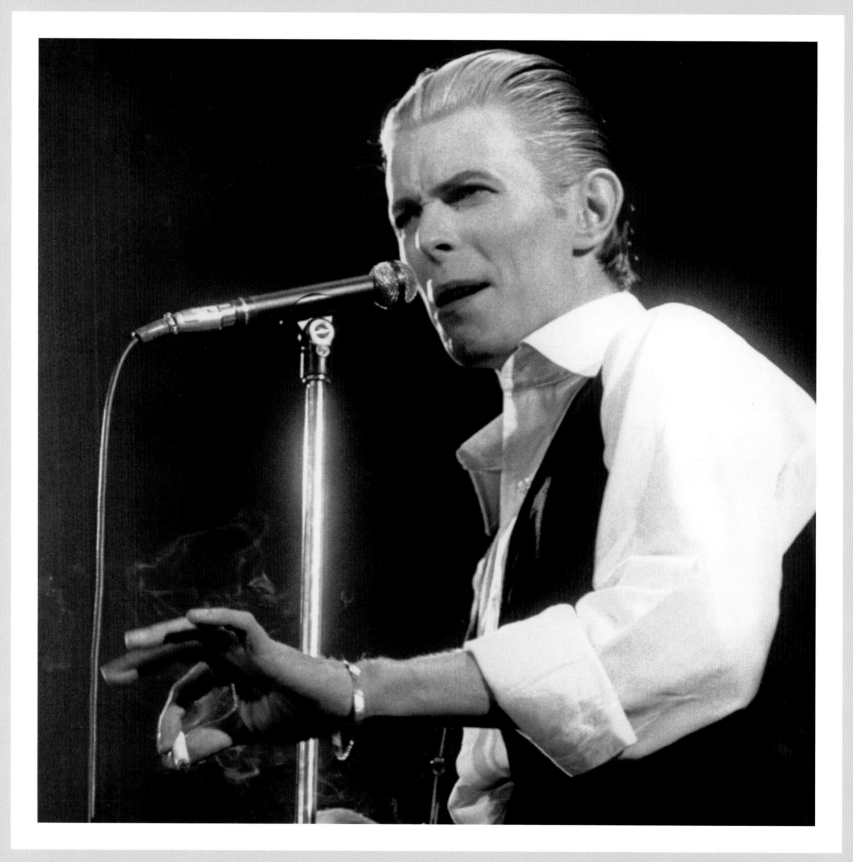

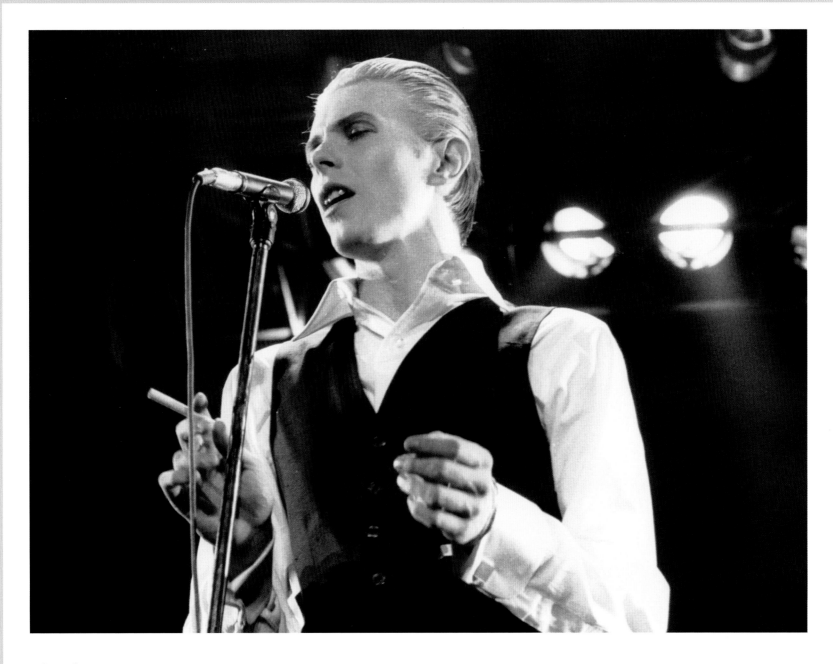

Triumphant return

Opposite and above: "The Thin White Duke" stalking the stage at Wembley, May 1976. On 2 May, after an absence of over two years, Bowie made his triumphant return to Britain, arriving at Victoria Station in an open-topped car to be greeted by hordes of fans. However, the British press, whose interest had been piqued by his political comments in Stockholm, were also lying in wait, and his homecoming would be overshadowed by reports that he had given a Nazi salute to the assembled fans. Bowie himself was furious at the suggestion, and when asked by a British journalist if it really mattered – after all wasn't it good publicity?–Bowie was quick to respond: "Yes, it does. It upsets me. Strong I may be. Arrogant I may be. Sinister I'm not". Despite the furore in the press, when he took to the stage at the Wembley Empire Pool on 3 May for the first of six consecutive sold-out shows, the fans welcomed him back with open arms, and Bowie was reduced to tears by the overwhelming audience response.

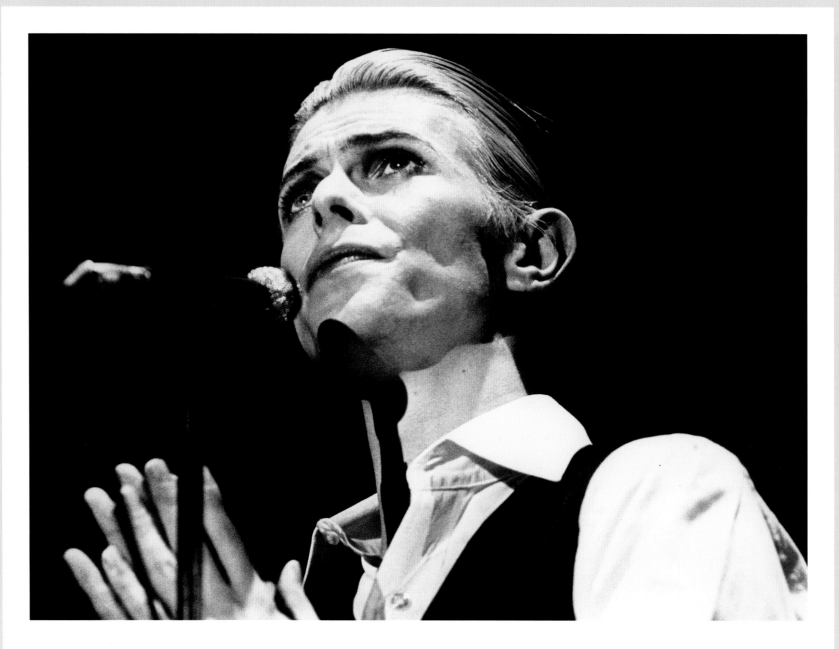

Chez Romy Haag

Opposite: With Romy Haag at the Alcazar Club in Paris. Following his highly successful week-long run of shows in England, Bowie took his Isolar Tour to Belgium and The Netherlands, before concluding with two nights at the Pavillion de Paris in France. Three nights were originally scheduled, but the last of these was ultimately cancelled due to a lack of ticket sales. After the last show on 18 May, David celebrated the end of the tour at the Alcazar Club with Romy Haag, whose career as a female impersonator and exotic dancer had begun at the venue. In the early hours of 19 May, the club was raided by the French drugs squad, but by this time David and Romy had reportedly returned to Bowie's hotel. Earlier in the year, David had purchased a new home for himself and his family in Corsier-sur-Vevey, near Montreux, Switzerland, and it was to here that he retreated after the 1976 tour. During this time he began to paint and collect art, and to indulge his passion for classical music and literature.

Above: David on stage at the Ahoy Arena, Rotterdam, on 13 May 1976.

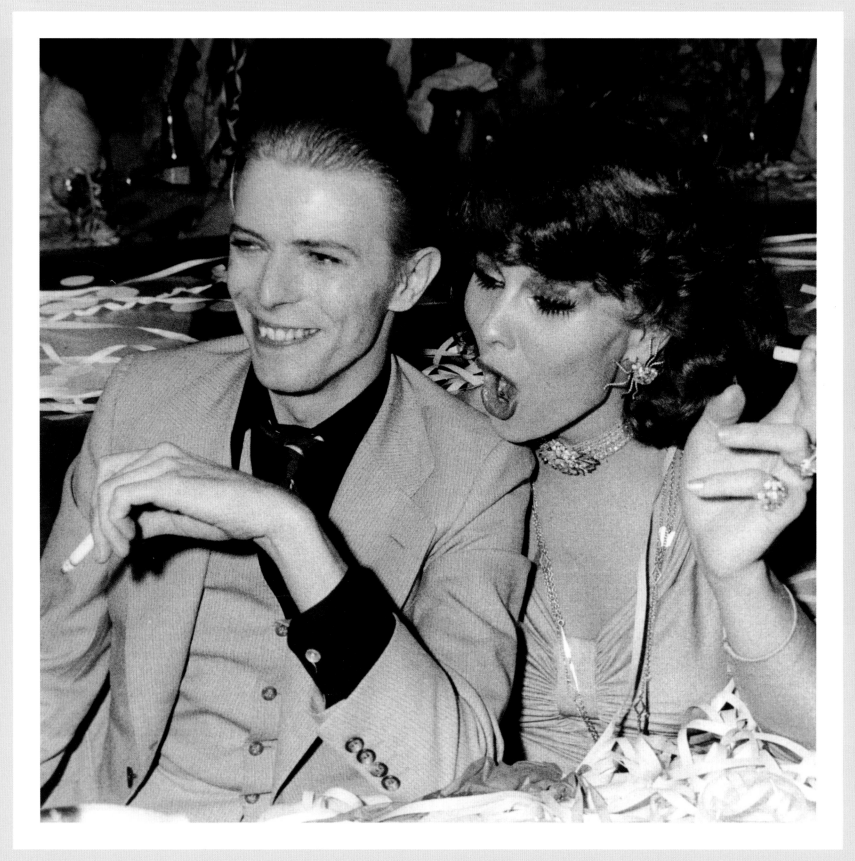

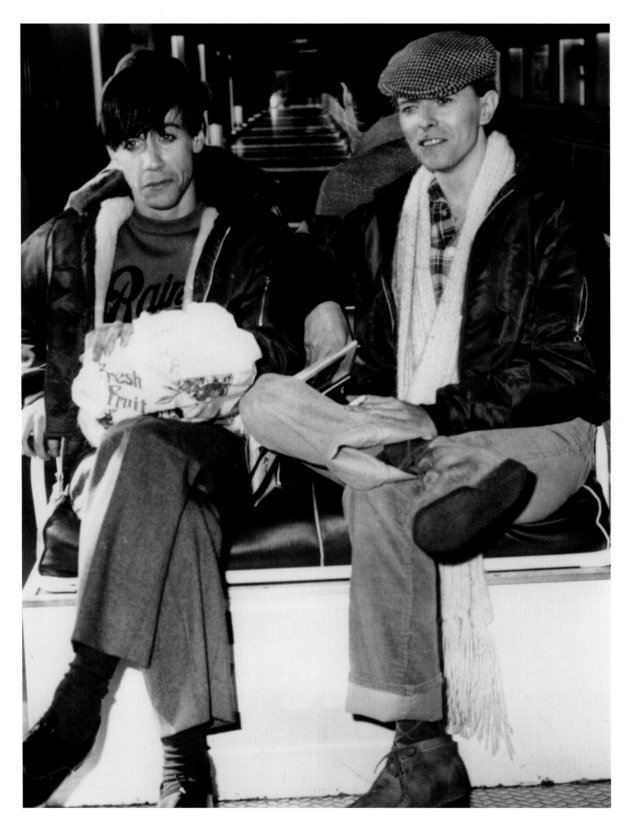

Low

Towards the end of May, RCA released the compilation album, *Changesonebowie*, which reached the top ten in both the UK and US, but within a matter of weeks, Bowie was working on new material, collaborating with Iggy Pop on his debut solo album, *The Idiot*, at the Château d'Hérouville in France, before recording *Low*. This album was also primarily recorded at the Château, but marked the beginning of Bowie's "Berlin period", with David relocating to the city with Iggy in the autumn of 1976 to complete work on the LP at the Hansa Studios. Recorded with the assistance of Brian Eno, the album represented Bowie's most experimental and least commercial work to date, but following its release in January 1977, *Low* confounded expectations by entering the UK chart at no. 2 and by climbing to 11 in the US. Released in February, the single "Sound And Vision" also proved to be a hit, peaking at no. 3 in the UK, despite a lack of promotion by Bowie himself, who spent March and April on tour with Iggy Pop (Left).

Opposite: Onstage at the Rainbow Theatre, London.

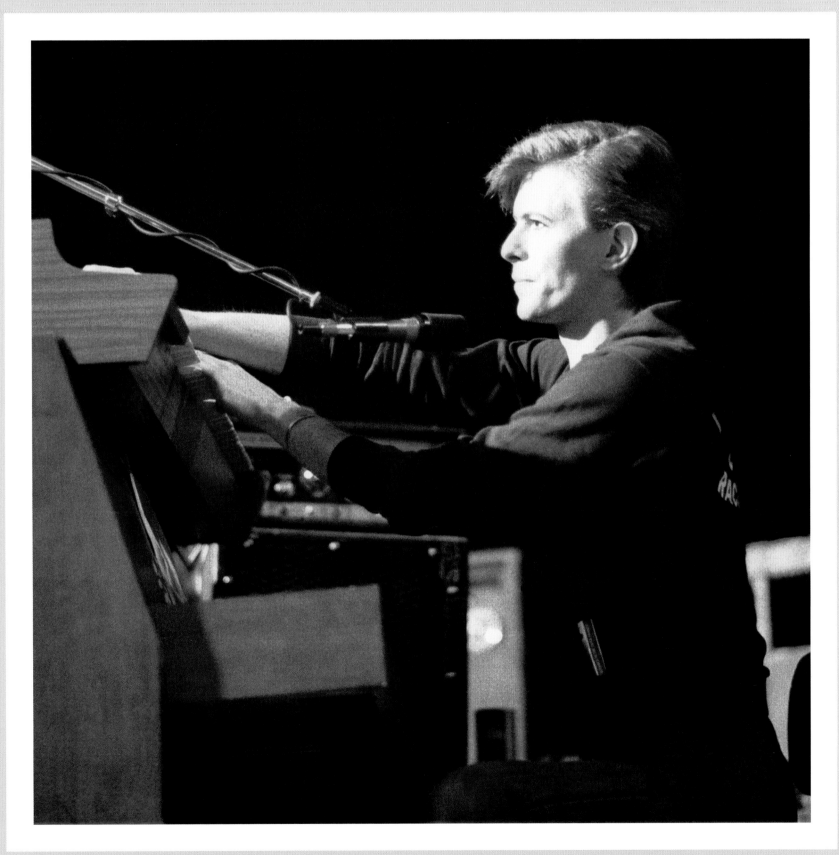

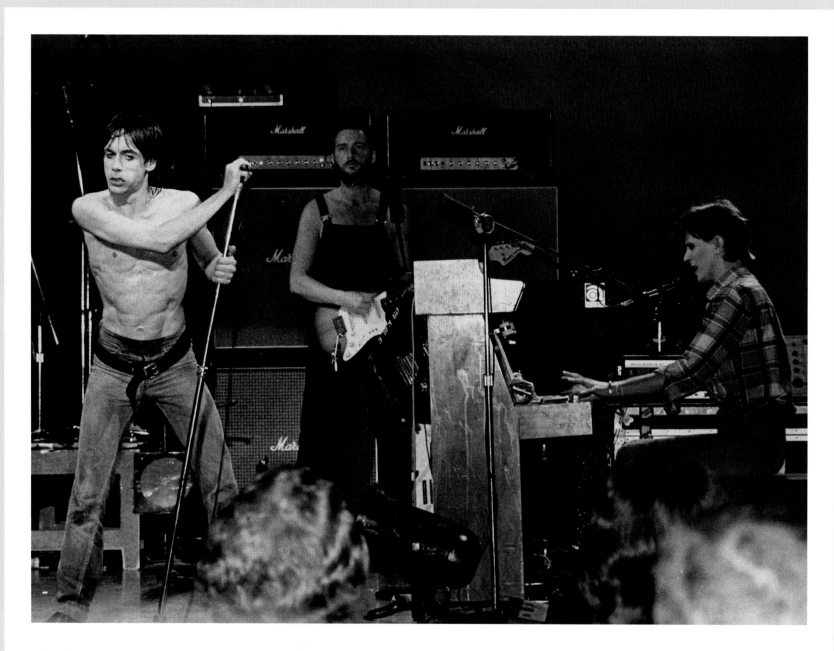

The Idiot Tour

Above: Bowie on stage with Iggy Pop and his band at the Berkeley Community Theater, San Francisco. After rehearsals in Berlin, Iggy Pop's Idiot Tour got underway at the Friars Hall, Aylesbury, on 1 March, with David joining Iggy's band to play keyboards. After gigs in Newcastle, Manchester and Birmingham, they performed a three-night residency at London's Rainbow Theatre, with support coming from British punk rock band The Vibrators. The UK leg of the tour concluded on 7 March, the same day that Iggy released "China Girl", before heading to North America for dates in Canada and the US. Interestingly, this was the first time that Bowie had travelled by plane for many years. On 15 April, Iggy and David appeared on the Dinah Shore Show, before giving their final performance of the tour in San Diego, California, the following day.

Opposite: David at Max's Kansas City nightclub in New York, 1977. Having closed in December 1974, the famous venue had reopened the following year, and like CBGB, quickly became a hotbed for the nascent punk scene, featuring appearances by groups such as Blondie, who supported Iggy Pop during the American leg of The Idiot Tour.

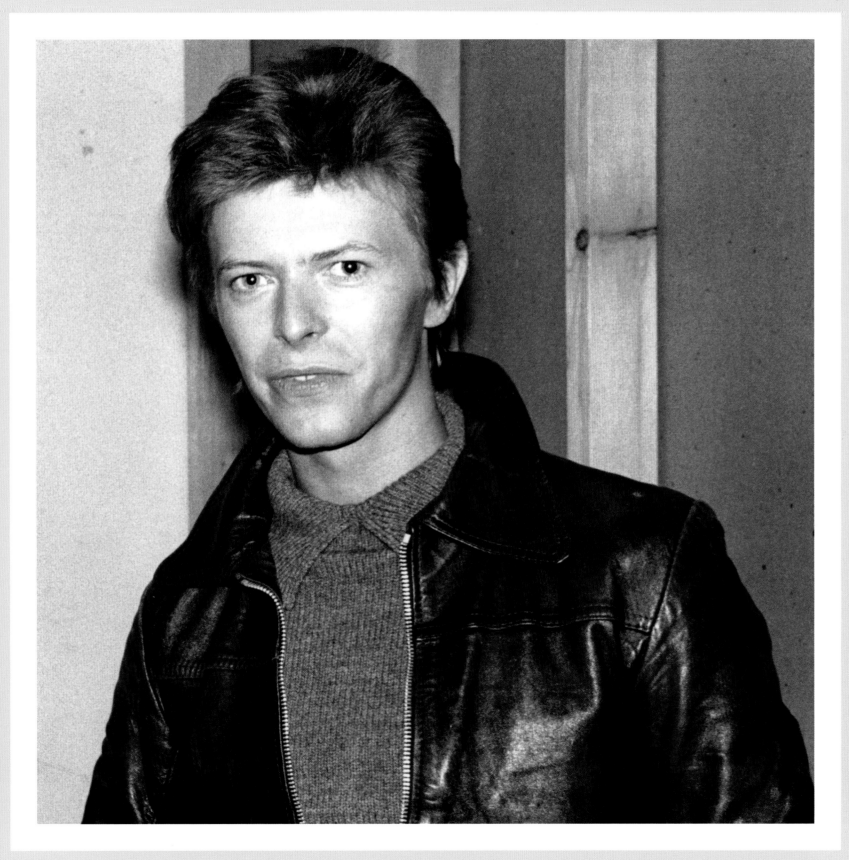

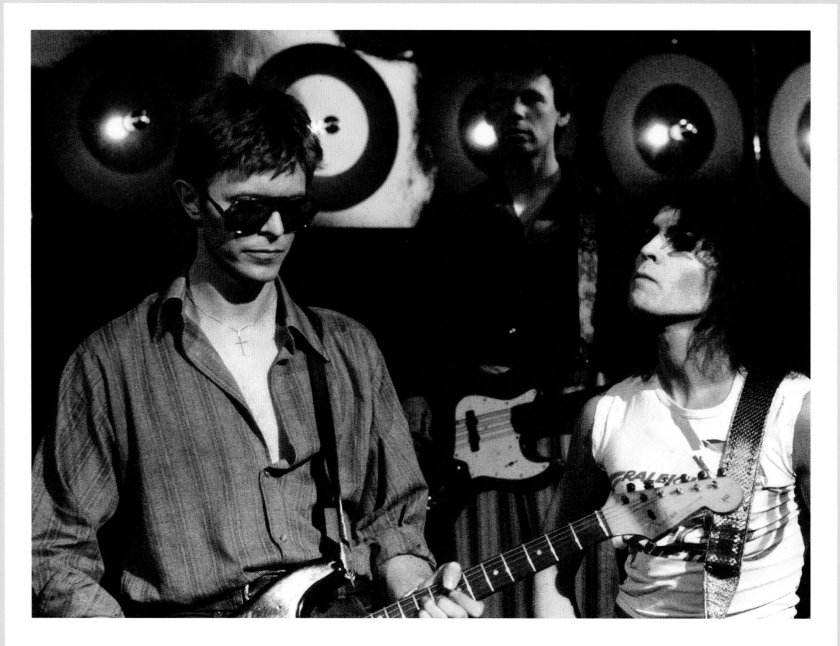

"Heroes"

After The Idiot Tour, David and Iggy returned to Berlin, where they worked on Iggy's *Lust For Life* LP, before sessions began for David's *"Heroes"* album. Once again, Bowie was joined for the sessions by Brian Eno, and this time he adopted Eno's "Oblique Strategies" technique during the recording process, seeking inspiration from a series of suggestions printed on cards. Guitarist Robert Fripp was also drafted in from New York, and although most of the album was committed to tape within a matter of days, the sessions continued into August. The following month, David was reunited with sometime friend and rival Marc Bolan (above), and also Herbie Flowers and Tony Newman, who were now in Marc's band, to record an appearance for a TV special. On 9 September, Bowie performed the title track from his new album and jammed with Bolan and his group, whilst just two days later he would record a rather more incongruous duet, singing "Little Drummer Boy" with Bing Crosby (opposite) for his Christmas show. Tragically, however, both Bolan and Bing would be dead before the programmes were broadcast at the end of the year.

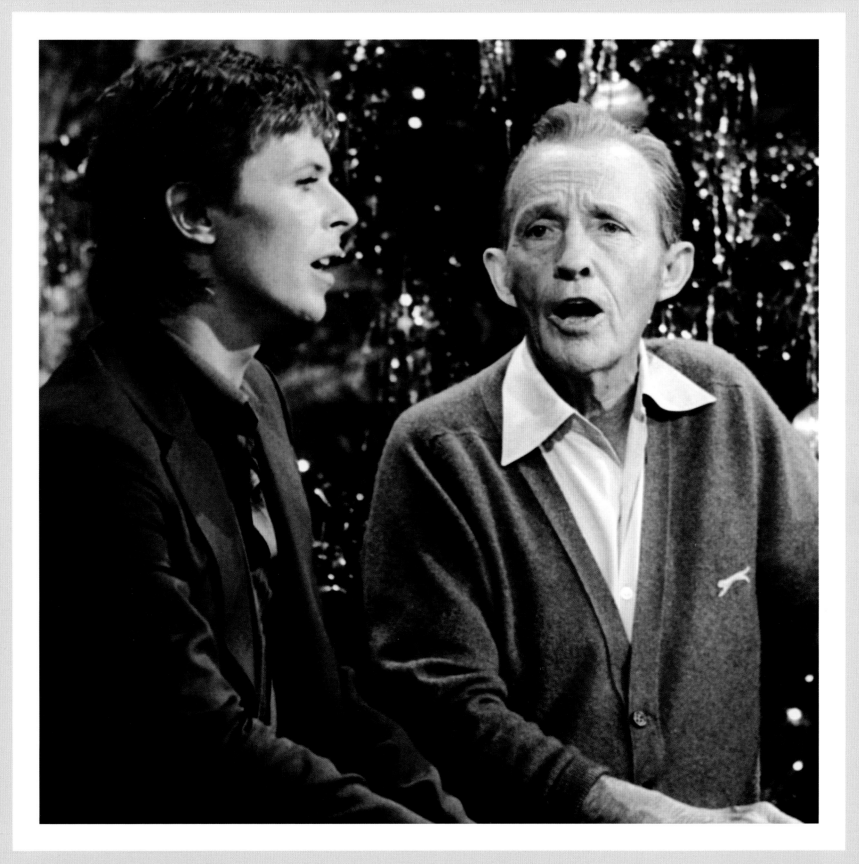

Promoting "Heroes"

In the autumn, when Iggy Pop resumed his tour, David decided not to join him. Instead, David turned his attention to the promotion of his *"Heroes"* LP and single, making television appearances in Rome, Amsterdam and Paris, and returning to *Top of the Pops* in the UK for the first time since 1972. In November, Bowie's promotional rounds took him back to New York, but despite all of this, the single failed to chart in the US and managed to climb to just no. 24 in the UK. The album performed much better in Britain, peaking at no. 3, but in the US sales were disappointing, with "Heroes" stalling at no. 35.

While in New York, David accompanied the Belgian actress Monique van Vooren (pictured here) to the premiere of *Close Encounters of the Third Kind*. She was one of many women with whom David was reported to be romantically linked at this time, including Sydne Rome, Bianca Jagger, and his secretary, Corinne "Coco" Schwabb.

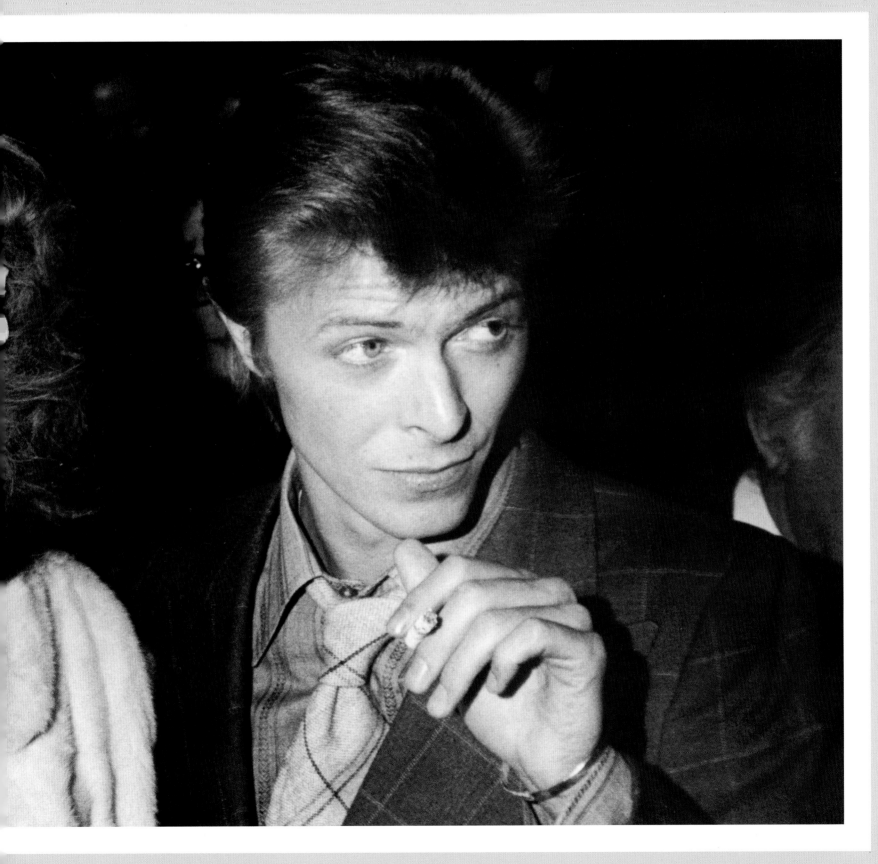

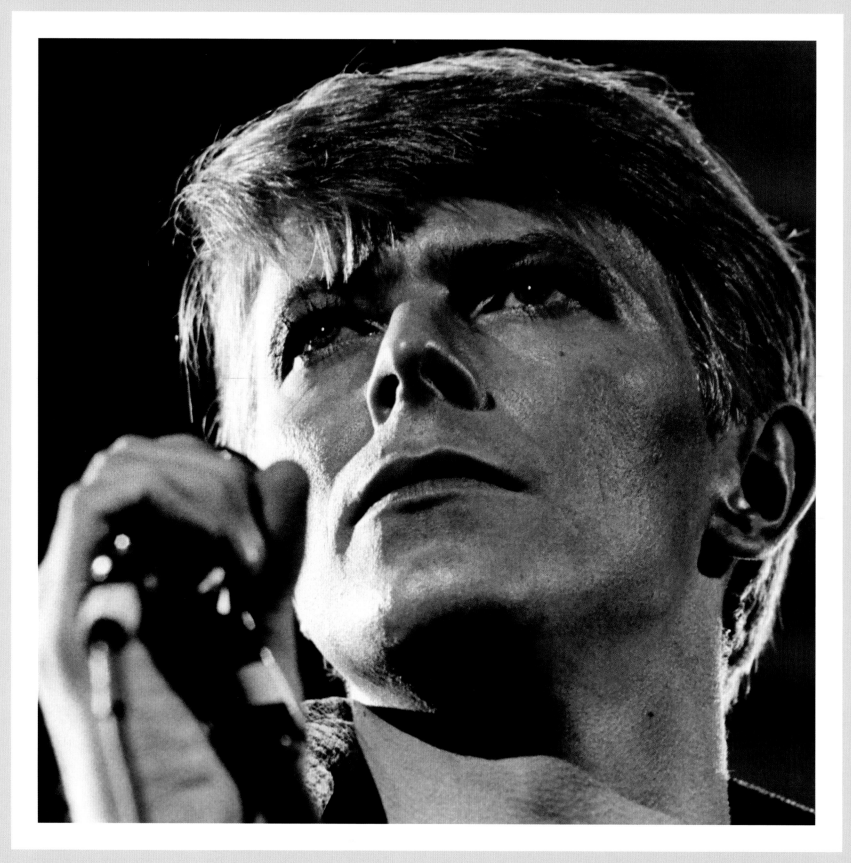

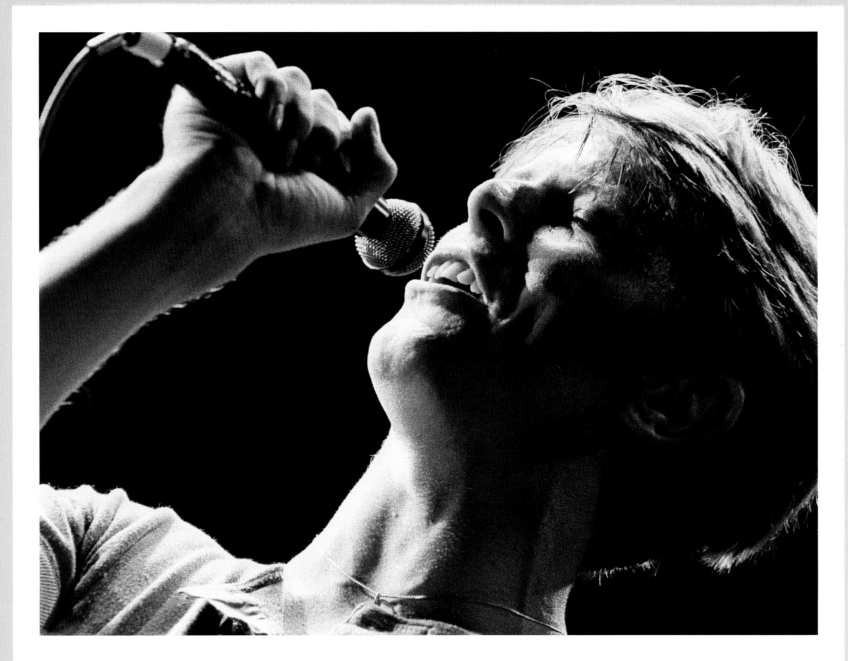

Isolar II

Opposite and above: David launching his Isolar II or Stage Tour, in March 1978. Despite a tumultuous start to the year, during which Angela Bowie attempted suicide after a disastrous effort at reconciliation with her husband, in January David Bowie found himself back in Berlin, filming for David Hemming's *Just A Gigolo*. With shooting complete in February, Bowie then announced his plans for a world tour, which launched in San Diego on 29 March. The outing would provide Bowie with his first opportunity to showcase much of the material from *Low* and *Heroes* live on stage, but with neither Brian Eno or Robert Fripp wishing to commit themselves to the tour, the first step was to recruit some new musicians. Carlos Alomar, George Murray and Dennis Davis had become the backbone of his group since the *Station to Station* sessions, but they were now joined by pianist Sean Mayes, violinist Simon House, synth player Roger Powell, and a young guitarist named Adrian Belew, who Bowie had poached from Frank Zappa.

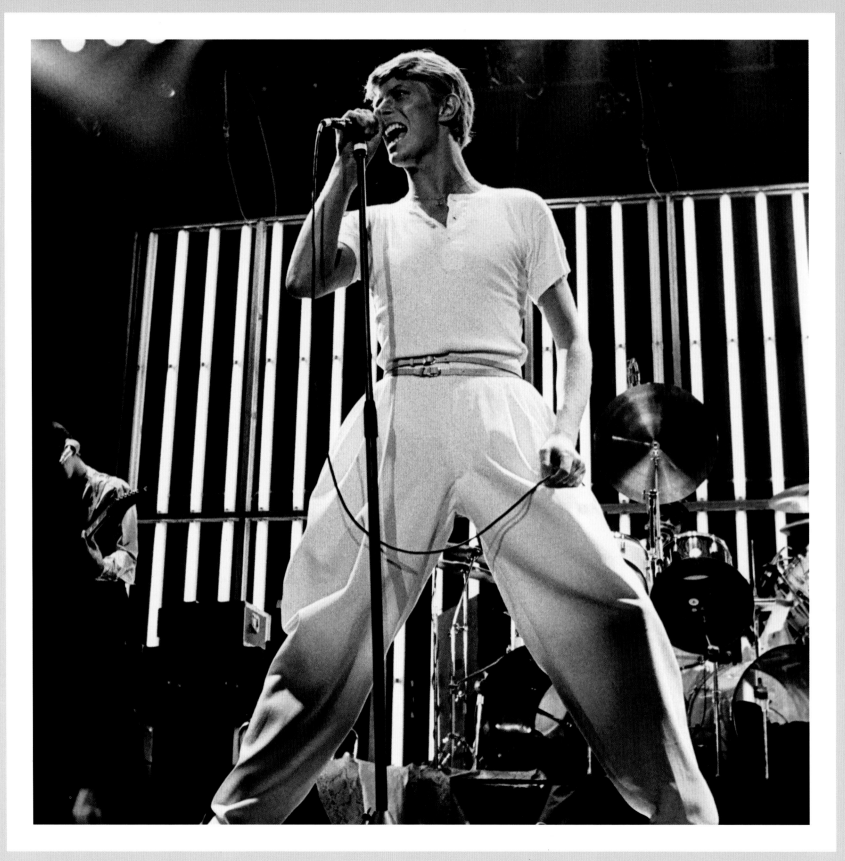

Bowie unmasked

Opposite: Bowie onstage at the San Diego Sports Arena at the end of March and in Canada in May (right). Ahead of the tour, Bowie had declared that this time, for the first time since before the Ziggy Stardust era, he would be taking to the stage as himself, unmasked, and without costume. Despite this, however, he maintained a theatrical stage presence during the shows, and although his look was somewhat tamer than Ziggy's and more relaxed than that of "The Thin White Duke", his wardrobe for the tour, which he developed with old friend and costume designer Natasha Korniloff, was not entirely conventional. The stage set was certainly less elaborate than had been seen on some of his previous tours, and continued the theme of stark lighting developed for the 1976 Isolar Tour. This time, however, rows of fluorescent tubes were employed to form a kind of cage, partially enclosing Bowie and his band.

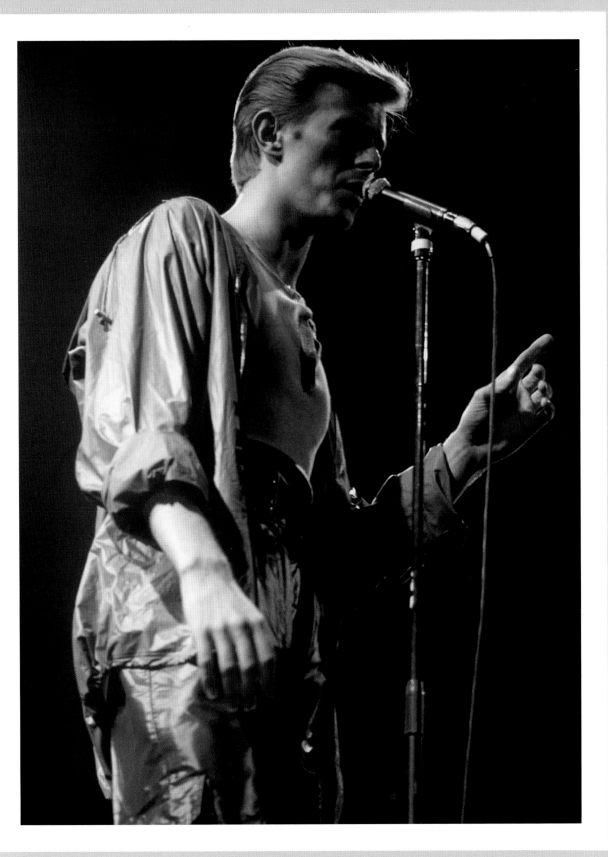

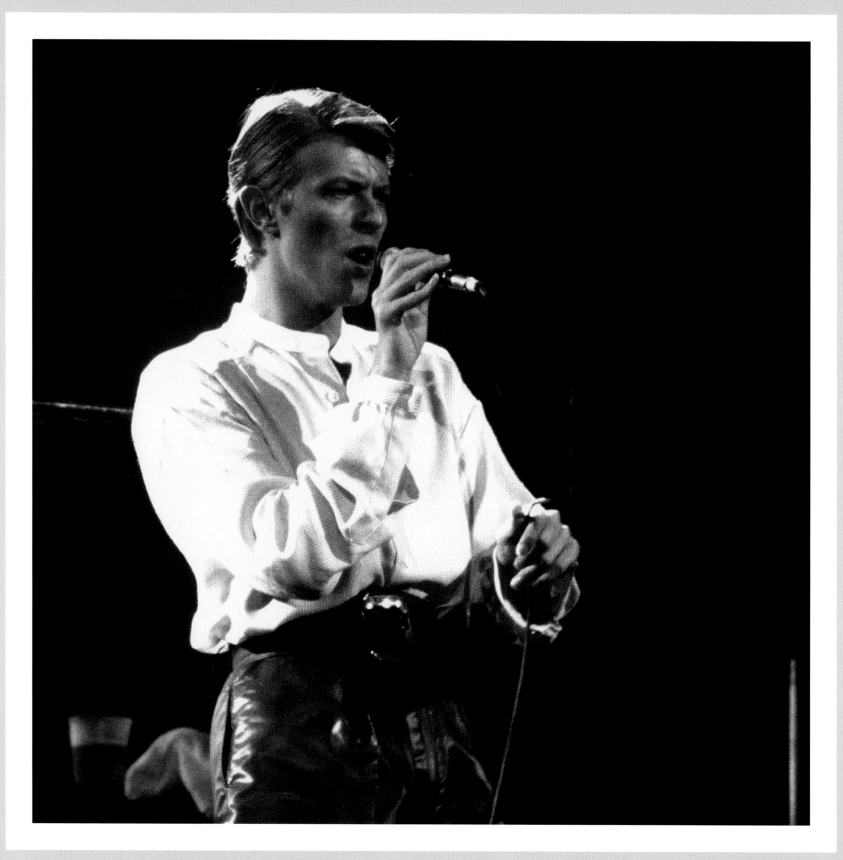

David Bowie on stage

Opposite and right: Performing at Madison Square Garden, New York during the Isolar II world tour in May 1978. The tour traversed the US throughout April and into May, and while Bowie took the opportunity to perform a number of songs from *Low* and *"Heroes"*, perhaps more surprising was the decision to revive and reinterpret several numbers from *Ziggy Stardust*, including "Five Years", "Soul Love", "Star", "Hang On To Yourself", "Ziggy Stardust", "Suffragette City" and "Rock 'n' Roll Suicide". These were performed to open the second half of each performance, while the shows were closed with a selection of tracks from *Station To Station*. On 10 April, Bowie's show from the Dallas Convention Center was filmed, with six songs being broadcast on American TV as *David Bowie On Stage*. Performances at the Providence Civic Center, the New Boston Garden Arena and the Philadelphia Spectrum were also recorded for the live album *Stage*.

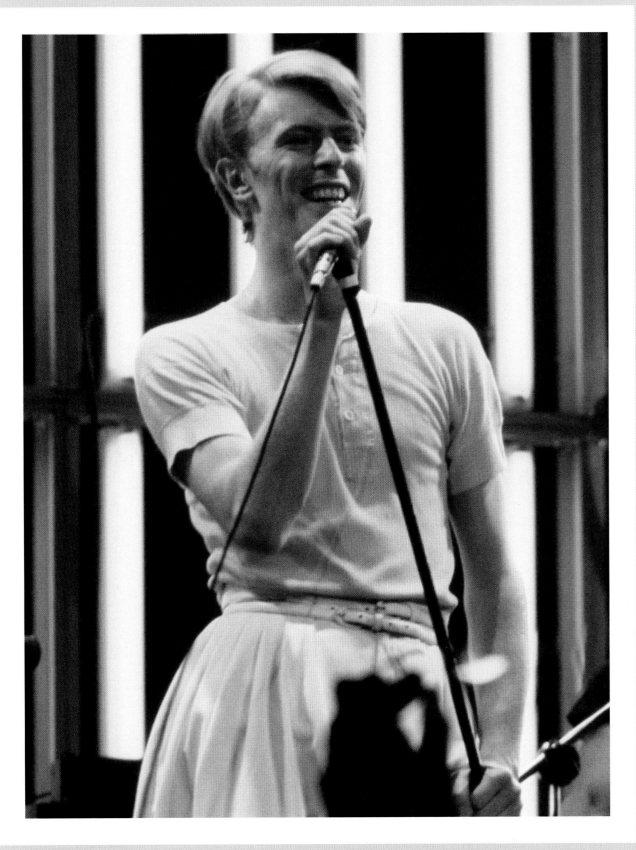

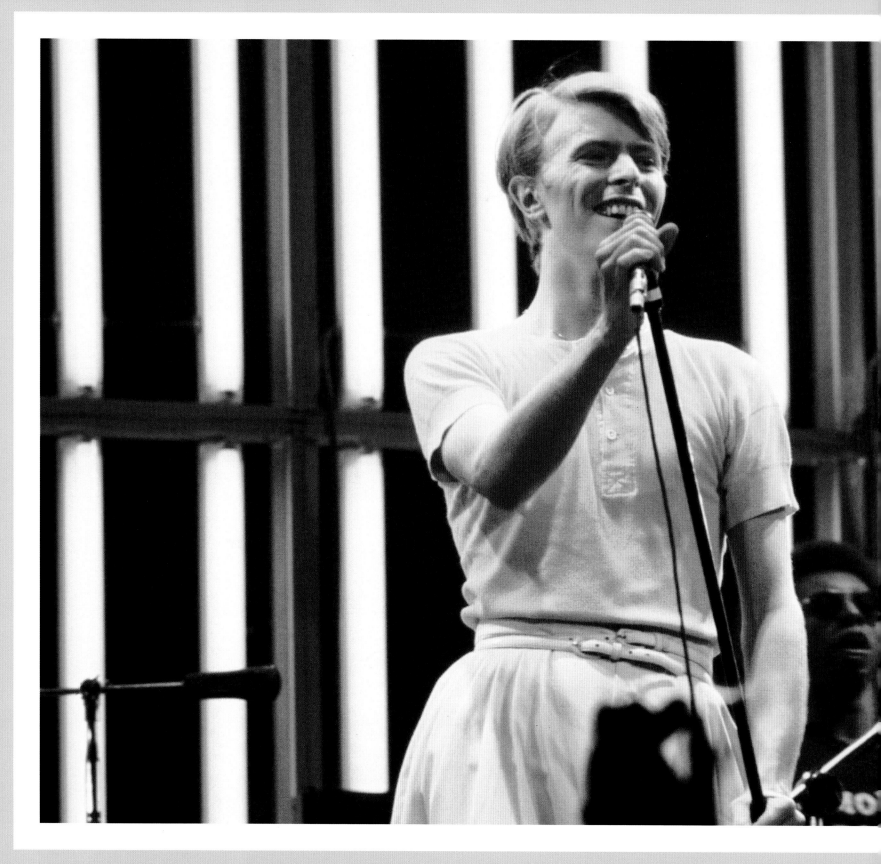

A new live album

Left: Bowie onstage at Madison Square Garden New York during the Isolar II world tour in May 1978. The US leg of Bowie's 1978 tour concluded with a three night run from the 7 to 9 May at the prestigious Madison Square Garden in New York. As usual, ticket demand was high, and the concerts attracted numerous celebrity guests, including Andy Warhol, Dustin Hoffman, Brian Eno and Robert Fripp. After the final show, Bowie left the Regency Hotel in New York to celebrate with Eno and Bianca Jagger at the famous Studio 54 club, before heading to CBGB's to take in a live band. They reportedly returned to their limousine to find that the tyres had been slashed. A few days later came the release of the Philadelphia Orchestra and Eugene Ormandy's version of *Peter and the Wolf*, for which Bowie had supplied narration the previous December, whilst before the month was out, Tony Visconti had completed mixing of the live album, *Stage*.

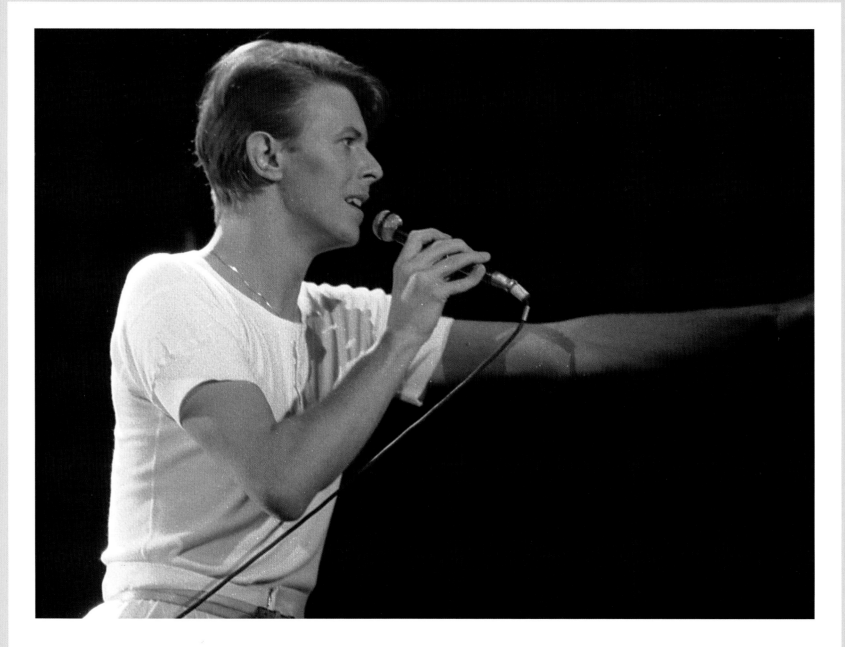

Touring in Europe

Above and opposite: Bowie performing in Hamburg on 15 May 1978. Less than a week after the Madison Square Garden shows, the world tour resumed at the Festhalle in Frankfurt, marking the first of six dates in Germany. The Isolar II Tour would prove to be the biggest that Bowie had yet embarked upon, for although he would perform at similar sized venues to those that he had visited in 1976, numerous extra dates were added to the European leg of the tour, and this time he would also perform to vast audiences in Australia and New Zealand. As the tour progressed through Europe, he maintained the momentum with a handful of promotional appearances. In Berlin he was interviewed by Alan Yentob for BBC2's *Arena Rock* show, whilst later in the month a studio concert was recorded in Bremen for the German TV show *Musikladen Extra*. From Germany, the tour headed to Vienna, Austria, where after the show he got his first opportunity to listen to Tony Visconti's mix of the *Stage* album, and then it was on to France, for dates in Paris, Lyon and Marseilles. The tour passed largely without incident, with only minor scuffles between fans and security staff in Detroit, and again in Berlin, where Bowie had earned the respect of both the fans and the press by chastising the hired muscle in German.

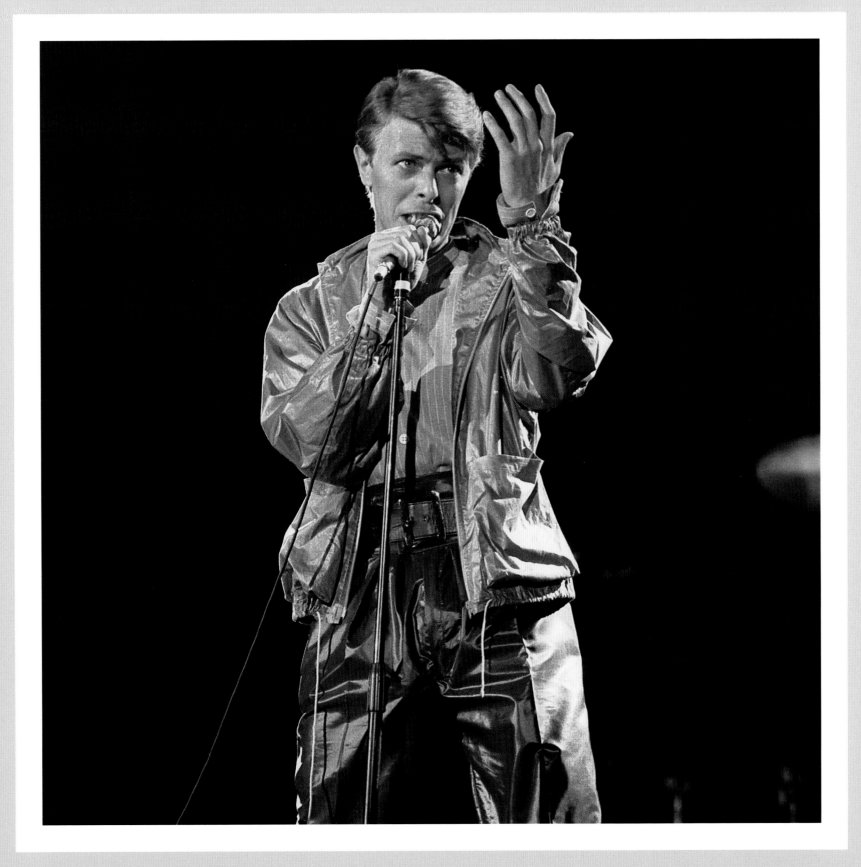

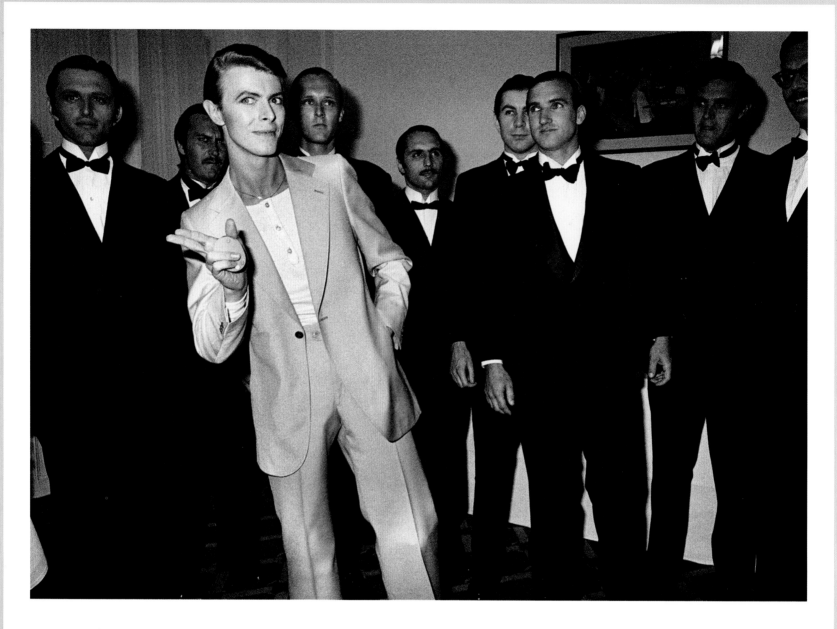

Just a Gigolo

Above: Ahead of the shows in France there was also time for Bowie to put in an appearance at the Cannes Film Festival, where a special industry screening of *Just a Gigolo* was being held.

Opposite: The European leg of the tour concluded on 1 July with the last of three shows at London's Earls Court. It was the first time that Bowie had performed at the venue since his disastrous appearance there in 1973, but this time round the press were enamoured. The final show was recorded by RCA, who captured the live premiere of "Sound And Vision" and *Just a Gigolo* director David Hemmings was also on hand to film the final

shows for a projected documentary. After Earls Court, there followed a four month break in touring, during which time Bowie returned to the studio to record *Lodger*. Despite being recorded in Switzerland and New York, the album marked the third collaboration between Bowie and Brian Eno, and was seen as concluding the "Berlin Trilogy". The world tour resumed in the Pacific in November, with Bowie performing to record-breaking crowds of over 40,000 in Australia and New Zealand. A huge commercial success, the Isolar II Tour closed in Japan on 12 December, following which Bowie decided to remain in the country over Christmas, seeking solitude and inspiration.

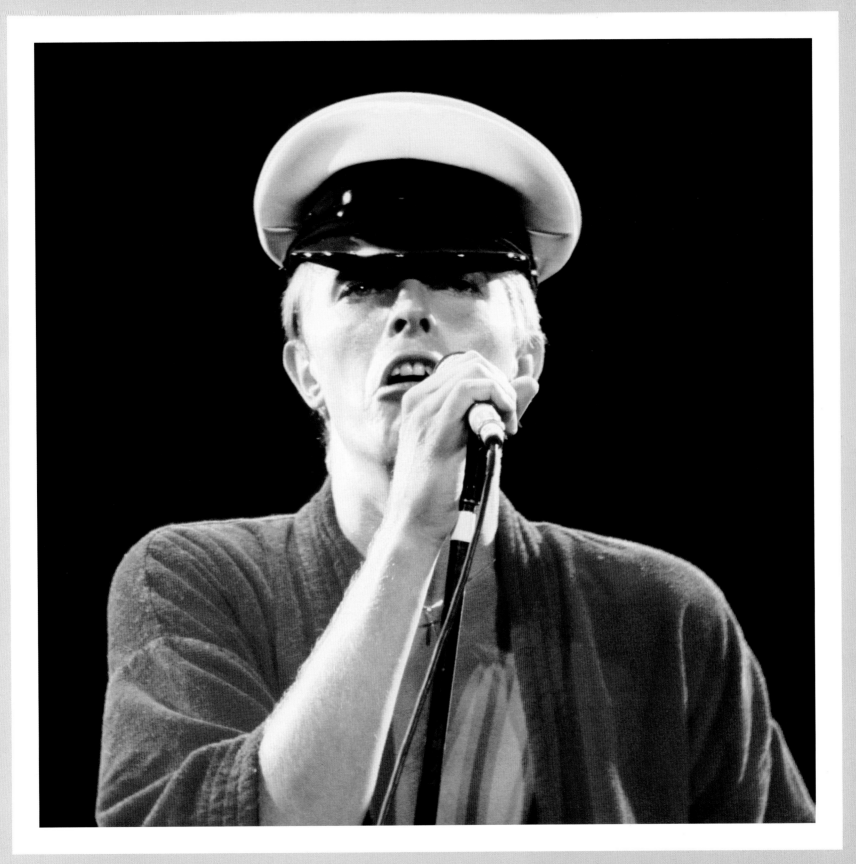

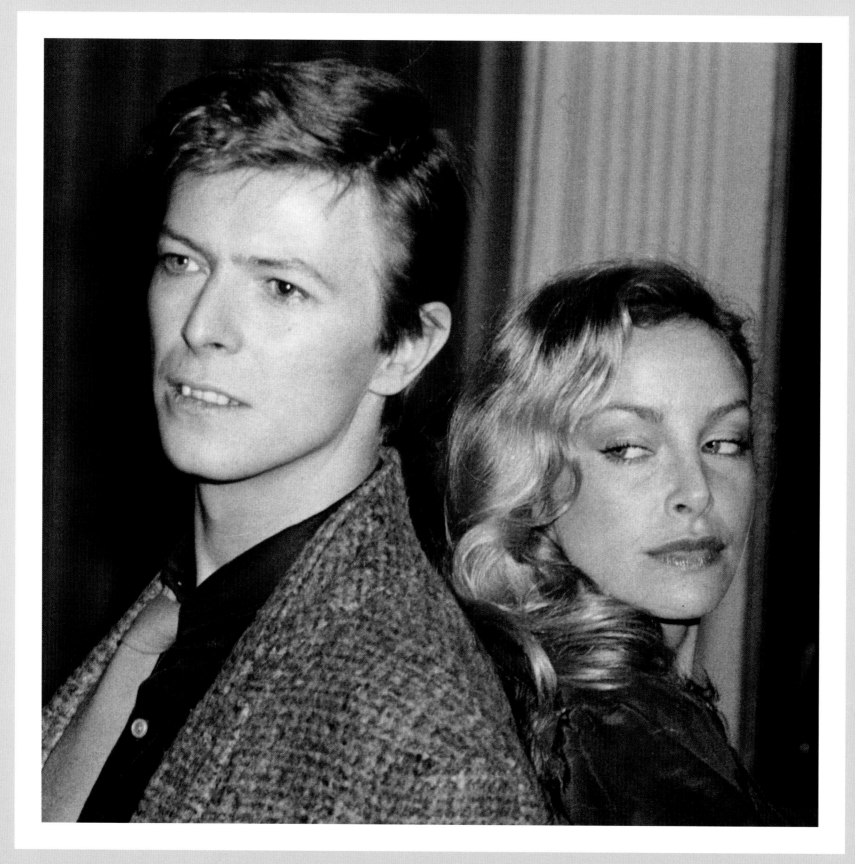

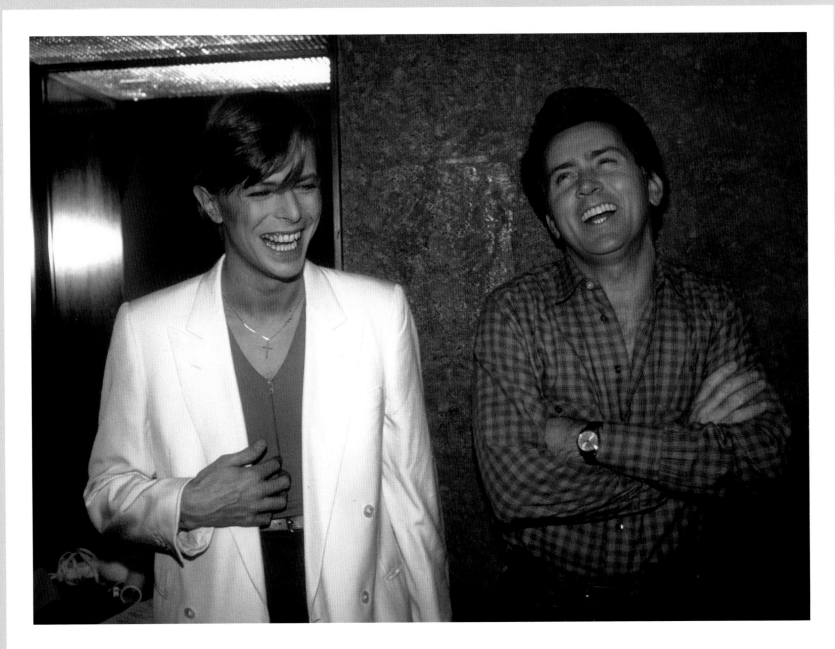

Boys Keep Swinging

Opposite: Bowie with Sydne Rome in February 1979, before the UK premiere of *Just a Gigolo*. Following the 1978 tour, David opted to spend 1979 in more relaxed fashion, doing the promotional rounds for the film and *Lodger*, which he completed in New York in March. That same month, Bowie made a guest appearance with Phillip Glass, Steve Reich and John Cale at Carnegie Hall, with *Lodger* being released in May. The album went on to reach the top five in the UK and the top twenty in the US, but with the exception of "Boys Keep Swinging" which reached no. 7 in the UK, a series of singles from the LP failed to perform in the charts. This prompted the release of the more radio friendly 1974 re-recording "John I'm Only Dancing (Again)" but, like the original, the song peaked at no. 12.

Above: Backstage at *Saturday Night Live* with Martin Sheen. The show was recorded in December, and featured Bowie performing "The Man Who Sold The World", "TVC15" and "Boys Keep Swinging". In the UK he ended the year with an appearance on Kenny Everett's New Year's Eve show, miming to a new version of "Space Oddity", which was filmed by David Mallet.

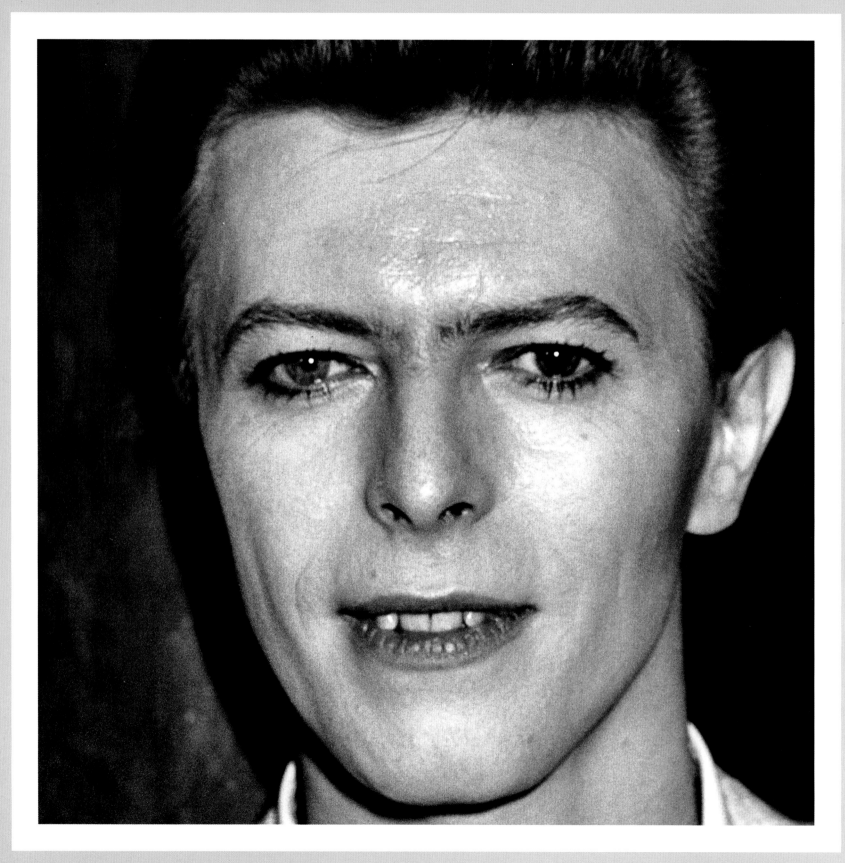

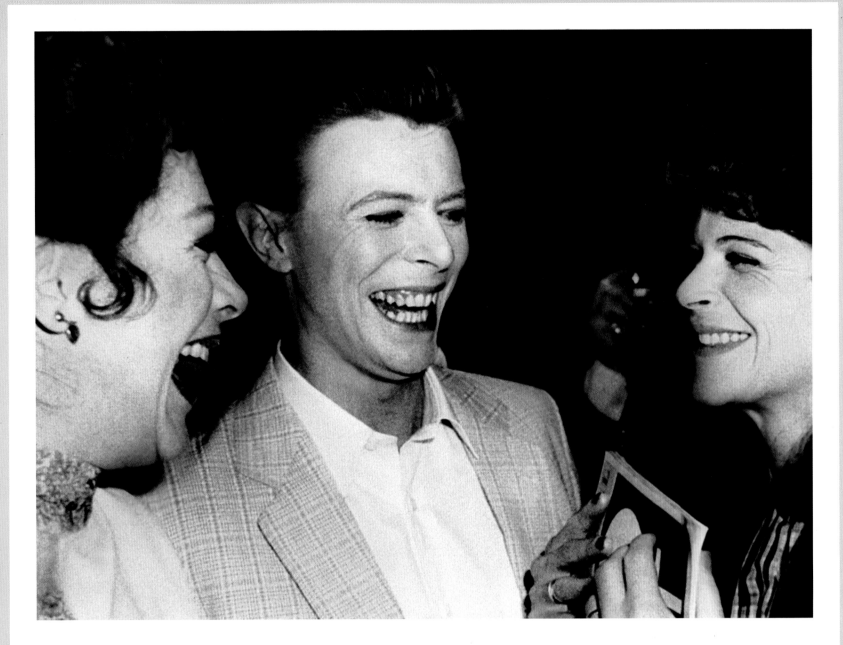

Bowie on Broadway

Above: With *The Elephant Man* co-star Patricia Elliott and comedian Gilda Radner in New York, September 1980. In February, having just been granted a divorce from Angela, David began work on the album *Scary Monsters (And Super Creeps)* in New York. Most of the tracks were recorded as instrumentals, with the LP being completed at London's Good Earth Studios in April. In the meantime, he took his version of Bertolt Brecht and Kurt Weill's "Alabama Song" to no. 23 in the UK charts and travelled to Japan to record an advertisement for the Saki drink, Crystal Jun Rock. He then returned to the States in July, to take the lead role in a theatrical production of *The Elephant Man*. After a short stint at the Denver Centre of Performing Arts, the show moved to the Blackstone Theatre in Chicago for three weeks, before hitting Broadway in September for a three-month run. Bowie received almost universal acclaim for his portrayal of John Merrick, and also had cause to celebrate as *Scary Monsters* and the single "Ashes To Ashes" topped the UK charts. However, on 8 December, David was devastated by the murder of his friend John Lennon.

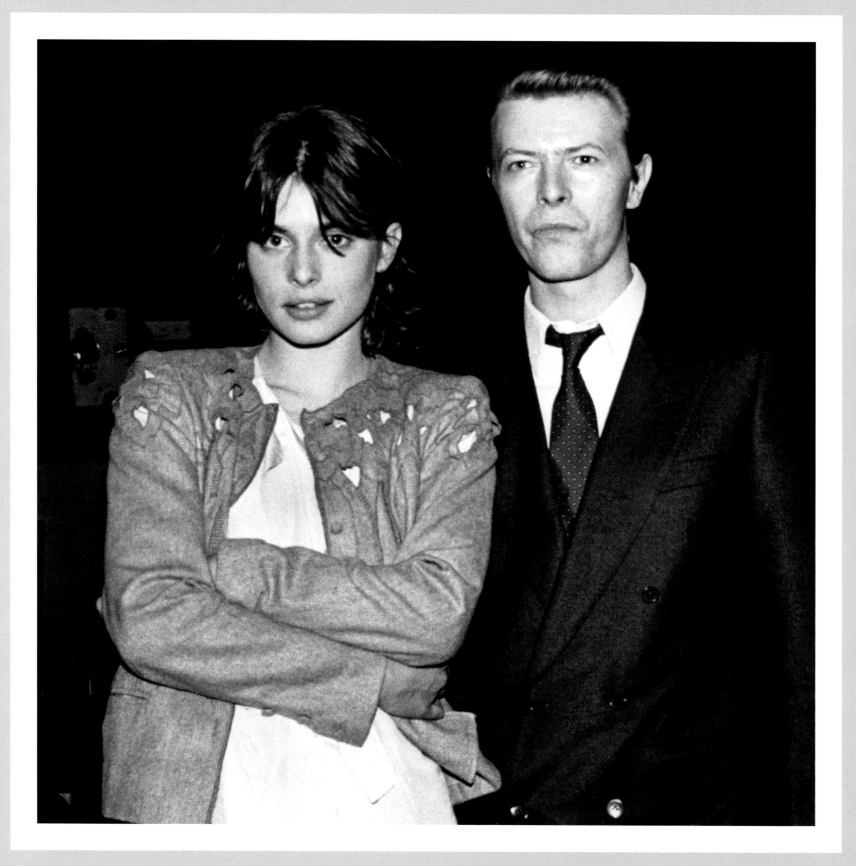

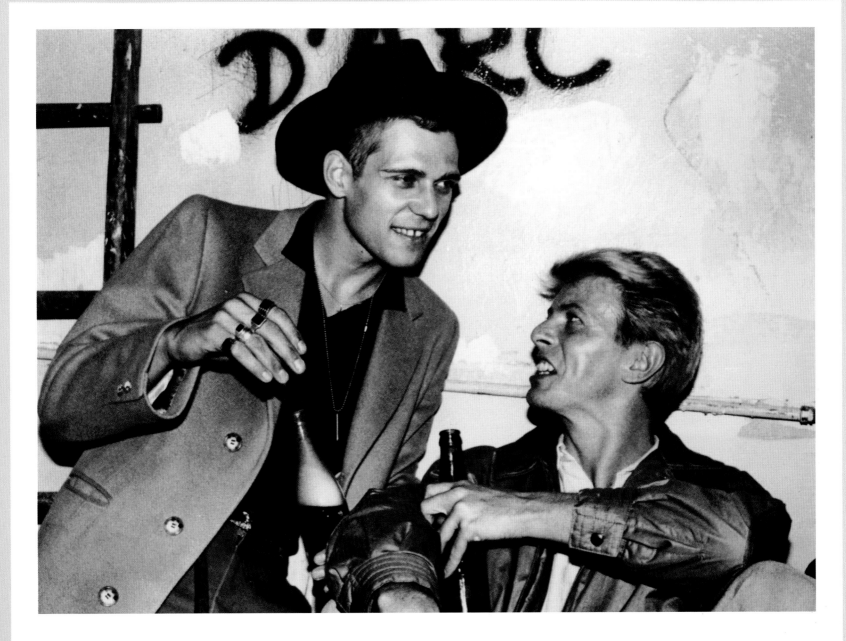

Collaborations

Opposite: David and Nastassja Kinski attend a screening of *Cat People* in April 1982. Stunned by Lennon's death, in January 1981 David cancelled plans for a spring tour and began to retreat from public life. He returned to Switzerland, where he collaborated with Queen on the no. 1 single "Under Pressure", and recorded the title track for Paul Schrader's *Cat People*, which starred Malcolm McDowell and Nastassja Kinski. In August he made a return to acting in the BBC production of Berthold Brecht's *Baal*, which spawned a successful EP, and the following year he played the role of a vampire in Tony Scott's erotic horror film *The Hunger* as well as

travelling to the Cook Islands to film *Merry Christmas Mr Lawrence*, starring opposite Tom Conti.

Above: David with Paul Simonon of The Clash in October 1982. That same month, RCA released Bowie and Bing Crosby's 1977 recording of "Peace On Earth/Little Drummer Boy", before going on to issue the limited edition picture disc collection *Fashions*, and also *Bowie Rare*. By this time however, David's relationship with the RCA was almost at breaking point and he began to look around for offers from other labels.

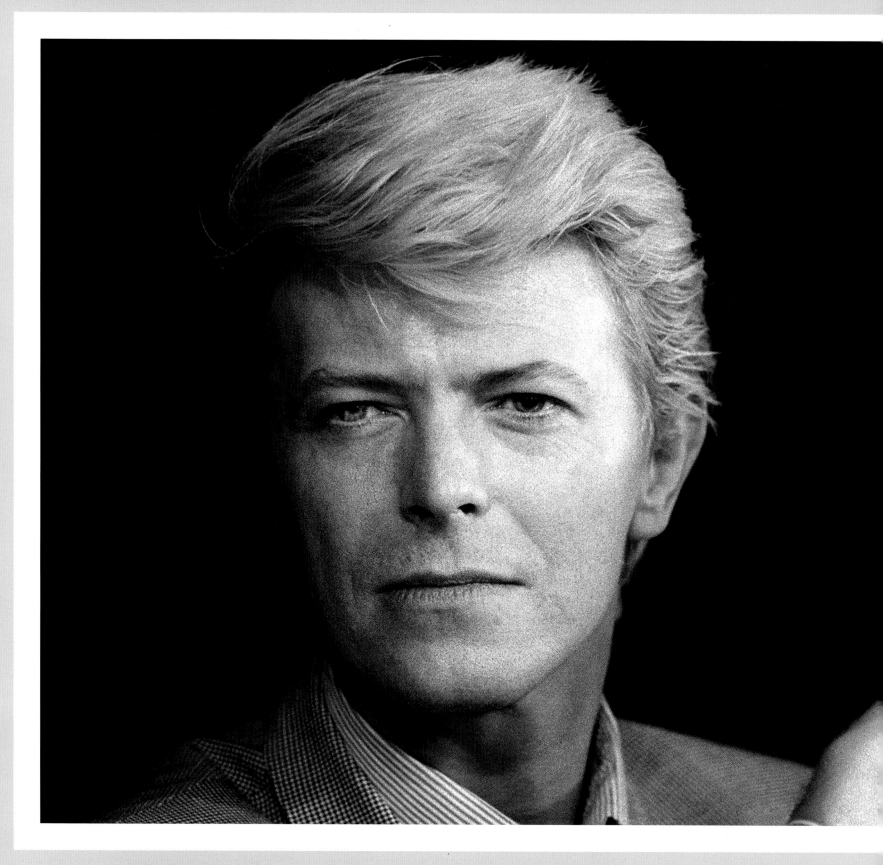

Let's Dance

Left: In December 1982, more than two years after the recording of *Scary Monsters*, Bowie entered Power Station Studios in New York to record *Let's Dance*. He had originally arranged to record the album with Tony Visconti, but looking to create a warmer, funkier album with mass appeal, he opted instead to work with Chic's Nile Rodgers. A number of former Chic members and associates were brought on board, including bassist Bernard Edwards, drummer Tony Thompson and backing singers Frank and George Simms. Session bassist Carmine Rojas and drummer Omar Hakim were also recruited, as was a young blues guitarist named Stevie Ray Vaughan. Having secured a deal with EMI, the album's title track was released as the first single in March 1983, and became Bowie's only single to top the charts on both sides of the Atlantic. The LP was also a major hit, as was the follow-up single, "China Girl", which Bowie had originally recorded with Iggy Pop in 1976. As "China Girl" climbed the charts in May, he attended the Cannes Film Festival, where Nagisa Oshima's *Merry Christmas Mr Lawrence* received its premiere and a positive response.

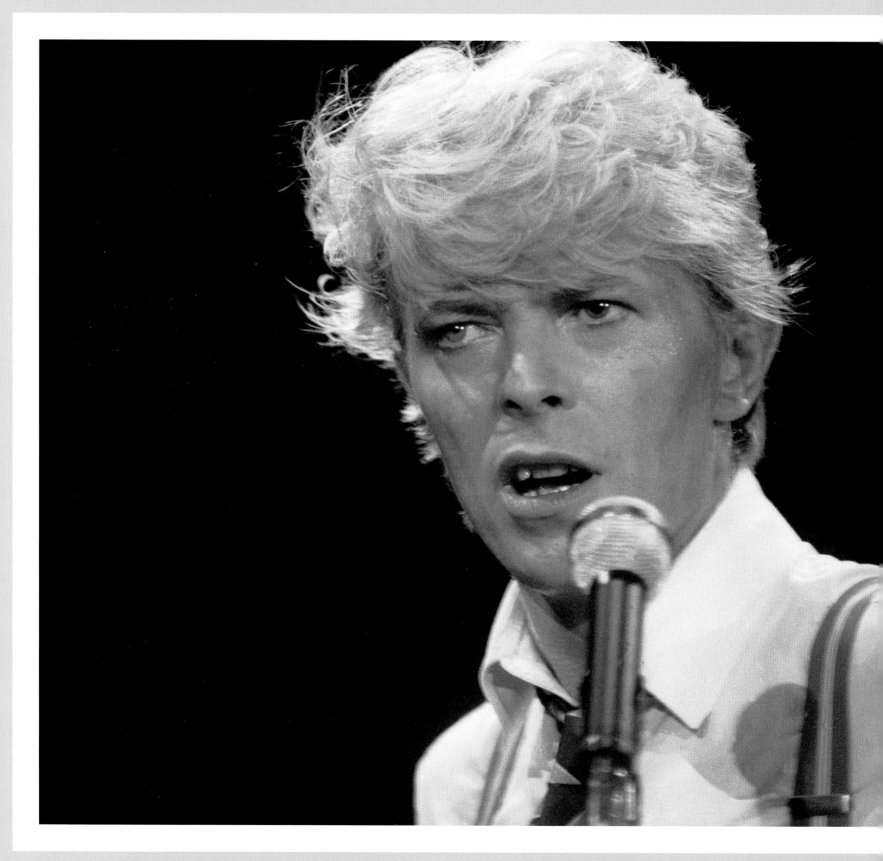

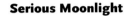

Serious Moonlight

Left: Bowie onstage at Wembley Arena, June 1983. Just days after his trip to
Cannes, he launched The Serious Moonlight Tour at the Vorst Forest Nationaal
in Brussels, Belgium. Carlos Alomar was brought back into the fold for the tour,
as was Earl Slick, who stepped in as a last-minute replacement for Stevie Ray
Vaughan. It had been some five years since Bowie had last been out on the road,
and ticket demand was exceptionally high, with the result that extra dates had
to be added throughout the tour. After a smattering of European appearances,
David flew to America to perform at the US Festival in San Bernardino, California,
on 30 May, where he played to a crowd of around 150,000. It was the biggest
audience Bowie had yet performed to, and he was reportedly paid a record-
breaking fee of $1.5 million for the gig.

From the US Festival it was back to Britain for three concerts at Wembley
Arena, all of which had sold out in just 24 hours. But while large numbers
of the public were clearly keen to show their support, certain sections of the
British music press, including journalists that had previously championed his
cause, appeared to be left cold by Bowie's latest incarnation. For some critics,
the calculated commercialism of *Let's Dance* and The Serious Moonlight Tour,
replete with its exuberant horn section and an apparently healthy, untroubled
and drug-free David, was a sign that Bowie had sold out in some way. They
bemoaned the passing of his cutting edge, variously describing him as mediocre
and family-friendly. Perhaps Bowie had finally realized his early aim of gaining
widespread acceptance as an all-round entertainer, but he was still not without
his detractors. On 8 June the tour arrived in Paris, where Bowie was to find
himself on the receiving end of criticism from Kevin Rowland of support band
Dexys Midnight Runners. However, he in turn would find himself being booed
from the stage after describing Bowie as "a bad Bryan Ferry".

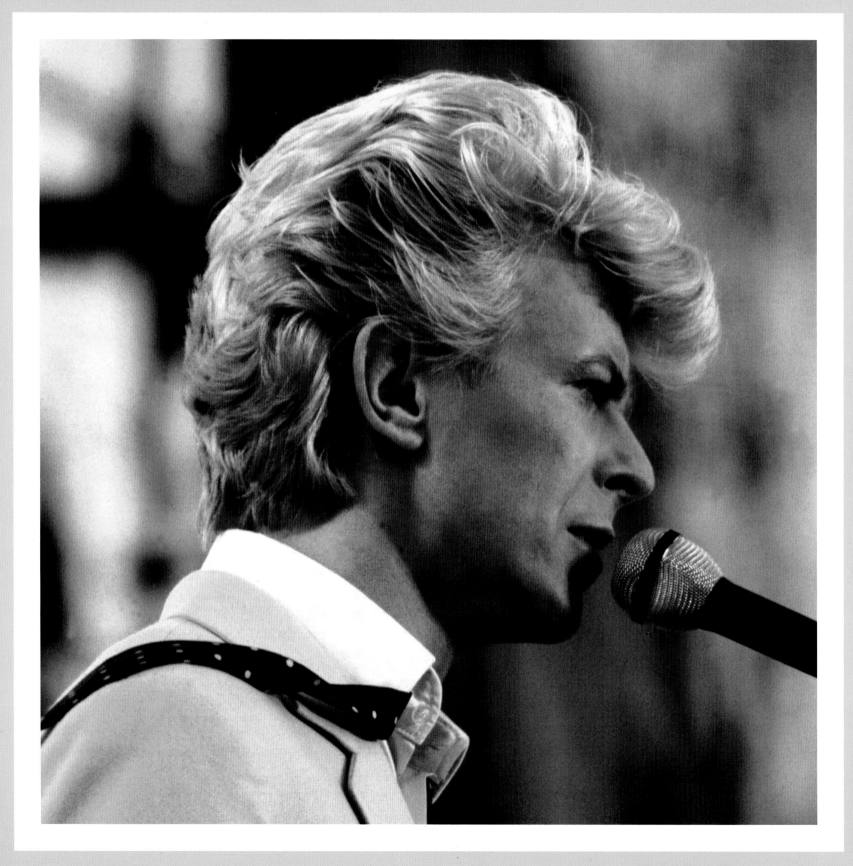

No show for Ziggy

Opposite and right: David onstage at the Ullevi Stadium in Gothenburg, on 11 June. Although Bowie was ostensibly once again playing it straight on this tour, the show was not without a degree of artifice. Conceived by Mark Ravitz, who had helped to bring The Diamond Dogs Tour to life, and illuminated by a sophisticated light show designed by Allen Branton, the stage set consisted of vast polythene Palladian columns and a huge hand, which pointed skywards towards a suspended crescent moon. Meanwhile Bowie, besuited in a range of pastel shades and sporting a peroxide-blond pompadour hairstyle reminiscent of his Konrads days, appeared in complete control as he delivered his greatest hits like a latter-day crooner. After Sweden he played a series of dates in Germany and the Netherlands, before returning to the UK at the end of June for a special charity show in aid of the Brixton Neighbourhood Community Association at the Hammersmith Odeon. It was almost ten years to the day since he had announced Ziggy's retirement from that very stage, but rumours of a Ziggy Stardust revival concert were to prove unfounded.

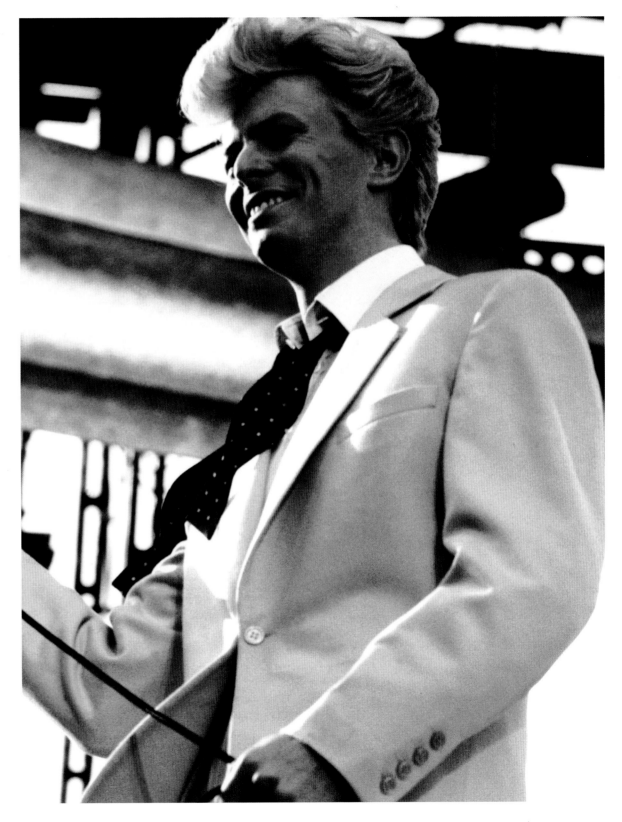

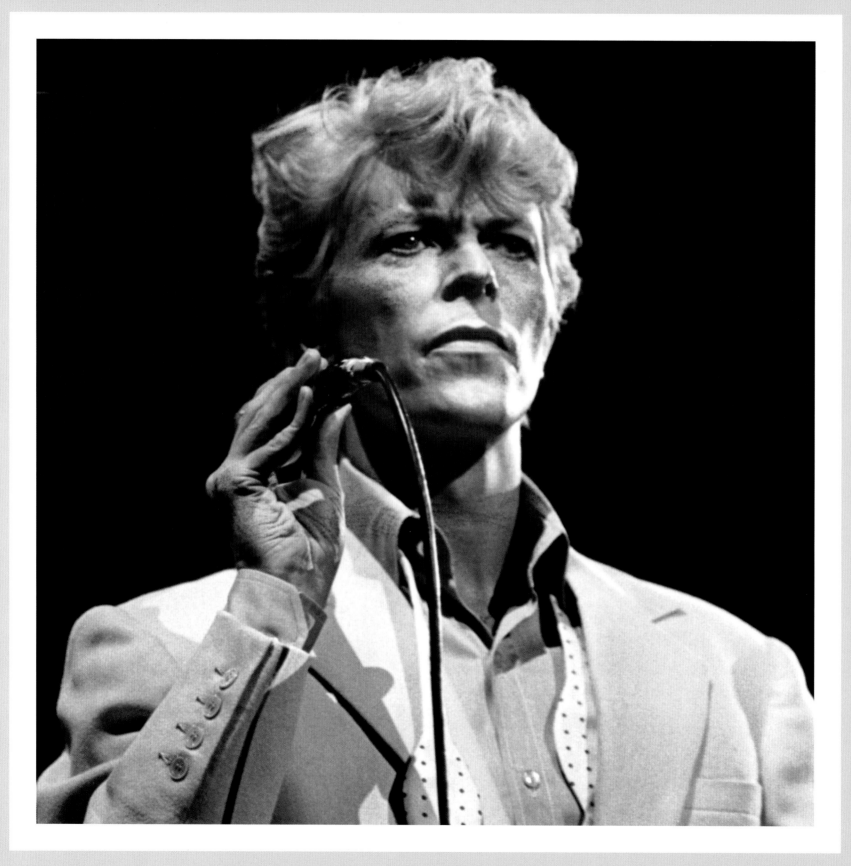

Reunited with Ronson

Opposite: Bowie onstage at Madison Square Garden, New York, in July 1983 and, right, at Earls Court, London. He began the month with three open air shows at the Milton Keynes Bowl in England, following which The Serious Moonlight Tour headed Stateside for its extensive North American leg, which opened in Quebec on 11 July. Two days later, the show at the Montreal Forum was broadcast live on radio. The video for the next single, "Modern Love", was filmed by David Mallet in Philadelphia on the 20th. The song would provide Bowie with yet another hit following its release in September, reaching no. 2 in the UK and 14 in the US. Mallet would also go on to film two shows in Vancouver on 11 and 12 September for the Serious Moonlight video release, ahead of which, David was reunited with Mick Ronson, who took to the stage in Toronto on the 4th to join Bowie and his band for a rendition of "The Jean Genie".

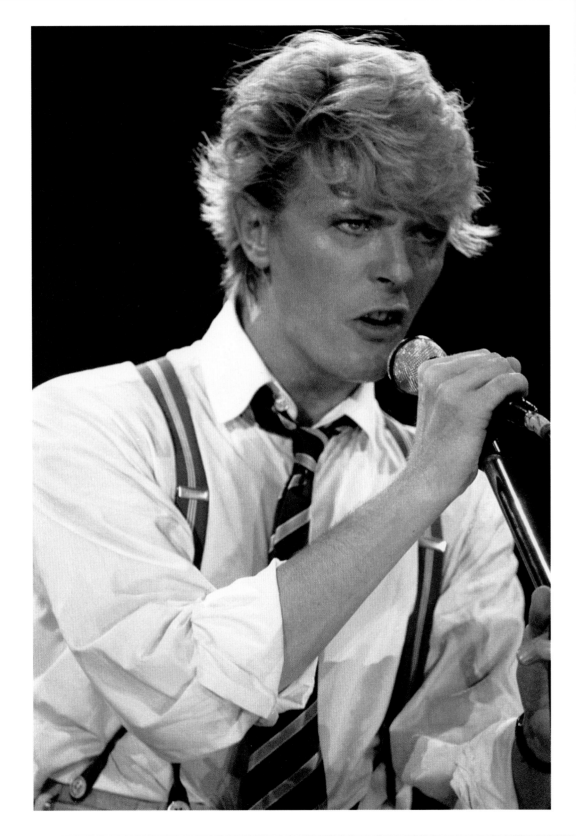

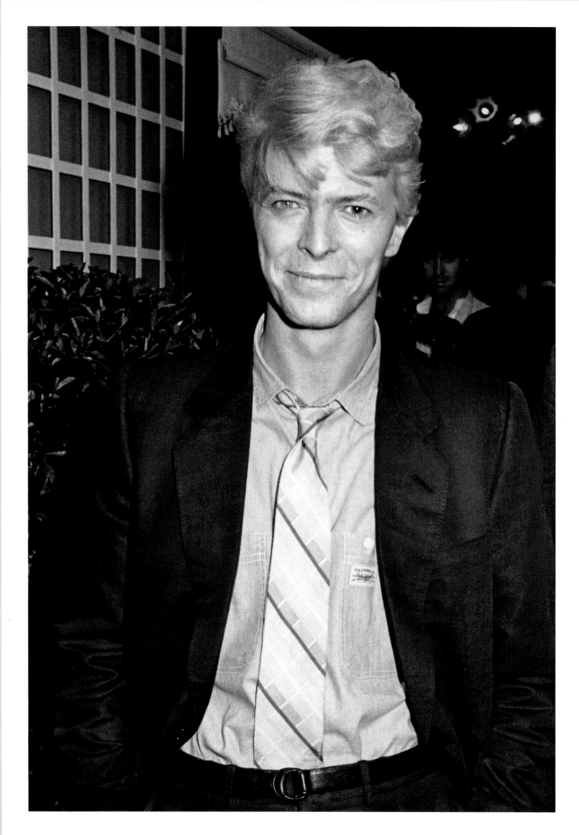

Imagine

Left: David in Los Angeles during The Serious Moonlight Tour. The US leg drew to a close at the Oakland Coliseum on 17 September, following which Bowie enjoyed a well-earned rest, before the tour recommenced in Japan on 20 October. Nagisa Oshima, director of *Merry Christmas Mr Lawrence*, was in attendance at the Nippon Budokan in Tokyo that night, and when the tour concluded in Auckland five weeks later, Bowie's young co-star from the movie, James Malcolm, joined the star on stage to release a pair of white doves. Throughout its duration the tour had broken box office records and two per cent of New Zealand's population were estimated to have attended the final concert. Although that performance officially marked the end of the tour, in December, Bowie went on to perform in Singapore, Thailand and also Hong Kong, where he marked the third anniversary of John Lennon's death with a rendition of "Imagine".

Opposite: David models for his waxwork likeness, which was unveiled by Madame Tussaud's in London towards the end of the year. At that time, the only rock icons to have been commemorated in such a way were The Beatles and Elvis Presley.

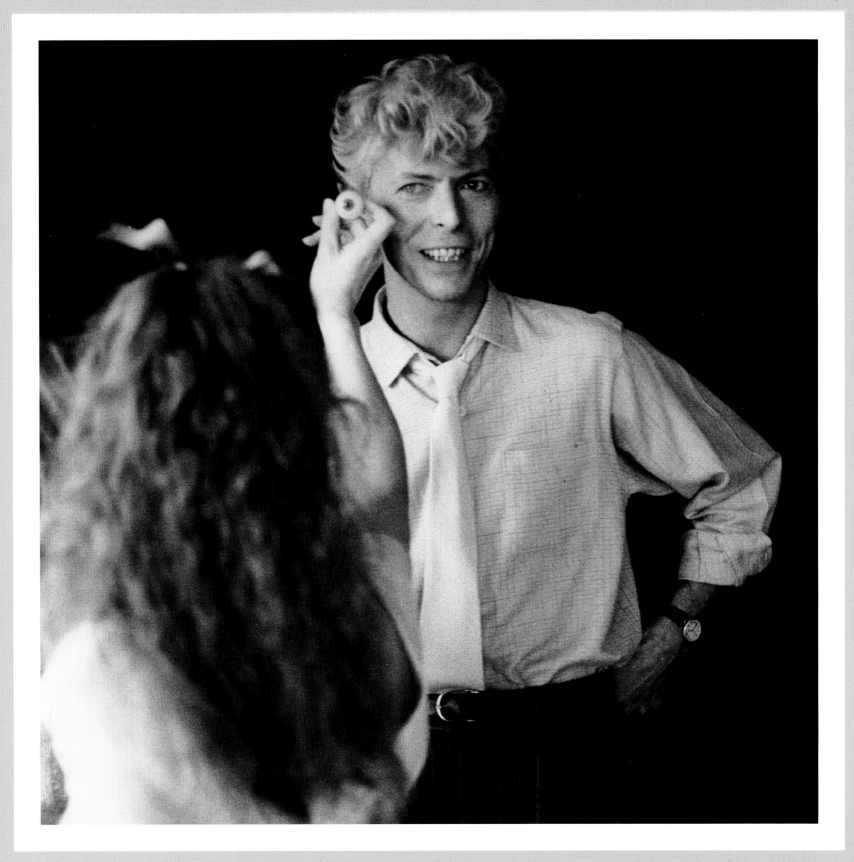

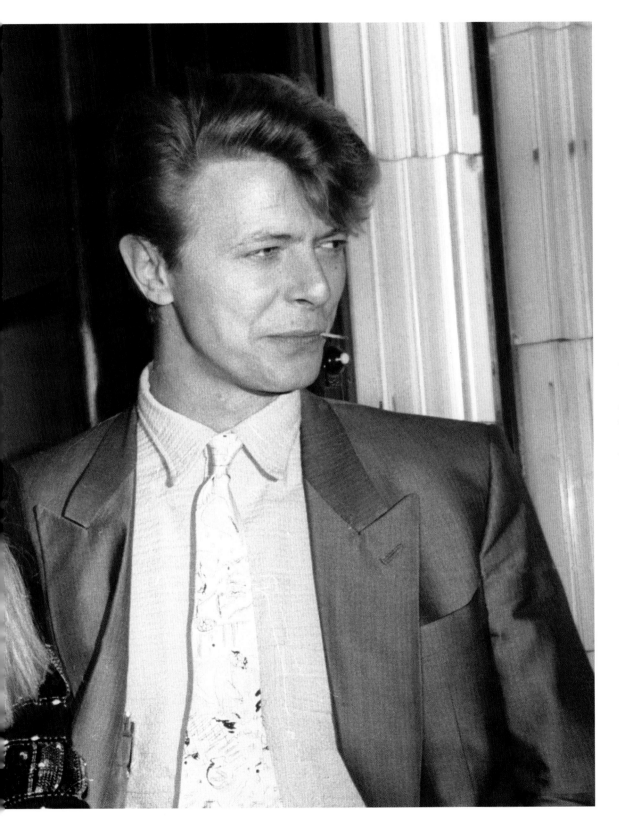

Renewing relationships

Left: David in London with Mick Jagger
and Jerry Hall in 1984. The first few months
of 1984 marked something of a hiatus in
Bowie's career, but by May, having spent
time with Iggy Pop in Indonesia, the pair
decided to renew their working relationship
for Bowie's *Tonight* LP. A new production
team was assembled, but Bowie had
little new material to offer, and just four
original compositions were recorded.
Bowie supplied "Loving The Alien" and
"Blue Jean", with "Tumble And Twirl"
and "Dancing With The Big Boys" being
co-written by Iggy. The remainder of the
LP comprised reworked versions of tracks
from Iggy's *Lust For Life* and *New Values*
LPs, and two covers; the Beach Boys' "God
Only Knows" and Leiber and Stoller's "I
Keep Forgettin'". Following its release,
Tonight briefly topped the UK charts, and
"Blue Jean", which was supported by Julien
Temple's epic "Jazzin' for Blue Jean" promo,
returned David to the top ten on both sides
of the Atlantic, but the LP itself was labelled
as not challenging by many critics.

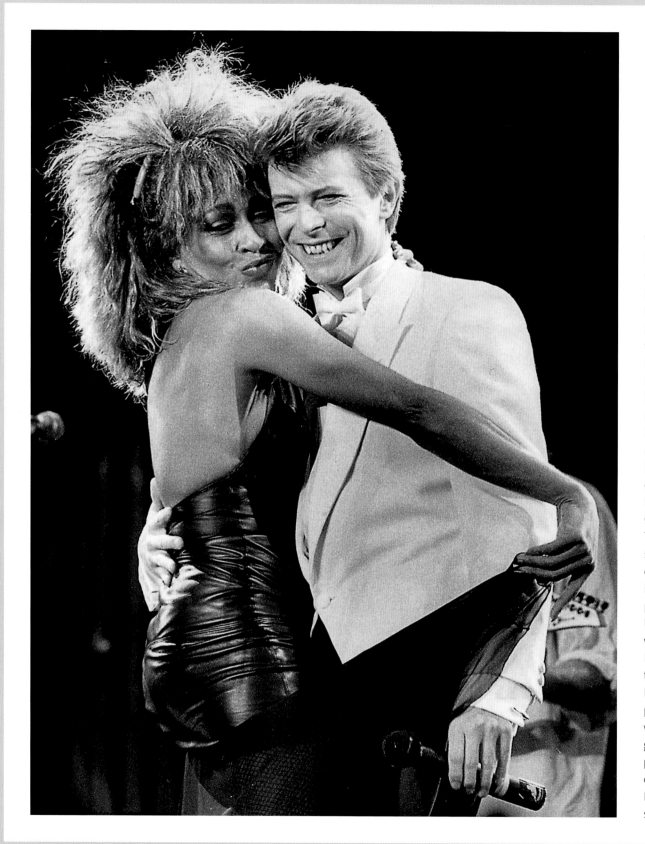

Tonight

Hoping to improve his fortunes, the next single to be gleaned from the new album was the title track, "Tonight", which David and Iggy Pop had initially written and recorded in 1977 for Iggy's second solo LP, *Lust For Life*. Whereas the original had been conceived as a lament to a dying lover however, in 1984 Bowie re-recorded the song as a reggae-infused duet with label-mate Tina Turner, who credited him with having helped her to renew her contract with Capitol/EMI the previous year. The new version was a more straightforward and supposedly commercial love song, but it fared poorly in the charts, peaking at no. 53 in both the UK and US. Nevertheless, when Tina Turner's Private Dancer Tour touched down at the Birmingham NEC on 23 March 1985, she decided to perform the song as an encore, with Bowie making a special guest appearance. They then performed a medley consisting of Bowie's hit single "Let's Dance" and the Chris Montez song of the same name.

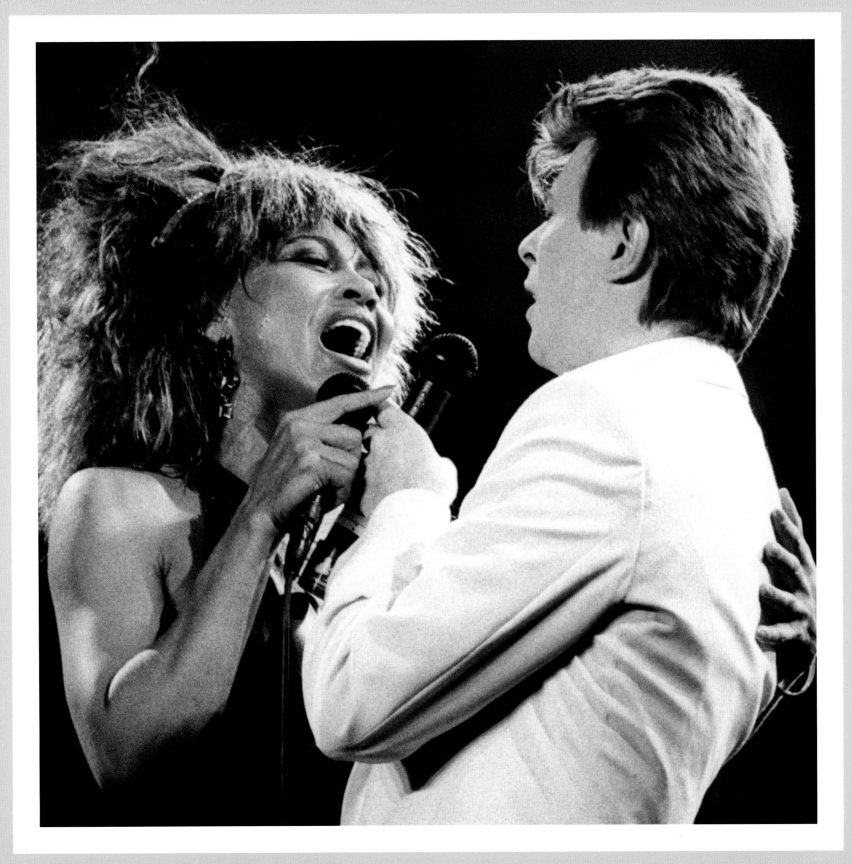

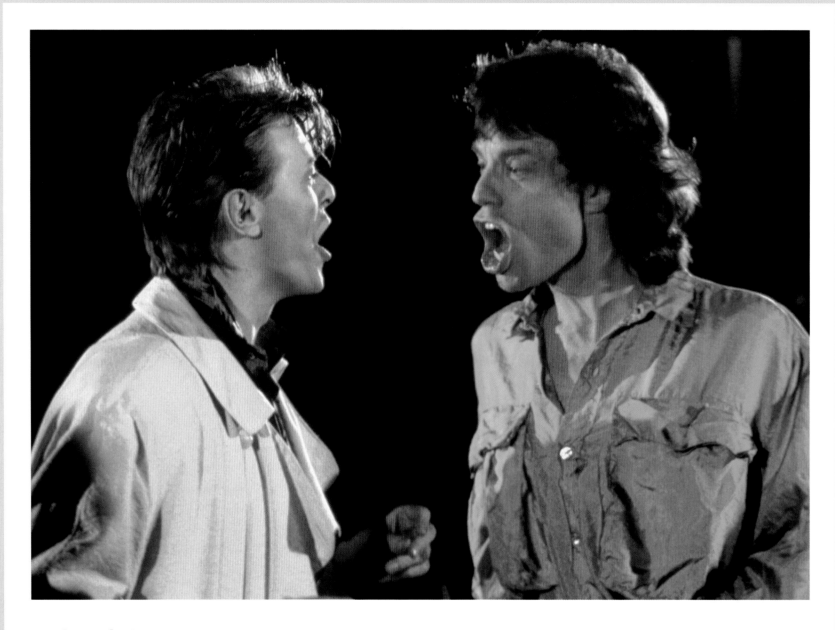

Dancing In The Street

Above: In late 1984, after the BBC covered the news of a terrible famine sweeping across Ethiopia, Bob Geldof and Midge Ure organized the recording of the charity single "Do They Know It's Christmas?". Bowie was unable to attend the sessions, and instead recorded a heartfelt message for inclusion on the B-side. However, as 1985 dawned, he had a more personal tragedy to contend with: the suicide of his half brother Terry Burns, who had spent much of his life as a resident at Cane Hill psychiatric hospital. David was deeply affected by Terry's death, but concerned that his presence would turn the funeral into a media circus, he chose to grieve privately at his home in Switzerland. By June he was

back in the UK and working at Abbey Road Studios, recording the theme song for Julien Temple's rock musical *Absolute Beginners*. At the same time, plans were being made for David and Mick Jagger to perform a duet via satellite link-up at the forthcoming Live Aid event, but when problems with the technology proved preclusive, they decided to record a version of "Dancing In the Street" to be broadcast on the day, accompanied by a video shot by David Mallet.

Opposite: Backstage at Live Aid with Bob Geldof's wife, Paula Yates.

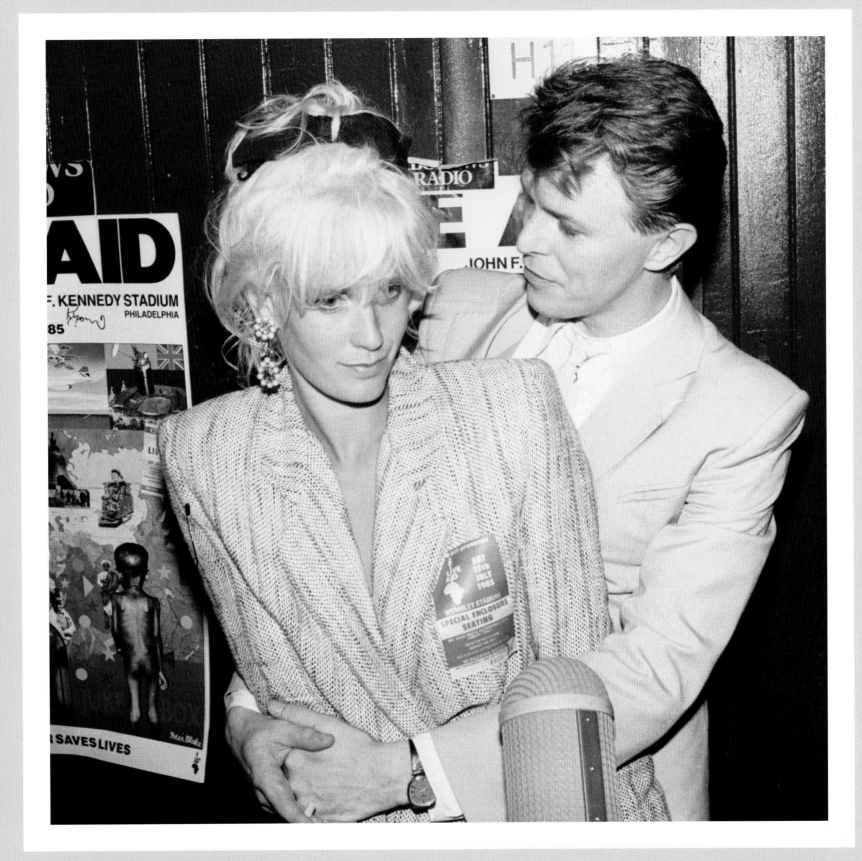

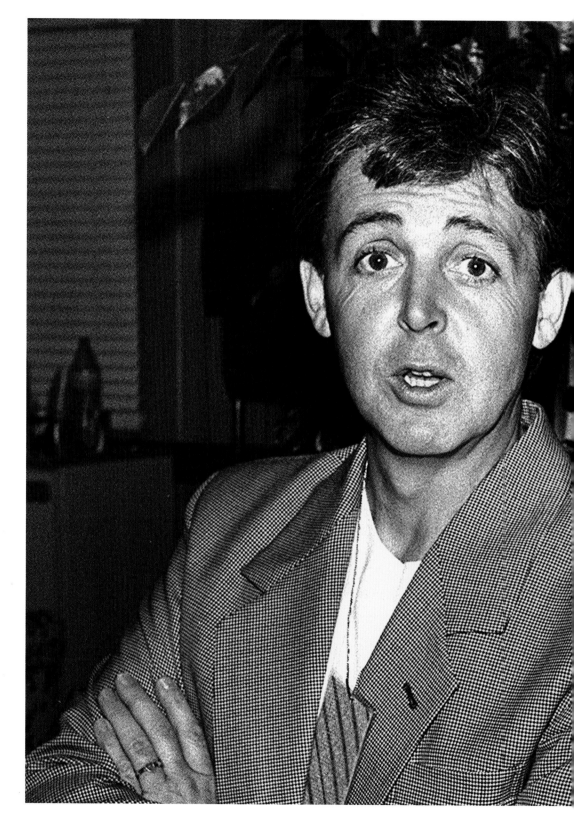

Live Aid

Right: David Bowie and Paul McCartney at the Live Aid concert at Wembley. Live Aid took place on 13 July 1985, with two charity concerts being held simultaneously at Wembley Stadium in London and JFK Stadium in Philadelphia. These were broadcast around the world by satellite to an estimated audience of over 400 million viewers, making Live Aid one of the most-watched televised events in history. Bowie and Jagger's "Dancing In The Street" video was screened twice, in addition to which David performed a short but accomplished set at Wembley, consisting of "TVC 15", "Rebel Rebel", "Modern Love" and "Heroes". He had also intended to perform "Five Years", but dropped the song to allow the screening of harrowing newsreel footage of the famine in Ethiopia, following which the donations came flooding in. As the event drew to a close, he returned to the stage to join Paul McCartney and a host of other stars for a rendition of "Let It Be", and to lead the final encore of "Do They Know It's Christmas?".

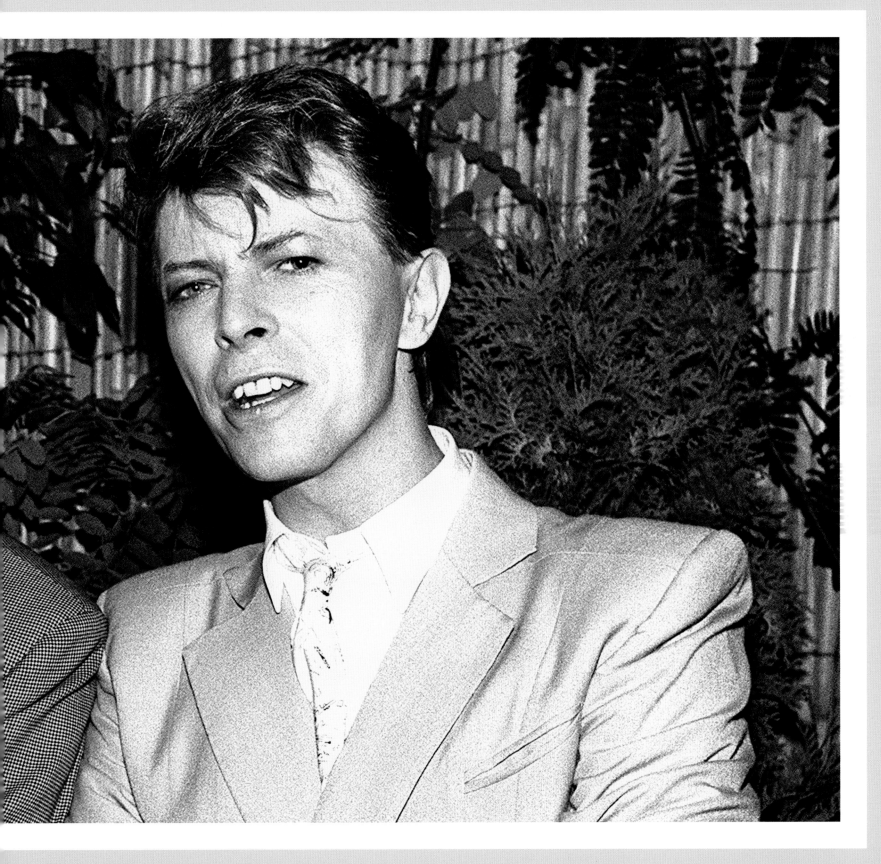

Absolute Beginners

Left: After Live Aid, Bowie's next move was to make a return to acting; filming his role as the tap-dancing ad man Vendice Partners in Julien Temple's *Absolute Beginners* between July and August. That same month saw the release of "Dancing In The Street", which provided him with his fifth no. 1 single – and he would narrowly miss the top of the charts with the theme from *Absolute Beginners* in early 1986.

Opposite: In late 1985 Bowie had taken on the role of Jareth the goblin king in Jim Henson's *Labyrinth*, also contributing five songs to the soundtrack. One of these, "Underground", went on to supply him with a minor hit following its release in June 1986, but the movie received a mixed reception, with the music press being particularly critical. Overall, the film also proved to be something of a box office failure, although in the UK, where it was screened six months later than in the US, it topped the charts over the Christmas period.

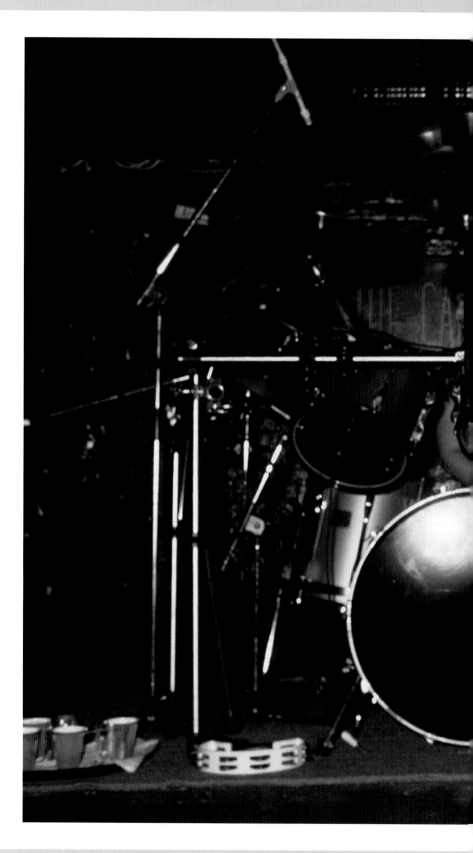

Never Let Me Down

Right: Bowie on stage with former classmate Peter Frampton at New York's Cat Club in March 1987. In May 1986 Bowie had returned to Mountain Studios in Montreux to collaborate with Iggy Pop on the latter's *Blah Blah Blah* album, before beginning work there on his own LP, *Never Let Me Down*. Although widely regarded as Bowie's most overproduced, mainstream album, and described by David himself as his nadir, *Never Let Me Down* nevertheless included more new compositions than his previous two albums combined, and also marked Bowie's return as a multi-instrumentalist, being the first time that he had contributed anything more than vocals since *Scary Monsters (And Super Creeps)* at the start of the decade. In March he issued "Day-In Day-Out", before embarking upon a press conference tour of North America and Europe, during which he would showcase tracks from the new album in order to promote the forthcoming Glass Spider Tour.

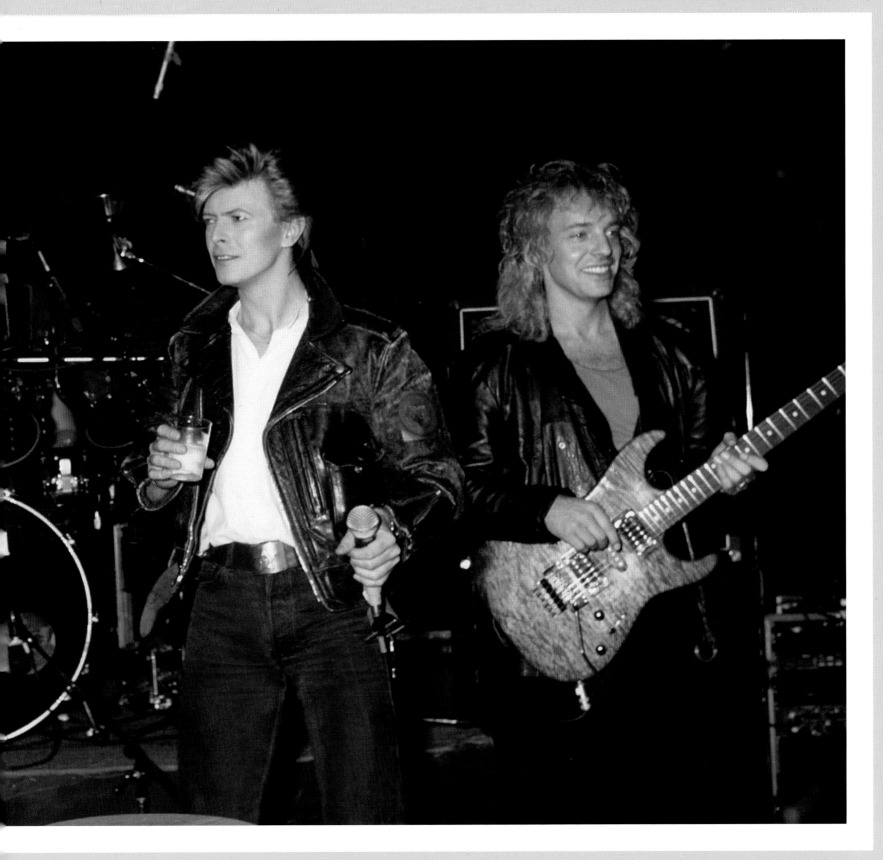

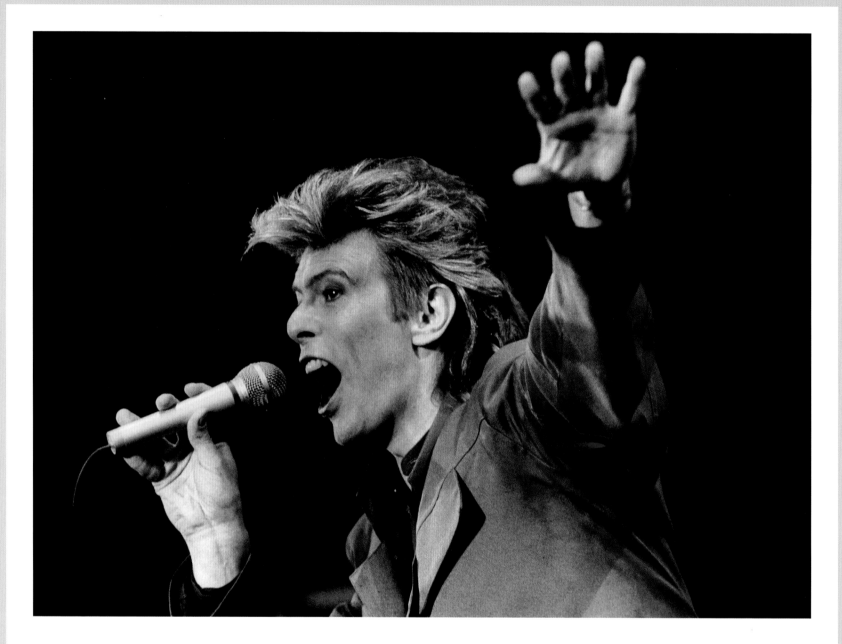

Glass Spider

Building on the success of his previous tours, and supported by a recently secured sponsorship deal with Pepsi, the Glass Spider Tour saw a return to the theatrical rock extravaganza not attempted since Bowie had taken Diamond Dogs on the road in 1974. Once again Allen Branton and Mark Ravitz would be called upon to work their magic with the lighting effects and stage set, whilst Tony Basil, another Diamond Dogs veteran, made her return as choreographer. The result was certainly spectacular. Audiences would be confronted by a stage set of scaffolding and raised gantries, straddled by a 50-foot illuminated spider, from which a troupe of dancers would abseil to the stage, followed by Bowie himself, who descended from the spider's jaws in a chair. After ten days of rehearsals in Rotterdam, the Glass Spider Tour launched at the city's Feyenoord Stadium on the 30 May, coinciding with "Joe" Bowie's 16th birthday. He took to the stage to be regaled with a rendition of "Happy Birthday" by a crowd of some 60,000 fans.

Opposite: On stage in the US during the Glass Spider Tour.

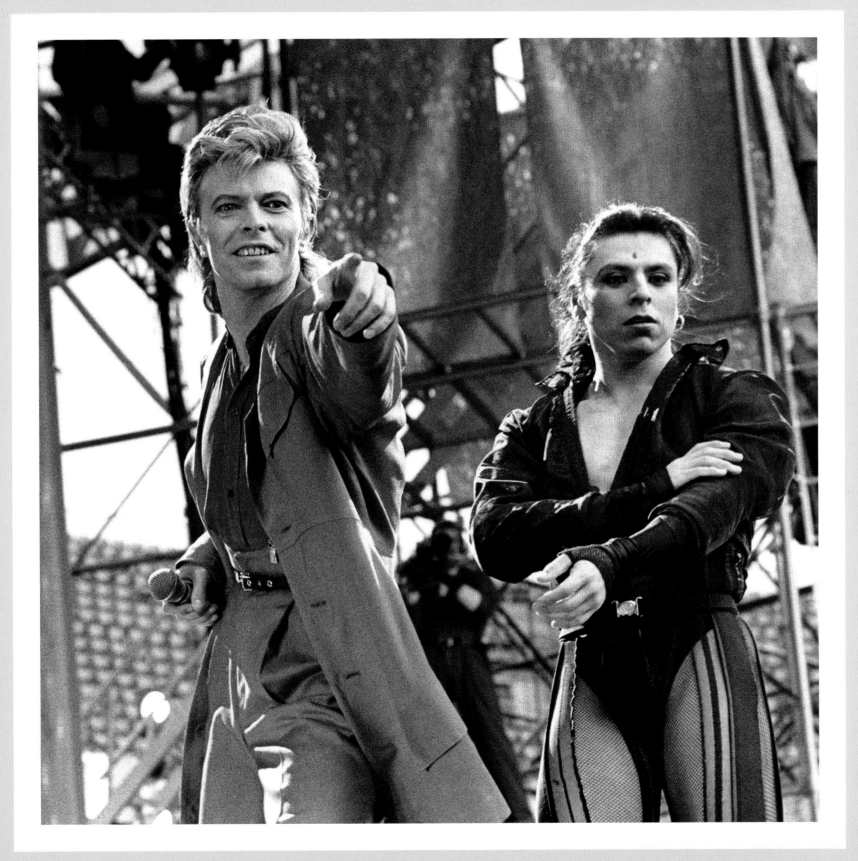

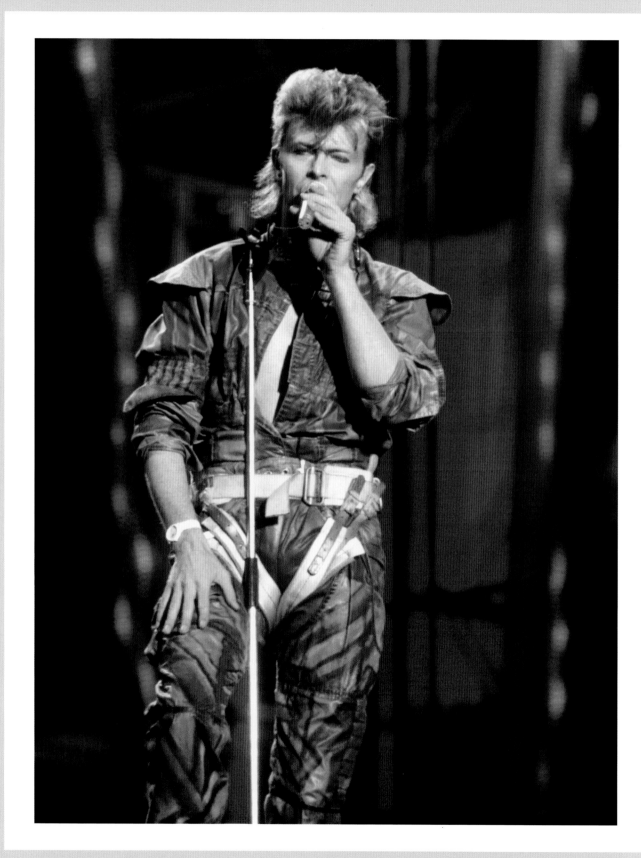

Arachnid catharsis

Left and opposite: With almost 90 performances across 15 countries, attracting an estimated three million fans, the Glass Spider Tour was one of the most ambitious, extensive and financially successful of Bowie's career. However, it was also criticized by some for being unintelligible and overblown, with the music taking second place to the spectacle, and the spectacle being swallowed up by the vastness of the stadia it was performed in. There were problems from the outset, the most tragic of which came just days into the tour with the death of a lighting engineer who fell from the set and in Europe and the UK the tour was blighted by bad weather. From Europe the tour headed to the US and then on to Australia, where David Mallet filmed performances for the Glass Spider video release, before ending in New Zealand in late November. In a cathartic moment at the end of the tour the huge spider was set ablaze in a field outside Auckland.

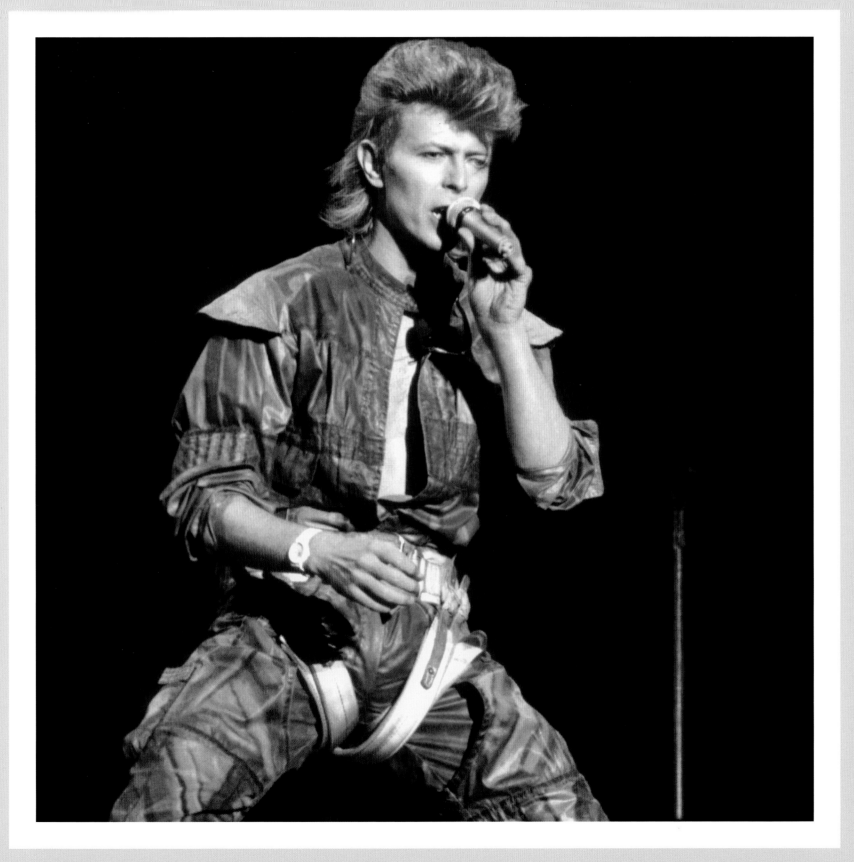

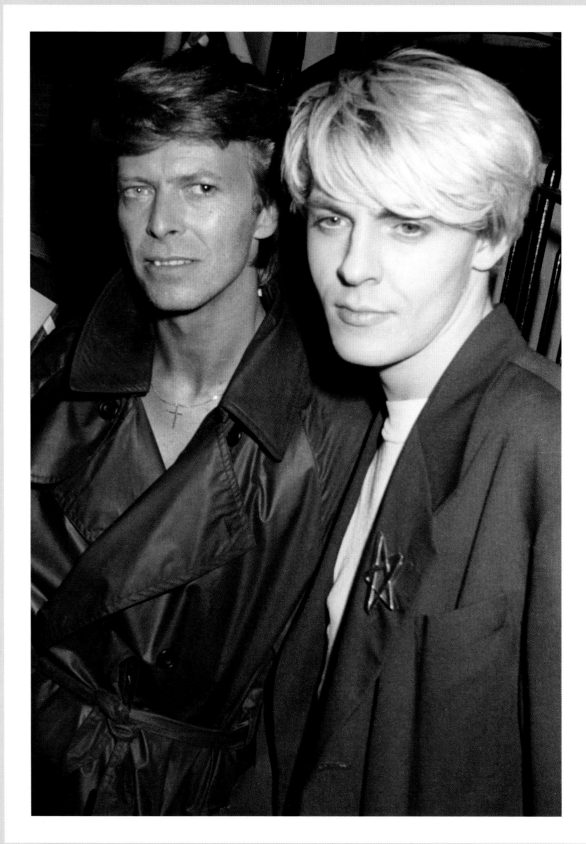

Intruders At The Palace

Left: David with Duran Duran's Nick Rhodes and (opposite) with Louise LeCavalier of the dance group La La La Human Steps. By the beginning of 1988, Bowie was seriously considering retiring from music. Both *Never Let Me Down* and the Glass Spider Tour had been mauled by the press, and he was struggling to see any way forward. However, after an abortive recording session with producer Bruce Fairbairn in LA, Bowie finally found some inspiration in a demo tape that had been handed to him by his press officer Sara Terry during the last tour of the States. Featuring guitar by her husband, Reeves Gabrels, the tape was a revelation for David. He had befriended Gabrels backstage during the Glass Spider Tour, but had no idea that he even owned a guitar, let alone could play one with such intensity and dexterity. After a brief phone call, Gabrels flew out to Switzerland in May, where he and David began discussing possible new directions, and on 1 July Gabrels made his first appearance with Bowie at the "Intruders At The Palace" benefit concert at London's Dominion Theatre, performing a new version of "Look Back In Anger", accompanied by Kevin Armstrong, Erdal Kizilcay and dancer Louise LeCavalier.

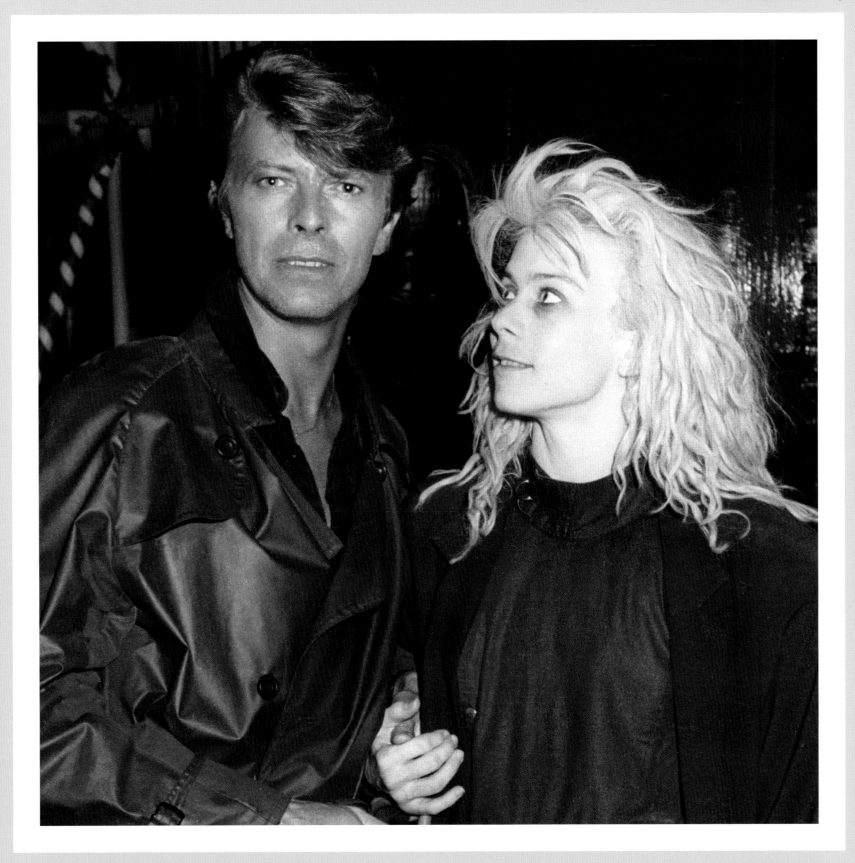

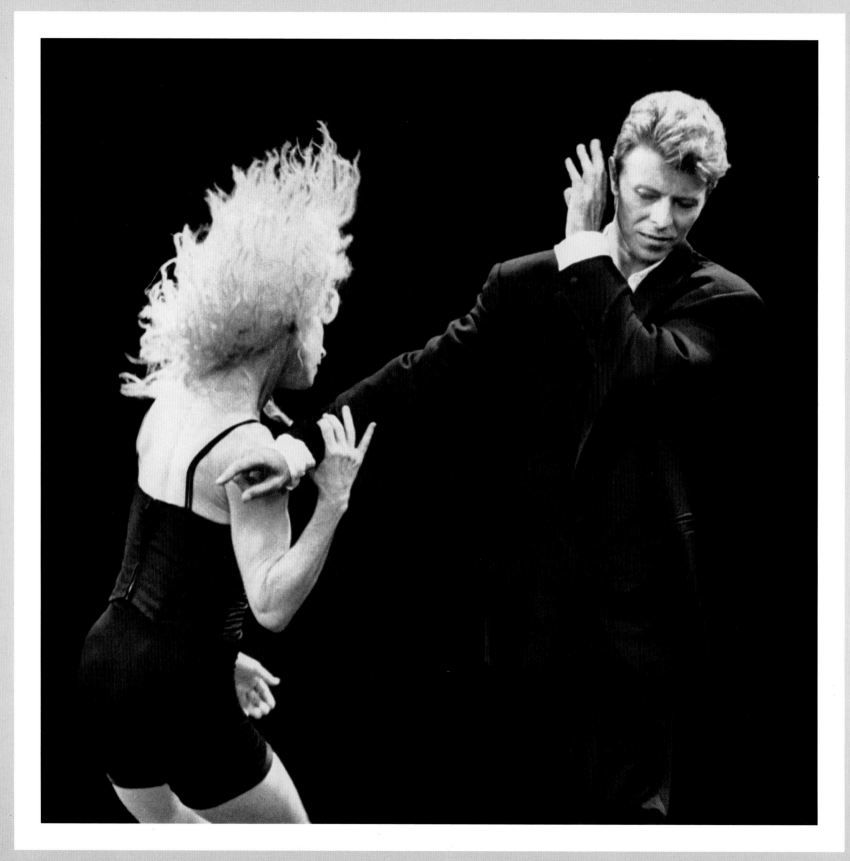

Wrap Around The World

Opposite: Although the ICA performance had originally been conceived as a one-off, on 10 September 1988, Bowie was given the opportunity to perform the piece as part of the Korean video artist Nam June Paik's "Wrap Around The World"; a multimedia event designed to promote and celebrate a host of geographically distant and diverse cultures, which would link live performances and video broadcasts from Japan, South Korea, China, the Soviet Union, the United States, Germany, Ireland, Israel, Brazil and Austria. Bowie and his group performed "Look Back In Anger" at the PBS studios in New York, with Bowie also holding a live satellite conversation with the Japanese actor and musician Ryuichi Sakamoto, who had starred opposite David as Captain Yonoi in *Merry Christmas Mr Lawrence*, and had also provided the film's score.

Right: David in December 1988 with his new girlfriend Melissa Hurley, a dancer who had worked on the Glass Spider Tour.

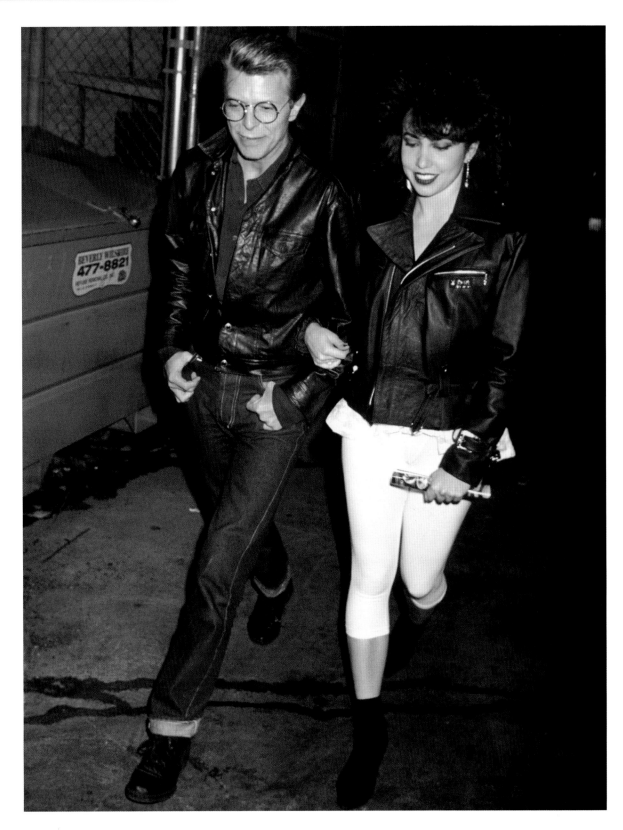

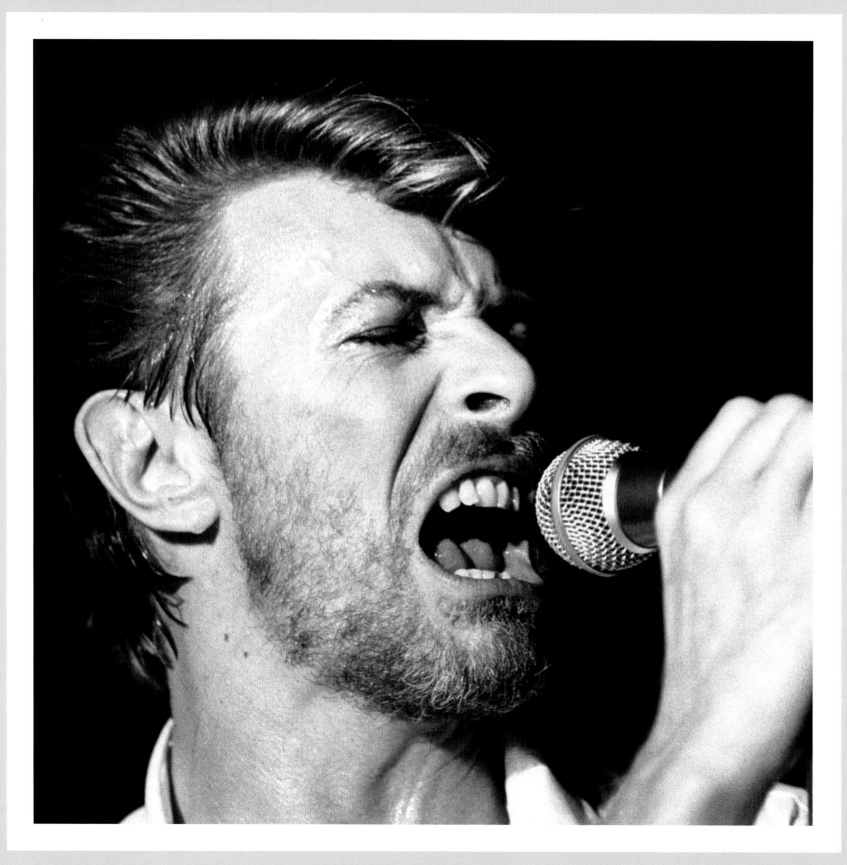

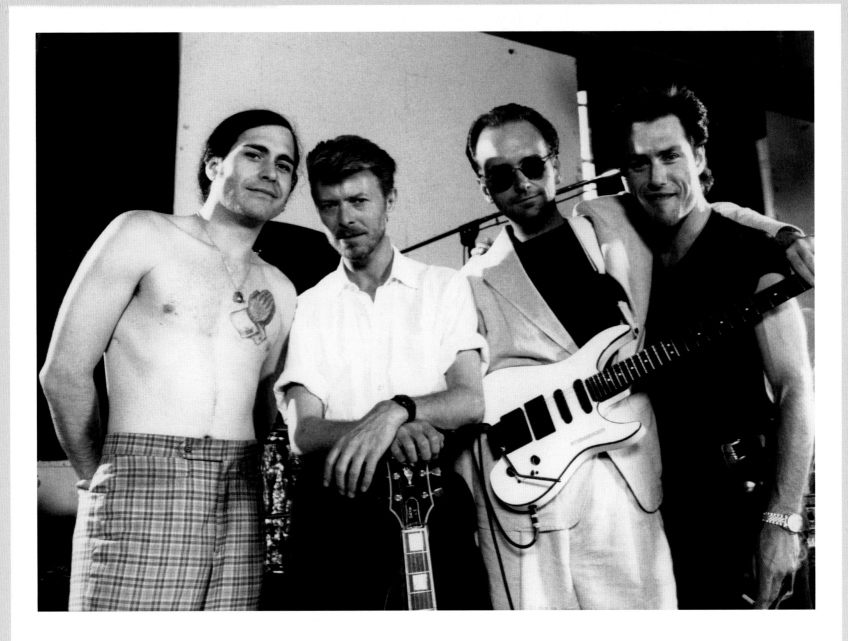

Tin Machine

Above: Tin Machine (left to right: Hunt Sales, David Bowie, Reeves Gabrels and Tony Sales), at the Manhattan Centre Studios, New York, May 1989. During the second half of 1988, Bowie and Gabrels returned to Switzerland, where they began working on new material with producer Tim Palmer. They briefly toyed with the idea of adapting Steven Berkoff's *West* into a concept album, but any notions of creating another art-rock album were soon to disappear when Bowie recruited out-and-out rockers Hunt and Tony Sales, who had played bass and drums on Iggy Pop's 1977 *Lust for Life* LP. Guitarist Kevin Armstrong, who had performed at Bowie's recent ICA gig and who had also been a part of Iggy's touring band, was brought in for the recording sessions, but essentially the band would be a four-piece, and moreover, it was decided that each member would have an equal say in the writing and recording process. The band, christened Tin Machine after one of their early song titles, would not simply be another Bowie backing band, but a new entity, with a life of its own, in which David was just another band member.

Opposite: On stage in Amsterdam with Tin Machine, June 1989.

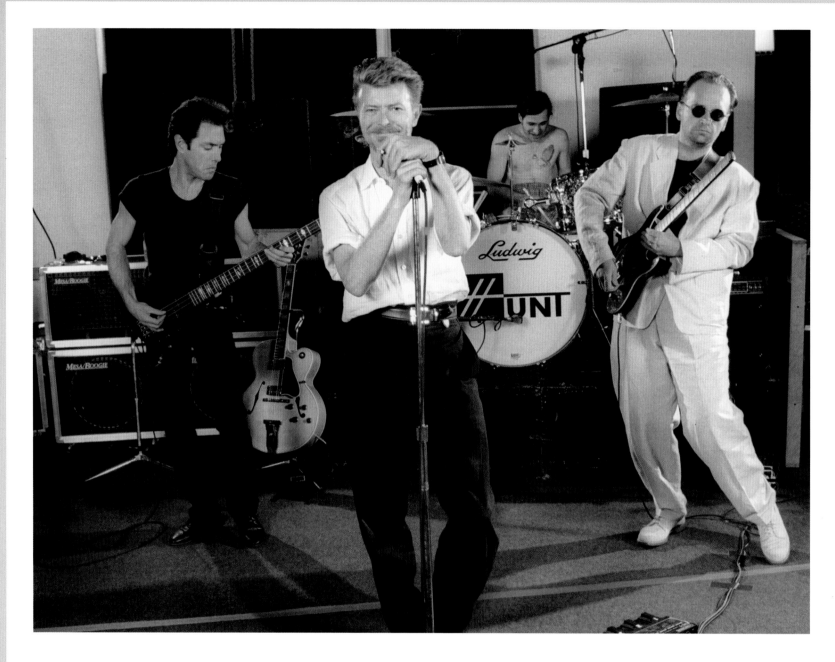

Tin Machine tour

Above: Completed in the Bahamas and mixed in New York, Tin Machine's self-titled debut album was released in May 1989, and marked a return to the spontaneity of some of his best earlier work. In one fell swoop he successfully managed to alienate a sizeable proportion of the middle-of-the road audience that he had attracted with the album *Never Let Me Down*, although the change in direction was also troubling for his label, EMI. Nevertheless, the album was more commercially successful, reaching no. 3 in the UK and 28 in the US.

Opposite: In June, Tin Machine embarked upon their first tour, which was a world away from the stadium rock of Glass Spider. The band played just 12 shows, beginning at The World club in New York on 14 June, and taking in low-key gigs in Denmark, Germany, the Netherlands and France, followed by five performances in the UK, which concluded on 3 July at the Forum in Livingston, Scotland. A few days later David returned to his birthplace, Brixton, for the opening of a new community centre that he had helped to fund.

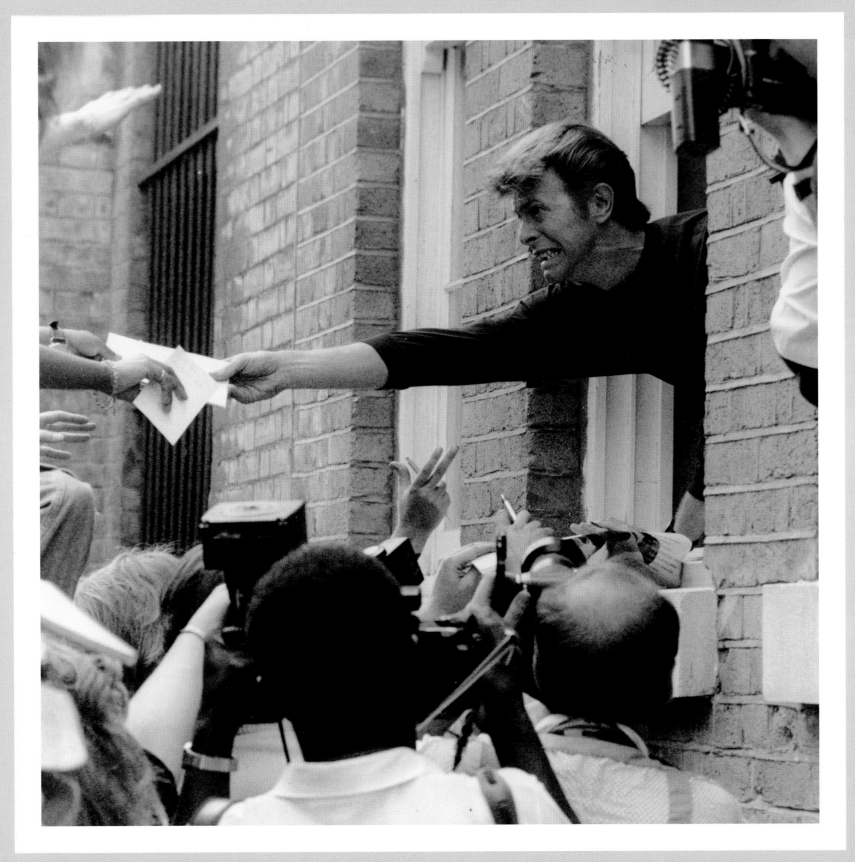

Chapter Four

Sound and Vision

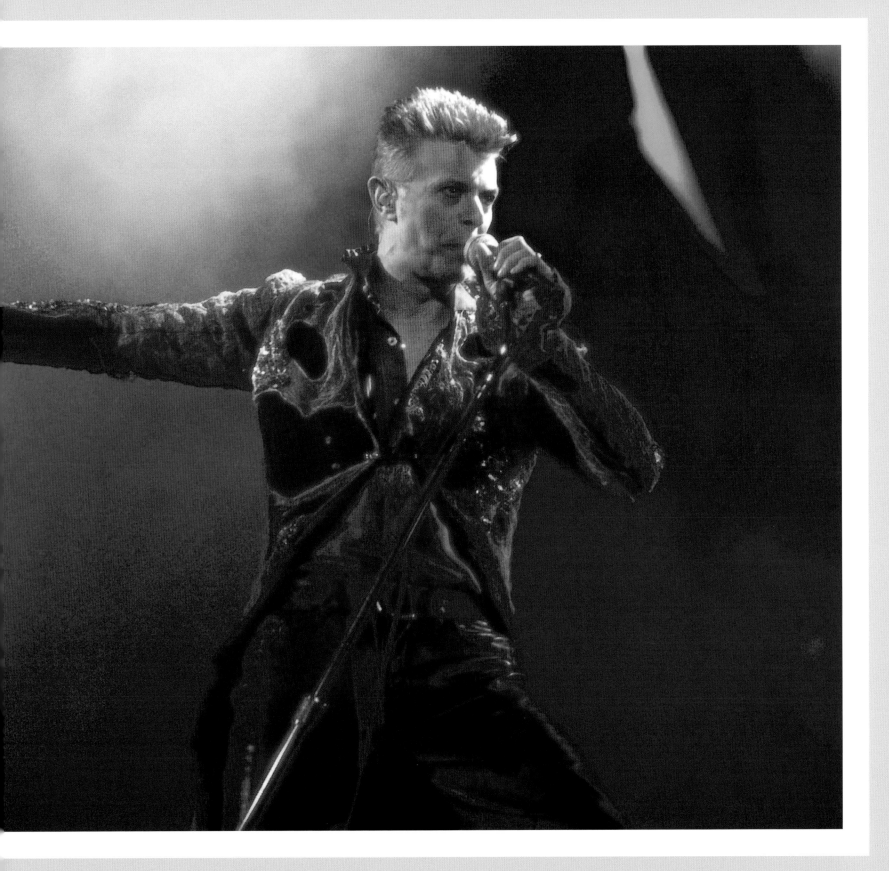

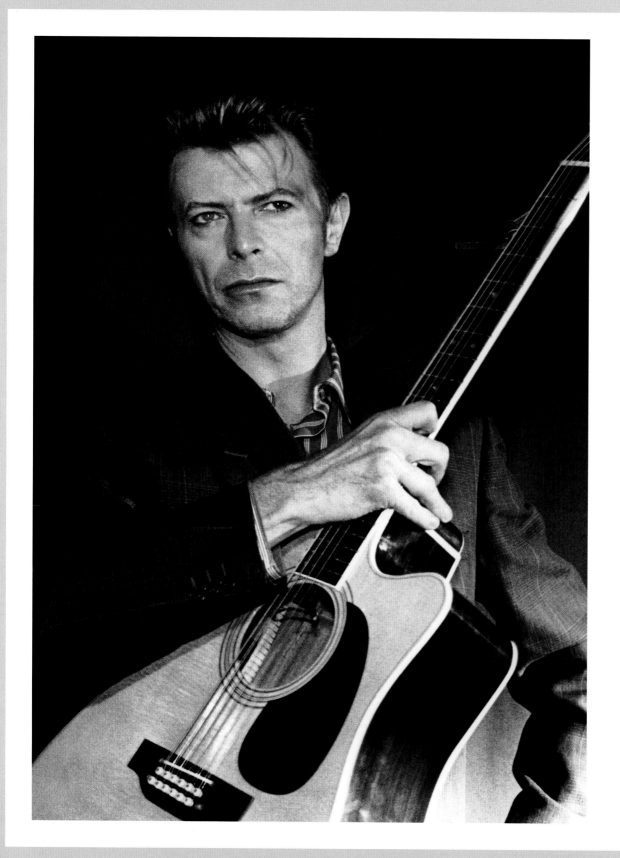

Sound + Vision

In the autumn of 1989, Tin Machine reconvened in Sydney, Australia, to begin sessions for their second album. The group debuted some of their new material at a one-off date in Sydney in November, but before the album was even complete, Bowie had taken the surprising decision to revisit his past. Prompted by the release of Rykodisc's extensive *Sound + Vision* compilation, in 1990 David embarked on the massive Sound + Vision Tour, essentially a greatest hits package that would see him perform over 100 shows across almost 30 countries between March and October. After the obvious excesses of the Glass Spider Tour, Bowie decided to take to the road with a stripped-down show, and having recorded two songs for Adrian Belew's solo album *Young Lions* in January, David assembled a four-piece band consisting of guitarist Belew, his drummer Michael Hodges and keyboard player Rick Fox, with the addition of Erdal Kizilcay on bass.

Left: Performing at the London Docklands Arena during the Sound + Vision Tour in March 1990

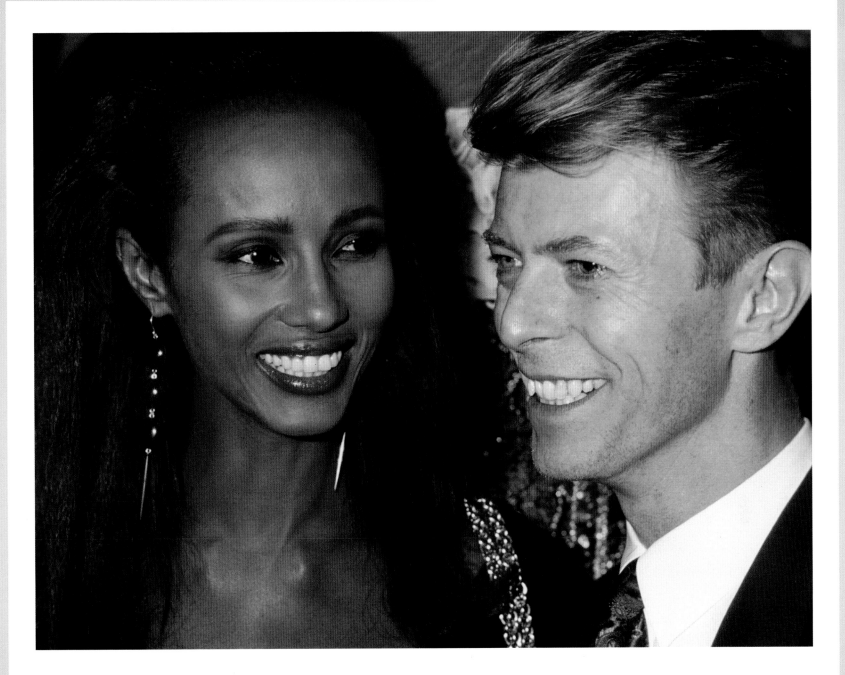

Iman

Above: Bowie and Iman at a charity fashion event in November 1990. Having indicated that the Sound + Vision Tour was a means to confront the weight of his back catalogue and exorcise some musical demons, Bowie appeared to relish performing the hits, and the tour was to prove a huge success. Offstage however, David's life was in a state of upheaval, and during the course of the tour he decided to break off his engagement with Melissa Hurley. Just two weeks after its conclusion however, David was to meet his future wife, Iman. Originally from Somalia, Iman had become one of the world's highest-earning models during the 1970s. By the time she met David she had begun to make forays into film and television, most notably in the Oscar-winning *Out of Africa*. David and Iman hit it off immediately, and at the end of the year he arranged a small role for her in *The Linguini Incident*, a comedy in which he was starring opposite Rosanna Arquette.

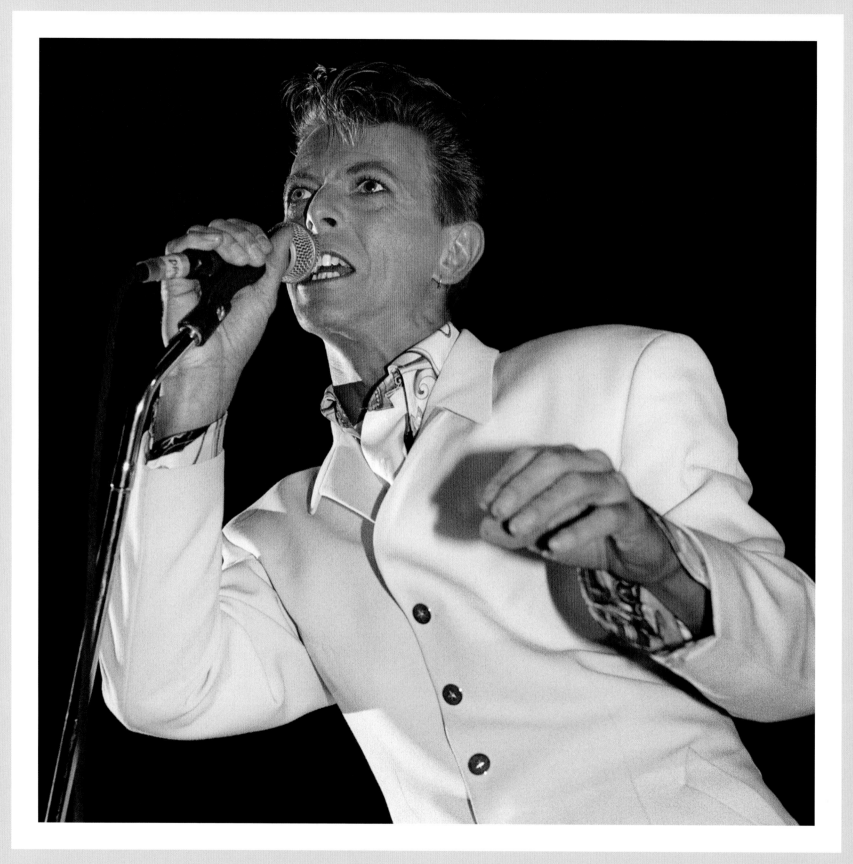

Tin Machine II

Opposite and right: Bowie onstage during Tin Machine's It's My Life Tour in 1991. In Early 1990, EMI and Rykodisc had followed up the release of the *Sound + Vision* box set with the greatest hits album *Changesbowie*, which provided David with his first no. 1 album since 1984's *Tonight*. By the end of the year however, Bowie and EMI had parted company, with the label apparently despairing of David's intentions to release another Tin Machine LP. Reeves Gabrels also had reservations about the project, although when David eventually found a deal with new label Victory Music in March 1991, these were tempered slightly as the focus shifted a little more towards melody and songwriting and away from the raw noise that had characterized their first album. *Tonight* producer Hugh Padgham was even brought in to help complete the LP, but when *Tin Machine II* was released in September, sales were very low. Undeterred, the band embarked on the It's My Life Tour, which would spawn the album *Tin Machine Live: Oy Vey, Baby*.

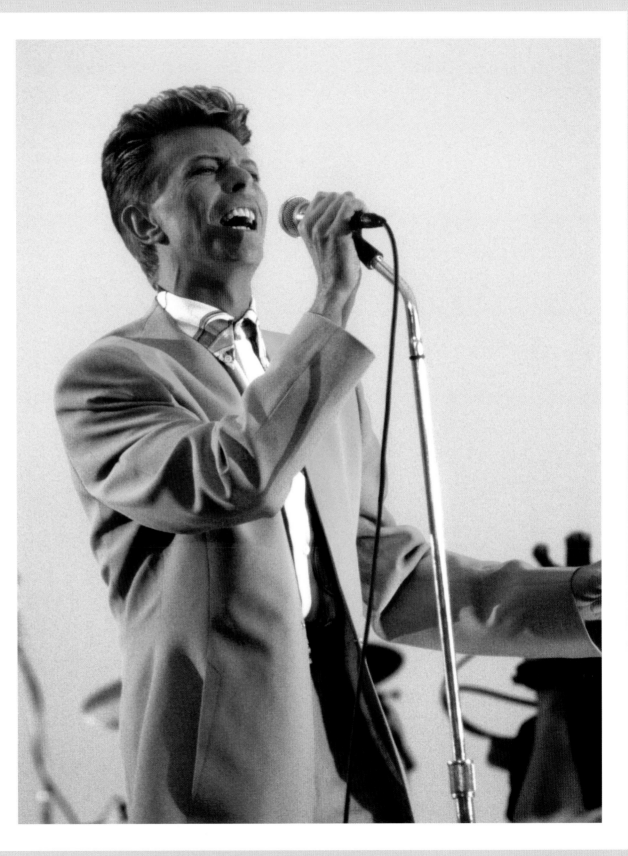

The Freddie Mercury Tribute Concert

Right: When Tin Machine's second tour concluded in
Japan in February 1992, it marked the end of the band.
For many, the whole Tin Machine 'experiment' would
come to be seen as an aberration in Bowie's career, but
for David himself, the project was absolutely necessary.
Tin Machine had not only freed him from the need to
please his audience, but had helped him to recapture
his passion for creativity and given him the space to
ponder what direction his career might take next. Before
returning to the studio to embark on his next solo venture
however, Bowie was to make a return to the stage with his
performance at the Freddie Mercury Tribute Concert, which
took place at Wembley Stadium on 20 April 1992. Backed
by Queen, David and Annie Lennox performed "Under
Pressure", before being joined by Mick Ronson and Mott
The Hoople's Ian Hunter, for renditions of "All The Young
Dudes" and "Heroes".

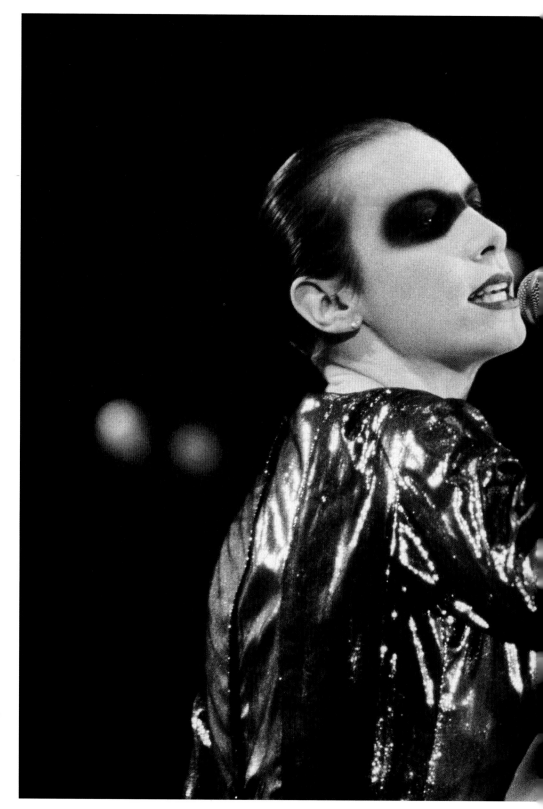

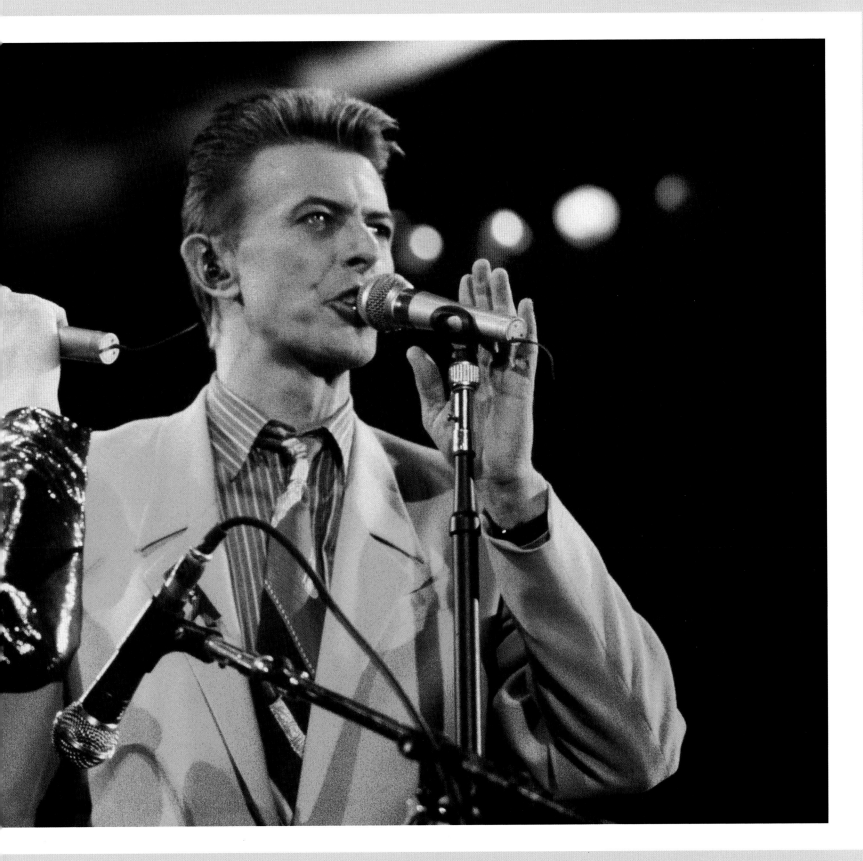

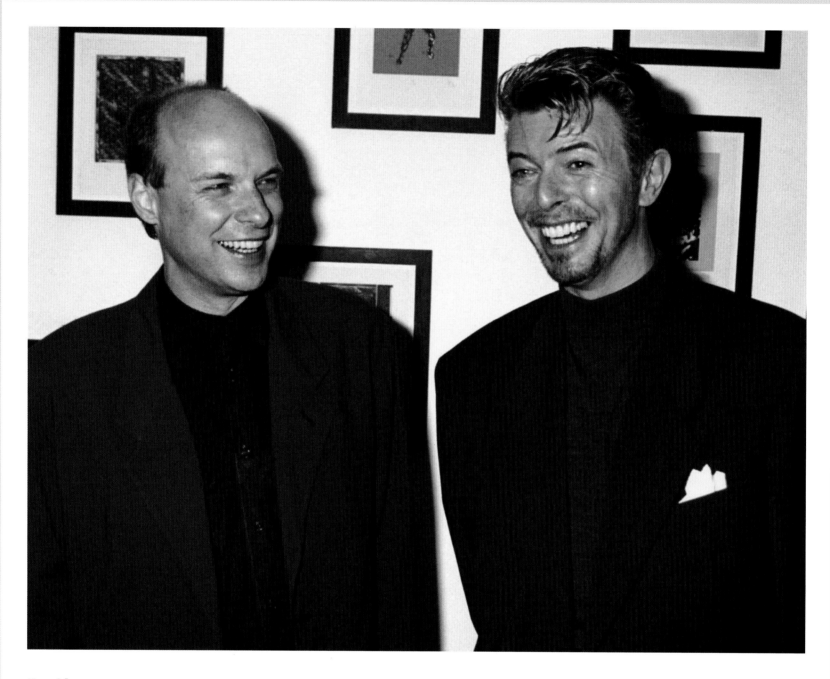

Outside

Above: In early 1994, Bowie began work on his next studio album, *1.Outside*, which saw him reunite with several former collaborators, including Reeves Gabrels, Erdal Kizilcay, Mike Garson, Kevin Armstrong, Carlos Alomar and perhaps most significantly, Brian Eno. Subtitled "the Ritual Art-Murder of Baby Grace Blue: A non-linear Gothic Drama Hyper-Cycle", the LP took the form of a concept album, populated by surreal and disturbing characters and events, and captured David at a creative high point. During the recording sessions, which continued into 1995, he would often paint and draw, and in April 1995 he mounted an art exhibition entitled New Afro/Pagan and Work 1975–1995 at The Cork Street Gallery in Mayfair, London. Later in the year he also contributed works to a charity art exhibition organized by Brian Eno.

Opposite: David and Iman in Mayfair, April 1995.

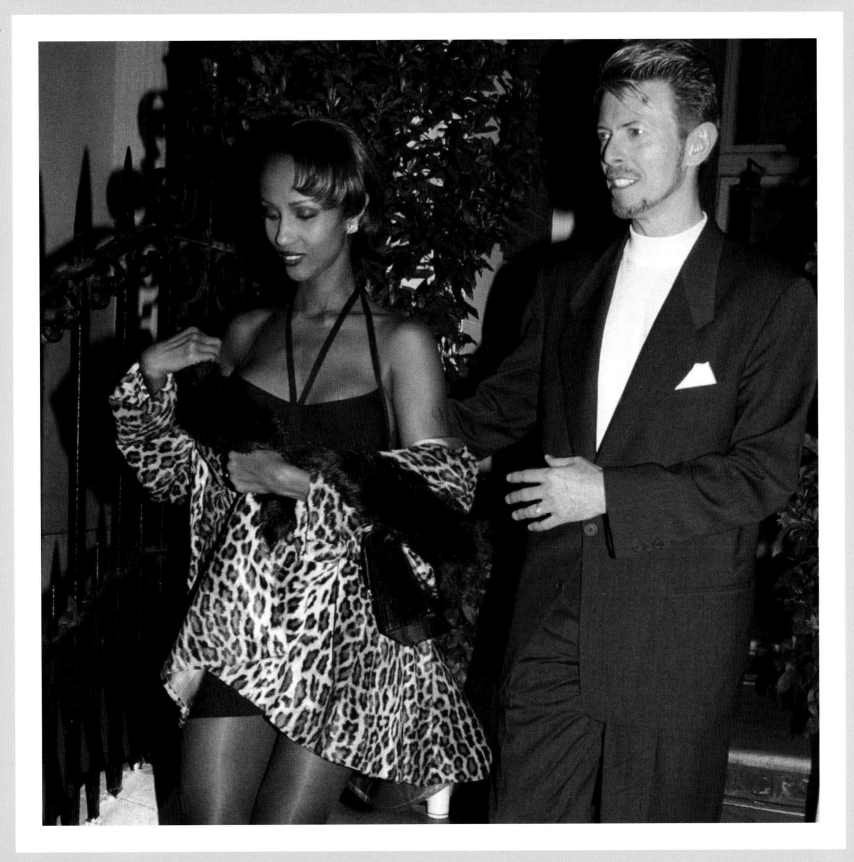

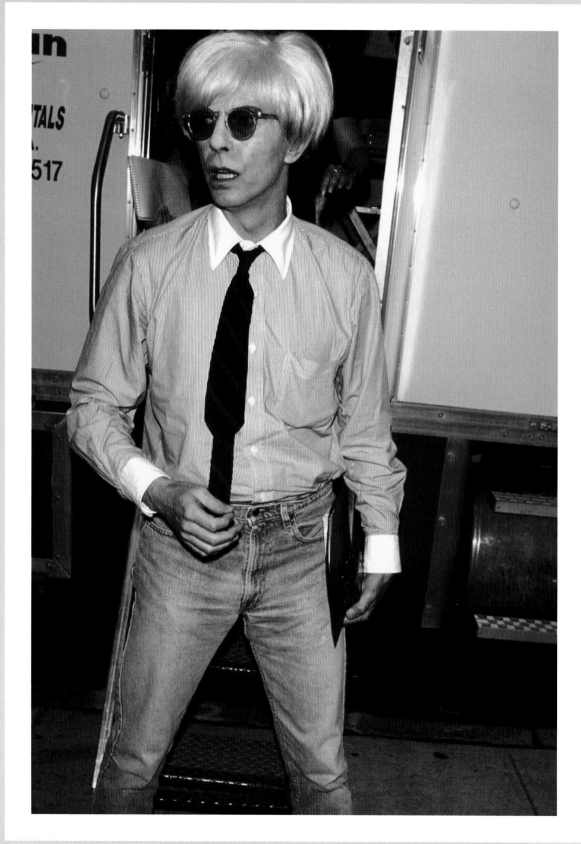

Hallo Spaceboy

Left: In the summer of 1995, David took on the role of the artist Andy Warhol in Julian Schnabel's biopic *Basquiat*, and then began making plans for a return to touring. He initially intended to perform just six shows, but his new label Virgin persuaded him to embark on a full scale tour in support of *1.Outside*. As a result, David launched the Outside Tour in September, with industrial rockers Nine Inch Nails providing support for the American dates. The European leg followed between November and December, with Bowie also making appearances at the MTV Europe Music Awards, and on the British music shows *Top of the Pops*, *Later... With Jools Holland* and *The White Room*.

Opposite: After a Break for Christmas, the tour resumed in Helsinki on 17 January 1996, before closing in Paris on 20 February. That same month, Bowie was on hand to receive the Lifetime Achievement Award at the Brit Awards, and narrowly missed the UK top ten with the single "Hallo Spaceboy". After a three-month break, he returned to the stage in June for the Outside Summer Festivals Tour, which included a headline appearance at the UK's Pheonix Festival.

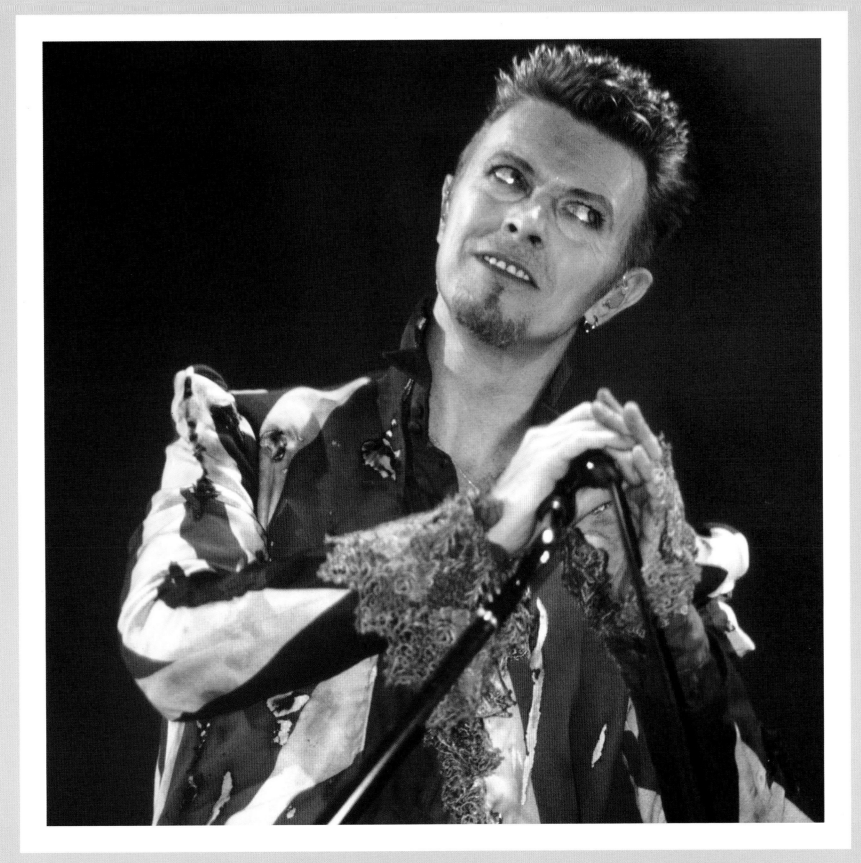

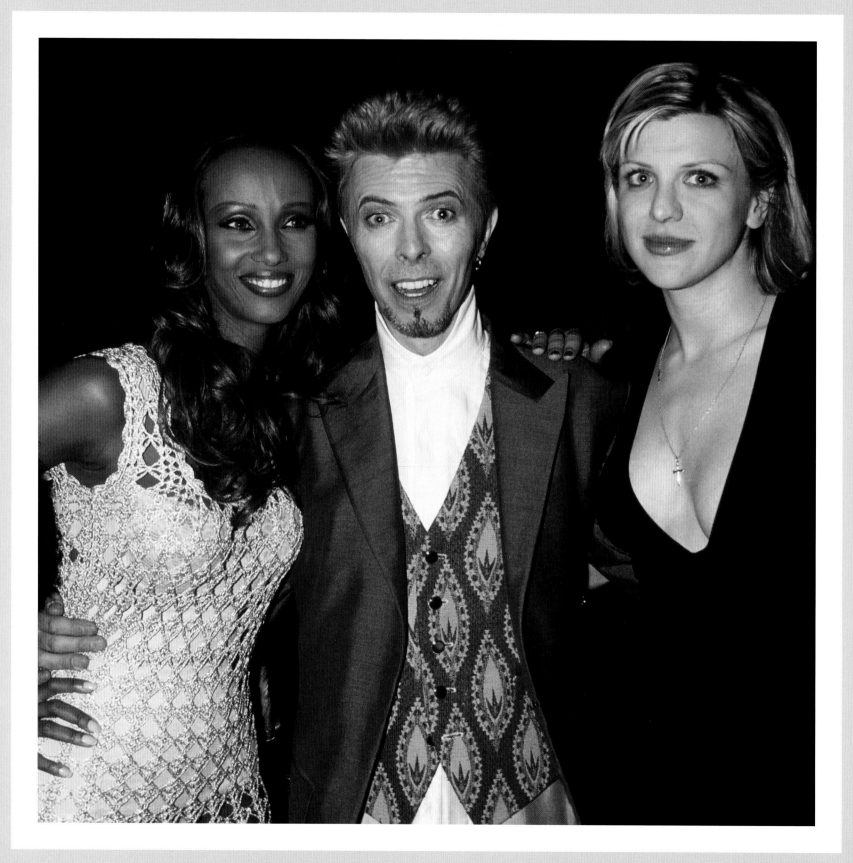

Bowie at fifty

Opposite: David with Iman and Courtney Love, January 1997.

Right: On 8 January 1997, Bowie turned 50, and chose to celebrate his birthday with a performance at New York's Madison Square Garden the following day. Billed as *David Bowie and Friends – A Very Special Birthday Concert*, the show was broadcast on pay-per-view television in the US. Bowie was joined on stage by a host of famous faces for a set that included some of his biggest hits. The concert was not to be a career retrospective, however. Bowie performed with his latest band, which consisted of Reeves Gabrels on guitar, Gail Ann Dorsey on bass, Zachary Alford on drums, and Mike Garson on keyboards, while Lou Reed was the only guest artist with whom David had any real history. The others consisted of Frank Black, the Foo Fighters, Robert Smith, Sonic Youth and Billy Corgan. Some critics complained at the lack of a nostalgia trip, but Bowie's penchant for self-reinvention and pushing the boundaries was a hallmark of his career, and as if to drive the point home, he performed most of the new album that he had been recording since the previous summer.

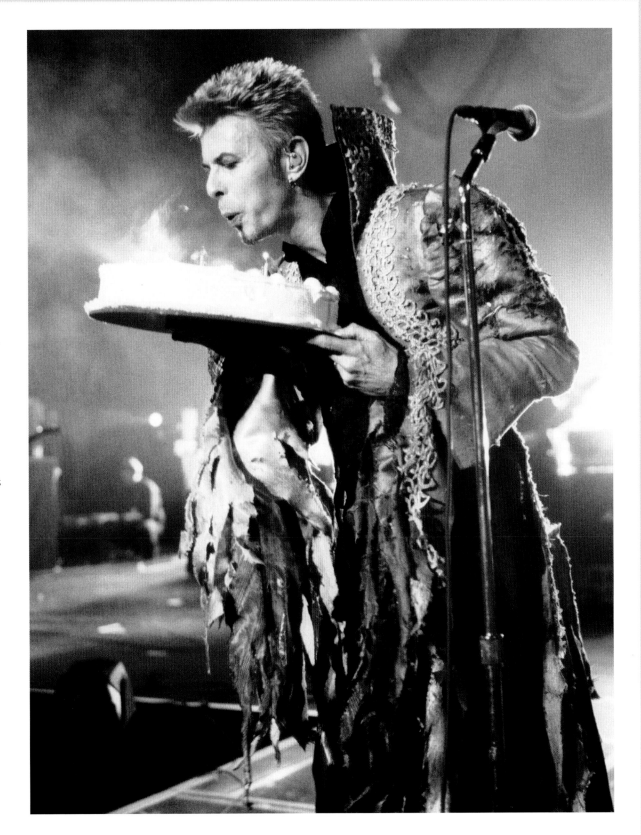

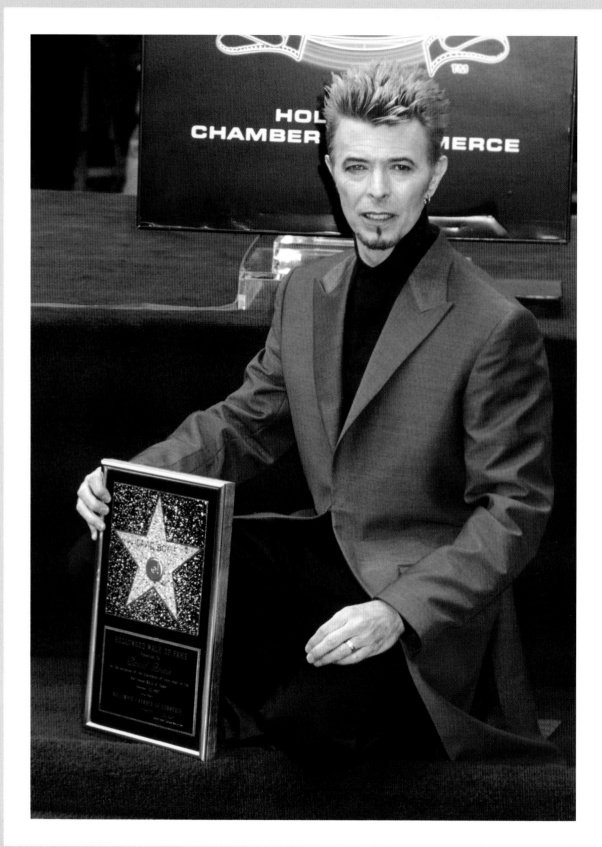

Earthling

Left: At the end of January 1997, Bowie issued the drum-and-base infused "Little Wonder" as the lead-off single from his *Earthling* LP, with the album following a week later. Having already performed much of the material live at a series of autumn gigs and at his birthday concert, the public was not entirely taken by surprise, but some critics viewed this latest change in direction as a commercial exercise, rather than an attempt by Bowie to capture the zeitgeist by exploring a current musical style that held a genuine fascination for him. In general the response was favourable however, with the album reaching no. 6 in the UK and being nominated for a Grammy. Already inducted into the Rock and Roll Hall of Fame, on 12 February 1997 David was honoured with a star on the Hollywood Walk of Fame.

In March and April Bowie made a number of television appearances, before taking *Earthling* on the road for a five-month tour, which launched in Germany on 7 June. Initially the show was split between more conventional numbers and a dance set, although this format was quickly abandoned. At the Phoenix Festival on 19 July however, he took the idea one step further by performing in the dance tent under the pseudonym Tao Jones Index, ahead of his headline slot the following day.

"hours..."

Right: David on stage at London's
Astoria during The "hours..." Tour,
1999. As 1997 segued into 1998, Reeves
Gabrels was keen to return to the studio
to begin work on a follow-up to *Earthling*,
but it seems the momentum was
temporarily lost. Instead, Bowie, Gabrels
and *Earthling* producer Mark Plati set
about mixing the live album *liveandwell.
com*, following which David took roles
in the films *Everybody Loves Sunshine*, *Il
Mio West* and *Mr Rice's Secret*. In August
David reunited with Tony Visconti for a
couple of recording sessions, whilst the
following month saw the launch of the
next big venture, the BowieNet website.
By May 1999 however, Bowie and
Gabrels had amassed a wealth of new
material. Much of it had been written
for the computer game, Omikron, but
it would also find its way onto Bowie's
next studio album, *"hours..."*. A more
contemplative affair than *Earthling*, the
LP reached no. 5 in the UK charts and
was supported by a promotional tour
that ran from August to December.
Always one step ahead of the pack,
Bowie's *"hours..."* was the first album by
a major artist to be made available via
download, ahead of its physical release.

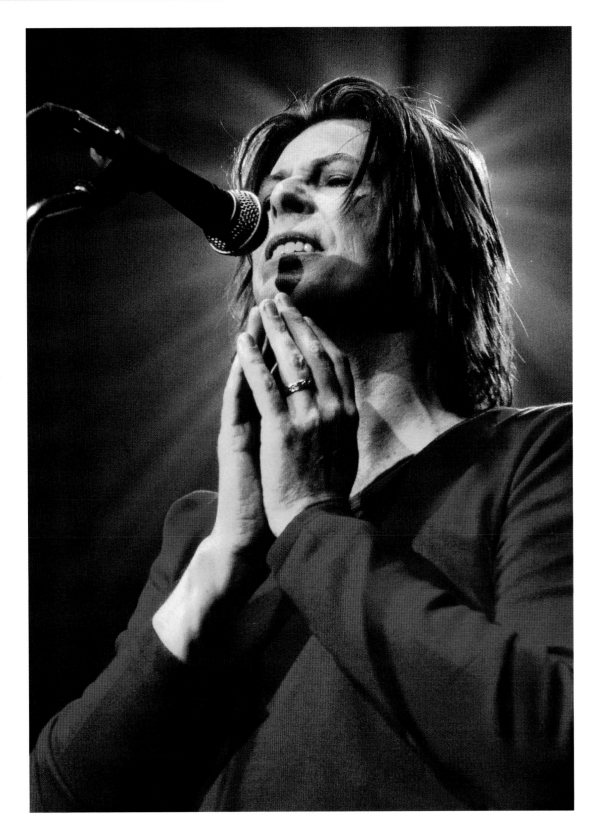

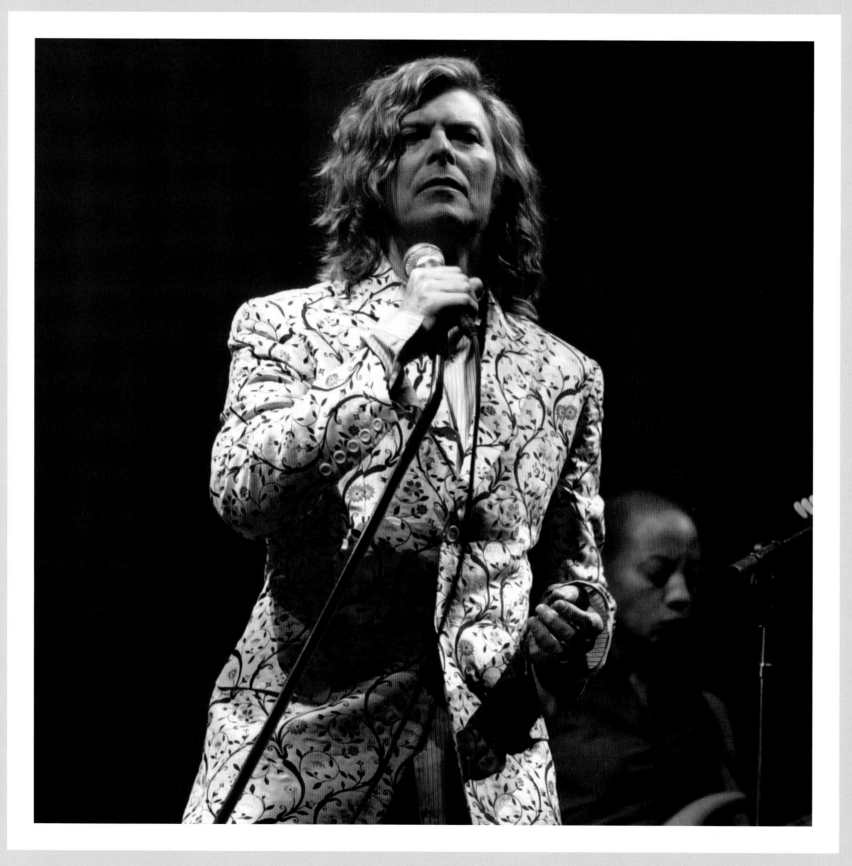

Glastonbury 2000

Opposite: David had intended to mark the dawn of the year 2000 with a live Millennium Concert performance in New Zealand, but in the end audiences would have to wait until June, when Bowie performed two gigs at New York's Roseland Ballroom, before making a long-awaited return to the Glastonbury Festival on the 25th. The last time he had performed at the festival was just after the release of *The Man Who Sold The World* in 1971, so there was some strange symmetry at work when Bowie appeared on stage some 24 years later with long tousled hair, sporting a flowery frock coat. Two days later he gave a more intimate live performance at the BBC Radio Theatre, a recording of which was released as a bonus disc with *Bowie at the Beeb*, which hit no. 7 in the UK after its release in September.

Right: By this time, David had become a father for the second time, with Iman having given birth to their daughter, Alexandria, on 15 August. For the rest of the year David was content to retreat from the spotlight in order to spend more time with his family, although in October he would film a cameo role in the movie *Zoolander* and make an appearance at the VH1 Fashion Awards, at which James Brown was also a guest.

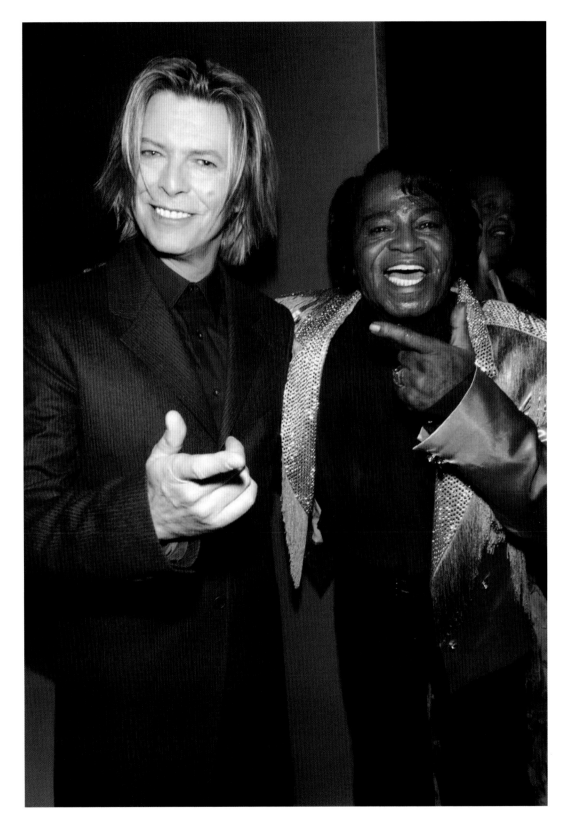

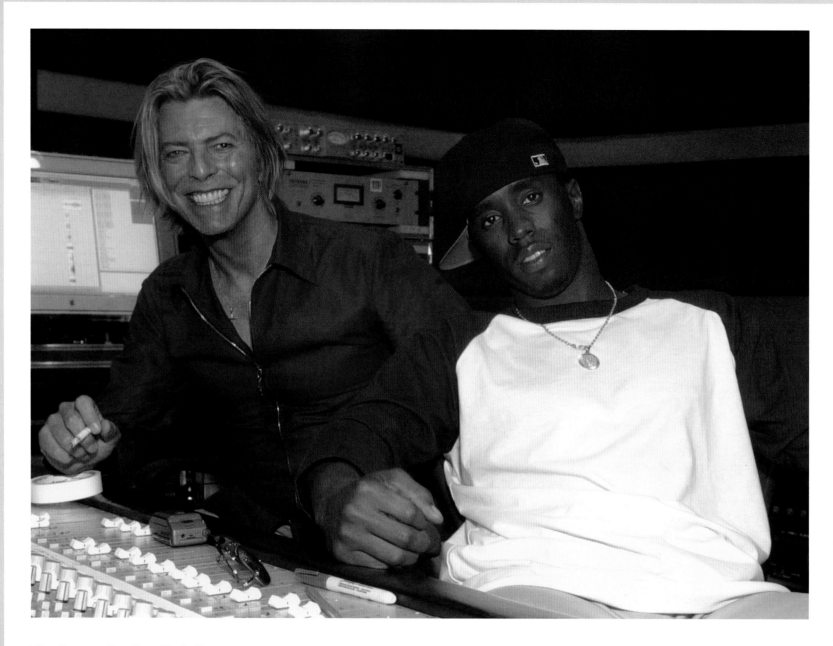

The Concert For New York City

Above: During the second half of 2000, David also recorded the album *Toy*, which included re-workings of some of his early songs, but by the end of the year Virgin/EMI seemed reluctant to issue the LP, and the project was shelved in favour of an album of "new" material. As a result, in early 2001 he began work on *Heathen*, which saw Tony Visconti back in the producer's chair for the first Bowie album since *Scary Monsters* in 1980. The recordings also marked the return of Carlos Alomar, and featured contributions from Pete Townshend and Dave Grohl. In addition to these sessions, in 2001 Bowie contributed to the soundtracks of *Intimacy*,

Moulin Rouge! and *Training Day*, for which he teamed up with American rapper Sean Combs (pictured above) to record "American Dream".

Opposite: At the beginning of the year, David had appeared at the Tibet House Benefit concert at New York's Carnegie Hall. He would end the year with another charity performance, opening The Concert For New York City at Madison Square Garden, where he joined a host of stars to raise money for victims of the September 11 attacks.

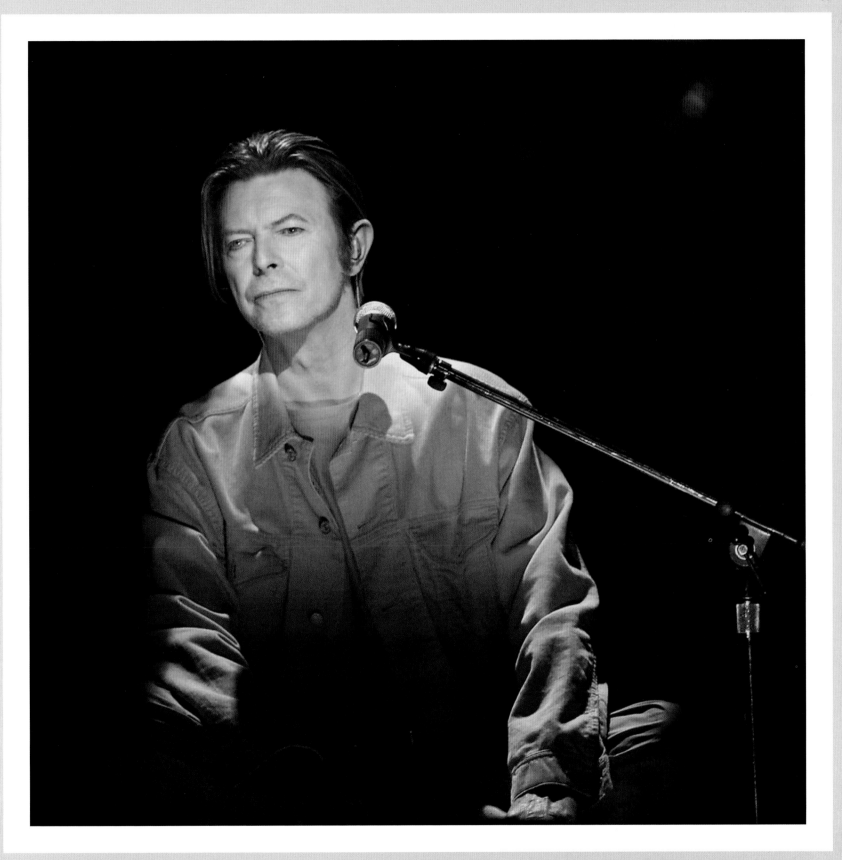

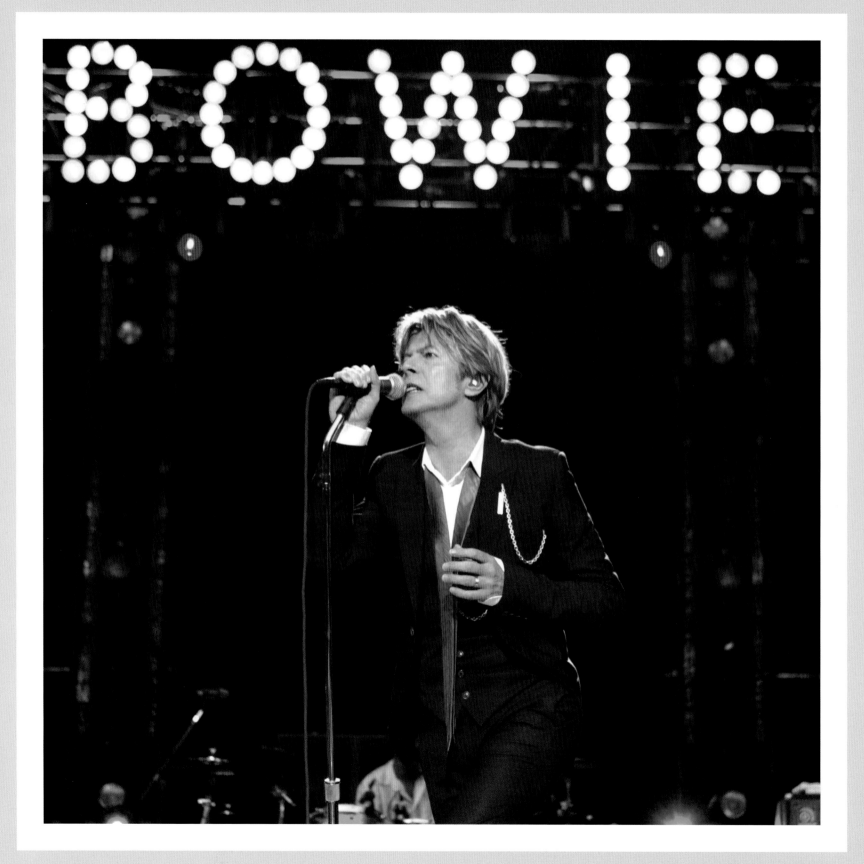

Heathen

Opposite: On stage at the Verizon Wireless Amphitheater, California, August 2002. Bowie's 25th studio album, *Heathen*, was released in June 2002 to widespread critical acclaim. It peaked at no. 5 in the UK and remained in the charts for some four months, while in the US the LP reached no. 14, proving to be his most commercially successful album in the States since *Tonight,* in 1984. After a warm-up show in New York, Bowie launched 2002's Heathen Tour on 29 June at London's Meltdown Festival, which he also curated. Essentially a summer festival tour, he travelled through Europe, before joining Moby's Area2 Festival tour of North America. Having recently conquered his nicotine addiction, David's voice was in fine condition, and even the decision to perform both *Low* and *Heathen* in their entirety during the early stages of the tour failed to arouse protest from the critics.

Right: On stage at The Music Hall at Snug Harbour, October 2002. After a break from mid-August to late September, the tour resumed for further European and American dates in the autumn, including five performances in New York that became known as the "New York Marathon Tour".

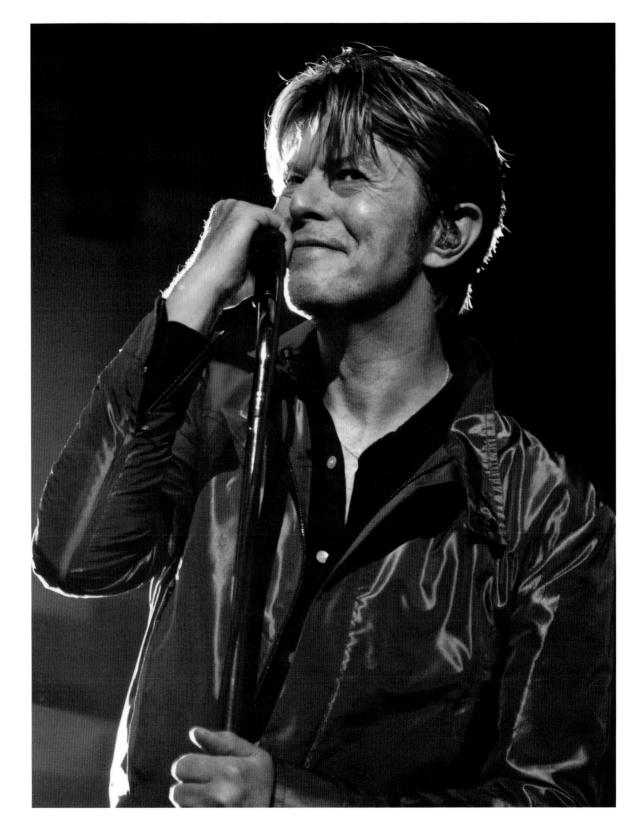

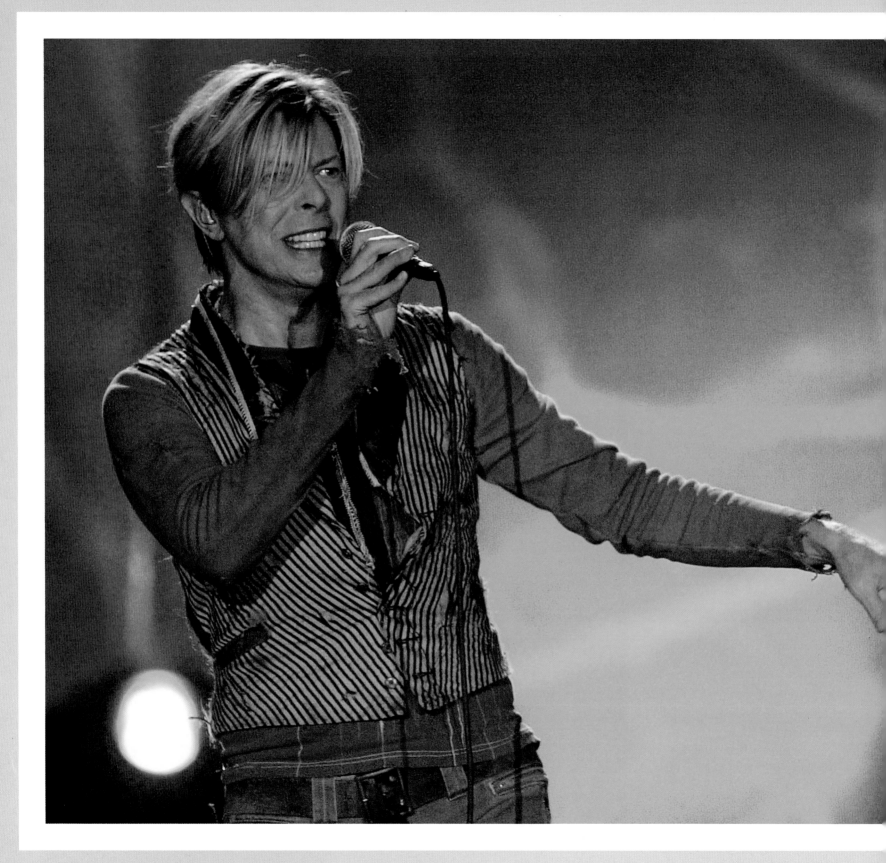

Reality

Left: Bowie performing at Manchester's MEN Arena in November 2003, during the A Reality Tour. Although his relationship with the Columbia label now meant that he was not being pressured for "product", by May 2003 David had all but completed his next album, *Reality*. Recorded with Tony Visconti and Bowie's touring band, which now included Earl Slick, Gerry Leonard, Mark Plati, Gail Ann Dorsey, Mike Garson and Sterling Campbell, the LP had an immediacy perfectly suited to live performance, and soon after its release in September, which was previewed by an exclusive performance that was broadcast live to cinemas worldwide, Bowie was back on the road with the A Reality Tour. Beginning on 7 October 2003 in Denmark, the tour would visit both Europe and North America twice, and also take in the Bahamas, Australasia and Asia. Owing to ill health, David had to end the tour 15 dates ahead of schedule, but by the time of its conclusion at the Hurricane Festival in Germany on 25 June 2004, the A Reality Tour was the longest that he had ever undertaken.

Having initially thought to have been suffering from nothing more serious than a trapped nerve, in July 2004 it was revealed that David had undergone heart surgery to relieve a blocked artery. He returned to New York to convalesce in July, although by the autumn he had begun to get out and about and on 8 September he gave his first performance for over a year at the Fashion Rocks charity show. This was held at New York's Radio City Music Hall, with proceeds going to victims of Hurricane Katrina.

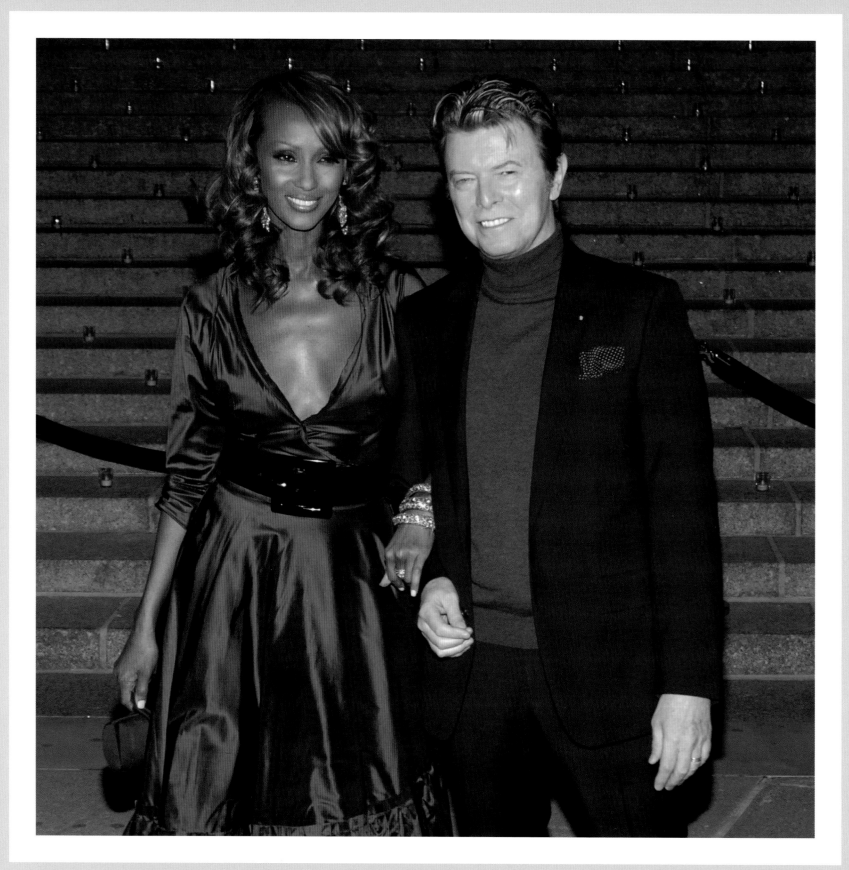

Moonage Daydream

Opposite: David and Iman arriving at the 2006 Tribeca Film Festival. In early 2006, David Bowie received a Grammy Lifetime Achievement Award, following which he appeared enter a state of semi-retirement, retreating from the spotlight to enjoy his life as a family man in the relative anonymity of New York. Later that year however, he made a guest appearance with David Gilmour at London's Royal Albert Hall, appeared as Nikola Tesla in Christopher Nolan's *The Prestige*, and performed alongside Alicia Keys at the Black Ball charity event. In 2007 David curated the High Line Festival, whilst in 2008 he contributed to Scarlett Johansson's album of Tom Waits covers, *Anywhere I Lay My Head*.

Right: In 2009 Bowie's son Duncan Jones won huge acclaim for his directorial debut *Moon*, which premiered at the Sundance and Tribeca Film Festivals ahead of its general release in July. That same month EMI reissued Bowie's breakthrough hit "Space Oddity" to mark the 40th anniversary of the *Apollo 11* moon landings. Distributed as a digital EP, which was designed to invite remixes from fans, the release suggested that perhaps Bowie, an ever-changing innovator, who has successfully mythologized his otherness with a host of space-age metaphors since the 1960s, is still as relevant as ever.

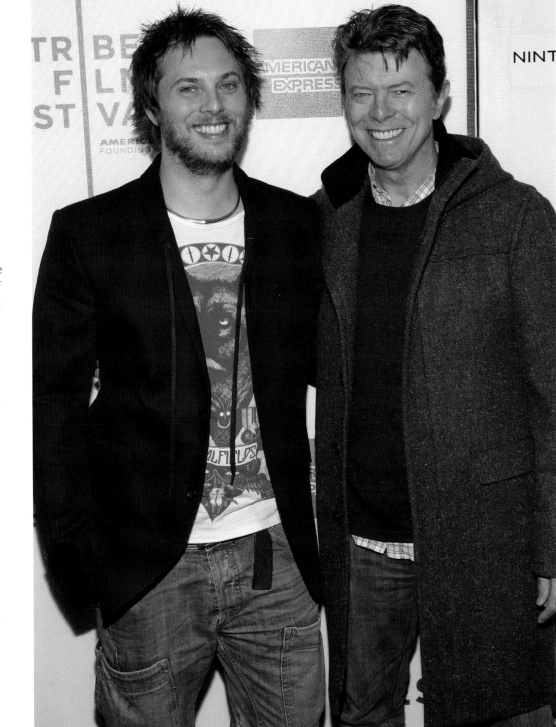

Chronology

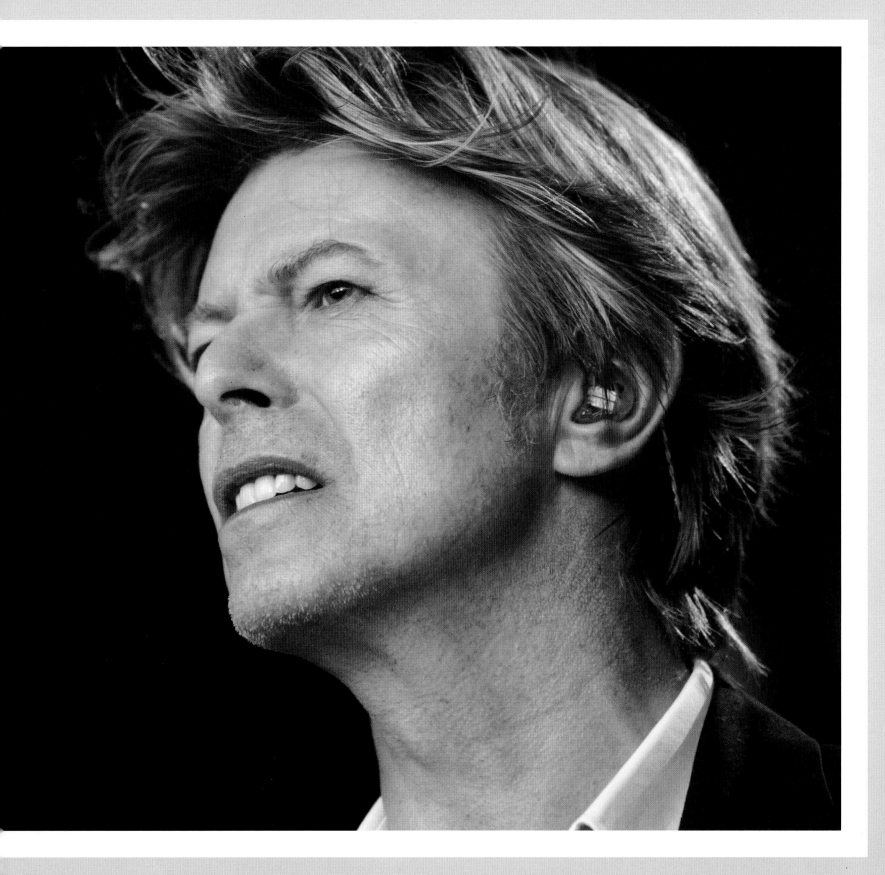

1947

January 8: David Jones born in Brixton, London

1958

August: David and schoolfriend George Underwood perform Lonnie Donegan's "Gambling Man" and "Putting on the Style" during a cub scout trip to the Isle of Wight

1962

February 12: David's eye is damaged in a fight with George Underwood

June: David joins The Konrads, making his debut performance at Bromley Tech's PTA fête on the 16th

1963

May: David takes a Saturday job at Vic Furlong's record shop

July: David leaves school and takes a job as a junior visualiser at the Nevundy-Hurst commercial art studio

August: The Konrads audition for the Rolling Stones' managers Eric Easton and Bob Knight, cutting an acetate of "I Never Dreamed" at Decca Records studios, West Hampstead

Summer: David and George Underwood perform as Dave's Reds & Blues and The Hooker Brothers

December 31: David's last performance with The Konrads at St David's College, West Wickham

1964

January / February: David performs a couple of gigs with The Wranglers, before forming The King Bees with guitarist Roger Bluck, bassist Dave Howard and drummer Robert Allen

April: David signs a management contract with Leslie Conn

May: Conn negotiates a single release with Decca. The King Bees record "Liza Jane" and "Louie, Louie Go Home"

June 6: David makes his television debut, as "Liza Jane" is played on the BBC's *Juke Box Jury*

June 19: The King Bees perform "Liza Jane" on *Ready, Steady, Go!* to be broadcast on the 21st

July: David meets Mark Feld, soon to become Marc Bolan

July 19: David auditions for The Manish Boys, making his first performance with the group at Chicksands US Air Base Leisure Centre, Bedfordshire on the 25th

July 27: Davie Jones And The King Bees performance of "Liza Jane" is broadcast on *The Beat Room* on BBC2

October 6: The Manish Boys record three tracks; "Hello Stranger", "Love Is Strange" and "Duke of Earl" at Regent Sound studios for Decca

November 6: Davie Jones & The Manish Boys perform at the Marquee, where David meets Dana Gillespie, whom he begins dating

Nov 12: David appears on the BBC's *Tonight* programme, as the spokes-man for the Society for the Prevention of Cruelty to Long-haired Men

December 1: Davie Jones & The Manish Boys join a UK package tour opening for Gene Pitney, Gerry & The Pacemakers, Marianne Faithful and The Kinks

1965

January: David's "Take My Tip" is recorded by Kenny Miller

January 15: David and The Manish Boys record "I Pity The Fool" and "Take My Tip" with producer Shel Talmy at IBC Studios

March: release of "I Pity The Fool / Take My Tip", credited to The Manish Boys

March 8: Davie Jones & The Manish Boys perform "I Pity The Fool" on the BBC's *Gadzooks! It's All Happening*

April 24: The Manish Boys final performance

May: David successfully auditions for The Lower Third at La Discothèque, London

June: Davie Jones & The Lower Third make their debut performance at the Happy Towers Ballroom, Edgbaston, Birmingham

July: recording sessions with Shel Talmy at IBC Studios

August: Davy Jones & The Lower Third release the single "You've Got A Habit Of Leaving / Baby Loves That Way"

September: David Bowie & The Lower Third perform at London's 100 Club. This is David's first billing under his new stage name

November: David secures the management services of Ralph Horton, and is signed to Pye by producer Tony Hatch

1966

January: release of "Can't Help Thinking About Me / And I Say To Myself" credited to David Bowie with The Lower Third

January: The Lower Third and David part company

February: David auditions musicians for his new band, selecting guitarist John Hutchinson, bassist Derek Fearnley, drummer John Eager and keyboard player Derek Boyes

February: David Bowie & The Buzz make their debut performance at the Mecca Ballroom, Leicester

March: David Bowie & The Buzz perform "Can't Help Thinking About Me" on *Ready Steady Go!*

April: release of "Do Anything You Say / Good Morning Girl" credited to David Bowie

April: former Manfred Mann manager Ken Pitt sees David and The Buzz perform at the Marquee and agrees to co-manage David with Ralph Horton

May: "Can't Help Thinking About Me / And I say To Myself" released in the US

June 6: "I Dig Everything" demo recorded at Pye Studios, London

June: John Hutchinson leaves The Buzz, to be replaced by 16-year-old Billy Gray on the 25th

August: release of "I Dig Everything / I'm Not Losing Sleep"

November: Sessions for the *David Bowie* LP begin at Decca Studios

December: release of "Rubber Band / The London Boys". David and The Buzz's final performance together at The Severn Club, Shropshire

1967

January: Ralph Horton quits as David's co-manager

January: a version of David's "Over The Wall We Go" is released by Oscar, who would later find fame as the actor Paul Nicholas

March: David performs with The Riot Squad at the Kodak Sports Ground, Harrow, London

April: David and The Riot Squad record "Little Toy Soldier", Silly Boy Blue" and "I'm Waiting For The Man" with engineer Gus Dudgeon at Decca Studios

April: release of "The Laughing Gnome / The Gospel According To Tony Day

June: Deram release *David Bowie* LP

July: release of "Love You Till Tuesday / Did You Ever Have A Dream". Released in the US on August 28

September 1: David's first recording session with producer Tony Visconti at Advision Studio, London

September 13 – 14: Michael Armstrong's silent horror *The Image* filmed in London

November 8: David makes his first TV appearance outside the UK, performing "Love You Till Tuesday" on Dutch show *Fan Club*

December 28: David makes his theatre debut in Lindsay Kemp's *Pierrot in Turquoise* at the Oxford Playhouse

1968

January 31: David's part in the BBC2 play *The Pistol Shot* is recorded at the BBC studios in west London, broadcast May 20 and December 24

March 5: *Pierrot In Turquoise* begins an 11-day run at the Mercury Theatre, Notting Hill Gate, London

March 26: *Pierrot In Turquoise* begins a five-day run at the Intimate Theatre

August: David forms music and mime act Turquoise with *Pistol Shot* co-star Hermione Farthingale and guitarist Tony Hill

September 14: Turquoise perform at The Roundhouse, Camden, London. David meets Angela Barnett for the first time

October: Tony Hill leaves Turquoise, David reforms the group as Feathers with the addition of John 'Hutch' Hutchinson from The Buzz

October 29 – November 4: David spends a week as an extra in *The Virgin Soldiers*, filmed at Twickenham Film Studios

November 17: Feathers first performance at London venue The Country Club

1969

January 22: David appear in a Lyons Maid ice cream commercial directed by Ridley Scott

January 26–February 7: fiming of promotional video showcase *Love You Till Tuesday*, includes the original recording of "Space Oddity" at Morgan Studios

February 11: following Hermione's departure, David Bowie & Hutch make their debut as a duet at Sussex University

February 15 – March 8: David tours in support of Tyrannosaurus Rex, performing a solo mime show

April 10: David begins dating Angela Barnett

May 4: David launches the Beckenham Arts Lab at The Three Tuns in Beckenham

June 20: David records new version of "Space Oddity", and signs new record deal with Mercury Records

July 11: Release of "Space Oddity / Wild Eyed Boy From Freecloud"

July 16: Sessions begin for David's second LP at Trident Studios

August 2: David wins an award for best-produced record at the Festival Internazionale del Disco in Tuscany

August 5: David's father, John Jones, dies of pneumonia at home in Bromley, aged just 57

October 2: David records his first appearance for *Top of the Pops*, broadcast on the 9th

Otober 8 – 26: David joins the Changes '69 tour in support of Humble Pie. The group features David's schoolmate, guitarist Peter Frampton

November 7–15: David embarks on his first headlining tour in Scotland, backed by Junior's Eyes

November 14: release of second LP, also entitled *David Bowie*

1970

January 7: David records "The Prettiest Star" at London's Trident Studios, featuring a guitar solo by Marc Bolan

Febraury 1: *Pierrot in Turquoise* Or *The Looking Glass Murders* filmed for Scottish television, broadcast July 8

February 3: David's last gig with Junior's Eyes at the Marquee, where he meets guitarist Mick Ronson

February 5: Ronson performs with David for the first time, recording a BBC radio session for DJ John Peel

February 22: David's new band, consisting of Tony Visconti on bass, John Cambridge on drums, and Mick Ronson on guitar, make their live debut at London's Roundhouse. From March 1, they will be billed as David Bowie & Hype

March 6: release of "The Prettiest Star / Conversation Piece"

March 20: David and Angela Barnett are married at Bromley Register Office

April: drummer John Cambridge is replaced by Mick "Woody" Woodmansey. David also informs Ken Pitt that his services are no longer required

May 10: David is presented with an Ivor Novello Award for "Space Oddity" in London

Summer: David formally signs with Tony Defries' Gem Management

June 26: release of "Memory Of A Free Festival Pt 1 / Memory Of A Free Festival Pt 2"

November 4: *The Man Who Sold The World* LP released in US

1971

January 15: release of "Holy Holy / Black Country Rock"

January 23–February 18: David makes a promotional trip to the US

March 26: Peter Noone record's David's "Oh! You Pretty Things", with David on piano, released April 30

April 10: UK release of *The Man Who Sold The World* LP

May 7: release of "Moonage Daydream / Hang On To Yourself" by David's side project, the Arnold Corns

May 30: birth of David and Angela's son, Duncan Zowie Haywood Jones

June 3: bassist Trevor Bolder makes his debut alongside David for John Peel's BBC radio show *In Concert*

June 20: David and Mick Ronson perform at the Glastonbury Fayre

September 9: David signs a deal with RCA in the US

December 4: *Hunky Dory* LP released in US, December 17 in UK

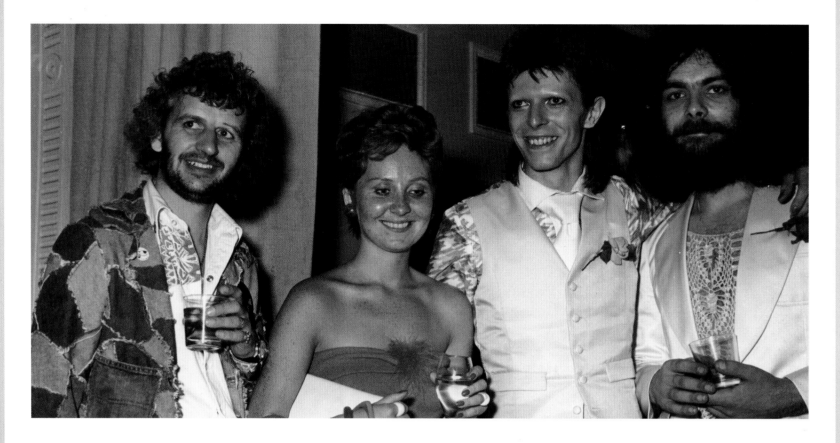

1972

January 7: release of "Changes / Andy Warhol"

January 29: David makes his live debut as Ziggy Stardust at the Borough Assembly Rooms, Aylesbury

February 8: David and his band perform on the BBC rock show, *The Old Grey Whistle Test*

February 10: the Ziggy Stardust Tour launches at the Toby Jug in Tolworth, Surrey

March 17: David's first meeting with Mick Rock, who will soon become Bowie's official photographer

April 9: David joins Mott The Hoople onstage at Guildford Civic Centre, Surrey, for an encore of "All The Young Dudes"

April 28: UK release of "Starman /

Suffragette City", released May 20 in US

June: release of *The Rise And Fall of Ziggy Stardust and the Spiders From Mars* LP

June 21: children's show *Lift Off With Ayshea* broadcasts a performance of "Starman". The Spiders From Mars receive their first billing at Dunstable Civic Hall

July 6: David and the Spiders perform "Starman" on *Top of the Pops*

July 8: Lou Reed makes his debut UK appearance as David's guest at the Royal Festival Hall, London

July 28: Mott The Hoople release "All The Young Dudes", written by David

July 29: "Starman" peaks at number 10 in the UK, providing David with his first hit

September 1: UK release of "John I'm Only Dancing"

September 8: release of Mott The Hoople's *All The Young Dudes* LP, produced by David and Mick Ronson

September 22: David Bowie & The Spiders From Mars give their first performance in the US at the Music Hall, Cleveland, Ohio. Mike Garson joins the band as pianist

November 8: release of Lou Reed's *Transformer* LP, produced by David and Mick Ronson

November 10: David's self-titled 1969 LP is reissued by RCA as *Space Oddity*

November 24: release of "The Jean Genie / Ziggy Stardust"

December 13: release of "Space Oddity / The Man Who Sold The World" in the US

1973

January 13: "The Jean Genie" peaks at number two in the UK

April 6: release of "Drive-In Saturday / Round And Round"

April 8: David Bowie & The Spiders From Mars make their Japanese debut in Tokyo

April 13: *Aladdin Sane* LP released in the UK

May 5: "Drive-In Saturday" peaks at number three in the UK, while *Aladdin Sane* debuts at number one

June 1: US release of "Time / The Prettiest Star"

June 22: UK release of "Life On Mars? / The Man Who Sold The World"

July 3: The Ziggy Stardust Tour ends at London's Hammersmith Odeon,

with David announcing, "Not only is this the last show of the tour, but it's the last show we'll ever do". Footage of the performance will eventually be released as *Ziggy Stardust and the Spiders from Mars: The Motion Picture*

July 14: "Life On Mars?" peaks at number three

September 7: Decca reissues "The Laughing Gnome / The Gospel According To Tony Day", which peaks at number six in the UK on October 13

October 12: release of "Sorrow / Amsterdam"

October 18–20: filming of The 1980 Floor Show for NBC's *Midnight Special*, to be broadcast in the US on November 16, marking the final performance for Ziggy Stardust & The Spiders From Mars

October 19: release of *Pin Ups* LP

November 3: "Sorrow" peaks at number three in the UK

1974

January 8: on David's 27th birthday, he and George Underwood go to see Fritz Lang's *Metropolis*, which will prove to be a major influence on David's *Diamond Dogs*

January 11: Lulu releases her version of David's "The Man Who Sold The World"

February 13: in Amsterdam, David is presented with the Edison award for most popular male vocalist

February 15: release of "Rebel Rebel / Queen Bitch"

March 2: "Rebel Rebel" peaks at number five in the UK

March 29: David leaves the UK, ultimately bound for New York, where he will take up residence

April 11: release of "Rock 'n' Roll Suicide / Quicksand"

April – May: David assembles a new band, with Mike Garson, Herbie Flowers and Tony Newman being joined by keyboard player and musical director Michael Kamen, guitarist Earl Slick and saxophonist David Sanborn

May 31: release of *Diamond Dogs* LP

June 14: release of "Diamond Dogs / Holy Holy" single, and the launch of The Diamond Dogs Tour, at the Forum in Montreal, Canada

October 5: tour relaunched as The Philly Dogs or Soul Tour

December 1: tour concludes at The Omni Arena, Atlanta

1975

January: David records "Fame" and "Across The Universe" with John Lennon in New York

January 26: BBC2 screens Alan Yentob's *Cracked Actor* documentary, shot during the previous US tour

February: David meets with English film director Nicholas Roeg in New York to discuss the possibility of starring in a film production of Walter Tevis' 1963 cult sci fi novel, *The Man Who Fell To Earth*

February 21: release of "Young Americans" single, which will prove to be a breakthrough hit in the US

March 1: David presents Aretha Franklin with the Grammy Award for "Best Rhythm & Blues Performance by a Female Artist"

March 7: release of *Young Americans* LP

March: David files a lawsuit against Tony Defries MainMan organisation, wishing to extricate himself from their employment, and to bring an end to all contractual obligations while also seeking damages

May: David relocates to Los Angeles, residing with Deep Purple bassist Glenn Hughes, before moving in with lawer and acting-manager Michael Lippman

July 6: filming for *The Man Who Fell To Earth* begins in New Mexico

July 25: release of "Fame / Right", which will provide David with his first number one single, when it tops the US charts in September

September 26: UK release of "Space Oddity / Changes / Velvet Goldmine", which will provide David with his first UK number one single

November 17 / 21: release of "Golden Years / Can You Hear Me"

1976

January: David fires Michael Lippman, going on to file a lawsuit against him

January 23: release of *Station to Station* LP

February 2: David launches The Isolar Tour at the Pacific Coliseum, Vancouver, Canada

March 18: premiere of *The Man Who Fell To Earth* at the Leicester Square Theatre, London, Angela Bowie attends in David's absence

March 20: David and Iggy Pop are arrested on suspicion of marijuana possession after a show in Rochester, New York. Five days later the case is adjourned for a year and eventually dropped

April 2: David and Iggy Pop are stopped at the Russian-Finnish border and biographies of Josef Goebbels and Albert Speer are confiscated

May 2: David returns to the UK, to be greeted by a welcoming committee at London's Victoria Station. It is alleged that he gives a Nazi salute to the assembled fans, which he vehemently denies in the press

May 20: release of compilation LP *Changesonebowie*. The album features a portrait of David by photographer Tom Kelley, best known for the nude shot of Marilyn Monroe that appeared in the first ever *Playboy*

June: David and his family move into his new home in Switzerland

July 9: release of "Suffragette City / Stay" in the UK

July: release of "Stay / Word On A Wing" in the US

September: David relocates to West Berlin with Iggy Pop

November 10: David is rushed to hospital suffering from a suspected heart attack, but is later diagnosed as suffering with exhaustion

December: David is awarded the Best Actor Of The Year award for *The Man Who Fell To Earth*, by the US Academy of Science Fiction, Fantasy & Horror Films

1977

January 14: release of *Low* LP

February 11: release of "Sound And Vision / A New Career In A New Town"

March 1–April 16: David joins Iggy Pop's The Idiot Tour, playing keyboards

March 18: release of Iggy Pop's *The Idiot* LP, co-written and recorded with David

June 17: release of "Be My Wife / Speed Of Life"

August 29: release of Iggy Pop's *Lust For Life* LP, co-written and recorded with David

September 9th: performances of ""Heroes"" and "Sleeping / Standing Next to You" are filmed for Granada TV's *Marc*, featuring Marc Bolan

September 11: David records ""Heroes"" and a duet of "Peace on Earth / Little Drummer Boy" with Bing Crosby for his *Merrie Olde Christmas* TV special, broadcast on November 30 in the US

September 20: David and Tony Visconti attend Marc Bolan's funeral at The Chapel, Golders Green, London

September 23: release of ""Heroes" / V-2 Schneider"

October 14: *"Heroes"* LP released

October 19: David appears on *Top of the Pops* with Tony Visconti to perform ""Heroes"". It is his first appearance on the show since 1972

December: David records the narration for a version of Prokofiev's *Peter and the Wolf*, recorded by the Philadelphia Symphony Orchestra and conducted by Eugene Ormandy

December 24: Bing Crosby's *Merrie Olde Christmas* TV special broadcast in the UK

1978

January: Angela Bowie overdoses on drugs in an apparent suicide attempt, due to the breakdown of her marriage

January 6: release of "Beauty and the Beast / Sense of Doubt"

January – February: filming of David Hemmings' *Just A Gigolo* in Berlin

March 29: the Isolar II or Stage

Tour launches at the San Diego Sports Arena, California

May 12: release of *David Bowie Narrates Prokofiev's Peter and the Wolf* LP, and Iggy Pop's *TV Eye* live LP, featuring David on four tracks

September: Decca re-release The King Bees' "Liza Jane"

September 8: release of live LP *Stage*

November 11: David's first performance in Australia, at the Adelaide Oval

November 17: release of "Breaking Glass / Art Decade / Ziggy Stardust"

December 12: the Isolar II Tour concludes in Tokyo, Japan

1979

February 14: Premiere of *Just a Gigolo* at the Prince Charles cinema, Leicester Square, London. David attends dressed in a kimono

March: performance of *Sabotage* with John Cale, Philip Glass and Steve Reich at New York's Carnegie Hall

April 27: release of "Boys Keep Swinging / Fantastic Voyage" in UK

May 18: release of *Lodger* LP

June 29: release of "DJ / Repetition" in UK

June: "Yassassin / Repetition" released in Holland and Turkey

August 20: "Look Back In Anger / Repetition" released in US

August 31 D. A. Pennebaker's film of Ziggy's retirement concert from 1973 is premiered as *Bowie '73* at the Edinburgh Film Festival

November: "John I'm Only Dancing (Again) / Golden Years" released in US

December 7: "John I'm Only Dancing (Again) / John I'm Only Dancing (1972)" released in UK

December 15: David performs "The Man Who Sold The World", "TVC15" and "Boys Keep Swinging" for an appearance on NBC's *Saturday Night Live*, to be broadcast January 5, 1980. His band is augmented by Jimmy Destri from Blondie and the vocalist and performance artist Klaus Nomi

December 31: a new version of "Space Oddity" is broadcast on Kenny Everett's New Year's Eve Show in the UK

1980

February 8: David and Angela are divorced, with David winning custody of his son

February 15: release of "Alabama Song / Space Oddity"

February / March: release of "Crystal Japan / Alabama Song" in Japan, taken from Japanese commercial for Crystal Jun Rock saki

April 27: David guests on two tracks with Iggy Pop at the Nollendorf Metropol, Berlin

May: video shoot for "Ashes To Ashes" at Hastings and Beachy Head, England

June: David visits the museum dedicated to John Merrick (the Elephant Man) at the London Hospital

July 29–August 3: David plays the lead in the stage adaptation of *The Elephant Man* at the Denver Center of Performing Arts

August 8: release of "Ashes to Ashes / Move On"

August 5–31: *The Elephant Man* relocates to the Blackstone Theater, Chicago

September 12: release of *Scary Monsters (and Super Creeps)* LP

September 23: *The Elephant Man* moves to the Booth Theater on New York's Broadway

October: David films a cameo appearance for Herman Weigel's *Christiane F.*

October 24: release of "Fashion / Scream Like A Baby"

1981

January 2: release of "Scary Monsters (and Super Creeps) / Because You're Young" single

January 3: David's Broadway role as *The Elephant Man* comes to an end

February 24: Lulu presents David with the award for Best Male Singer at the *Daily Mirror*'s Rock and Pop Awards

March: release of "Up The Hill Backwards / Crystal Japan"

April: release of *Christiane F.* soundtrack

August: David stars in a BBC TV production of Berthold Brecht's *Baal*

October 26: Queen release "Under Pressure", co-written and performed by David

November 1981: release of compilation LP, *Changestwobowie*, and single "Wild Is The Wind / Golden Years"

1982

February 13: release of David Bowie in Berthold Brecht's *Baal* EP

March: release of "Cat People (Putting Out Fire)"

March 1: David begins filming his role in *The Hunger*

September: David films his role in *Merry Christmas Mr Lawrence*

October: release of "Peace on Earth / Little Drummer Boy"

November: release of the limited edition singles picture disc box set *Fashions*

December: release of compilation album, *Bowie Rare*

1983

January: David films an uncredited cameo role as the shark in Graham Chapman's comedy movie *Yellowbeard*

March 17: release of "Let's Dance / Cat People (Putting Out Fire)"

April 14: release of *Let's Dance* LP

May: release of "China Girl / Shake It"

May 10: premiere of *Merry Christmas Mr Lawrence* at the Cannes Film Festival

May 18: The Serious Moonlight Tour begins at the Vorst Forest Nationaal, in Brussels, Belgium

May 30: David performs at the US Festival, Glen Helen Regional Park, San Bernadino, Californiar

August 25: *Merry Christmas Mr Lawrence* released in the UK, one day earlier than in the US

September: release of "Modern Love / Modern Love (Live)"

September 4: Mick Ronson joins David as a special guest at the Canadian National Exhibition Stadium, Toronto, Canada

October: release of live album, *Ziggy Stardust: The Motion Picture*

November 26: The Serious Moonlight Tour concludes in Auckland New Zealand

December 3–8: the "Bungle In The Jungle" tour of South-East Asia

December 23: David introduces Raymond Briggs' *The Snowman* on Channel 4

1984

May: release of the 1969 promotional film, *Love You Till Tuesday*

August: filming of Julien Temple's epic "Jazzin' for Blue Jean" promo, to be released as a short feature in cinemas supporting Neil Jordan's *The Company Of Wolves*

September: release of "Blue Jean / Dancing With The Big Boys"

September 1: release of *Tonight* LP

September 14: Iggy Pop collects an award for "China Girl" on David's behalf, at the MTV Awards, Radio City Music Hall, New York

November: release of single "Tonight / Tumble And Twirl", featuring Tina Turner

December: David records a message for the B-side of "Do They Know It's Christmas"

1985

January: David's half-brother Terry Burns commits suicide close to Cane Hill Hospital, where he had been a long-term resident

February: release of John Landis' *Into The Night*, featuring a cameo appearance from David as the hitman Colin Morris

February: release of "This Is Not America / This Is Not America (Instrumental)", a song from the John Schlesinger movie, *The Falcon and the Snowman*

March 23: David joins Tina Turner onstage at the Birmingham NEC to perform "Tonight" and "Let's Dance" (as a medley incorporating the Chris Montez song of the same name)

May: release of "Loving The Alien / Don't look Down"

June: David and Mick Jagger record "Dancing In The Street" and shoot an accompanying video in London

July 13: David appears at Live Aid at Wembley Stadium, where the video for "Dancing In The Street" is also screened

July – August: filming of *Absolute Beginners* at Shepperton Studios

August: release of "Dancing In the Street"

Autumn: filming of Jim Henson's *Labyrinth* at Elstree Studios

November 19: David gives an impromptu performance in New York, joining Ronnie Wood, Iggy Pop and Stevie Winwood onstage at the China Club

1986

March: release of "Absolute Beginners" single

April 2: premiere of *Absolute Beginners* movie in London

June 20: Bowie and Jagger perform "Dancing In the Street" for the Prince's Trust concert at Wembley Arena

June: release of "Underground" from *Labyrinth*, and "When The Wind Blows", from the animated film of the same name

June 23: *Labyrinth* soundtrack LP released

June 27: the movie *Labyrinth* premieres in the US

October 23: release of Iggy Pop's *Blah Blah Blah* LP, written and recorded in collaboration with David

November 28: UK release of the movie *Labyrinth*

1987

March: release of single "Day-In Day-Out / Julie"

March 17–30: press tour promoting the LP *Never Let Me Down*

April 27: release of *Never Let Me Down* LP

May: David films a Pepsi commercial with Tina Turner in Amsterdam

May 30: David launches The Glass Spider Tour at Stadion Feyenord, Rotterdam

June: release of "Time Will Crawl / Girls"

August: release of "Never Let Me Down / 87 And Cry"

November 28: The Glass Spider Tour concludes at Western Springs Stadium, Auckland, New Zealand

December: David films his role as Pontius Pilate for Martin Scorsese's *The Last Temptation of Christ*, in Morocco

1988

July 1: David and guitarist Reeves Gabrels perform a new version of "Look Back In Anger" at the Intruders At The Palace benefit concert, London

August: formation of Tin Machine, with Reeves Gabrels, and the Sales brothers, Hunt and Tony

September 10: performance of "Look Back In Anger" broadcast from New York as part of

multimedia artist Nam June Paik's *Wrap Around The World* satellite broadcast

1989

May 22: release of *Tin Machine* LP

May 31: Tin Machine perform "Heaven's In Here" at the Coca-Cola International Music Awards, The Armory, New York

June: release of "Under The God / Sacrifice Yourself"

June 14 – July 3: The Tin Machine Tour

September: release of "Tin Machine / Maggie's Farm"

October: release of "Prisoner Of Love / Baby Can Dance"

November: Tin Machine perform a one-off gig at Moby Dick's, Sydney, Australia

1990

March: release of "Fame '90"

March 4: The Sound + Vision Tour opens at the Colisee, Quebec, Canada

September 29: The Sound + Vision Tour concludes at the River Plate Stadium, Buenos Aires, Argentina

October: David meets the supermodel Iman Mohamed Abdulmajid and the couple soon begin a relationship

November–December: filming of *The Linguini Incident*, which also features Iman

1991

February 6: David makes a guest appearance with Morrisey at the Inglewood Forum, Los Angeles

April: David films his role as Sir

Roland Moorecock for an episode of the TV series *Dream On*

Summer: David films his role as Phillip Jeffries for David Lynch's *Twin Peaks: Fire Walk With Me*

August: release of "You Belong In Rock 'n' Roll / Ampalura (Indonesian version)"

August 16: Tin Machine play a warm up show at the Baggot Inn, Dublin, Ireland

August 19: Tin Machine play a warm up show at the Waterfront Rock Café, Dublin, Ireland

August 25: Tin Machine play a press show at Rockit Cargo LAX, Los Angeles

October: release of "Baby Universal" single

October 5: Tin Machine launch their It's My Life Tour at the Teatro Smeraldo, Milan, Italy

1992

February 17: Tin Machine's It's My Life Tour concludes at the Budokan Hall, Tokyo, Japan

April 20: David performs at the Freddie Mercury Tribute Concert at Wembley Stadium, backed by Queen, and joined by Annie Lennox, Mick Ronson and Mott The Hoople's Ian Hunter

July 27: release of live album, *Tin Machine Live: Oy Vey, Baby*

August: release of "Real Cool World"

1993

January 5: David appears in a cameo role in the ITV comedy series *Full Stretch*

March: release of single "Jump They Say"

April 5: release of *Black Tie White Noise* LP

June: release of "Black Tie White Noise" single

October: release of "Miracle Goodnight / Looking For Lester"

November: release of *The Buddha Of Suburbia* soundtrack LP, and the single of the same name, featuring Lenny Kravitz

December: David co-hosts the Concert of Hope AIDS benefit at Wembley Arena

1994

April: release of live album, *Santa Monica '72*. A live version of "Ziggy Stardust" from the album is also released as a single

1995

April: David mounts an art exhibition at London's Cork Street Gallery, entitled, New Afro/Pagan and Work 1975 – 1995

Summer: David films the role of Andy Warhol in Julian Schnabel's biopic *Basquiat*

June: release of compilation album *RarestOneBowie*

September: release of "The Heart's Filthy Lesson" single

September 14: The Outside Tour begins at Meadows Amphitheater, Hartford, Connecticut

September 25: release of *1.Outside* album

November: release of "Strangers When We Meet / The Man Who Sold The World (Live)"

November 23: performance of "The Man Who Sold The World" at MTV's European Music Awards

1996

January: Release of "Hello Spaceboy" single

January 17: David is inducted into the Rock and Roll Hall of Fame

February 19: David performs "Hallo Spaceboy" (with the Pet Shop boys), "Moonage Daydream" and "Under Pressure" at the Brit Awards, at London's Earls Court, and is presented with the award for "Outstanding Contribution"

February 20: final date of The Outside Tour in Paris

June 4–July 21: The Outside Summer Festivals Tour

September 6–14: series of US dates, referred to as the "East Coast Ballroom Tour"

October 19 and 20: The Bridge School benefit concerts at the Shoreline Amphitheater, Mountain View, California

October: performance at the VH1 Fashion Awards

November 4: release of "Telling Lies" single

1997

January 9: David Bowie and Friends – A Very Special Birthday Concert takes place at New York's Madison Square Garden to celebrate David's 50th birthday the previous day

January 27: release of "Little Wonder" single

February 3: release of *Earthling* LP

February 12: David unveils his star on the Hollywood Walk of Fame

March 21: release of "Dead Man Walking" single

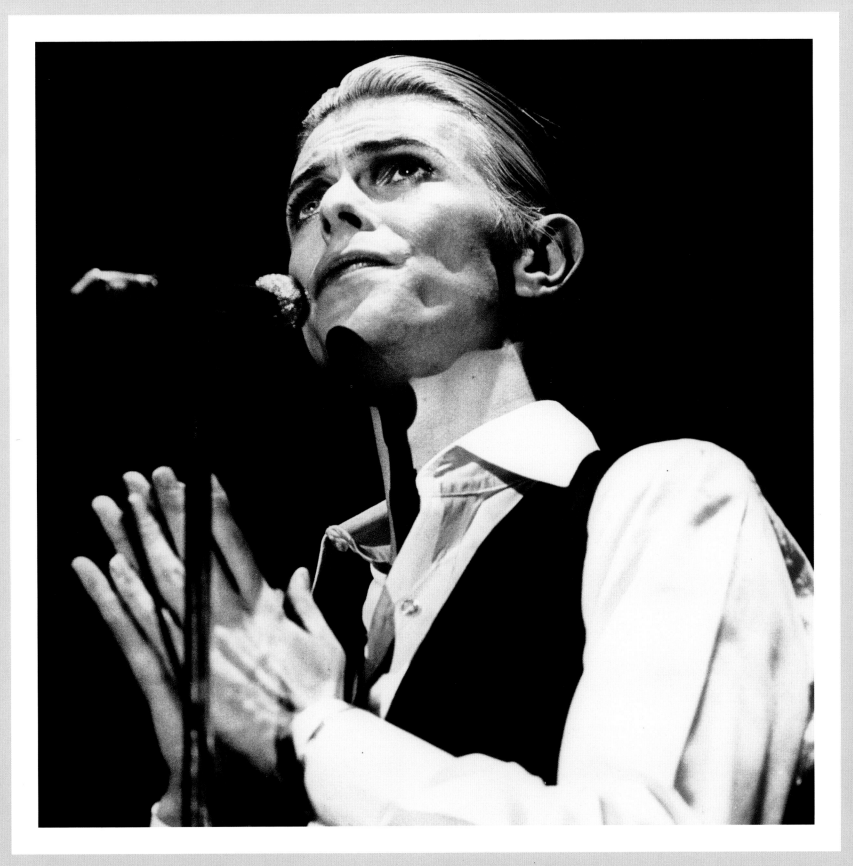

June 7: The Earthling Tour begins at the Flughafen Blankense, Lubeck, Germany

August 18: release of "Seven Years In Tibet" single

August 26: release of "Pallas Athena / V-2 Schneider (live)" under the pseudonym, The Tao Jones Index

October 14 release of "I'm Afraid Of Americans" single

November 7: last date of The Earthling Tour in Buenos Aires, Argentina

December: release of a new version of Tin Machine's "I Can't Read", as featured in the movie *The Ice Storm*

1998

January 29: David performs at Howard Stern's birthday party at the Hammersmith Ballroom, New York

February 21: David begins filming *Everybody Loves Sunshine*

June: filming of *Il Mio West* in Italy

July: filming of *Mr Rice's Secret* in Canada

September 1: David launches BowieNet in the US

1999

February 16: David performs "20th Century Boy" with Placebo at the Brit Awards, held at London's Docklands Arena

March: David films his role for the TV series *The Hunger: Sanctuary*

March 12: Comic Relief appearance on UK TV

March 29: David joins Placebo on stage at the Irving Plaza, New York

May 8: David receives an honorary doctorate from Berklee College of Music, Hynes Convention Center, Boston

August 23: David performs a set for *VH1 Storytellers*

August – December: a series of live appearances, comprising the "hours..." promotional tour

September 9: David introduces Lauryn Hill at the MTV Music Video Awards, Metropolitan Opera House, New York

September 20: release of singles "Thursday's Child" and "The Pretty Things Are Going To Hell"

September 26: David introduces Eurythmics on NBC's *Saturday Night Live 25 Year Special*

October 28: David performs "Thursday's Child", and is presented with the Legend Award at the inaugural WB Music Awards in Las Vegas

2000

January 18: release of "Survive" single

June 16 and 19: David performs at New York's Roseland Ballroom

June 25: David performs at the Glastonbury Festival

June 27: BBC *Concert* recorded at Broadcasting House

July 17: release of "Seven" single

July 24: Yahoo! Internet Life Online Music Awards (live Webcast)

August 15: birth of David and Iman's daughter, Alexandria Zahra Jones

October: David films a cameo role in the movie *Zoolander*

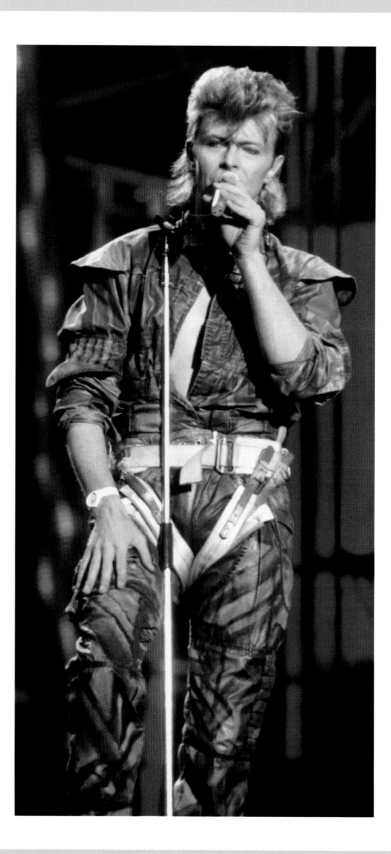

2001

February: films interview for Eric Idle's *Rutles 2: Can't Buy Me Lunch*

February 26: David performs at the Tibet House Benefit Concert, Carnegie Hall, New York

October 20: David opens The Concert For New York City, Madison Square Garden, New York

2002

February 22: David performs at the Tibet House Benefit Concert, Carnegie Hall, New York

May 10: performance at the MTV Tribeca Film Festival, Battery Park City, New York

May 30: David performs at the Robin Hood Foundation charity auction, Javits Center, New York

June 3:, release of "Slow Burn" single

June 10:, release of *Heathen* LP

June 11: performance at Roseland Ballroom, New York, for BowieNet members

June 14:David performs at NBC *Today Show*'s 7th Annual Summer Concert Series, Rockerfeller Plaza, New York

June 29:, The Heathen Tour launches at the Meltdown Festival, Royal Festival Hall, London

September 3: David receives the "Outstanding Achievement" prize at the *GQ* Men Of The Year Awards, Natural History Museum, London

September 16:, release of "Everyone Says 'Hi'" Single

October 15: David performs at the VH1 / Vogue Fashion Awards, Radio City Music Hall, New York

October 23: The Heathen Tour concludes at the Orpheum Theater, Boston

November 4: release of compilation album, *Best Of Bowie*. A DVD of the same name is released on the 11th

November 12: release of "I've Been Waiting for You" single

2003

February 28: David performs at the Tibet House Benefit Concert, Carnegie Hall, New York

March 24: release of LP and DVD *Ziggy Stardust And The Spiders From Mars: The Motion Picture* (new mix by Tony Visconti)

September 8: *BowieNet* show at London's Riverside Studios is transmitted to cinemas worldwide

September 15: release of *Reality* LP

September 18: David performs at NBC *Today Show*'s Annual Summer Concert Series, Rockerfeller Plaza, New York

September 29: release of "New Killer Star" single

October 7: first show of David's A Reality Tour, at the Forum, Copenhagen, Denmark

October 15: performance of "Fashion" transmitted from Rotterdam to the "Fashion Rocks charity show at the Royal Albert Hall, london

November 17: release of *Reality* (Tour Edition) LP

December: promotional performance, Paradise Island, Bahamas

2004

February: release of "Never Get Old / Love Missile F1-11" in Japan

June 25: final show of A Reality Tour, at the Hurricane Festival, Germany (further dates cancelled due to illness)

2005

May 3: release of compilation album *The Collection*

September 8: David and Mike Garson perform "Life On Mars?" at Fashion Rocks, Radio City Music Hall, New York, following which David joins Arcade Fire onstage to perform "Five Years", and "Wake Up"

September 15: David joins Arcade Fire onstage at Central Park Summerstage, New York, for renditions of "Queen Bitch" and "Wake Up"

November 7: release of compilation album, *The Platinum Collection*

2006

March: David films his role as Nikola Tesla in Christopher Nolan's *The Prestige*

May 29: David joins David Gilmour onstage at the Royal Albert Hall, London, for encore performances of "Arnold Layne" and "Comfortably Numb"

September 21: David features in an episode of Ricky Gervais' comedy series *Extras* (filmed in June)

November 10: David performs with Alicia Keys at the Black Ball charity event in New York

December 26: release of David Gilmour's live single "Arnold Layne", featuring David Bowie

2007

March 19: release of compilation album *The Best of David Bowie 1980/1987*

May: David curates the inaugural High Line Festival in New York

2008

May 16: release of Scarlett Johansson's album, *Anywhere I Lay My Head*, featuring David on two tracks

June 29: release of compilation album *iSelectBowie*, distributed with *The Mail On Sunday*

June 30: release of live album, *Live Santa Monica '72*

October 14:, *iSelectBowie* released in North America

October 23: release of live album, *Glass Spider Live*

2009

January 22: premiere of *August* at the Sundance Film Festival, featuring David as Cyrus Ogilvie

July 6: release of live album, *VH1 Storytellers*

July 20: release of *Space Oddity* EP

2010

January 26: release of live album *A Reality Tour*

Discography

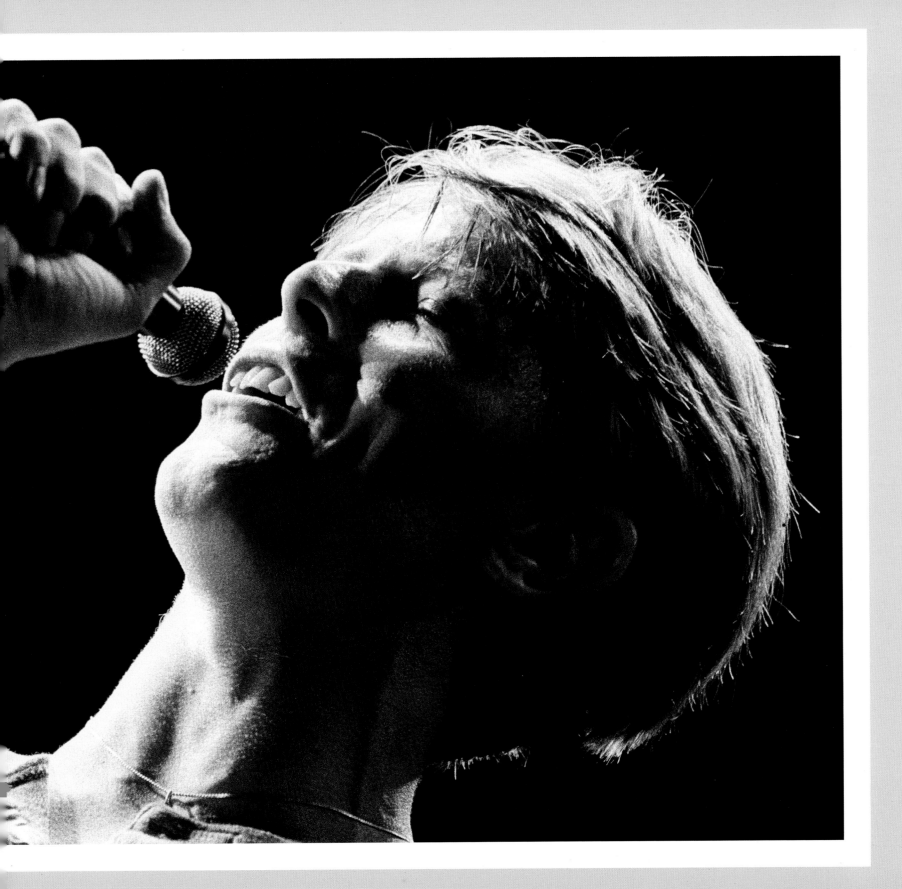

ALBUMS

1967

DAVID BOWIE

Deram: Mike Vernon. All songs written by David Bowie.

Side One

1. "Uncle Arthur" – 2:07
2. "Sell Me a Coat" – 2:58
3. "Rubber Band" – 2:17
4. "Love You Till Tuesday" – 3:09
5. "There Is a Happy Land" – 3:11
6. "We Are Hungry Men" – 2:58
7. "When I Live My Dream" – 3:22

Side two

1. "Little Bombardier" – 3:24
2. "Silly Boy Blue" – 4:36
3. "Come and Buy My Toys" – 2:07
4. "Join the Gang" – 2:17
5. "She's Got Medals" – 2:23
6. "Maid of Bond Street" – 1:43
7. "Please Mr. Gravedigger" – 2:35

1969

SPACE ODDITY

Philips, Mercury (US): Tony Visconti. All songs written by David Bowie.

Side One

1. "Space Oddity" – 5:15
2. "Unwashed and Somewhat Slightly Dazed" – 6:55
3. "(Don't Sit Down)" ✧ – 0:39
4. "Letter to Hermione" – 2:28
5. "Cygnet Committee" – 9:33

Side two

1. "Janine" – 3:18
2. "An Occasional Dream" – 2:51
3. "Wild Eyed Boy From Freecloud" – 4:45
4. "God Knows I'm Good" – 3:13
5. "Memory of a Free Festival" – 7:05

1970

THE MAN WHO SOLD THE WORLD

Mercury (US), RCA: Tony Visconti. All songs written by David Bowie except as noted.

Side One

1. "The Width of a Circle" - 8:05
2. "All the Madmen" - 5:38
3. "Black Country Rock" - 3:32
4. "After All" - 3:31

Side two

1. "Running Gun Blues" - 3:11
2. "Saviour Machine" - 4:25
3. "She Shook Me Cold" - 4:13
4. "The Man Who Sold the World" - 3:55
5. "The Supermen" - 3.38

1971

HUNKY DORY

RCA: Ken Scott, David Bowie. All songs by David Bowie except as noted.

Side One

1. "Changes" - 3:37
2. "Oh! You Pretty Things" - 3:12
3. "Eight Line Poem" - 2:55
4. "Life on Mars?" - 3:53
5. "Kooks" - 2:53
6. "Quicksand" - 5:08

Side two

1. "Fill Your Heart (Biff Rose and Paul Williams) - 3:07
2. "Andy Warhol" - 3:56
3. "Song for Bob Dylan" - 4:12
4. "Queen Bitch" - 3:19
5. "The Bewlay Brothers" - 5:17

1972

THE RISE AND FALL OF ZIGGY STARDUST AND THE SPIDERS FROM MARS

RCA: David Bowie, Ken Scott. All songs written by David Bowie except as noted.

Side One

1. "Five Years" - 4:44
2. "Soul Love" - 3:33
3. "Moonage Daydream" - 4:35
4. "Starman" - 4:13
5. "It Ain't Easy" (Ron Davies) - 3:00

Side two

1. "Lady Stardust" - 3:20
2. "Star" - 2:50
3. "Hang on to Yourself" - 2:40
4. "Ziggy Stardust" - 3:13
5. "Suffragette City" - 3:25
6. "Rock 'n' Roll Suicide" - 3:00

1973

ALADDIN SANE

RCA: Ken Scott, David Bowie. All songs written by David Bowie except as noted.

Side One

1. "Watch That Man" - 4:30
2. "Aladdin Sane (1913-1938-197?)" - 5:06
3. "Drive-In Saturday" - 4:33
4. "Panic in Detroit" - 4:25
5. "Cracked Actor" - 3:01

Side two

1. "Time" - 5:15
2. "The Prettiest Star" - 3:31
3. "Let's Spend the Night Together" (Mick Jagger and Keith Richards) - 3:10
4. "The Jean Genie" - 4:07
5. "Lady Grinning Soul" - 3:54

1973

PIN UPS

RCA: Ken Scott, David Bowie

Side One

1. "Rosalyn" - original by The Pretty Things (Jimmy Duncan, Bill Farley) - 2:27
2. "Here Comes the Night" - original by Them (Bert Berns) - 3:09
3. "I Wish You Would" - original by The Yardbirds (Billy Boy Arnold) - 2:40
4. "See Emily Play" - original by Pink Floyd (Syd Barrett) - 4:03
5. "Everything's Alright" - original by The Mojos (Nicky Crouch, John Konrad, Simon Stavely, Stuart James, Keith Karlson) - 2:26
6. "I Can't Explain" - original by The Who (Pete Townshend) - 2:07

Side two

1. "Friday on My Mind" - original by The Easybeats (George Young, Harry Vanda) - 3:18
2. "Sorrow" - original by The McCoys (Feldman, Goldstein, Gottehrer, The Strangeloves) - 2:48
3. "Don't Bring Me Down" - original by The Pretty Things (Johnny Dee) - 2:01
4. "Shapes of Things" - original by The Yardbirds (Paul Samwell-Smith, Jim McCarty, Keith Relf) - 02:47
5. "Anyway, Anyhow, Anywhere" - original by The Who (Pete Townshend, Roger Daltrey) - 3:04
6. "Where Have All the Good Times Gone" -original by The Kinks (Ray Davies) - 02:35

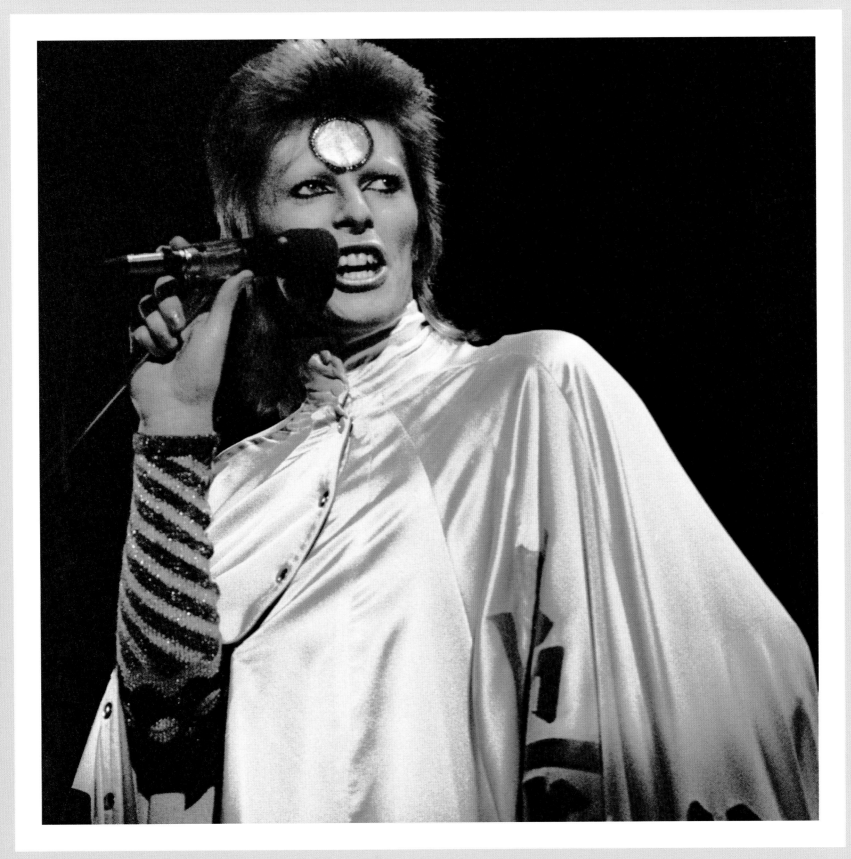

1974

DIAMOND DOGS

RCA:David Bowie. All songs by David Bowie except as noted.

Side One

1. "Future Legend" - 1:07
2. "Diamond Dogs" - 5:58
3. "Sweet Thing" - 3:38
4. "Candidate" - 2:40
5. "Sweet Thing (Reprise)" - 2:32
6. "Rebel Rebel" - 4:33

Side two

1. "Rock 'n' Roll with Me" - 4:01
2. "We Are the Dead" - 4:59
3. "1984" - 3:27
4. "Big Brother" - 3:20
5. "Chant of the Ever Circling Skeletal Family" - 2:03

DAVID LIVE

RCA:Tony Visconti; recorded at Tower Theater, Philadelphia, PA. All songs written by David Bowie except as noted.

Side One

1. "1984" - 3:20
2. "Rebel Rebel" - 2:40
3. "Moonage Daydream" - 5:10
4. "Sweet Thing" (containing "Sweet Thing"/ "Candidate"/"Sweet Thing (Reprise)") - 8:48

Side two

1. "Changes" - 3:34
2. "Suffragette City" - 3:45
3. "Aladdin Sane" - 4:57
4. "All the Young Dudes" - 4:18
5. "Cracked Actor" - 3:29

Side three

1. "Rock 'n' Roll with Me" (lyrics: Bowie, music: Bowie, Warren Peace) - 4:18

2. "Watch That Man" - 4:55 3. "Knock on Wood" (Eddie Floyd, Steve Cropper) - 3:08
4. "Diamond Dogs" - 6:32

Side four

1. "Big Brother" (containing "Big Brother"/"Chant of the Ever-Circling Skeletal Family") - 4:08
2. "The Width of a Circle" - 8:12
3. "The Jean Genie" - 5:13
4. "Rock 'n' Roll Suicide" - 4:30

1975

YOUNG AMERICANS

RCA: Tony Visconti, David Bowie and Harry Maslin. All songs written by David Bowie except where noted.

Side One

1. "Young Americans" – 5:10
2. "Win" - 4:44
3. "Fascination" (Bowie, Luther Vandross) - 5:43
4. "Right" - 4:13

Side two

1. "Somebody Up There Likes Me" - 6:30
2. "Across the Universe" (John Lennon, Paul McCartney) - 4:30
3. "Can You Hear Me" - 5:04
4. "Fame" (Bowie, Carlos Alomar, Lennon) - 4:12

1976

STATION TO STATION

RCA:David Bowie, Harry Maslin. All songs written by David Bowie except where noted.

Side One

1. "Station to Station" - 10:14
2. "Golden Years" - 4:00
3. "Word on a Wing" - 6:03

Side two

1. "TVC 15" - 5:33
2. "Stay" - 6:15
3. "Wild Is the Wind" (Ned Washington, Dimitri Tiomkin) - 6:02

1977

LOW

RCA:David Bowie, Tony Visconti. All tracks written by David Bowie, except where noted.

Side One

1. "Speed of Life" - 2:46
2. "Breaking Glass" (Bowie, Dennis Davis, George Murray) - 1:52
3. "What in the World" - 2:23
4. "Sound and Vision" - 3:05
5. "Always Crashing in the Same Car" - 3:33
6. "Be My Wife" - 2:58
7. "A New Career in a New Town" - 2:53

Side two

1. "Warszawa" (Bowie, Brian Eno) - 6:23
2. "Art Decade" - 3:46
3. "Weeping Wall" - 3:28
4. "Subterraneans" - 5:39

HEROES

RCA:David Bowie, Tony Visconti. All lyrics by David Bowie; all music by David Bowie except where noted.

Side One

1. "Beauty and the Beast" - 3:32
2. "Joe the Lion" - 3:05
3. "'Heroes'" (Bowie, Brian Eno) - 6:07
4. "Sons of the Silent Age" - 3:15
5. "Blackout" - 3:50

Side two

1. "V-2 Schneider" - 3:10
2. "Sense of Doubt" - 3:57

3. "Moss Garden" (Bowie, Eno) - 5:03
4. "Neuköln" (Bowie, Eno) - 4:34
5. "The Secret Life of Arabia" (Bowie, Eno, Carlos Alomar) - 3:46

1978

STAGE

RCA:David Bowie, Tony Visconti. All tracks written by David Bowie except where noted.

Side One

1. "Hang on to Yourself" - 3:26
2. "Ziggy Stardust" - 3:32
3. "Five Years" - 3:58
4. "Soul Love" - 2:55
5. "Star" - 2:31

Side two

1. "Station to Station" - 8:55
2. "Fame" (Bowie, Carlos Alomar, John Lennon) - 4:06
3. "TVC 15" - 4:37

Side three

1. "Warszawa" (Bowie, Brian Eno) - 6:50
2. "Speed of Life" - 2:44
3. "Art Decade" - 3:10
4. "Sense of Doubt" - 3:13
5. "Breaking Glass" (Bowie, Dennis Davis, George Murray) - 3:28

Side four

1. ""Heroes"" (Bowie, Eno) - 6:19
2. "What in the World" - 4:24
3. "Blackout" - 4:01
4. "Beauty and the Beast" - 5:08

1979

LODGER

RCA:David Bowie, Tony Visconti. All lyrics by David Bowie; all music composed by David Bowie and Brian Eno except where noted.

Side One

1. *"Fantastic Voyage"* - 2:55
2. *"African Night Flight"* - 2:54
3. *"Move On"* (Bowie) - 3:16
4. *"Yassassin"* (Bowie) - 4:10
5. *"Red Sails"* - 3:43

Side two

1. *"D.J."* (Bowie, Eno, Carlos Alomar) - 3:59
2. *"Look Back in Anger"* - 3:08
3. *"Boys Keep Swinging"* - 3:17
4. *"Repetition"* (Bowie) - 2:59
5. *"Red Money"* (Bowie, Alomar) 4:17

1980

SCARY MONSTERS (AND SUPER CREEPS)

RCA:David Bowie, Tony Visconti. All songs by Bowie unless noted.

Side One

1. *"It's No Game (Part 1)"* - 4:15
2. *"Up the Hill Backwards"* — 3:13
3. *"Scary Monsters (and Super Creeps)"* - 5:10
4. *"Ashes to Ashes"* - 4:23
5. *"Fashion"* - 4:46

Side two

1. *"Teenage Wildlife"* - 6:51
2. *"Scream Like a Baby"* - 3:35
3. *"Kingdom Come"* (Tom Verlaine) - 3:42
4. *"Because You're Young"* - 4:51
5. *"It's No Game (Part 2)"* - 4:22

1983

LET'S DANCE

RCA:David Bowie, Nile Rogers. All songs by Bowie unless noted.

Side One

1. *"Modern Love"* - 4:46
2. *"China Girl"* (Bowie, Iggy Pop) 5:32
3. *"Let's Dance"* - 7:38
4. *"Without You"* - 3:08

Side two

1. *"Ricochet"* - 5:14
2. *"Criminal World"* (Peter Godwin, Duncan Browne, Sean Lyons) - 4:25
3. *"Cat People (Putting Out Fire)"* (lyrics: Bowie, music: Giorgio Moroder) - 5:09
4. *"Shake It"* - 3:49

ZIGGY STARDUST THE MOTION PICTURE

RCA:David Bowie, Mike Moran. All songs by Bowie unless noted.

Side One

1. *"Hang on to Yourself"* - 2:55
2. *"Ziggy Stardust"* - 3:09
3. *"Watch That Man"* - 4:10
4. *"Wild Eyed Boy From Freecloud"*/*"All the Young Dudes/ Oh! You Pretty Things"* - 6.37.

Side two

"Moonage Daydream" - 6:17
7. *"Space Oddity"* - 4:49
8. *"My Death"* (Jacques Brel, Mort Shuman) - 5:45

Side three

1. *"Cracked Actor"* - 2:52
2. *"Time"* - 5:12
3. *"Width of a Circle"* - 9:35

Side four

1. *"Changes"* - 3:35
2. *"Let's Spend the Night Together"* (Mick Jagger, Keith Richards) - 3:09
3. *"Suffragette City"* - 3:02
4. *"White Light/White Heat"* (Lou Reed) - 4:06
5. *"Rock 'n' Roll Suicide"* - 4:20

1984

TONIGHT

EMI/DB 1 (UK):David Bowie, Derek Bramble & Hugh Padgham

Side One

1. *"Loving the Alien"* (Bowie) - 7:11
2. *"Don't Look Down"* (Iggy Pop, James Williamson) - 4:11
3. *"God Only Knows"* (Brian Wilson, Tony Asher) - 3:08
4. *"Tonight"* (Bowie, Pop) (performed by David Bowie and Tina Turner) - 3:46

Side two

1. *"Neighborhood Threat"* (Bowie, Pop) - 3:12
2. *"Blue Jean"* (Bowie) - 3:11
3. *"Tumble and Twirl"* (Bowie, Pop) - 5:00
4. *"I Keep Forgettin'"* (Jerry Leiber, Mike Stoller) - 2:34
5. *"Dancing with the Big Boys"* (Carlos Alomar, Bowie, Pop) (performed by David Bowie and Iggy Pop) - 3:34

1986

LABYRINTH

EMI:David Bowie, Trevor Jones

1. *"Opening Titles Including Underground"* (Bowie, Jones) - 3:21
2. *"Into the Labyrinth"* (Jones) - 2:12
3. *"Magic Dance"* (Bowie) - 5:13
4. *"Sarah"* (Jones) - 3:12
5. *"Chilly Down"* (Bowie) - 3:46
6. *"Hallucination"* (Jones) - 3:02
7 *"As the World Falls Down"* (Bowie) - 4:51
8. *"The Goblin Battle"* (Jones) - 3:31
9. *"Within You"* (Bowie) - 3:30
10. *"Thirteen O'Clock"* (Jones) - 3:08
11. *"Home at Last"* (Jones) - 1:49
12. *"Underground"* (Bowie) - 5:57

1987

NEVER LET ME DOWN

EMI: David Bowie, David Richards. All songs by Bowie unless noted.

1. *"Day-In Day-Out"* - 4:38
2. *"Time Will Crawl"* - 4:18
3. *"Beat of Your Drum"* - 4:32
4. *"Never Let Me Down"* (Bowie, Carlos Alomar) - 4:03
5. *"Zeroes"* - 5:46
6. *"Glass Spider"* - 4:56
7. *"Shining Star (Makin' My Love)"* - 4:05
8. *"New York's in Love"* - 3:55
9. *"'87 and Cry"* - 3:53
10. *"Too Dizzy"* (Bowie, Erdal Kizilcay) - 3:58
11. *"Bang Bang"* (Iggy Pop, Ivan Kral) - 4:02

1993

BLACK TIE WHITE NOISE

EMI:David Bowie, Nile Rogers. All songs by Bowie unless noted.

1. *"The Wedding"* - 5:04
2. *"You've Been Around"* (Bowie, Reeves Gabrels) - 4:45
3. *"I Feel Free"* (Jack Bruce, Pete Brown) - 4:52
4. *"Black Tie White Noise"* (featuring Al B. Sure!) - 4:52
5. *"Jump They Say"* - 4:22
6. *"Nite Flights"* (Noel Scott Engel) - 4:30
7. *"Pallas Athena"* - 4:40
8. *"Miracle Goodnight"* - 4:14
9. *"Don't Let Me Down & Down"* (Tarha, Martine Valmont) - 4:55
10. *"Looking for Lester"* (Bowie, Nile Rodgers) - 5:36
11. *"I Know It's Gonna Happen Someday"* (Morrissey, Nevin) 4:14
12. *"The Wedding Song"* - 4:29

THE BUDDHA OF SUBURBIA

BMG: David Bowie, David Richards. All songs by David Bowie.

1. *"Buddha of Suburbia"* - 4:28
2. *"Sex and the Church"* - 6:25

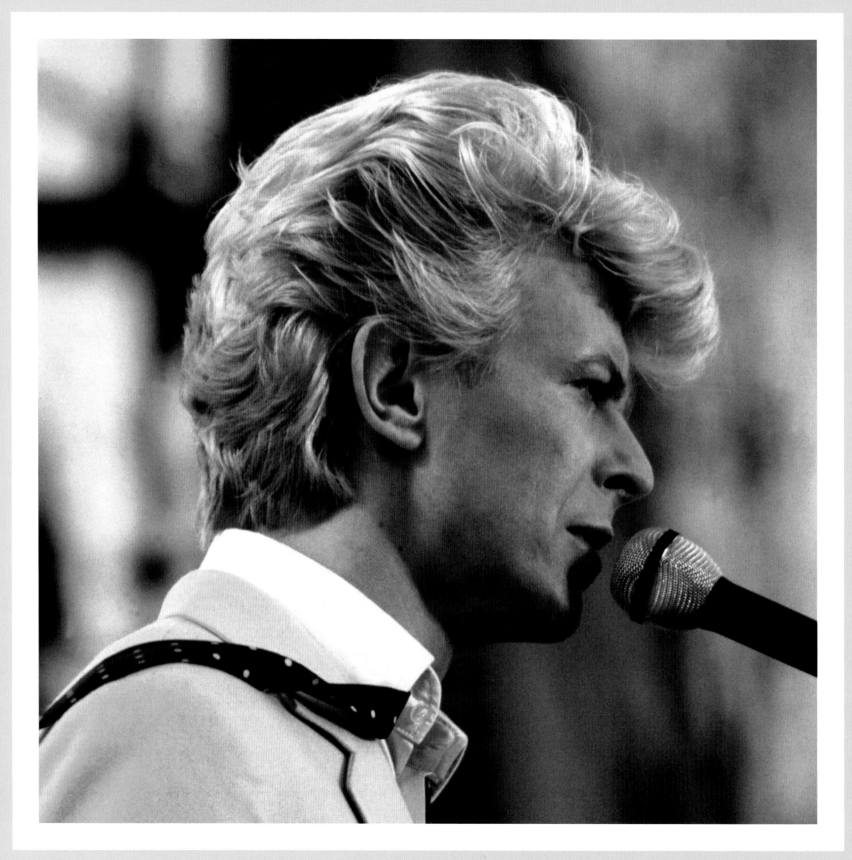

3. "South Horizon" - 5:26
4. "The Mysteries" - 7:12
5. "Bleed Like a Craze, Dad" - 5:22
6. "Strangers When We Meet" - 4:58
7. "Dead Against It" - 5:48
8. "Untitled No. 1" - 5:01
9. "Ian Fish, U.K. Heir" - 6:27
10. "Buddha of Suburbia" (featuring Lenny Kravitz on guitar) - 4:19

1995

OUTSIDE

Arista: All songs by David Bowie and Brian Eno except where indicated. The character performing is named after the track.

1. "Leon Takes Us Outside" Leon Blank (Bowie, Eno, Gabrels, Garson, Kizilcay, Campbell) - 1:25
2. "Outside" Prologue (Armstrong, Bowie) - 4:04
3. "The Hearts Filthy Lesson" Detective Nathan Adler (Bowie, Eno, Gabrels, Garson, Kizilcay, Campbell) - 4:57
4. "A Small Plot of Land" The residents of Oxford Town, New Jersey (Bowie, Eno, Gabrels, Garson, Kizilcay) - 6:34
5. "(Segue) – Baby Grace (A Horrid Cassette)" Baby Grace Blue (Bowie, Eno, Gabrels, Garson, Kizilcay, Campbell) – 1:39
6. "Hallo Spaceboy" Paddy - 5:14
7. "The Motel" Leon Blank – 6:49
8. "I Have Not Been to Oxford Town" Leon Blank - 3:47
9. "No Control" Detective Nathan Adler - 4:33
10. "(Segue) - Algeria Touchshriek" Algeria Touchshriek (Bowie, Eno, Gabrels, Garson, Kizilcay, Campbell) - 4:23
11. "The Voyeur of Utter Destruction (as Beauty)" The Artist/Minotaur (Bowie, Eno, Gabrels) - 4:21
12. "(Segue) - Ramona A. Stone/I Am With Name" Ramona A. Stone and her acolytes (Bowie, Eno, Gabrels,

Garson, Kizilcay, Campbell) - 4:01
13. "Wishful Beginnings" The Artist/Minotaur - 5:08
14. "We Prick You" Members of the Court of Justice - 4:33
15. "(Segue) – Nathan Adler" Detective Nathan Adler (Bowie, Eno, Gabrels, Garson, Kizilcay, Campbell)
16. "I'm Deranged" The Artist/Minotaur - 4:31
17. "Thru' These Architects Eyes" Leon Blank (Bowie, Gabrels) – 4:22
18. "(Segue) – Nathan Adler" Detective Nathan Adler (Bowie, Eno, Gabrels, Garson, Kizilcay, Campbell) - 0:28
19. "Strangers When We Meet" Leon Blank (Bowie) - 5:07

1997

EARTHLING

BMG: David Bowie, Mark Plati, Reeves Gabrels. All lyrics written by David Bowie. All music composed by Bowie, Reeves Gabrels and Mark Plati unless otherwise stated

1. "Little Wonder" - 6:02
2. "Looking for Satellites" - 5:21
3. "Battle for Britain (The Letter)" 4:48
4. "Seven Years in Tibet" (Bowie/Gabrels)- 6:22
5. "Dead Man Walking" (Bowie/Gabrels)- 6:50
6. "Telling Lies" (Bowie)- 4:49
7. "The Last Thing You Should Do" - 4:57
8. "I'm Afraid of Americans" (Bowie/Eno)- 5:00
9. "Law (Earthlings on Fire)" (Bowie/Gabrels) - 4:48

1999

HOURS

Virgin: David Bowie, Reeves Gabrels. All songs by Bowie & Gabrels; track 6 also by Alex Grant.
1. "Thursday's Child" - 5:24

2. "Something in the Air" - 5:46
3. "Survive" - 4:11
4. "If I'm Dreaming My Life" - 7:04
5. "Seven" - 4:04
6. "What's Really Happening?" - 4:10
7. "The Pretty Things Are Going to Hell" - 4:40
8. "New Angels of Promise" - 4:35
9. "Brilliant Adventure" - 1:54
10. "The Dreamers" - 5:14

2002

HEATHEN

ISO/Columbia: David Bowie, Toni Visconti. All songs by Bowie unless noted.

1. "Sunday" - 4:45
2. "Cactus" (Black Francis) - 2:54
3. "Slip Away" - 6:05
4. "Slow Burn" - 4:41
5. "Afraid" - 3:28
6. "I've Been Waiting for You" (Neil Young) - 3:00
7. "I Would Be Your Slave" - 5:14
8. "I Took a Trip on a Gemini Spaceship" (Norman Carl Odam) - 4:04
9. "5:15 The Angels Have Gone" - 5:00
10. "Everyone Says 'Hi'" - 3:59
11. "A Better Future" - 4:11
12. "Heathen (The Rays)" - 4:16

2002

BEST OF BOWIE

EMI/Virgin (US): Producer varies track by track - cross reference to album listings. All songs by Bowie unless noted.

CD One

1. "Space Oddity" (from Space Oddity, 1969) - 5:15
2. "The Man Who Sold the World" (from The Man Who Sold the World, 1970) - 3:55
3. "Oh! You Pretty Things" (from Hunky Dory, 1971) - 3:12

4. "Changes" (from Hunky Dory, 1971) - 3:33
5. "Life on Mars?" (from Hunky Dory, 1971) - 3:48
6. "Starman" (from The Rise and Fall of Ziggy Stardust and the Spiders from Mars, 1972) - 4:16
7. "Ziggy Stardust" (from Ziggy Stardust, 1972) - 3:13
8. "Suffragette City" (from Ziggy Stardust, 1972) - 3:25
9. "John, I'm Only Dancing" (1972) - 2:43
10. "The Jean Genie" (from Aladdin Sane, 1973) - 4:08
11. "Drive-In Saturday" (from Aladdin Sane, 1973) - 4:36
12. "Sorrow" (Bob Feldman, Jerry Goldstein, Richard Gottehrer) (from Pin Ups, 1973) - 2:53
13. "Diamond Dogs" (from Diamond Dogs, 1974) - 6:05
14. "Rebel Rebel" (from Diamond Dogs, 1974) - 4:30
15. "Young Americans" (U.S. single A-side, 1975) - 3:16
16. "Fame" (David Bowie, Carlos Alomar, John Lennon) (from Young Americans, 1975) - 4:17
17. "Golden Years" (single version, 1975) - 3:22
18. "TVC 15" (from Station to Station, 1976) - 5:33
19. "Wild Is the Wind" (Dimitri Tiomkin, Ned Washington) (from Station to Station, 1976) - 6:02

CD two

1. "Sound and Vision" (from Low) 3:00
2. ""Heroes"" (Bowie, Brian Eno) (single version, 1977) - 3:32
3. "Boys Keep Swinging" (Bowie, Eno) (from Lodger, 1979) - 3:18
4. "Under Pressure" (Bowie, Freddie Mercury, Brian May, John Deacon, Roger Taylor) (with Queen, 1981) - 4:02
5. "Ashes to Ashes" (single version, 1980) - 3:38
6. "Fashion" (single version, 1980) 3:23
7. "Scary Monsters (and Super Creeps)" (single version, 1981) - 3:27

8. "Let's Dance" (single version, 1983) - 4:07

9. "China Girl" (Bowie, Jim Osterberg) (single version, 1983) - 4:18

10. "Modern Love" (single version, 1983) - 3:56

11. "Blue Jean" (from Tonight, 1984) - 3:12

12. "This Is Not America" (with The Pat Metheny Group, 1985) - 3:43

13. "Loving the Alien" (single remixed version, 1985) - 4:43

14. "Dancing in the Street" (Marvin Gaye, William "Mickey" Stevenson, Ivy Jo Hunter) (with Mick Jagger, 1985) - 3:14

15. "Absolute Beginners" (single version, 1986) - 5:39

16. "Jump They Say" (radio edit, 1993) - 3:53

17. "Hallo Spaceboy" (Bowie, Eno) (Pet Shop Boys remix, 1996) - 4:25

18. "Little Wonder" (Bowie, Reeves Gabrels, Mark Plati) (single version, 1997) - 3:40

19. "I'm Afraid of Americans" (Bowie, Eno) (V1 radio edit, 1997) - 4:26

20. "Slow Burn" (radio edit, 2002) - 3:55

2003

REALITY

ISO/Columbia: Toni Visconti, David Bowie. All songs by Bowie unless noted.

1. "New Killer Star" - 4:40
2. "Pablo Picasso" (Jonathan Richman) - 4:06
3. "Never Get Old" - 4:25
4. "The Loneliest Guy" - 4:11
5. "Looking for Water" - 3:28
6. "She'll Drive the Big Car" - 4:35
7. "Days" - 3:19
8. "Fall Dog Bombs the Moon" - 4:04
9. "Try Some, Buy Some" (George Harrison) - 4:24
10. "Reality" - 4:23
11. "Bring Me the Disco King" - 7:45

2008

LIVE SANTA MONICA '72

EMI: Recorded Civic Auditorium, Santa Monica, CA. All songs by Bowie unless noted.

1. Introduction - 0:13
2. "Hang on to Yourself" - 2:46
3. "Ziggy Stardust" - 3:23
4. "Changes" - 3:27
5. "The Supermen" - 2:55
6. "Life on Mars?" - 3:28
7. "Five Years" - 4:32
8. "Space Oddity" - 5:05
9. "Andy Warhol" - 3:50
10. "My Death" (Eric Blau, Mort Shuman, Jacques Brel) - 5:51
11. "The Width of a Circle" - 10:44
12. "Queen Bitch" - 3:00
13. "Moonage Daydream" - 4:53
14. "John, I'm Only Dancing" - 3:16
15. "I'm Waiting for the Man" (Lou Reed) - 5:45
16. "The Jean Genie" 4:00
17. "Suffragette City" - 4:12
18. "Rock 'n' Roll Suicide" - 3:01

GLASS SPIDER LIVE

Immortal Records: Recorded at Sydney Entertainment Centre, Sydney, Australia. All songs by Bowie unless noted.

1. Intro/Up the Hill Backwards/Glass Spider - 9:48
2. Day-In Day-Out - 4:35
3. Bang Bang (Iggy Pop, Ivan Kral)
4. Absolute Beginners - 7:00
5. Loving the Alien - 7:13
6. China Girl (Bowie, Pop) - 4:56
7. Rebel Rebel - 3:46
8. Fashion - 5:00
9. Never Let Me Down (Bowie, Carlos Alomar) - 3:58
10. "Heroes" (Bowie, Brian Eno) - 4:28
11. Sons of the Silent Age - 3:08
12. Young Americans/Band

Introduction - 5:00
13. The Jean Genie - 6:01
14. Let's Dance - 4:56
15. Time - 5:10
16. Fame (Bowie, John Lennon, Alomar) - 6:50
17. Blue Jean - 3:53
18. I Wanna Be Your Dog (Pop, Ron Asheton, Scott Asheton, Dave Alexander) - 3:53
19. White Light, White Heat (Lou Reed) - 3:56
20. Modern Love - 3:43

2009

VH1 STORYTELLERS

EMI: Recorded live at the Manhattan Center, New York. All songs by Bowie unless noted.

1. "Life on Mars?" - 4:22
2. "Rebel Rebel" (truncated) - 3:15
3. "Thursday's Child" (Bowie, Reeves Gabrels) - 6:43
4. "Can't Help Thinking About Me" - 6:31
5. "China Girl" (Bowie, Iggy Pop) - 6:48
6. "Seven" (Bowie, Gabrels) - 5:01
7. "Drive-In Saturday" - 5:22
8. "Word on a Wing" - 6:35

2010

A REALITY TOUR

ISO/Columbia: Jerry Rappaport. Recorded live at the Point Theatre, Dublin. All songs by Bowie unless noted.

1. "Rebel Rebel" - 3:30
2. "New Killer Star" - 4:59
3. "Reality" - 5:08
4. "Fame" (Bowie, John Lennon, Carlos Alomar) - 4:12
5. "Cactus" (Black Francis) - 3:01
6. "Sister Midnight" (Bowie, Alomar, Iggy Pop) - 4:37
7. "Afraid" - 3:28
8. "All the Young Dudes" - 3:48

9. "Be My Wife" - 3:15
10. "The Loneliest Guy" - 3:58
11. "The Man Who Sold the World" - 4:18
12. "Fantastic Voyage" (Bowie, Brian Eno) - 3:13
13. "Hallo Spaceboy" (Bowie, Eno) - 5:28
14. "Sunday" - 7:56
15. "Under Pressure" (Bowie, Freddie Mercury, John Deacon, Brian May, Roger Taylor) - 4:18
16. "Life on Mars?" - 4:40
17. "Battle for Britain (The Letter)" (Bowie, Reeves Gabrels, Mark Plati) - 4:55

Disc two
1. "Ashes to Ashes" - 5:46
2. "The Motel" - 5:44
3. "Loving the Alien" - 5:17
4. "Never Get Old" - 4:18
5. "Changes" - 3:51
6. "I'm Afraid of Americans" (Bowie, Eno) - 5:17
7. ""Heroes"" (Bowie, Eno) - 6:58
8. "Bring Me the Disco King" - 7:56
9. "Slip Away" - 5:56
10. "Heathen (The Rays)" - 6:24
11. "Five Years" - 4:19
12. "Hang on to Yourself" - 2:50
13. "Ziggy Stardust" - 3:44
14. "Fall Dog Bombs the Moon" - 4:11
15. "Breaking Glass" (Bowie, Dennis Davis, George Murray) - 2:27
16. "China Girl" (Bowie, Pop) - 4:18

SINGLES

Title is followed by Bowie's alternate identity or collaborator

1964

"Liza Jane" - Davie Jones with the King Bees

1965

"I Pity the Fool" - The Mannish Boys
"You've Got a Habit of Leaving" - Davy Jones & the Lower Third

1966

"Can't Help Thinking About Me"
Davy Jones & the Lower Third
"Do Anything You Say"
"I Dig Everything"
"Rubber Band"

1967

"The Laughing Gnome"
"Ragazzo Solo, Ragazza Sola"

1970

"The Prettiest Star"
"Memory of a Free Festival"

1971

"Holy Holy"
"Moonage Daydream"- part of Arnold Corns
"Hang On to Yourself" - part of Arnold Corns

1972

"Changes"
"Starman"
"John, I'm Only Dancing"
"The Jean Genie"

1973

"Drive-In Saturday"
"Time"
"Life on Mars?"
"Let's Spend the Night Together"
"Sorrow"

1974

"Rebel Rebel"
"Rock 'n' Roll Suicide"
"Diamond Dogs"
"Knock on Wood"
"Rock 'n' Roll with Me"

1975

"Young Americans"
"Fame"
"Golden Years"

1976

"TVC 15"
"Suffragette City"
"Stay"

1977

"Sound and Vision"
"Be My Wife"
"'Heroes'"

1978

"Beauty and the Beast"
"Breaking Glass"

1979

"Boys Keep Swinging"
"DJ"
"Yassassin"
"Look Back in Anger"
"John, I'm Only Dancing (Again)"

1980

"Alabama Song"
"Crystal Japan"
"Ashes to Ashes"
"Fashion"

1981

"Scary Monsters (and Super Creeps)"
"Up the Hill Backwards"
"Under Pressure" with Queen
"Wild Is the Wind"

1982

"Cat People (Putting Out Fire)"
"Peace on Earth/Little Drummer Boy" - with Bing Crosby

1983

"Let's Dance"
"China Girl"
"Modern Love"
"Without You"
"White Light/White Heat"

1984

"Blue Jean"
"Tonight" - with Tina Turner

1985

"This Is Not America" - with Pat Metheny Group
"Loving the Alien"
"Dancing in the Street" - with Mick Jagger

1986

"Absolute Beginners"
"Underground"
"Magic Dance"
"When the Wind Blows"

1987

"Day-In Day-Out"
"Time Will Crawl"
"Never Let Me Down"

1989

"Under the God" - as part of Tin Machine
"Tin Machine" / "Maggie's Farm (live)" - part of Tin Machine
"Prisoner of Love" - part of Tin Machine

1990

"Fame '90"

1991

"You Belong in Rock 'n' Roll" - part of Tin Machine
"Baby Universal" - as of Tin Machine
"One Shot" - part of Tin Machine

1992

"Real Cool World"

1993

"Jump They Say"

"Black Tie White Noise" - with Al B. Sure!
"Miracle Goodnight"
"The Buddha of Suburbia" - with Lenny Kravitz

1994

"Ziggy Stardust"
1995

"The Hearts Filthy Lesson"
"Strangers When We Meet" / "The Man Who Sold the World (live)"

1996

"Hallo Spaceboy"
"Telling Lies"

1997

"Little Wonder"
"Dead Man Walking"
"Seven Years in Tibet"
"Pallas Athena" - Tao Jones Index
"I'm Afraid of Americans"
I Can't Read

1999

"Without You I'm Nothing" - with Placebo
"Thursday's Child"
"The Pretty Things Are Going to Hell"

2000

"Survive"
"Seven"

2002

"Slow Burn"
"Everyone Says 'Hi'"
"I've Been Waiting for You"

2003

"New Killer Star"

2004

"Never Get Old"
"Rebel Never Gets Old"

2006

"Arnold Layne" - with David Gilmour

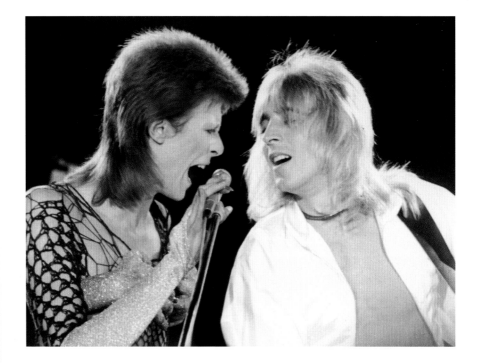